VOYAGING OUT

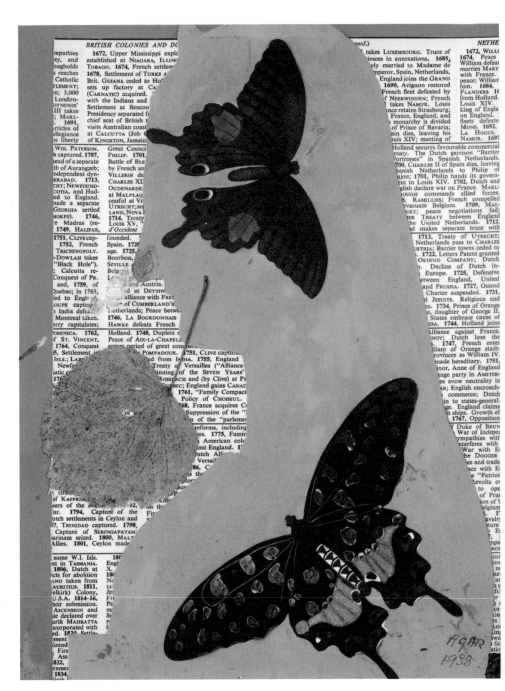

Carolyn Trant

VOYAGING OUT

BRITISH WOMEN ARTISTS FROM SUFFRAGE TO THE SIXTIES

 Thames & Hudson

Dedicated to the memory of my great-grandmother Clara Legge (1881–1980), who named one of her daughters after Sylvia Pankhurst, and to Cynthia Heymanson Buckwell (1944–2013).

Page 2: Eileen Agar, *Butterfly Bride*, 1938. Collage on paper.

First published in the United Kingdom in 2019 by
Thames & Hudson Ltd, 181A High Holborn, London WC1V 7QX

Voyaging Out: British Women Artists from Suffrage to the Sixties
© 2019 Thames & Hudson Ltd, London
Text © 2019 Carolyn Trant

Development edit by James Attlee
Design by Karolina Prymaka

British Library Cataloguing-in-Publication Data
A catalogue record for this book is available from the British Library

ISBN 978-0-500-02182-8

Printed in China by RR Donnelley

To find out about all our publications, please visit
www.thamesandhudson.com. There you can subscribe to our e-newsletter, browse or download our current catalogue and buy any titles that are in print.

CONTENTS

INTRODUCTION

It is probable...that both in life and art, the values of a woman are not the values of a man. When a woman comes to write a novel she will find that she is perpetually wishing to alter the established values – to make serious what appears to be insignificant to men, and trivial what is to him important...

Virginia Woolf, 'Women and Fiction', 1929

Stories about artists have been popular since the time of Vasari, but the 'history' of the art of the first half of the twentieth century seems rather skewed by the absence of a coherent narrative about those artists who were women. Of course, like the 'discovery' of America, they were there all the time, and many are currently being discovered by way of exhibitions and catalogues, to much surprise and delight. This book aims to put the lives and work of British women artists of that period into some form of context.

Written by an artist rather than a critic or historian, *Voyaging Out* examines women's contributions to visual culture from a female perspective. Considering women working in a variety of artistic practices, the book looks at who knew whom, what ideas they might all have been discussing, the effect of topography on their artworks; it discusses war, significant others and how belonging to artist groups affected work, fame and fortune.

The subject headings are a hook on which to hang women's stories. Some of the women were known to me, often in one way or another through my long association with Peggy Angus. They all seemed strong and idealistic, many with a reckless generosity and hospitality, and were enormous fun; how could they, who had such breadth of knowledge themselves, not now be better known?

The shadow of Peggy Angus hovers over this book in many ways. She would doubtless be delighted by the manner in which artists such

as Grayson Perry and Jeremy Deller are now, as she did, rattling the cage. Like Peggy, these artists show real respect for all kinds of work, and the different reasons for making it. Artists today are branching out into curating, writing and making television series; now is a time for rethinking art, and its history and presentation, too.

Context aids our understanding and appreciation of art but it can also be a curse when life stories start to overwhelm the artworks. Tragedy – Nina Hamnett's descent into alcoholism, Dora Carrington's suicide – can overshadow a productive output. But so can women artists' work be overshadowed by that of male artists, particularly when the language of art 'movements', with their leaders and disciples, skews discussion. This survey, looking at the lives of women in dialogue with their work, is an affirmative one.

In *The Voyage Out*, Virginia Woolf's first female heroine journeys towards the realization of her sense of self, raising questions about what being a woman might mean. Do Woolf's ideas in 'Women and Fiction' about the tension between women's values and men's still ring true? And does it apply to the visual arts as much as to fiction? Many of the artists in this book would have disputed that their work was fundamentally different from men's; others might have agreed. Linda Nochlin was possibly right when she asserted in 1988 that there is often a different kind of 'greatness' for women's art than for men's. I leave it to the reader to decide.

Chapter 1

DAUGHTERS OF THE SUN
the life class

Virginia Woolf saw December 1910 as the moment when the decline of Liberal, patriarchal, Imperialist England began and 'human character changed';[1] but it may have been presaged two years earlier when Lytton Strachey queried a stain on her sister Vanessa's dress. '"Semen?" he said. Can one really say it? I thought and we both burst out laughing. With that one word all barriers of reticence and reserve went down.'[2] 1910 was also the year of Roger Fry's exhibition 'Manet and the Post-Impressionists' at the Grafton Galleries in London, during a year marked by intensified, militant suffrage campaigns and the emergence of the New Woman.

Changes in the opportunities available for women in both work and leisure were accelerated by the outbreak of war. Married women had benefited from increasing social and financial independence following the Married Women's Properties Acts passed between 1870 and 1893. Being single was no escape from family responsibilities: all women were expected to care for elderly parents. Even the more enlightened girls' schools encouraged an ethos of female self-sacrifice that inhibited the sense of total immersion in work that is vital to creativity.

Women painters during this period were routinely dismissed as 'amateurs' or hobbyists, and professional artistic training for women was limited, if not prohibited. While many women considered themselves professional artists, the allocation of scholarships and exhibition opportunities always favoured the men. Women with private income who could afford to fund their vocation were still damned, because 'being professional' was understood to mean 'supporting yourself from the sale of your work'. At the heart of the matter lay attitudes to the body. Until the 1960s, the teaching of painting in art school was based on the study of the nude, and for women this presented a problem. Men and women were segregated in art classes and women were usually only allowed to

work from plaster casts or a 'semi-draped' human figure, exposure to flesh being considered a threat to their emotional and 'innately hysterical natures'. Women therefore received an inferior education in cramped, crowded studios, while male students received preferential treatment; segregated classes continued in many major art schools until after the Second World War. Meanwhile, Irish artists of both sexes had to travel to London or Europe to take part in life-drawing classes – they were unheard of in Ireland.

A previously little-discussed aspect of the way professional artists made studies for paintings during the period was the use of life-size jointed mannequins. A male model would pose with the female mannequin and a female model with the male, so that the two living subjects would never be in dangerous proximity. These antiquated practices were an embarrassment to Pre-Raphaelite artists, who prided themselves on their realism and truth to nature. It is little wonder nineteenth-century paintings of figure groups can seem so stilted. Once the government began to fund art schools such as the Royal College of Art (RCA), moral outrage around the issue of nude female models increased; there was even debate in Parliament about whether it was more titillating for models to be nude or partially clothed. Male artists hated having women in their life classes because their presence meant male models were obliged to wear a posing pouch. Around 1922, Peggy Angus began a campaign at the RCA – 'down with the Codpiece' – but got nowhere beyond receiving a private lecture on the unpredictability of male anatomy.

The end of the First World War in 1918 was supposed to have ushered in a new openness about bodies, modern warfare having done much to render old etiquettes redundant; however, the popular notion of the artist and 'his' model (even though many models were men) still contributed a morally suspect air to the profession. In 1879, Annie Swynnerton, a Manchester-born painter, and her lifelong friend the painter and suffragist Susan Isabel Dacre founded the Manchester Society of Women Painters. Its aims were to allow women to study the figure from life in women-only classes; to create more opportunities for them to exhibit their work; and to train women teachers who would question the whole direction of art and the way it was taught.

The work of three women, born between 1877 and 1890 – one a social and political reformer, one a bohemian and one a professional

artist – illustrates how attitudes to the depiction of people were changing and introduces ideas about social class, topography and friendship that will run like a thread through this book. These women artists were Sylvia Pankhurst, Nina Hamnett and Laura Knight.

Given her fame as a political activist and a campaigner for women's rights, most people do not immediately think of Sylvia Pankhurst as an artist, but a display at Tate Britain in 2013[3] did much to reintroduce her work to the art world. Both as an artist and as an individual her social and political ideals diverged increasingly from those of her mother, the suffragist Emmeline Pankhurst, and her sister Christabel, particularly over their neglect of the needs of working-class women. Sylvia Pankhurst was influenced early on by her father's friends, the artists and socialists Walter Crane and William Morris, and by the Pre-Raphaelites, an artistic movement originally full of social idealism. She won a free place at Manchester School of Art in 1899, a scholarship to the RCA in London and a travelling scholarship to Italy, where she was the only woman in the life class at the Accademia in Venice. Her feeling for social realism encouraged her out onto the street, where she made studies and paintings of people in everyday life.

Sylvia's studies in Venice were cut short when her mother became ill. She returned to London, using her rented room to hold a self-help life-drawing class for women and starting a campaign about the injustice of the proportion of scholarships to art school available to them. She persuaded Keir Hardie, then leader of the Labour Party, with whom she had secretly begun a serious intellectual and intimate relationship, to bring the issue up in the House of Commons, but with little success. (Two portrait sketches she did of Hardie were later donated to the National Portrait Gallery, although she was not happy with either of them.)

She chose to become the official artist and designer of the Women's Social and Political Union (WSPU) as new campaigns began in earnest in London, using the WSPU's symbolic colours of purple, white and green, representing dignity, purity and hope. Creating an immediately recognizable visual identity in this way was a relatively new concept, but her murals still had a foot in the nineteenth century: 6-metre (20-foot)-high canvases of women sowing grain and harvesting corn, featuring angels and doves, they had none of the formal dynamics characteristic of the revolutionary art being produced in Russia at the same time. Instead,

they related more closely to contemporaneous artistic trends in Germany, where Käthe Kollwitz was using similar symbolic imagery as a rallying cry against the working conditions faced by weavers. The content of her work was a riposte to the anti-suffrage portrayal of women as strident viragos who neglected their children, at a time when the WSPU was trying to gain more middle-class support. Her use of religious and agricultural imagery countered the argument that feminism was against the laws of nature and religion. Sylvia nonetheless struggled to find a balance in her work between the demands of aesthetics and politics, attempting to negotiate the unclear and contested line between art and propaganda.

Travelling across the country in 1907 for a project called Working Women in Britain, Sylvia made realistic paintings and pastels, horrified to see the conditions experienced by workers of both sexes in industry. Her art became her way of bearing witness, showing the monotony of the repetitive work done by women, from packing fish to stooking corn; enduring the heat of the mills or cold in the fields. By 1910, increasingly radical in her politics and associated with the Independent Labour Party (ILP), she became torn between her art and her political commitment, between social realism and allegory. Moreover, as an anti-capitalist she hated selling her work to rich patrons.

Imprisoned in 1913 as a result of her campaigning and subjected to being force-fed, Sylvia made sketches that were disseminated to the press on her release, exposing the harsh practices she had seen in jail. Much of the work in her studio was destroyed while she was in prison, suggesting it was regarded by the authorities as inflammatory; a century on, two of her paintings are included in the Parliamentary Art Collection.

Art and sexual politics were becoming increasingly intertwined during this period. In 1914 Mary Richardson, a Canadian artist living in Bloomsbury, slashed the Velázquez painting known as *The Rokeby Venus* (1647) with an axe she had smuggled into the National Gallery under the guise of doing some sketching. 'I have tried to destroy the picture of the most beautiful woman in mythological history as a protest against the Government for destroying Mrs Pankhurst'[4] she subsequently wrote to the press, shouting at the police as she was led away: 'you can get another picture but you cannot get another life'. Richardson's act was a symbolic gesture of defiance against patriarchy, the seventeenth-century

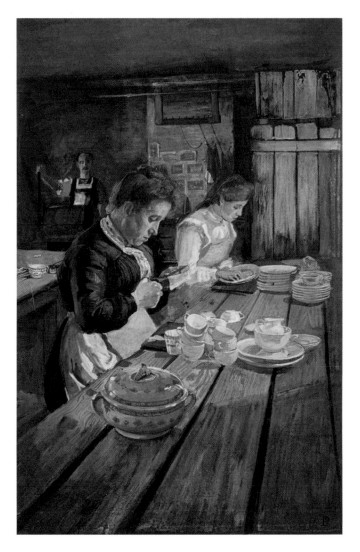

Sylvia Pankhurst, *Old Fashioned Pottery: Transferring the Pattern onto the Biscuit*, 1907. Bodycolour. Hand-painting pottery was skilled work, but poorly paid.

picture of idealized female beauty serving as a symbol of male fantasy embodied in both the artist and contemporary male viewers. Unsurprisingly, copycat actions failed to get much public support, even from men who agreed with the suffrage campaign. *Blast*, the avant-garde journal edited by artist Wyndham Lewis, ran a patronizing open letter that urged protestors to 'stick to what you understand…leave works of art alone'.[5]

Sylvia, a committed pacifist, was against attacks on either art or property. Once the war began she largely gave up her artistic career to pursue a 'better world for humanity'.[6] Much loved by the East End poor, she campaigned vigorously for the rights of working people, using her creative skills to set up a toy factory for unemployed women. Setting up a new nursery school she declared 'if there were no legal marriage there would be no illegitimate children'.[7] Towards the end of the war she began a thirty-year relationship with the Italian printer and typographer Silvio Corio, an anarchist who had been expelled from Europe and was as politically commited as she was. Charged with sedition in 1921, she quoted the artists William Morris and William Blake in her defence. She gave birth to her first child, Richard, at the age of forty-five, still without marrying, and became heavily involved in supporting Ethiopia (then Abyssinia) in its struggle against the encroachment of fascist Italy. She remained passionately engaged with the Ethiopian cause, eventually moving to live in Addis Ababa, taking her paints with her; she died there in 1960. In the 1950s Winsor & Newton planned to include her in their list of 'Britain's Most Distinguished Amateur Artists' but she declined the honour. 'The designation hardly applies to me', she wrote, 'who gave up her profession in the hope of becoming more useful and the idea does not appeal to me much...I would like to be remembered as a Citizen of the World.'[8] Her example provokes a very topical discussion about where the responsibilities of artists lie.

Married Love, a study of female sexuality and desire written by British academic Marie Stopes, argued for equality in marriage. First published in London in 1918, it sold out its first printing within a fortnight but remained banned as obscene in the USA until 1931. As a young newlywed Stopes had been so ignorant about sex that she didn't realize her marriage had never been consummated and she was determined to educate other young women. The writings of British physician and sexologist Havelock Ellis on homosexuality had been widely disseminated, but the vogue during this period for women dressing 'mannishly' was often as much about labelling oneself a new independent woman as it was about lesbianism, which in any case was not illegal. Rebecca West, the writer and suffragist, wrote a story for *Blast* about the hypocrisy of marriage, and journals such as *The Free Woman* criticized it as a form of legalized prostitution, some radical quarters denouncing it further as 'legalized

breeding' dependent on an 'old morality'. West's son Anthony was born in 1914 out of wedlock after her affair with the novelist H. G. Wells.

A bohemian forerunner of the women artists included in this book was the painter Gwen John. Studying at the Slade in the 1890s and then in Paris with American painter Whistler, she had an intense affair with the sculptor Rodin, subsequently living her own independent life as a single woman in France. The unrelenting fecundity of her brother Augustus's entourage was one of the reasons she gave for her decision not to return to England. In her own words, Gwen had a 'passionate selfishness', which stood her in good stead, both in her life and in the pursuit of her artistic career.

A very different personality to emerge during this period was Nina Hamnett, one of the bohemian set who were as famous for being muses and models as artists and whose experimentation with personal freedoms often overshadowed their work. For a woman, being wild at this time often meant just being outside without a hat, smoking and wearing make-up, as the Café Royal set of women artists loved to do to shock the passers-by. For more sensationalist accounts of art history, Hamnett falls into a category usually occupied by male artists: promiscuous, often drunk, her career was ended by her tragic death in 1956 when she fell, by accident or design, from a window onto railings below.

That she was actually a very good painter is a detail in her biography that is often overlooked. Her portrait of Dolores Courtney reveals her as a serious artist, one who had seen and studied the post-impressionist exhibitions (1910 and 1912/13) of Roger Fry. Courtney was working as an artist at the Omega Workshops, London, between 1915 and 1917, where Hamnett was engaged in making and decorating fabrics, rugs, clothes, murals and furniture. Hamnett's sometime-husband, the Norwegian Roald Kristian, better known by his adoptive name of Edgar, was also at the studios, creating woodcuts that reveal a familiarity with the work of contemporary German artists like Franz Marc. From a Spanish family, Courtney was born in Russia but had studied in Paris; to the London of 1914 she brought knowledge of both French and Russian contemporary art before returning to Paris in 1920. The Omega Workshops were a melting pot of new ideas.

Unlike Sylvia Pankhurst, Hamnett, born in Wales, had a chequered family life, attending local art schools at a very early age, supporting

Dolores Courtney, *Le Samedi*, 1917. Oil on canvas. Fry liked his students to copy the Old Masters but Courtney chose to copy a Derain, whose work was very well thought of into the 1920s.

herself by modelling or giving tuition privately to individual pupils. Later she took over the classes previously taught by Walter Sickert at the Westminster School of Art. At twenty-one, new access to a small stipend allowed her a limited independence and she lived hand to mouth, cultivating an extraordinary circle of wealthy and aristocratic patrons who would bail her out on occasion, both with accommodation and with cast-off dresses that she wore with panache. She met Aleister Crowley in Paris and 'presented her virginity' to a young acolyte of his – 'previously ignorant' she 'didn't think much of it', except in terms of 'a sense of spiritual freedom and that something important had been accomplished'.9 Paris became her second home from before the outbreak of the First World War until 1926 and she was the best-known British woman painter in the city, although her paintings were too realist for French taste.

Her devil-may-care attitude endeared her to people of all social classes and her work revealed her genuine interest in her fellow human beings. The *joie de vivre* of her two memoirs *Laughing Torso* (1932) and

Is She a Lady? (1955) only makes her subsequent decline into poverty, squalor and alcoholism more tragic. Her 'psychological portraits' were an attempt to 'represent accurately the spirit of the age'. Fred Etchells called her an 'avid spider' who 'pounces on every vital trait of her sitters'.[10] Roger Fry, her one-time lover, painted her and it is now suggested that, as a sort of unofficial ambassador between London and Paris in the 1910s and 1920s, she had some influence on his work. They both drew each other nude, but Hamnett would not have been easily able to exhibit her drawings of him at the time.

The title of Hamnett's memoir *Laughing Torso* is borrowed from a small sculpture by French artist Henri Gaudier-Brzeska, made of her in Paris from a stolen fragment of marble from a mason's yard. Before he tragically died in the First World War, Gaudier-Brzeska gave her some sound advice. 'Don't mind what people say to you,' he told her, opposed as always to what he called the *sale bourgeois*, 'find out what you have in yourself and do your best, that is the only hope in life.' After she had posed for him in the nude for the sculpture he had immediately stripped off his own clothes and posed for her in return. She had escaped England and its small-mindedness.

In 1915, following her brief marriage to Edgar (entered into to help him stay in England), she became pregnant, but was so malnourished that her baby son, born two months premature, died soon after birth. She makes no mention of the baby in her memoirs. Monogamy, she declared, didn't suit her. Sex, from which she apparently gained little satisfaction, was primarily a matter of companionship; bi-sexual, she was actually rather indifferent to grand passions. James Joyce called her 'one of the few vital women he had ever met', but for her the border between life and art became increasingly blurred.

One work in particular – *Acrobats*, dating from 1910 – could be seen as prophetic in its imagery of display and instability, but it is also glorious in its colour, its bravado and the dynamics of its composition. Hamnett shared a hotel room for a time with an acrobatic dancer from Anna Pavlova's troupe, as well as two monkeys and a snake, recalling: 'I found the circus people most charming and unpretentious...and very cosmopolitan.'[11]

Close friendships with Fry, Sickert and fellow Welshman Augustus John should have ensured a continuing reputation for her early work.

Nina Hamnett, *Acrobats*, 1910. Oil on canvas.

Sickert reviewed her first solo exhibition, saying 'she draws like a born sculptor...and paints like a born painter. Either gift is rare.' Her extensive collection of press cuttings about her work was always important to her. On one early cutting she later pencilled: 'It was a pity I had no one to back me in those days otherwise I might have been Dame Laura Hamnett.'

Laura Knight pursued her artistic career in a more dedicated and professional way than Nina Hamnett, but she incorporated her own life into her work as Hamnett did. Although not as overtly political as Sylvia Pankhurst, she fought her own battles with artistic institutions and societal prejudices. Another devotee of circus life, she quotes circus performer 'Joe' in her memoir *A Proper Circus Omie*: 'Just look Laura at all those people who seem hardly able to put one foot in front of the

other as they trudge along,' he tells her. 'I am over fifty myself now, but I can't ever forget the time when I'd look at such a crowd and say to myself: You walk the ground – I walk the air.'[12] Of course, any high-wire performer runs the risk of coming crashing to the ground as Hamnett eventually did.

Knight is now chiefly remembered for her drawings of dancers, circus people and gypsies and for the painting *Ruby Loftus Screwing a Breech Ring*, an image of a young woman working in a munitions factory completed as a war artist in 1943. She remained firmly in the realist, figurative tradition; largely self-taught, she was born in 1877 and was therefore much older than many of the women included in this book, yet her early work is already much freer and fresher than most late-Victorian painting.

Her career was marked by many 'firsts'. She was the only female artist to be given war artist commissions in both world wars and in 1946, at the age of sixty-nine, the only British artist commissioned to cover the Nuremberg trials (see page 187). Exhibiting at the Royal Academy of Arts (RA) continuously from 1903 to 1970, she was the first woman to have a retrospective exhibition there in 1965 and she exhibited more pictures there than any other artist.When she became a Dame of the British Empire in 1929, at a time when such awards were seldom bestowed, it was recognition that through her success she had improved the status of women artists and was now a household name in her own right. Paradoxically, however, the fact she became the first woman Associate Member of the Royal Academy (ARA) in 1930, and a full Royal Academician in 1936, led to her later being seen as the epitome of a conservative academic painter, when she regarded herself, with some justification, as a modern realist. Her particular interest in what might be called ordinary working people, maintained throughout her life, was merely a different kind of modernism.

Her decision, as part of a hanging committee at the RA, to reject a painting by Wyndham Lewis – his controversial portrait of T. S. Eliot – led her to have a big falling out with the artist Augustus John, resulting in his resignation from the Academy while she stayed on. It was a disappointing episode from an artist who had always challenged authority herself, but is possibly an understandable instance of conformity in someone who had spent many years never knowing where her next

meal was coming from. She always stood up for her beliefs as a feminist, however. In a letter in response to the Master of Eton's comments about the lack of great women artists in the *Nottingham Evening Post* in 1930, she wrote that it was a 'lack of encouragement and opportunity, not ability' that denied women greatness.

Knight knew about Roger Fry and the Bloomsbury set, but she mistrusted the self-confidence of their class and background. Her interest in gypsies, shared by many artists of the period, reveals her to be an unselfconscious bohemian and egalitarian. Her personality allowed her to mix with anyone. Romany are the supreme anti-capitalists, their tradition dictating that all their worldly goods are burnt along with their caravans at their death. Rather than indulgence in a form of exoticism, Laura's many portraits of the Romany community were made with their full collaboration and approval. The relaxed poses of the circus performers she portrayed with respect showed that they too were comfortable in her company.

The idea of the wandering life has always been appealing and Knight's artwork was often about movement. From the start she liked to work from moving models, typically an informal group of figures on a windy beach. She was fascinated by dance, even taking dancing lessons herself with one of her favourite models, a Tiller Girl who set up a *barre* in her studio. Dancing was important across social classes in the early years of the twentieth century, from ordinary people enjoying themselves to new and avant-garde dance forms emerging in artistic circles. Isadora Duncan, famed for her free-flowing clothes and movements, was in London around 1900, while the Ballets Russes was touring Europe from 1909. Painting dancers and circus performers had to be done at great speed and from the beginning of her career Knight liked to paint directly onto canvas without preliminary drawing, a break with standard academic practice. Moving pictures in the cinema were also a new and dynamic influence; in 1884 the Lumière brothers had invented the cinematograph, their first 46-second film showing workers leaving factories at the end of the day. Over a thousand picture halls opened in London in the following decades, spreading to the provinces too, and cinema influenced artists of the vorticist and futurist movements.

Born in the Midlands into a modest working-class family, Laura had been a strong-willed, physically robust child, criticized at Nottingham

School of Art for being too vigorous and 'un-feminine'; much later, the term used to describe her was 'irrepressible'. Such women fulfilled the worst fears of anti-suffragists, who felt the natural order of things was being overturned. The art tuition she received was limited. At Nottingham School of Art she met star student Harold Knight and learnt much from his painstaking dedication. They decided to marry in 1903, after Laura sold her picture *Mother and Child* to the RA and Harold received a large and well-paid commission.

When she was only seventeen, Laura had been excited by an exhibition of the Newlyn, St Ives and Falmouth Artists in Nottingham in 1894. Artists' colonies – like the Barbizon School in France and the Hague School in Holland – had been set up across Europe in the late nineteenth century, in which artists painted the lives of the rural poor in reaction to the academic vacuity of the art establishment of the time. The Knights visited Holland several times, where Laura also had the opportunity to see paintings by Vincent Van Gogh, but she didn't understand the intensity of his vision. The couple moved to an artist colony in Staithes on the harsh North Yorkshire coast, where they could live cheaply; Laura took in private students to make ends meet and made studies of women and children in the fishing community. Laura Knight began exhibiting at the Leicester Galleries in London, before another move in 1907 to the livelier artistic community of Newlyn in Cornwall and then to nearby Lamorna Cove, where both the sparkling light on the sea and the bohemian freedoms on offer were more in tune with her personality.

Here Charles Mackie, a Scottish artist, urged her to stop being influenced by other people's work and trust in her powers of observation and paint what she saw. Her palette lightened and working *en plein air* she documented picnics on the beach and by the sea on enormous canvases. Everyone admired her hard work and vitality, and increasing sales success gave her confidence. She soon overtook the academically trained Harold, who was constrained by his technical ability, capturing in her paintings the new spirit of the age. Without concerning herself with avant-garde experimentation she worked, as she put it, 'straight from the subconscious', and showed great aptitude for being in the moment in a very contemporary way. Her two core beliefs were confidence in the supremacy of the artist's personal vision

and insistence on the interconnectedness of life and art. Her style was now set, changing little for the rest of her life and for the most part was uncontroversial. Two paintings, however, did cause heated debate in the early twentieth century.

Even in the free and easy Cornwall community the locals would not pose nude; artists' models had to be brought down from London by those who could afford it, and even then there were sometimes complaints when the artists worked outside. *Daughters of the Sun*, exhibited at the RA in 1911, is seen as one of the first modern paintings to challenge assumptions about the female nude. 'How holy is the human body when bare of other than sun,'[13] wrote Laura. The painting is about fresh air on the skin and not supposed to be erotic in any way. The young women lounging about on the rocks are not even completely undressed but the attitude of the female figure in the foreground, looking back and inviting the viewer into the rest of the picture, was seen as a deliberate challenge to the 'male gaze'. Most local critics liked and accepted it and the painting was displayed widely, but it caused controversy when it toured in exhibitions. Badly damaged during the First World War, Laura kept it face to the wall for years and it eventually rotted from mould.

1911, the year Laura exhibited *Daughters of the Sun*, was the same year Walter Sickert was exhibiting his Camden Town Murder Series in London, paintings that threw down their own gauntlet to challenge the whole academic concept of the nude; after the perverse Victorian idealizations of Academicians such as Lawrence Alma-Tadema and Lord Leighton, Sickert thought the whole concept of the nude had become an 'obscene monster' and degrading for everyone involved.[14] He chose to show the stark reality of naked flesh in unconventional poses – not much 'sun on bare skin' on the bedsteads in his Camden interiors, but both he and Laura were breaking down the barriers between the naked and the nude. Laura drew nude men when she could find any happy to pose for her. There was a tramp she befriended who was perfectly uninhibited in posing for her on several occasions, but we don't know what the other male artists at Lamorna would have felt about exposing themselves completely to her gaze, as Fry and Gaudier-Brzeska had done for Nina Hamnett.

Laura then made a much more problematic work, particularly in the eyes of the RA; although it was well received in Newlyn, London critics

thought it vulgar. Originally called *Self Portrait*, the painting depicted her standing at an easel on which is positioned a painting of her friend Ella Naper. Painted in the studio using mirrors, Laura is viewed from behind, as is the naked Ella, who is visible both in the flesh and in the portrait on the easel. This triple arrangement of artist, model and painted image has many classical antecedents as well as evoking Velázquez's *Rokeby Venus* – soon to be attacked by Slasher Mary – but it was a step too far for the establishment. The suggestion that the artist *is the woman in the picture*, even when the painting's title was changed from *Self Portrait* to the bland and less specific *The Model*, meant it was rejected by the RA. Paula Modersohn-Becker had been painting nude self-portraits in Germany since the turn of the century but in London it was taboo. In *Ways of Seeing* John Berger famously claimed that 'men look at women. Women watch themselves being looked at', but in this picture neither woman looks at the other, or at us, and the effect is unsettling. Painted and first exhibited in 1913, twenty-five years later *The Times* was still calling *The Model* 'regrettable'. It was eventually bought by the National Portrait Gallery in 1971.

When in 1926, Laura's friend Dod Procter, who had like many female artists adopted a deliberately androgynous name, submitted a picture entitled *Morning* to the RA exhibition, it made *her* the most talked about artist in Britain. Not even a nude, it showed sixteen-year-old Cissie Barnes, a Cornish fisherman's daughter, lying on a bed in her nightdress with the sun shining across and delineating her form. Somehow the position of her hands and touchingly vulnerable feet and the way we are made to feel we are seeing into her dreams made viewers feel like unwitting voyeurs of an ordinary working-class girl. It caused an uproar.

Both the public and critics responded enthusiastically to its sensuous but sombre style and its evocation of the west coast light. Frank Rutter, art critic for *The Sunday Times*, wrote that *Morning* was 'a new vision of the human figure which amounts to the invention of a twentieth-century style in portraiture'. It was bought by a *Daily Mail* critic, who presented it to the nation in 1927 amid much publicity; voted Picture of the Year at the RA Summer Exhibition in 1927 it went on to be shown in New York at the beginning of a two-year tour before being hung in the Tate Gallery.

However, in 1929 another overtly sensuous painting by Procter – *Virginal* – once more resulted in salacious publicity, this time because it was *rejected* by the Academy. There was always a languorous sexuality in the way Procter posed her female models, whether clothed or unclothed. They are almost surreal, in the style of Paul Delvaux, although she actually claimed Picasso as an influence. 'You would have never suspected THAT influence would you? I digested him well,' she is reported as saying.[15] Cissie Barnes, three years older now, also modelled for *Virginal*, posing standing naked holding a dove. Procter considered the painting one of her best works. It shows the influence of Renoir as well as Northern Renaissance painter Lucas Cranach the Elder, the sensually detailed softness of the dove contrasting with the cool, post-cubist monumentality of the female body, akin to the work of contemporaries like Meredith Frampton. The skin tones are remarkably painted but Procter's frank depiction of pubic hair and genitalia may have been too shocking for the Academy.

Virginal made Procter famous, even though it was rejected, and she did eventually become an Academician, but despite her moments of celebrity she did not maintain a reputation in the manner of Laura Knight. Like Laura, Dod was easy-going and adventurous; she enrolled at Stanhope Forbes School of Painting in Newlyn when she was fifteen,

Dod Procter, *Morning*, 1926. Oil on canvas. Painted in Newlyn, this picture took a local Cornish fisherman's daughter for its model.

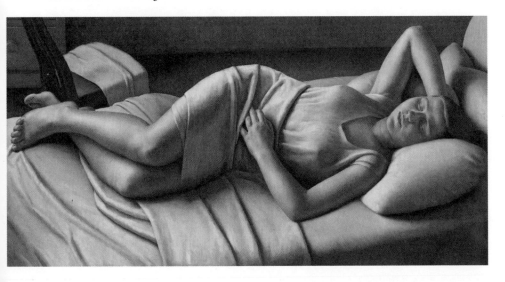

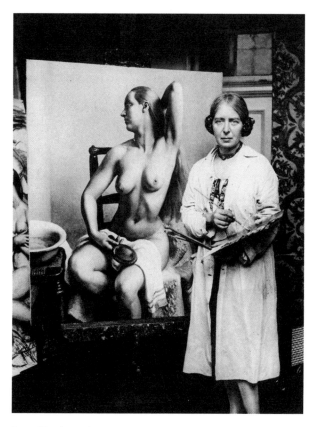

Laura Knight working on *The Toilet Girl* in 1927. This unattributed photograph appeared in *The Sketch*, 16 November 1927.

later marrying a young *plein air* painter, Ernest Procter, who was four years her senior. They both went to Paris to further their studies. Ernest was a pacifist and a Quaker so worked during the war for the ambulance service in France, while Dod was left behind ill and depressed, with a small child and continual financial problems. After the war they both worked at the Omega Workshops, eventually being given a commission from a wealthy Chinese client to decorate a palace in Rangoon, before returning to Cornwall. Ernest died in 1935. Although she was sometimes a much better painter than Laura, her later work was less successful and she fell out of favour relatively quickly. Meanwhile, Laura became the grand old lady of the art world, exhibiting until her death aged ninety-two, even though her painting never transcended 'narrative' for those critics with an eye on the trajectory of modernism.

It is worth noting the way that women making sensual depictions of other women caused such a stir during this period. A newspaper image and article of 1930 shows Laura Knight working on a painting of the model Eileen Mayo, unerotically titled *The Toilet Girl*. Laura, with her plaited hair, photographed in a workmanlike overall, looks the professional she always was. The article celebrated 'Mrs Knight' becoming the second woman to become an ARA since 1769 when the RA was founded, the first being Annie Swynnerton in 1922, the two of them helping to break down some of the prejudices against women painters.

The press were never slow to spot an opportunity to whip up a 'scandal'. Marita Ross, another popular artist's model of the 1930s and 40s who had previously been a dancer, wrote gossipy and sometimes titillating items for the *Daily Express* among other publications, in which she exposed the less glamorous side of the profession. She wrote a poem about how artists' models were expected to be trim and fashionable and starve themselves like fashion models; the issue of unrealistic objectification is not in any way a new phenomenon. Models were often painters themselves. Eileen Mayo trained at the Slade and the Central School of Arts and Crafts in London; she always made it clear that she was an artist herself and that modelling was simply a way to pay the rent, pointing out in frequent press articles about her work that she had learnt a lot about painting from the artists she sat for. She modelled for both Procter and Knight, who were always supportive of her work and solicitous about her welfare: Mayo worked very long hours as a model, often going home too tired to start painting herself. Modern artists were beginning to shift the emphasis of life modelling away from being an academic exercise to one that explored the relationship between themselves and their models, either in abstract terms of the space between them or from a more psychological point of view. Letters in the Tate Archive between Procter, Knight and Mayo discuss how together they might explore the 'boundaries of erotic desire'.

The life class remained a fundamental basis of art education until the 1960s. Stylized figures by early avant-garde artists often showed few sexual characteristics but the subject remained dogged by controversy. Critics of Roger Fry's post-impressionist exhibitions declared Van Gogh a lunatic, claiming that his distortions of the body proved the New Art was insane. This was particularly distressing for Fry, whose talented

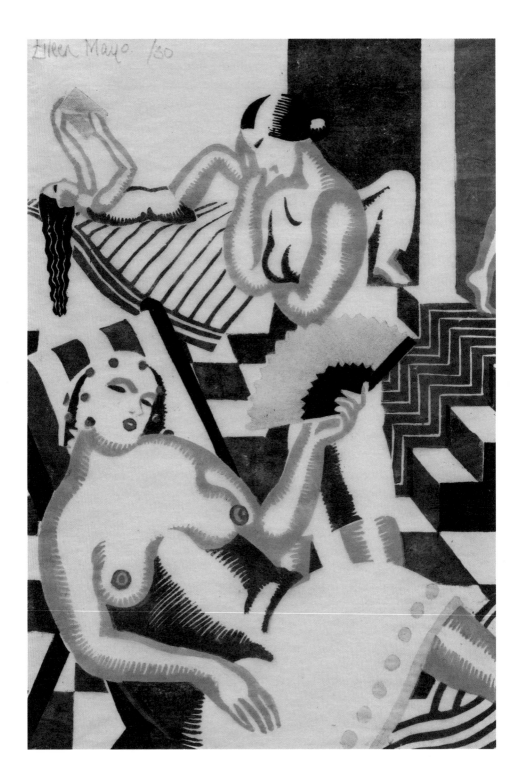

artist wife Helen Coombe developed paranoid schizophrenia and was hospitalized for life in 1910. Models were not always female, but there seemed less controversy about the men – although in Scotland, a Joan Eardley[16] exhibition that included a nude painting of her friend Angus Neil completed in 1954 attracted 'shock horror' headlines, the newspaper helpfully printing her address as well, so that she had men turning up on her doorstep demanding to 'model'. Even as late as this the vengeful reviewer felt uncomfortable with a lesbian artist painting a picture of a man looking like, well, a naked man and not the Apollo Belvedere.

The artist Cecil Collins broke some of the rules and taboos around the life class while teaching at the Central School of Arts and Crafts early in the 1960s, influenced by Laban and his theories of movement developed at Dartington Hall in Devon. Traditionally, the model in a life class maintained a static pose; watching someone move while naked was considered far too erotic. Even after 1960, models found Collins' request that they mingle with the students, often in time to music, made them feel vulnerable; however, many women enjoyed his classes. Collins was a maverick in his approach; the realist artists William Coldstream and Euan Uglow, with their precise 'dot-to-dot' measuring system, maintained a more traditional approach in their teaching at the Slade. During the 1960s, new artistic preoccupations meant some London art schools lost faith in mandatory life-drawing classes altogether, believing they stifled creativity. With nudity no longer an issue, tutors went through the motions by setting up a conventional pose for their students, then disappearing to do something more interesting. Within a few years it was easy to forget the pioneering work done by so many women artists in the previous period in changing the ways the human body was portrayed.

Eileen Mayo, *The Turkish Bath*, c. 1927. Linocut. The work looks flagrantly seductive.

Chapter 2

BLESSED COMPANY
being in the right group

The artists' groups formed in post-war London, inspired by the ideas that emerged from the post-impressionist exhibitions staged by Roger Fry, often revealed acute sensitivity about gender; some excluded women altogether. Isolated in this way, especially if they had too many domestic duties to attend to, women missed out on discussing the aesthetic ideas of the day as well as the practical benefits that would have come from sharing models with other artists.

The increasing numbers of women admitted to public art schools gave rise to anxiety that the 'influx' of women would lead to artistic mediocrity and the 'feminization' of art. Newly empowered upper-class women were buying pictures by artists of both sexes as well as products from the Omega Workshops and the Rebel Art Centre; by 1900 nearly four thousand women in Britain were trying to make a living as artists, alongside around ten thousand men.[1] The new freedoms women were experiencing, along with a 30 per cent drop in the birth rate, triggered a crisis in masculinity. Wyndham Lewis was disdainful of women, while Augustus John swept around in flowing cloaks with a harem of women and children emphasizing his fecundity. Either way, free-ranging masculinity needed emancipated women to provide sex without marriage and children outside wedlock, and women financially independent enough not to need supporting.

Virginia Woolf perceptively wrote that women have continually served as looking glasses, 'reflecting the figure of man back to himself twice his normal size'.[2] Augustus John's painting of Dorelia McNeill, *Woman Smiling* (1909), shows her in a self-confident, gypsy-like pose. Dodo, as she was known, needed to be strong, giving birth to her babies in caravans and doing the washing in cold stream water, living John's vision of a bohemian paradise. Her colourful clothes inspired many

women artists in the early years of the century. She modelled for both Gwen and Augustus John, becoming the latter's muse and mistress in a ménage-a-trois with his wife Ida, bearing him four children. She and Gwen toughened up together on their own vagabond tour to the south of France in 1903, sleeping in haystacks at night. Dodo was lucky; Ida John (née Nettleship), who had been a student at the Slade between 1892 and 1898, had five pregnancies in five years, dying from puerperal fever in 1907 at the age of thirty.

Wyndham Lewis, founder of the vorticist movement, believed in a virile and aggressive aesthetic reflecting the new century's sense of fragmentation and speed. He despised the 'good taste' of men like Fry, and was essentially misogynistic, despite cheering on the suffragettes in their struggle, probably for the joy of the fight. Ezra Pound wrote articles extolling art that was about masculine force and intense feeling, which, like the futurists, he believed women incapable of. Lewis associated women with 'amateur art'.[3] Even Pound's well-bred wife Dorothy Shakespear played along: despite being both artistically trained and talented, she wrote that 'drawing is a traditional family hobby'; she never sold her work and on the back of one radical drawing wrote 'not to be shown to anybody'.[4] She chose to remain a very private person, despite making some strong vorticist designs between 1912 and 1918, including covers for Pound's *Ripostes* and for *Catholic Anthology* before reverting to making watercolour landscapes.

Nina Hamnett's friend Gladys Hynes was altogether more assertive. Her illustrations for Pound's *Cantos* are considered among her best work: black ink drawings of figures and beasts woven around the initial letters of each section, not apparently influenced by vorticism at all. Born in India to a family of fiercely patriotic Irish Republicans, she studied in London and then in Cornwall with Stanhope Forbes, before settling in Hampstead and following her own course. As an artist of independent means she could afford to pick and choose her contacts and enthusiasms. As a campaigner for women's rights, Hynes doubtless had some interesting conversations with Pound, as well as Wyndham Lewis. Lewis was totally opposed to feminism, seeing it as leading to androgyny, emotionalism and, ultimately, empowerment of the 'Crowd', which in turn he saw as 'an immense anaesthetic towards death'.[5]

Gladys Hynes, *The Chalk Quarry*, 1922. Oil on canvas.

As the male and female figures depicted in vorticist art are barely sexually distinguishable it may be that female artists saw them as preferable to the sentimental or faintly pornographic depictions of women made in previous decades; nevertheless, there were only two official female members among the vorticists: Jessica Dismorr and Helen Saunders. The futurist C. R. W. Nevinson, discussing the formation of the Rebel Art Centre with Wyndham Lewis, is reputed to have said 'let's not have any of those damned women'[6] in the group even though Lewis's lover, Kate Lechmere,[7] was helping to finance it. Lechmere was an artist herself, but her pre-war cubist pictures have all been lost or destroyed; she stopped painting around 1914. She met Lewis while she was working

at the Omega Workshops in the period before Lewis argued with Fry and broke their association, evidently finding his volatility exciting. Together they founded the Rebel Art Centre as a place where artists could develop as they wished, inspired by cubism, futurism, expressionism and Lechmere's experience at the Académie de La Palette in Paris.

Lechmere recalled there was 'a girl (at the Centre) who claimed her drawings were so erotic she couldn't show me. Lewis had to go and look at them behind a closed door'.[8] Renee Finch[9] had submitted a male nude with blue pubic hair to the Allied Artists Association exhibition around this time and been accused of immorality, illustrating the attitudes prevalent at the time; threatened with police action she had been forced to withdraw her picture.[10] Women, however, were still expected to make and hand round cups of tea at the Rebel Art Centre, which soon ran out of funds and folded. Few progressive art schools in England developed in the way the Bauhaus did in Germany after 1919.[11]

The first vorticist manifesto *Blast,* which came out in 1914, was totally subsidized by Lechmere and her mother, and she and Lewis fell out over the debt. In the collective portrait *The Vorticists at the Restaurant de la Tour Eiffel, Spring 1915,* painted retrospectively by William Roberts in 1962, Jessica Dismorr and Helen Saunders both appear at the back of the group, rather than as part of the convivial gang with wine glasses in their hands. They had both studied at the Slade, Dismorr from 1902 and Saunders part-time at the beginning of 1907. They joined the Rebel Art Centre in 1914.

The two women appear to have been very different personalities. Dismorr exemplified the Edwardian New Woman: the fourth of five daughters of a wealthy businessman, all of whom vowed never to have children, she had been given exceptional freedom as well as funding for private art classes in London and for travel to explore artistic ideas in Paris and Germany. By 1912 she was described as a painter well worth watching, Gaudier-Brzeska claiming in *The Egoist* in 1914 that 'people like Miss Dismorr and Miss Saunders are well worth encouraging in their endeavours towards a new light'. Dismorr's paintings became increasingly simplified and angular, with shapes bounded by dark lines and she made strong black-and-white drawings for John Middleton Murry's magazine *Rhythm.* Her 1911 proto-vorticist drawing of Isadora Duncan linked into the contemporary interest in dress reform for women espoused by

figures like Ka Cox and the Neo-Pagan circle around the poet Rupert Brooke. *The Observer's* art critic P. G. Konody thought Dismorr should have been included in Fry's 'Second Post-Impressionist Exhibition' and she was exploring a range of radical ideas well before she met Lewis.

Lewis wore a sharp suit or sometimes working-class men's clothing to denote masculinity; he respected Dismorr's work but his tirades about the 'nature of women' and the 'feminizing of intellectual life'[12] meant she received very conflicting messages from him, both as an attractive woman and someone from a privileged background. Kate Lechmere was critical of her both on a professional level and out of sexual jealousy.

She was a brief romantic episode for Lewis but she felt more deeply about him, as well as often feeling more sexually drawn to women. The new freedoms she wanted to embrace were problematic; she was afraid of her own strong sensuality, which alarmed and disturbed her. These conflicting emotions may have led to her mental breakdown and eventual suicide. Friends described her taking off her clothes in the middle of Oxford Street in an attempt to prove her modern credentials – and perhaps to prove to Lewis that she was 'game for anything'; but she was no Nina Hamnett. Frances Hodgkins wrote in a letter to her friend Yettie Frankfort[13] that she had 'known Dismorr in a wild phase of her life, when she was determined to trample on her own puritanism with alarming psychological results'.

Dismorr's fellow vorticist Helen Saunders came from a very supportive, middle-class family, who took a positive view of women's suffrage.[14] Her gouache *Untitled Drawing* possibly functions both as feminist social comment and as a stage in the development of her ideas about abstraction. Like Dismorr, Saunders also had a difficult relationship with Wyndham Lewis, and she later refused a marriage proposal from Walter Sickert. Her belief was that marriage, especially between two artists, would threaten her own creative integrity and the time to do her own work. Saunders had a marvellous sense of colour and was one of the first nonfigurative artists of either sex to be included in the Whitechapel Gallery's 'Twentieth Century Art' exhibition in 1914. *Dance* (c. 1915), now at the University of Chicago, shows figures in motion to the syncopations of the Jazz Age. Many such studies by her still exist, while most of Dismorr's vorticist work was destroyed by her executor after her death, in case it cast doubts on her sanity.

Helen Saunders, *Untitled Drawing* (also known as *Untitled Gouache: Female Figures Imprisoned*), c. 1913. Ink and watercolour on paper.

Saunders' artistic radicalism eventually wavered as she was discouraged by the rivalrous, male-dominated art world. By the 1920s she was painting landscapes, portraits and still lifes influenced by Cézanne. Both Dismorr and Saunders wrote for *Blast* and tried to make a feminist argument for the movement's rejection of 'femininity'. Both women were excluded from the 'Vital English Art – Futurist Manifesto' of 1914; as Richard Cork has written, 'their sex contradicted the fundamental Futurist belief in masculinity'.[15]

Another group excluding women from membership was Sickert's Camden Town Group, even as it set out to record the changing realities of urban life. Sickert liked women, though he couldn't see past his preconception of them as potential wives and mothers. The group was committed to observation of working-class life and the modern city, with a particular focus on interiors and intimate scenes. First set up around 1907, the group's ban on women was already becoming untenable by

1913, the year Emily Davison threw herself under the King's horse. It disbanded soon afterwards. It has been suggested that the ban had partly been intended as a way of excluding some of the painters' wives – Harold Gilman had recently separated from his wife – as well as Sickert's friends, the artists and life partners Ethel Sands and Anna 'Nan' Hudson. Sands was a serious exhibiting artist but she had no need to earn her living from her work, a key measure of professionalism in the eyes of the group.

The position adopted by the Camden Town Group towards women barred some very talented painters, among them Stanislawa de Karlowska and Sylvia Gosse, who joined the London Group instead. The London Group had a good record of providing support and equal opportunities to women artists, and women comprised as much as a third of its membership. It espoused no overriding ideology beyond challenging the academicism of the Royal Academy of Arts (RA) and the New English Art Club (NEAC) and women felt comfortable within it. It also supported a considerable number of émigré artists from Europe who had settled in London before the war, allowing them to introduce new ideas from Paris, Germany and Central Europe.

Karlowska came from a wealthy Polish family, and had studied art in Warsaw, Cracow and Paris before she met her husband-to-be Robert Bevan. They settled in Swiss Cottage, where Bevan joined the Camden Town and Cumberland Market Groups and supported Gaudier-Brzeska and his partner Sophie as well as other Polish émigrés. Bevan was not a particularly successful artist himself but Karlowska assisted him unwaveringly, sometimes quite happily at the cost of her own painting. Over the years they built up a strong collection of other people's work, generously buying from their friends whenever they could afford it. Karlowska took her own work very seriously and always painted under her own name, travelling independently back and forth to France and Poland. She regarded London with a dispassionate and inquisitive eye. Her flat perspectives and slightly elongated figures depict very modern street scenes. She painted underground trains and omnibuses and observed the way women and children position themselves in a new way in the city as the decades progressed, walking at ease and unaccompanied in the street, waiting for buses and going out shopping. Painters now made a range of different social classes their subject matter and some male painters looked a little unsure of how to respond in these new

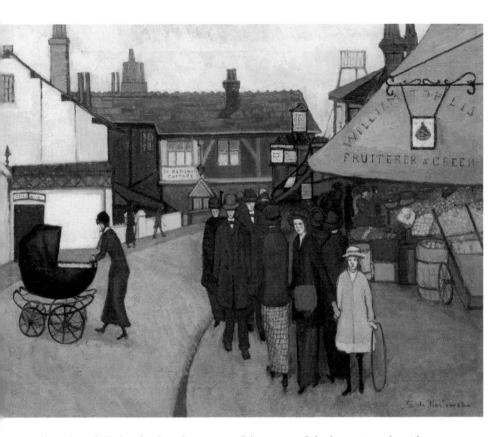

Stanislawa de Karlowska, *Swiss Cottage*, 1914. Oil on canvas. Suburban topography with its fast developing road and rail connections was a dynamic subject matter for Karlowska. Large Victorian houses were divided up into flats and bedsits or turned into boarding houses, and life on the streets became busier.

circumstances. Women artists experienced a different kind of transition, as they explored a new freedom to stare.

While the Camden Town Group painters were criticized for the drabness and monotony of their scenes, Stanislawa's paintings were individual and colourful. She found beauty in unexpected places: she records a lock on the Regent's Park Canal in Camden Town as a bridge is being raised; warehouses and telegraph poles; cranes at work in Berkeley Square; tradesmen's vans; and hoardings with posters on them. Modern life now included mass entertainment, as well as – in the paintings of Sickert, for example – isolation, alienation and even the threat of murder.

Karlowska's paintings show little sign of patronizing those she depicts and there is genuine excitement in her approach to modernity.

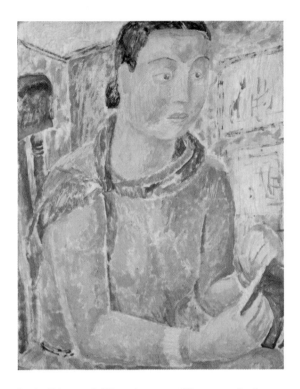

Jessica Dismorr, *Self Portrait*, *c.* 1929. Oil on gesso. In the
1930s Dismorr also painted poets she knew, including Dylan
Thomas, Cecil Day-Lewis and William Empson.

Her 'otherness', both as a woman and a foreigner, aligns her more
closely with the work of the painter L. S. Lowry, who was working at a
similar time, than it does the Camden Town Group; both she and Lowry
liked Courbet and Daumier. As a rent collector Lowry also had an
ambiguous position on the street, although he regarded his subjects
with what looks suspiciously like affection.

The paintings of domestic interiors by Camden Town artists
suggest they recognized the claustrophobia of the home life experienced
by many women, but were they merely reflecting it or contributors
to it themselves? Sickert's sister, Helena Swanwick, was a Girton-
educated feminist, pacifist and active suffragist, but the painters' own
wives and women friends in their paintings often look a bit glum. But
this couldn't be said of Karlowska: she was even photographed smoking
a cigarette in 1910, by then a sure sign of a woman's bohemian and

artistic inclinations but only recently separated from its association with prostitution.

There is an advantage to being associated with a group if it means your work can hang near Sickert's in the Tate and be rediscovered in due time by academics and critics. Sylvia Gosse had her own particular vision that even contemporary critics noted for its originality; previously thought of as an unoriginal disciple of Sickert, the influence may in fact have flowed the other way.[16] Trained at St John's Wood Art School and the RA, Gosse helped Sickert run his private art school at Rowlandson House, Camden Town, acting as co-principal, and keeping the school afloat financially from her private income until it closed in 1914. She was also an excellent etcher and printmaker. She looked after Sickert's wife throughout her terminal illness, and set up a fund to support him through his old age after his wife's death. Shy and retiring she may have been, but Gosse is misrepresented in Gilman's portrait of her in 1913; he gives her staring rabbit eyes, his impressionist paint-marks making her look somewhat disordered and confused. In her own etched self-portrait she is revealed as a self-aware expressive woman, as well as a professional artist dressed in the practical clothing of her trade. Her participation over a long period arguing the case for selections on hanging committees for the London Group suggests she was valued for her commitment, skill and critical judgment.

By the end of the First World War, the prevailing tendency to form radical artistic groups was replaced by a new desire for order and stability; the cleansing rhetoric of the vorticists no longer suited the times. Kate Lechmere enlisted as a nurse during the war and afterwards developed a millinery business, frequented by Edith Sitwell among others. Jessica Dismorr suffered her first major breakdown in 1921, possibly as a result of her own wartime experiences as a nurse. She had been at the heart of the London avant-garde world, her poems and illustrations had been published in *Blast*, but alongside Helen Saunders, she was critically sidelined as a handmaiden to Lewis and Pound. After the war she retreated into more tentative statements and rough calligraphic marks, but she was still exploring new ideas about form and colour. In 1925, immediately after the opening of her solo show at the new Mayor Gallery, Lewis severed all connections with her: she was apparently 'too excitable' for him. The timing was brutal. Her subsequent watercolour

landscapes for the 7&5 Group around 1926 are a little reminiscent of David Jones in their delicate fragility, as are some of her later watercolour portraits (see page 36).

Her partner in artistic experiments was her friend Catherine Giles, who had also worked in the Voluntary Aid Detachment during the war. Together they visited France and Italy every year to study the work of the 'Primitives'. Giles bought a cottage in Alfriston, near Lewes in East Sussex, with a studio for Dismorr, which she used until her death; it was very near Charleston Farmhouse, the home of Clive and Vanessa Bell and Duncan Grant, but there does not seem to have been much contact between these painters and visitors to Charleston, even though Clive Bell had bought a painting of Dismorr's in 1913. Vanessa was presumably buried in her work.

Dismorr was inspired to create more abstract paintings during the 1930s by the pots and bowls brought back by her friend Rachel Levy, who had been on an archaeological expedition with Henri Frankfort in Mesopotamia. She liked the work of Henry Moore and also of Ben Nicholson, whom she would have known through the 7&5 Group, and she contributed to an Artists International Association (AIA) exhibition after she returned to live in Hampstead in 1937.[17] In 1939 she hanged herself, whether from apprehension about the looming threat of war, which broke out five days after her death, or like Virginia Woolf, because she couldn't face yet another breakdown. As Yettie Frankfort put it,[18] her suicide was 'the sacrifice of her own complexity'.

Catherine Giles, who was devastated by her death, had become a Roman Catholic and joined the Guild of Catholic Artists in 1929; the trips she had taken with Dismorr to Italy had affected her religious feelings as well as her response to landscape it seemed. She knew she wasn't as good a painter as Jessica but wanted to improve the standard of art in British churches. She died in 1955. Only a handful of her tempera paintings survive, but the lives of women like her are worth remembering for the insight they give into alternative paths taken by female artists of the time.

Helen Saunders, similarly neglected, died accidentally in the freezing winter of 1963 from a gas leak in her rented London house. Richard Cork has written that 'since Saunders' early work earned her a respected place in experimental circles, the gathering obscurity of her later years

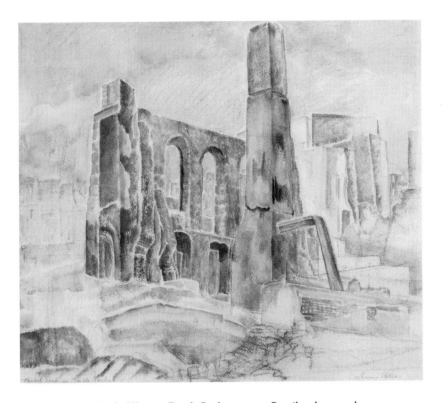

Catherine Giles, *Bombed House in Temple Gardens*, c. 1944. Pencil and watercolour on paper. This moving picture shows a hollowed-out city, made almost of bones – an uncanny, insubstantial emptiness echoing the fragile nature of bodies and civilization.

seems cruel. She endured the neglect with uncomplaining stoicism, for her innate warmth prevented her from succumbing to bitterness.' [19]

Another wonderful painter who was greatly traumatized by the events of the First World War was Winifred Knights. Shocked by Zeppelin raids over her home in Streatham she also witnessed the Silvertown explosion at a munitions factory in London's East End in January 1917, from the top deck of a tram. She spent the following year recovering from a breakdown, on her cousin's farm in Worcestershire. Attending the Slade a little after Helen Saunders, she was the first woman to be awarded a Rome Scholarship and faced direct hostility from older male students. Her work, strongly informed by social and political idealism, languished in obscurity until recent times. The Rome Scholarship Committee had set the title of *The Deluge* for submissions for the scholarship, with the war in mind: a catastrophe that by 1918

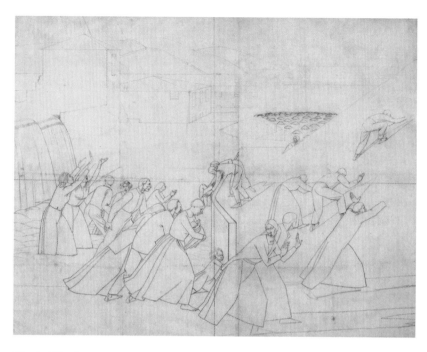

Winifred Knights, preparatory drawing for *The Deluge*, 1920.

was often being referred to in biblical terms. Although Knights's image shows the influence of vorticism, she remained aloof from any particular group. The headline in the *Daily Graphic* that reported her success – 'Girl Artist Remodels the Flood!' – misrepresents the facts: she was actually twenty-one years old.[20] Charles Wilkinson's 'humorous' annotated sketch of her in 1920 was both cruel and misogynistic, depicting the usually elegant Winifred from behind bending down over her canvas, by implication overpowering her male rivals with her work.[21] There was criticism that her success had deprived men of their livelihood. She calmly responded that they had all had their chances, many better than those she had herself.

Her finished painting showed fleeing figures escaping from an explosion[22] as much as from a flood; as she used members of her own family as models it was a very personal response. The model for the woman holding a baby was her mother, who had lost a five-month-old baby son in 1915, an event that caused Knights to lose her Christian faith – the cleric on the right is running without turning back, having nothing to offer, while the ark in the background is already sailing away.

Knights is easily identifiable in the foreground, her gaze a constant focal point, as some figures go 'over the top' on the hill on the right. The discipline she had experienced under the tutelage of Professor Henry Tonks at the Slade[23] and the Slade's overall approach to painting, which some chafed against, were perfectly compatible with modernism and she synthesized her own individual approach, enjoying the contrasts between tradition and modernity. Inspired by fifteenth-century Quattrocento painting and Italian painter Vittore Carpaccio in particular, she nevertheless admired the vorticists and the war art of Paul Nash and Stanley Spencer, and an exhibition of the art of Modigliani at Heal's in London, which she saw in 1919.

Knights's watercolour *Leaving the Munitions Works, 1919*, was bought by the painter and Royal College of Art (RCA) tutor Allan Gwynne-Jones, who had been wounded on the Somme; it is poignant that he wanted to own this particular piece, which shows men joining with predominantly women workers in the work of decommissioning munitions after peace was declared. Another of her tempera paintings, which includes a portrayal of herself among workers who are listening to a woman trade unionist at Roydon Mill, Essex, won the 1919 Slade summer composition prize. Through her aunt, Millicent Murby, her close confidant and Treasurer of the Fabian Society Women's Group, she became interested in female emancipation.

Knights also drew inspiration from the writings of the poet and philosopher Edward Carpenter[24] and his ideas of rural purity: her work is often implicitly about the contrast between town and country. In her personal life, the unfashionable, simple homespun clothes and broad-brimmed hat she wore defined her identity; figures in her paintings often have bare feet, as advocated by Carpenter, liberated to feel the earth beneath them. The braided hair she wore coiled over her ears was a homage to the women in Leonardo da Vinci's paintings and a reaction to the 'cropheads' among her contemporaries, with their ubiquitous bobs. The painters Masaccio and Giotto were her 'blessed company', important figures in her personal religion, based on art rather than faith. In Italy her landscapes portrayed humanity's collaboration with nature and documented fast-disappearing rural traditions, part of her vision of ideal communities that in many ways were fierce and austere. Many projects were abandoned due to the demands of her meticulous

technical methods. She believed, like Leonardo, in quality not quantity, making extensive preparatory drawings and over-paintings, but her rigour may have been counterproductive as the cool, finished paintings sometimes look overworked beside her rich preparatory sketches. Would her extreme perfectionism have been modified by the cut and thrust of working in an artist's group?

Knights's marriage to fellow Rome Scholarship student Thomas Monnington added to her happiness during the four years she spent in Italy and allowed her to extend her time there, but on their return to London she found herself somewhat overshadowed by the success of her husband, who was elected to the all-male Faculty of Painting at the British School of Rome. Prestigious commissions followed for Monnington. Knights helped him by acting as a model and as an assistant on large paintings but didn't consider their partnership primarily an artistic one. Her first pregnancy in 1927 ended in a stillbirth, a tragedy that devastated them both.

In 1928 Knights secured a major commission to make a painting for the newly renovated St Martin's Chapel in Canterbury Cathedral. The project was initially overseen by George Bell, the Dean of Canterbury, a noted champion of contemporary art, but when he left Kent to become Bishop of Chichester, artistic interference by his successors seemed to sap her inspiration. The chapel's architect Herbert Baker disliked 'revolutionary modernism', which he thought ugly and distorted, and as architect on the project he ruled the roost. Even Henry Tonks encouraged her to do as she was told. The original subtle and beautiful colour sketches she made eventually resulted in a rather stark and conventional painting, *Scenes from the Life of Saint Martin of Tours*, completed in 1933. Her painting is given added poignancy by its depiction of a newly born child about to be raised from the dead. Painted using her sister's baby son as a model, the figure may have represented her own, lost baby brother as well as the stillborn son she was never allowed to see or mourn; Monnington had insisted on a quick burial in unconsecrated ground so they could forget and move on.

When a second son was born the following year her old anxieties returned, exacerbated by the outbreak of war five years later; she could not paint, even when a nanny was hired to look after the baby, and was unable to pursue sales or commissions with any confidence. With

Monnington away from home working with the camouflage unit in Leamington, the couple became increasingly estranged. It isn't known when an undiagnosed brain tumour first took hold and what its effects on her health were; she died suddenly in 1947. There was no obituary of this once fêted painter and her only National Biography entry is as a wife: Monnington, whose work she had greatly influenced when they were both in Rome, became president of the RA in 1966. When the London office of the British School of Rome folded in 1989 and sold up the artwork in its collection, Knights's painting *The Deluge* – a somewhat mysterious and poorly documented work – was bought and exhibited by the Tate Gallery. Near it hung a picture by Mary Potter, an old student friend of hers, whom she knew as Mary Attenborough at the Slade.

By 1919 many artists rejected the focus on French art that still dominated the London Group and a new group of painters and sculptors sprang up called the Seven and Five Society (also known as the 7&5 Group), and Mary Potter was one of the first women to be accepted as a member in 1922. Some of the men among its members had seen active service or been conscientious objectors and therefore had good reasons for seeking out a sense of universal brotherhood and for espousing a new internationalism. The group's first catalogue emphasized that they had no wish to form a new 'ism', stating that 'there has of late been too much pioneering along too many lines in altogether too much of a hurry'.

At an early exhibition by the 7&5 in 1927 at the Beaux Arts Gallery in London, ten out of the twenty-five artists included were women. The group favoured a lyrical and neo-classical style, its main rule being a ban on photographic realism. By 1929, the direction of the 7&5 had changed: Ben Nicholson was transforming it into a vanguard movement with a stricter, more dogmatic approach towards abstraction, resulting in a purge of members of both sexes. Earlier work was now derided as timid, provincial and conservative; the vocabulary used to describe it – terms like lyrical, fresh or naïve, suggesting folk or peasant art – together with criticism of the use of scale and the medium of watercolour, all suddenly suggested female preoccupations, despite the fact that there were men working in similar ways and choice of scale and materials was sometimes dictated by post-war shortages.

Critical reception reinforced these judgments; rather than forging a new movement, women's art was seen as too personal, concerning

itself too much with fleeting sensations. Helen Sutherland and Jim (H. S.) Ede, creators of Kettle's Yard, Cambridge, spoke up in support of the women's work, describing it as feminine in what was supposed to be a complimentary way. Ben Nicholson disagreed, saying he was only interested in seeing work that was sustained and enduring. Even Winifred Nicholson suffered critically from being labelled the ex-wife of a 'major British painter'. Ben Nicholson identified his former wife with the 7&5 Group to suit his vision of his own history; when talking about the group he was careful to emphasize the difference between his own and his ex-partner's work, using gendered terms to do so. 'It would be misleading to bracket our names', he wrote, 'because the work we were doing at that time was extraordinarily different, the difference between very bright flower paintings (feminine) and very sober brown and grey still lifes (masculine).'[25] Several commentators, including Clive Bell, undermined early work by 7&5 Group members by associating it with domesticity. Ironically, when Ben Nicholson first exhibited his *White Relief* of 1935 it was seen as the apogee of English modernism by modernist commentators, while at the same time being described in the popular press as highly desirable because it fitted in with fashionable interiors and furnishings. The fact that the work of the women in early 7&5 exhibitions is now rarely shown in context continues to skew the history of the art of the 1920s and 30s in favour of one particular strand of modernism.[26]

Smaller 'groups' formed around alternative ateliers, such as the Brook Green School, founded by artist and sculptor Leon Underwood. Underwood wanted to support artists' individuality, but he was so charismatic as a teacher that his own ideas often proved overwhelmingly influential. His women students included Gertrude Hermes, Edna Ginesi, Frieda Lawrence's daughter Barbara Weekley and the artist Eileen Agar. Agar funded the four issues of *The Island*, a journal of art and literature edited by her husband, the expatriate Hungarian writer Joseph Bard. Founded by Underwood, *The Island* served as the Brook Green School's unofficial manifesto.

Gertrude Hermes had a strong appreciation for the natural world and had originally wanted to work on the land. *The Swimmers* (1924), her first major wood engraving, was much admired for the vigorous physicality of its figures. It was made at a time when engraving was

Gertrude Hermes, *Butterfly*, 1937. Walnut.

being taken more seriously as an art form, rather than just a medium of illustration, and the excellence of female wood engravers was beginning to be noticed. Hermes also worked as a sculptor, and her engravings turn a two dimensional print-form into an extraordinarily plastic representation of bodies, its light and dark tones used in a totally modern way.

'Wild Girl', an exhibition of Hermes's work at the Hepworth Gallery in Wakefield, Yorkshire, in 2015, showed her engravings and her much-less-known sculptures together. The title referred to her many quiet acts of rebellion: remaining uncommercial, giving her work away to family and friends and insisting in 1966 that women members should finally

be allowed to attend the dinner after the Annual General Meeting of Academicians from which they had traditionally been excluded; Hermes was made an ARA (Associate Member of the Royal Academy) in 1963 and a full Royal Academician from 1971.

Leon Underwood believed art needed content, not mere abstract aesthetics, in order to make a contribution to humanity; in his view poetic imagination was more important than style or method. Many women artists agreed and felt they had been left behind in the rush to be avant-garde. Gertrude Hermes was important because she, along with Blair Hughes-Stanton, her husband from 1922 to 1933, saw wood engraving as just another medium for making art with its own particular set of tools and materials, rather than as a craft activity with illustrative and commercial associations. Their work looked distinctively modern.[27] They were joined by a large number of excellent women wood engravers, including Clare Leighton, Monica Poole, Gwenda Morgan and Joan Hassall, all following in the footsteps of the founder of the Society of Wood Engravers, the pioneer Gwen Raverat. Wood engraving, which required no heavy litho stones or potentially hazardous chemicals and little specialized equipment, was ideal for a domestic situation.[28]

Gwen Raverat, *Winter* or *Back of the Mill*, 1936. Wood engraving.

At the Grosvenor School of Modern Art, founded privately in 1925 by the wood engraver Iain Macnab in his house in Pimlico, another charismatic teacher, the artist Claude Flight, introduced his pupils to the linocut, a new medium unencumbered with traditional baggage. Flight thought the printing press too mechanical, an idea taken further by Peggy Angus and Rena Gardiner some thirty years later.[29]

Linocuts had been made popular by Franz Cižek in Vienna as a cheap, accessible medium for teaching art to children. Women felt comfortable at Claude Flight's school; his partner Edith Lawrence[30] was a textile artist. Eileen Mayo enrolled and the V&A bought one of her first linocuts; she helped take the medium out of the classroom and into the gallery setting, where it was treated as a serious art form. Her early prints showing the lives of women, such as *The Turkish Bath* (c. 1927; page 26) are particularly exciting.

One of the greatest printmakers at the Grosvenor School was Sybil Andrews. Born in Bury St Edmunds, Andrews had been apprenticed as a welder and worked in an aeroplane factory during the war, studying art via a correspondence course. Powerful, with a dynamism akin to the revolutionary fervour of Russian art of the period, her prints are the equal of those of any male practitioner. Although the prevailing aesthetic at the Grosvenor School developed out of vorticism, dominated by a sense of speed and movement, the prevailing aesthetic was socialist and democratic, although the surrealist artist Emmy Bridgwater, who attended briefly, found too many upper-class girls there for her liking. Despite their modern imagery and style, the prints were usually done by hand on Japanese paper, newly available from the legendary London paper merchant T. N. Lawrence in Bleeding Heart Yard, Farringdon.

Claude Flight's group split up in 1939; Sybil Andrews eventually left London for Vancouver Island, although she always said her heart remained with the plough horses and agricultural labourers of her home in Suffolk. In an increasingly complicated modern world, artists' groups were no longer likely to resemble monolithic movements but became more agile and short-lived, reflecting very particular preoccupations. Rather than gathering around manifestos or establishing schools, women artists in particular in the first half of the twentieth century would be shaped instead through the more informal structures created through friendship and topography.

Chapter 3

NOT MERELY A WINDOW
a new kind of representation

It is refreshing to look at the work of two artists who transcend cat-
egories with ease: Winifred Nicholson and Frances Hodgkins.[1] They
had a high reputation among their peers, acclaimed for finding a new
kind of representation fitted to a modern age. Winifred and Frances
are routinely associated with the 7&5 Group, but the group was only
a small part of their lives and work and they both left it voluntarily.[2]
Frances didn't like becoming a part of groups as a matter of principle,
only joining them briefly, like many women, for the exhibiting oppor-
tunities they provided.

One of the few times the two artists spent extended periods of time
in each other's company was in 1932, when they went pony-trekking
together in Cornwall, discussing life and art. Winifred, Frances reported,
'had been having a certain amount of emotional difficulties just then,
and she told me that all women had, and that's why there were so few
good women painters'. She replied that after the age of sixty it was pos-
sible to become clear of entangling relationships and then really settle
down to painting. Winifred, writing much later, appeared to disagree:
'I don't think I've ever found myself free from emotional things that
interrupt your painting,' she wrote, 'because if it isn't your contemporary
people it's your children, or your children's children...and all the time
there are human complications if you allow them to get in the way.'[3]

A quarter of a century younger than Frances, Winifred Nicholson
(née Roberts) had studied at the Byam Shaw School of Art before and
just after the First World War. She came from the heart of the estab-
lishment – a liberal family of pioneering women – and both her parents
encouraged her early interest in painting. At the Byam Shaw the regime
was based around strict academic draughtsmanship and she was told
that she saw 'far too many colours', although strong colour was of course

a feature of the Pre-Raphaelite painting Byam Shaw himself had most admired. Despite the criticisms, she seems to have had the strength of mind to carry on with what she believed in. Winifred married Ben Nicholson in 1920; however, her approach to painting was arrived at quite independently of her husband. An extended trip to India, Ceylon (now Sri Lanka) and Burma (now Myanmar) in 1919–20 opened her eyes to different ways of seeing colour, and she wrote articles and letters about her radical colour theories throughout her life.

Frances Hodgkins was born in New Zealand and studied there first of all, and was therefore not associated with any particular British school of art. Before the First World War she had been an impressionist, spending time in France; afterwards she went to Newlyn, in Cornwall, where, she would write to her mother, she found herself 'too modern for people down here...I am conscious of the cold eye of distrust and disapproval by the older members of St Ives'.[4] However, she was fortunate to meet the artists Arthur Lett-Haines and Cedric Morris, who championed her work and provided both financial and moral support. She also met Dod Procter and Laura Knight, who influenced her use of scale and choice of subject matter.

She liked vorticist work, showed concern for millworkers, women and children in Manchester without adopting social realism, and later experimented with abstraction and surrealism. Despite these interests and influences she always maintained a position that was completely her own. Her 'still-life-landscapes' – arrangements of fruit, eggs, shells and vases seen against a floating table surface or landscape characterized by mysterious shifts of shape and perspective – fitted well with the prevailing 7&5 Group aesthetic. Colourful and exuberant, her work bore the traces of all the periods and cultures she had encountered on her travels.

England's capital, however, she found grey and grim, writing to her sister that 'God never meant New Zealanders to live in London'.[5] She stayed in France whenever she could, increasing the difficulty of establishing a name for herself in England. In 1925 she met the gallerist Lucy Wertheim,[6] a keen pursuer of new talent, who began collecting her work. In 1930, Wertheim included several of Frances's paintings in the opening exhibition at her new London gallery. This was where she met Arthur Howell of St George's Gallery, who launched her career with a major exhibition. Frances wasn't included in Herbert Read's 1933

Frances Hodgkins, *Double Portrait No. 2 (Katharine and Anthony West)*, c. 1937–39. Oil on canvas. The portraits Hodgkins painted were more about the process of painting itself than the personality of the sitter. She completed this one about 1939, using existing portrait sketches made while staying with the Wests before the war.

'Art Now' exhibition, but she was included in 'Living Art in England' in 1939 at the London Gallery alongside the surrealist painters Ithell Colquhoun and Eileen Agar.

In 1934 Hodgkins moved to the Isle of Purbeck in Dorset, but she did not have the same sense of the spirit of place as the British-born painter Paul Nash, even though they both lived in the village of Worth Matravers at different times, as did Eileen Agar. With a poetic quality akin to Braque, her painting came to be associated with neo-romanticism and both John Craxton and John Minton admired her work. In 1939 she was chosen to represent Britain at the Venice Biennale but the war meant her work could not be sent abroad. She died in Dorchester in 1947.

Clive Bell wrote an extraordinary review of her in *The Listener* in 1936, titled 'The Feminine Touch', which must take the prize as the most appalling piece of gendered criticism in a very wide field: 'Hers

is essentially feminine painting,' he wrote, 'gay, intelligent and never pushed an inch beyond her scope...Miss Hodgkins' pictures make us think of those comments on life with which women often charm us, the least little bit artificial maybe, influenced possibly by a man, but illuminating in the best sense of the word. Personally I regret what I take to be the masculine influence of Dufy in some of her pictures, Paul Nash in others. She is at her best when she is most herself and therefore most feminine.' Male critics more frequently described her work as 'masculine'. They sensed its strength and originality, which seems to have surprised and unsettled them in a woman.

In a more accurate assessment, sculptor Barbara Hepworth wrote that Hodgkins's work 'had great strength and purity and was so individual that it was like discovering some new world'.[7] Geoffrey Gorer, writing in *The Listener* in June 1947, stated that 'Frances Hodgkins is a serious woman painter as Emily Brontë or Jane Austen are serious women writers. Like these women she has a contribution to make to the experience of the world which no man could provide.'

As an outsider to the English scene, making her way in life without family support or close emotional ties, she had few material possessions. Rootless and unsettled by two world wars she was extraordinarily courageous and avoided being sucked into any particular group or 'ism', declaring 'I personally hate all systems – I am a rebel'. She frequently changed her way of working, unsettling for the galleries that exhibited her and for art historians exploring her work later. 'I grow sick from hearing from intelligent people that they wish I hadn't "changed my style". How do they expect progress except through change?'[8]

Hodgkins became even more innovative in the last two decades of her life, possibly because the death of her mother in 1926 liberated her from any residual guilt about wholeheartedly pursuing an artistic career. Haines and Morris often rescued her when she was very ill, or was without water or electricity. A witty companion and a flamboyant and colourful dresser, she adopted a certain outrageousness in her manner as a way of protecting her inner privacy, stating with an understandable exasperation that 'I paint as I do because it is my point of view and it seems to me futile to go on discussing why I do this and that.'[9]

Winifred Nicholson's painting, in the words of her friend the poet Kathleen Raine,[10] 'grew out of her life with complete naturalness and

simplicity. The day's painting was a kind of fragrance breathed by that day and no other, its imaginative essence, its heart.'[11] Despite their variety, all her paintings, Raine suggests, 'are alike in saying, like a character of Virginia Woolf's *To the Lighthouse*, "Time stand still now!" Because each day's here and now is so fully present, it lives on.'

The still life or plant in Winifred's work, in a similar way to the use of such subjects in a painting by Frances Hodgkins, was often seen against a window, but in a fluid space where both the view through the window and the objects on the windowsill were intimately connected. She needed peace and order in her world and space for uninterrupted thought, and her distillations of time, place and mood are precisely organized but incredibly fresh, appearing as if newly seen. 'In the ebb and flow of the outer world I must have a place where the harmony of the space is giving its verdict.'

She painted large landscapes with the same simplicity of vision as her still lifes. 'I don't want anything in the world,' she wrote to a student friend. 'I just like existing every minute, and watching things coming and things going, and then coming again, like storms and sunshine and then storms again. I don't want anything at all for the simple reason that I have everything, or rather, which is the same thing, everything has me.'[12]

Winifred lived with Ben Nicholson and their children Jake, Kate and Andrew at Banks Head, the farmhouse she had bought in Cumberland near her parents. It was a mutually beneficial partnership: in the early days her paintings were much more popular and sold better than her husband's. They travelled frequently to Switzerland, where she had a villa near Lake Lugano, a wedding present from her father, where she enjoyed painting the luminous light. After her divorce she continued to travel to Europe to paint, spending half her time in France for several years and also making extended visits to her parents in Cumberland. She kept Banks Head, creating a garden there and encouraging wild flowers. 'To me they [flowers] are the secret of the cosmos,' she wrote; 'sparks of light, built of and thrown out into the air as rainbows are thrown, in an arc.'[13] Later she kept goats and bees and ran a small school. She met Ben regularly until his second wife, the sculptor Barbara Hepworth, had triplets in 1934. After 1936 they rarely saw each other, although they kept up a strong correspondence for the rest of their lives.

Winifred Nicholson, *Polyanthus and Cineraria*, 1923. Oil on board. Winifred loved light, whether shining through windows, in mirrors or – later in her life – through prisms. In this early work the scumbled 'paint as paint' on a luminous white ground does not aspire to realism but achieves it nonetheless. Light is portrayed with the heaviest streak of pigment. The 'frame within a frame' of the windows suggests another modernist concern.

At Banks Head she enjoyed a simple domestic life. 'The expressing of perfect home, perfect wife, perfect mother is very close to the expressing of perfect musical harmony', she believed, 'and when one reaches that point the two dragons [Art and Life] become friends and helpmates.'[14] In the early years at Banks Head there was only an open fire for cooking on; photographs show a calm, uncluttered interior, where she could pay great attention to natural detail: wood, stone walls, the grain of a windowsill – what Jim Ede called 'insubstantial substance'. She is very much associated with Ede, whose house in Kettle's Yard, Cambridge, is still preserved to great effect, right down to the quality of light coming through the windows and reflected in carefully placed mirrors. Ede wrote, in a somewhat dubious compliment, that it was

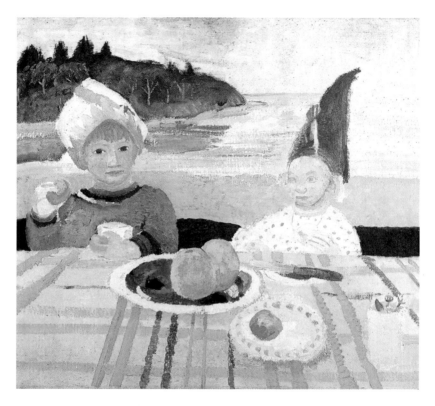

Winifred Nicholson, *Kate and Jake, Isle of Wight*, 1932. Oil on canvas. The painting depicts two of Winifred's three children during a stay on the Isle of Wight between 1931 and 1932, a sad time following her separation from Ben Nicholson. Painting one's own children can be tricky but was a feat that Winifred navigated with skill. She seemed naturally able to incorporate her children into her life and work. Kate went on to become a painter herself.

'because she is a woman that she has so deep a knowledge of growth – the life and nature of plants and of landscape.... She paints a pot of flowers and in it you feel the laws of universal birth.'[15]

In Paris, where from 1932 onwards she lived for half the year, she met Sophie Taeuber-Arp, and befriended Jean Hélion, Naum Gabo and Piet Mondrian, becoming the first person in Britain to buy one of Mondrian's paintings. Mondrian trusted her sense of colour enough to ask her to buy his paints for him when he visited England. She believed he represented the 'brave new thought, basing its beauty on reality and proportion'.[16] Mondrian told her not to use green, as it was not an 'abstract colour'. Colour was to be liberated from form; Matisse used objects to denote colours, not the other way around. 'Sunlight,

moonlight, candlelight, electric light, all change the colour of an object,' she wrote. 'A human eye, a bird's eye, a bee's eye, a butterfly's eye, all see colour differently. So the local colour of an object does not belong to an object. The colour that seems to sit on it is subjective, fleeting, effervescent, and is all as allusive as magic.'[17]

She wrote an article 'Can The Blind See Colour Green?' for the *Christian Science Monitor* in 1954. Ben, Barbara and Winifred were all interested in Christian Science, which had become popular in the 1930s as an alternative to formal religion. In 1927 Winifred fell through a trap-door while hanging an exhibition with the painter Christopher Wood; she broke her back and her future looked uncertain: a Christian Science practitioner helped her recover both her health and her confidence.

Winifred moved towards total abstraction for a period after the break-up of her marriage, signing her abstract work Winifred Dacre for a period, a change insisted upon by Ben, but she found it made her paintings flat and continued to paint 'realistic' paintings at the same time. What mattered to her was that the picture had a life of its own. She resolved the conflict at the end of her life when some of her prismatic paintings verged on the abstract once more.

The new art of the mid twentieth century was not focused on copying nature but was instead an act of creation in itself. Winifred spent her last decades trying to find a new colour in the spectrum beyond violet, influenced in the way she saw colour by her travels in Asia. 'What I have tried to do', she wrote, 'is paint pictures that can call down colour, so that a picture can be a lamp in one's home, not merely a window.'[18]

In 1972, Ede organized a solo exhibition of Winifred's work at Kettle's Yard; her work was already popular with private collectors but the Tate Gallery didn't buy her paintings until 1975. By contrast, Frances Hodgkins was well regarded by the avant-garde by the 1940s and the Tate acquired her work from 1944 onwards.

Chapter 4

A ROOM OF ONE'S OWN
from cupboard to studio

Imaginative work...is not dropped like a pebble on
the ground...[it is] like a spider's web, attached...
to life at all four corners.... When the web is pulled
askew, hooked up at the edge, torn in the middle, one
remembers that these webs are not spun in mid air
by incorporeal creatures, but are the work of suffering
human beings, and are attached to grossly material
things, like health, money and the houses we live in.

Virginia Woolf, *A Room of One's Own*, 1929

While artist groups offered exhibition opportunities for female artists,
they didn't necessarily provide places in which they could work. For
many women, finding such a space was crucial, both physically and
psychologically.

A comfortable family background was not enough to guarantee a
female artist an environment in which she could work, as is demon-
strated by the life of Edna Clarke Hall. A prize-winning student at the
Slade, she was deemed the 'most imaginative artist in England' by a
Times art critic in 1926, but is little known today. While her work is
held in the collections of the Tate, the V&A, the Ashmolean Museum
in Oxford and the British Museum, it is mostly in the form of drawings
and watercolours that historically have been given less serious critical
consideration. Rather than making confrontational images that engaged
with challenging ideas, she preferred to explore inner states, explaining
in her unpublished autobiography 'The Heritage of Ages' that she 'just
wanted to draw a subject quickly, seize it, convey an impression',[1] for

which oil paint wasn't the appropriate medium. Surprisingly modern in her approach to life, fully aware of the new bohemian ideas circulating during her time at the Slade, where her friends included Gwen John and Ida Nettleship, she remained a Romantic, her work arising from the wellspring of her inner vision.

Edna Clarke Hall's father, the philanthropist Benjamin Waugh, was the founder of the National Society for the Prevention of Cruelty to Children (NSPCC), and it was a young colleague of his, William Clarke Hall, who suggested she should go to the Slade. Although he initially acted in the role of a mentor and was thirteen years older than she was, he eventually proposed marriage. Edna was thirteen when they first met; she entered the Slade aged just fourteen. Her marriage at the age of nineteen signalled the end of her studies. Photographs of Edna Clarke Hall show her to have been a beautiful young woman, a modern Romantic. Her husband William, meanwhile, was still emotionally a Victorian, the product of a strict Plymouth Brethren background he had rebelled against but not totally shaken off; his work standing up for the rights of children may have given rise to further emotional conflicts. Despite appreciating his wife's honesty and openness, he sometimes objected that she behaved like a gypsy, with her informal bearing and penchant for going barefoot. She had two sons and made tender drawings of them – she always had a sketchbook to hand – but felt emotionally neglected by her adored husband because of his lack of interest in her creative output; he never came to terms with the modern approach of her later work, after she abandoned the more traditional pre-Raphaelite imagery of her early years. The fact she had to be a little circumspect about how she worked added to Edna's sense of isolation. Her husband was often away because of his job; he founded the probation service and sometimes sent deprived children back to Upminster for his wife to look after. Living in Essex, she lost touch with her former Slade student friends and fell out with Gwen John, who was critical of her decision to marry and have children.

Edna Clarke Hall never regretted having a family, but like many women artists she felt frustrated later in life that she hadn't fulfilled her early promise or achieved quite what she had hoped to. An intense and passionate personality, often light-hearted and humorous, she also had a strong moral sense and could be overly self-judgmental.

The characters of Catherine Earnshaw and Heathcliff in Emily Brontë's *Wuthering Heights* were a springboard for Clarke Hall's imagination; she too loved to sleep outside, go barefoot and climb trees. Working in a barn on the family smallholding, the proliferation of drawings she left scattered around the building often became covered in owl droppings. Her work was out of kilter with the times; her exquisite series of colour studies of a sycamore seed on the ground or new shoots unfurling were intense, exploratory and joyous: expressive portrayals of emotion, evanescent as light across a moor. She is best seen as belonging to a line of British gothic artists infused both with the wildness of Fuseli and the Romanticism of Blake, executed with an ease in figurative drawing acquired at the Slade. Her writings, such as the poems she included in her Poem Pictures, have a self-revelatory honesty about the longings and frustrations she felt that is startling, given the time of writing.

In 1914 she had a one-woman show at the Chenil Gallery arranged by her previous professor at the Slade, Henry Tonks, but after that she did little 'serious work'. Society, with its conventional constrictions on how women, especially those with husbands and children, should behave, was perhaps more to blame for her problems than her husband. Nevertheless, her frustrations led her to embark on a romantic friendship with the poet Edward Thomas, who had also married young and sometimes felt trapped inside his relationship.[2] Thomas's wife Helen was a child of nature just like Edna – both were part of a new band of Edwardian women who enjoyed bodily physicality: the sensation of wet grass and warm sun on their naked bodies in the countryside. Helen Thomas understood her husband's dark and quixotic mood swings and accepted his passionate attachments.

Edward Thomas had renewed his friendship with William Clarke Hall during the First World War, while stationed at a barracks near their house. He and Edna went for long country walks while William was away working; scholars of Thomas's oeuvre suggest she may be the 'Woman' featured in his poems, a muse if not an actual lover. Thomas's death in 1917 may have been a contributing factor in her mental breakdown after the war. She sought psychological help from her doctor Henry Head, who had known the work done by Dr Rivers with shell-shocked soldiers at Craiglockhart. He would have been aware of the 'talking cure' promoted by Freud and he proposed two therapies to help her

All my wealth of years
Offer'ed was in vain.
I Cast into the ditches
All my wealth of riches
Scorn'ed with sharp disdain
Laughter turn'd to tears
Tears to hidden pain,
Till the heavens did borrow
All my wealth of sorrow
For a healing rain.

Edna Clarke Hall, *Poem Picture, All My Wealth of Years...* 1926. Watercolour.

recover.[3] The first was to explore the root causes of her distress through her artwork, which he saw as the equivalent of verbalizing subjective feelings; the second was to advise her husband of the importance of providing her with a studio in which she could regain a sense of her inner self in her own physical and emotional space, his conclusions very similar to those reached by Virginia Woolf in *A Room of One's Own*, first published over a decade later in 1929.

Clarke Hall's illustrations to *Wuthering Heights*, begun in 1903 and never published in their entirety, were works she returned to at times of stress throughout her life. Her intense self-identification with Cathy was possibly one way of dealing with her frustrations, in accordance with Henry Head's advice. All her work sprang from emotional compulsion rather than aesthetic consideration, and these merged when, inspired by Blake, she went on to make the Poem Pictures, her own handwritten verses with images, creating a more metaphysical representation of a 'soul in chains'. The words to these are frank, sensually erotic and integral to the images. They are reminiscent of Cathy's distressed laments for the lost Heathcliff, a figure who for Clarke Hall perhaps represents her husband's alter-ego, combined with wilder romantic qualities of her own – qualities for which she thinks she yearns, but which remain at a safe distance.

A kind of peace was achieved when her husband took her doctor's advice and provided her with a studio in Gray's Inn, London, near his work, and she began to exhibit again at the Redfern Gallery regularly over the next two decades. Over the doorway of the studio she inscribed 'On the lintel you will see Edna Clarke Hall, but within you will find neither Edna Waugh nor Edna Clarke Hall, but something sprung independently from both.'

William was knighted in 1932 and died the same year. Friends set up a trust so Edna could continue working and she had a retrospective show in Manchester in 1939. Unfortunately, her studio and all its contents were destroyed in the Blitz, a severe blow. Making quick drawings remained her natural response to life until severe arthritis in her hands meant she was forced to stop working at the age of eighty; she lived on to reach her centenary. With so much of her work missing and the remainder now rarely exhibited it is hard to arrive at a considered judgment of her achievement.

Another young artist who was both highly gifted and successful from an early age was Elsi (Mildred) Eldridge.[4] She studied under Eric Ravilious at the Royal College of Art (RCA) and worked with Evelyn Dunbar and Charles Mahoney on the Brockley murals (page 183), although the artists later recalled the only thing they had in common was that they all hated London.[5] The trajectory of Eldridge's career illustrates the complications that can arise from early success, as well as the challenges of finding a suitable workspace and maintaining a career after marriage. The work she produced after a Rome Scholarship in 1934 shows a similar sensibility to Winifred Knights's of ten years earlier, dominated as it is by female figures, and all her final-year paintings at the RCA sold straight away.

Well travelled and highly intelligent, Eldridge was a strong personality who could afford to buy herself an open-top Bentley on the profits of a 1937 exhibition at the Beaux Arts Gallery; however, such commercial triumphs soon required her to make difficult compromises – she didn't like the way people talked about her work and her new 'abstract' experiments, writing that 'they invent idiotic meanings to a painting'.[6] To escape the fashionable social set in both Italy and London, as well as an unwelcome offer of marriage – 'how can you marry someone whose work you do not admire?', she asked[7] – she started teaching in Wales, where she met and subsequently married the poet R. S. Thomas.

Thomas was a curate, and then a priest; the couple's son Gwydion, born in 1945, was to describe their ecclesiastical accommodation in remote parts of Wales as damp and cold: this was from choice rather than poverty, as they both disliked 'mod-cons'. They moved parish three times, into smaller and smaller accommodation, R. S. following his own dream ever westward, thinking (mistakenly) they were moving to a Welsh-speaking parish. In their final cottage in Sarn, Eldridge had to keep her work in black plastic bags to protect it from damage; normally stoical, she cried when she knew they would be leaving the large rectory at Manafon.[8]

Although the stronger partner in many ways, Eldridge played the part of supportive wife. According to her son she kept house for fifty years, cooking four meals a day at regular hours, making clothes out of the skins of rabbits and moles, knitting and mending, while still pursuing the drawing and painting that was for her, as it was for Clarke Hall, as natural as breathing.[9] The couple lived in silence, undemonstrative,

locked in their own thoughts. They each had their own workrooms, but met at regular mealtimes; they were a close unit and it suited them both. While they often discussed his work, Eldridge maintained it was best to 'keep your hearts together but your tents separate', something she must have learnt during the course of their shared life. They made a strange pair, the sophisticated English bohemian and the dour and chauvinistic Welshman. In his poem 'The Way of It', Thomas acknowledged his debt, writing of how 'with her fingers' Eldridge turned 'paint into flowers', of how she was 'at work always' and of the great consolation she brought him, so that 'if there are thorns in my life, it is she who will press her breast to them'.

Eldridge made twenty watercolour images for 'Recording Britain', the documentary project set up by Kenneth Clark in which artists recorded a picture of Britain before it was destroyed by war.[10] *Baptism in the River Ceiriog, Denbighshire* (1941) portrays an example of the survival of a rare tradition in an enclosed community – a laconical note on the back comments that such events were 'not often practised now as pneumonia follows without fail' – but increasingly her work now sold to private individuals rather than public collections. She had fallen out of the public eye after moving away from London and from the 1950s turned to making accessible illustrative work for the Medici Galleries, about which she had mixed feelings, as well as beautiful natural history studies. The RCA ethos encouraged a pragmatic approach to working in order to pay bills and Eldridge needed to pay her son's school fees: she felt the primitive lifestyle they had adopted shouldn't limit his choices; moreover, his absence at boarding school would mean both his parents could work.

Turning her back on her previous life, Eldridge became instead the catalyst that inspired her husband's poetry while also making everyday life for the family possible. After her death in 1991, Thomas wrote some of his most tender love poems. Her fame as an artist may have been a subconscious spur to Thomas; a well-read woman, she introduced him to the work of W. B. Yeats among other poets and under her influence his own poetry took a leap forward. He showed no overt interest in her work – they both regarded poetry and visual art as distinctly separate territories – but she helped open his eyes to nature: 'Look, Look, Look' she would tell him, as she had done her pupils at Moreton Hall School, where she was remembered fondly as an inspiring teacher.

Elsi Eldridge, *Self – St Lukes, 1970*. Pencil, watercolour and gouache. This is a rather extraordinary self-portrait. The artist's house was full of bleached bones, and she collected dead animals that she hung up to decompose. She remarked of her dead father in his coffin: 'Everyone looks rather lovely when they are dead.... I hope that even I might make a lovely skeleton.'[11] Eldridge's dark sense of humour did amuse Thomas's parishioners on occasion.

Despite the many domestic demands upon her, between 1951 and 1955 Eldridge nevertheless completed a huge and quite extraordinary mural project for the canteen of a nurses' home at a hospital near Oswestry, now relocated to Glyndŵr University, Wrexham. Technically ambitious, incorporating 36 metres (118 feet) of oil panels,[12] *The Dance of Life* deals with the alienation of modern existence and man's need to reconnect with the natural world, long before there was much concern about issues like pollution and the environment. Like many women artists of the period, Eldridge was, in her own way, an eco-feminist. Much of her work portrays women working in harmony with the circular rhythms of nature,[13] while the male figures depicted are aligned with technology and control.

Mural painting was popular in the 1950s, introduced into hospitals as a way of aiding the healing process; *The Dance of Life* was created for the nurses' canteen and required regular cleaning from ketchup stains. The first panel, 'Musicians and Bee-keepers', is a lyrical image of the custom of 'telling the bees' of important events, a practice she had

observed during her earlier travels in Yugoslavia. Other panels included 'The Beauty of Natural Decay', 'Man Cares for the Animals' and 'The Veil of Life'. The detailed studies of animals and birds are exquisite, accurate observations that fit tightly into the overall design. In one panel, navigation buoys and oversized lobster cages loom over a small boy who stands by them, threatening his childish innocence. He is clutching the hand of a monkey – a reference perhaps to her own son's toy monkey, or a further comment on the need to remember our place in the natural world. Figures in white overalls imprisoned in the lobster pots suggest a mistrust of new technologies. Her mural influenced her husband's later poetry and when Stanley Spencer saw it in 1958 he wrote to Eldridge that 'just one look at the heavenly sheep panel would remove all fear and gloom'. Author and art critic Alan Powers has suggested they are the most moving large-scale works after Spencer's own murals at Burghclere, Hampshire,[14] but the image that remains in the mind's eye comes once again from her son's account of how she painted the mural on the floor of the drawing room at the rectory, rolling up the canvas piece by piece as the work progressed, hanging some parts over doors to dry as she worked, trying to protect it from damp and damage.

The importance to women artists of dedicated, autonomous spaces to work in recurs time and again; the way in which Stanley Spencer's first wife Hilda Carline was forced to shut her paintings away in a cupboard and find alternative ways of expressing her creativity while Spencer complained about her domestic failures is just one of many examples. Hilda succumbed to mental instability and there is always a danger that such stories focus on women's inability to cope with their frustrating lives. The emphasis should perhaps be on how well so many *do* manage to transcend their difficult and unfulfilling circumstances.

Both former Slade students, sisters-in-law Hilda and Nancy Carline couldn't have had more different experiences of marriage. Nancy Higgins, twenty years younger than Hilda, got caught up in the Carline-Spencer entourage when she married Hilda's cosmopolitan brother Richard Carline. Politically on the left of the Artists International Association (AIA), Richard was involved with realist artists from the USA in the 1930s, and was soon spending more time on politics than painting. As a couple, the Carlines helped refugees from Germany settle in London, visited the 'Degenerate Art' exhibition in Germany in 1937 and were

friends with German political artist John Heartfield. Nancy remained apolitical; she liked German expressionism, but also Renaissance artists such as Titian and Tintoretto. She incorporated different influences into her art, which remained figurative but never embraced social realism. She managed to pursue her career alongside motherhood, with the help of a supportive husband. Her family life was a haven of calm compared with Hilda Carline's.

Stanley Spencer was an idiosyncratic visionary from the small village of Cookham in Berkshire, the son of a music teacher and organist who couldn't afford private education, his background a far cry from the cosmopolitan, intellectual Carlines of Hampstead. Born in 1889, Hilda Carline was of the generation of women caught up doing farm work during the First World War. She enrolled at the Slade in 1919, but her previous art education, along with her father and her brothers, had been at a private school in Hampstead run by Percyval Tudor-Hart, who was inspired by the post-impressionists and Kandinsky – the complete opposite of Tonks at the Slade, Tudor-Hart had encouraged bold, abstract and primitive work.

For a few years Hilda Carline pursued her own vision, exhibiting with the London Group, the New English Art Club (NEAC) and at the Royal Academy (RA). It was while at the Slade that Hilda met Stanley Spencer, and the two artists married in 1925; their daughters, Shirin and Unity, were born in 1925 and 1930. The marriage was disastrous for Carline's painting, both psychologically and practically: while brilliant, Spencer was also egocentric, critical and unreasonable. They were both stubborn, but Spencer gradually chipped away at her self-confidence.

Despite her parents' modern views, Carline's painter brothers had always been given space in the family home to work while she had had to make do with dark corners of the house. After her marriage, Stanley had a studio while she worked in her daughter's bedroom and constantly had to put her work away. This gradually sapped her inspiration. By the time she got divorced in 1937 she had gone back to her mother's house, along with her children, and her mental health was going into a decline, although she still tried to paint, 'making sense of her losses through art', as Nancy saw it.[15] Hilda Carline's work as an artist has long been overshadowed by the torrid saga of Stanley Spencer's love life. Even after the couple's divorce and Spencer's subsequent unconsummated

Dorothy Hepworth, *Portrait of Patricia Preece*, c. 1928. Pencil on paper.

marriage with Patricia Preece, Spencer never really considered himself not married to Hilda, and always dreamt of a reconciliation; his continuing obsession with her is evident in much of his art. Hilda's sister-in-law Nancy could see the dilemma – Stanley admired Hilda's work and wanted an artist wife, but he got very angry at her lack of domesticity. When she turned to gardening as a form of therapy, he was critical that she was not devoting any time to her painting, writing that she couldn't expect him to respect her 'when to my symphonic efforts you keep up a dreary beating of old tin cans which is all your sewing and gardening means to me'.[16] He also thought he knew best when it came to looking after the children.

Another source of discord came to be Spencer's relationship with Patricia Preece – born Ruby Vivian Preece in 1900 – and her lover, fellow artist Dorothy Hepworth. The daughter of an army officer, Patricia enrolled at the Slade in 1918, where she met Hepworth; her early work was praised by Vanessa Bell, Duncan Grant and Roger Fry and later bought by Kenneth Clark. Hepworth was the more serious painter of the two, but no work signed by her is in a public collection today.

Dorothy Hepworth's family were wealthy and initially financed the London studio that Preece and Hepworth first shared, but the family fell on hard times after the stock market crash of 1929. Dorothy was a couple of years older than Patricia, quiet and diffident and dressed in the current, sexually ambivalent, mannish style, while Patricia was a live wire, outgoing and sociable, flirting with men until they got serious. They were both nervous about being identified as lesbians, so they sometimes made a pretence of being sisters.

At the beginning of the 1920s they visited Parisian ateliers, where the lesbian milieu around Natalie Barney and Romaine Brooks created a more comfortable ambience. Back in England, Augustus John declared Preece one of the six greatest painters in Britain. The truth about her work only came to light in 1966, when Michael Dickens, a friend of Hepworth, wrote a play about them; Patricia had been signing Dorothy's pictures as her own, deceiving both the art world and the dealers with whom she negotiated the sales. It seems that Dorothy colluded with this practice, whether through extreme personal shyness or the force of Patricia's personality it will probably never be known. She was happy for Patricia to deal with galleries and dealers and many would now say they were merely combining their separate strengths into one successful career, out of financial necessity.

Preece certainly knew how to manipulate people with her charm and around 1930 she turned her spotlight on Spencer. The Hepworths' last act of generosity before their financial disaster had been to buy Dorothy a cottage in Cookham, ostensibly because her health was fragile and the village was not too far from London. Short of cash, Preece began modelling in the nude for Spencer, who became obsessed by her; the story of how he showered her with valuable jewelry and tried to persuade Hilda to accept her as his second wife is well known. Preece married Spencer in 1937, while still living and sleeping with Hepworth, eventually

rendering him homeless and impecunious with two families to support; she used all possible legal means to prevent him from divorcing her and was able to claim a widow's pension after he died.

Hilda Carline's work blossomed for a while after her separation from Stanley and she even agreed to make a portrait of Preece – ironically, Nancy Carline reports that Preece admired Hilda's work more than Spencer's. However, Hilda suffered a further mental breakdown, and died from breast cancer in 1950, aged fifty-one; Spencer remained, in his way, loving and attentive to the end. By the outbreak of the Second World War, Preece and Hepworth had virtually disappeared from the art scene, Patricia still exhibiting her lover's paintings under her own name and supplementing her income dealing in antiques. Hepworth outlived Preece by twelve years, obsessively painting self-portraits and dying in 1978, aged eighty. They are buried together at Cookham cemetery.

Madge Gill was born into very different circumstances to those of the Carlines or Edna Clarke Hall; having suffered serious disadvantage, her art was a way of making her life bearable. By 1920, she had already been subject to a number of traumatic events. Born illegitimate in London's East End, she was taken from her family into a Barnardo's orphanage when she was nine years old and from there transported to Canada to be 'in service' on a succession of farms where she was mistreated. She escaped back to London aged eighteen and lived with her aunt, working as a nurse in Leytonstone, and soon married her cousin, her aunt's son, in 1907. The marriage was an abusive relationship that resulted in three children; one son died in the great flu epidemic of 1918, another was seriously injured in a motorbike accident, requiring constant attention, and she also endured the tragedy of a daughter who was stillborn. Her husband died of cancer in 1932. Gill became extremely ill and as a result, lost the use of one of her eyes, which was replaced with a glass replica.

Gill is usually classified as an outsider artist, partly because she had no formal training, although this was also often the accepted case for wealthy girls who could dip in and out of private ateliers at will. She didn't start working as an artist until 1920, when she was first possessed by a spirit medium called Myrninerest, an event that was repeated in regular, delirious, trance-like states until her death in 1961.

Madge Gill, 1-m (3¼-ft)-wide section of an untitled artwork in pen and ink on calico, 1947. Gill made hundreds of beautiful coloured drawings, mostly of women, alone or in a crowd. With their blank, staring eyes and faint smiles, they might represent Gill's stillborn daughter, or the situation of women more generally. Diagonal chequerboard patterns and flowing clothes suggest a hallucinatory dance of life and death.

Her aunt introduced her to spiritualism and on recovery from her illness she seems to have entered a period of frenetic creative activity: craftwork, sewing, writing and drawings that she signed with the name of her medium. After two years she was admitted to a clinic for women's diseases in Hove and from there her artwork began to reach the art world. A woman doctor in whom she confided took her drawings to the Society for Psychical Research in London, where experts judged them to be more than just examples of 'automatic drawing', instead calling them 'inspired'.

At the age of fifty, Gill submitted some work to the Whitechapel Gallery's annual open exhibition, where it attracted a lot of attention in the press. She didn't want to sell her art and refused the offers of West End gallery shows, explaining that the work belonged to Myrninerest, but she continued to exhibit at the Whitechapel Annual for another

fifteen years. Increasingly unwell, housebound and self-absorbed, looked after by her surviving son, she continued to work furiously right to the end of her life.

After her death Gill's hoard of her own work began to be sold and was snapped up by collectors, including the French artist Jean Dubuffet and the Collection de l'Art Brut in Lausanne, Switzerland. In London, the Grosvenor Gallery gave her a retrospective in 1968, and her work featured in the Hayward Gallery's 'Outsider Art' exhibition of 1979. Peggy Angus and Olive Cook[17] viewed Dubuffet's championing of 'Outsider

Art' as positively 'colonial' and his own adoption of 'childlike primitivism' as an imperialist position.[18] So how should Gill's art be judged and how did she consider it herself? In one letter she poignantly wrote 'I wish I were normal', implying the huge amount of daily drawing she did was onerous as well as being necessary and therapeutic; in another she states her admiration for the American naïve painter Grandma Moses.

Where does the line between psychological need, obsession and normal art activity lie? Some of her rolls of drawings are enormous – one was 40 metres (130 feet) wide – and her son helped her construct mechanisms for revealing the fresh drawing surface bit by bit; like Eldridge, the space she had in which to work was limited. Her drawings in pen and ink are beautifully intricate and aesthetically satisfying, but she had little interest in them ever being exhibited – the annual Whitechapel show would have only shown a tiny fraction of what she was producing. Her insistence that the work was done by Myrninerest was an excuse both to avoid selling it and a way of avoiding categorizing herself. The world of her alter ego was a safe space, her medium's name an anagram of My Inner Rest. Was her evasion similar to that of Dorothy Hepworth, hiding behind Patricia Preece? Gill ignored the distinction between drawing on paper and making intricate designs on dresses and household fabrics, a forerunner in this respect to Tracey Emin, for whom she could be a direct inspiration. A predilection for forms of art-making beyond oil paint and sculpture was a shared passion for many women artists of the period and might be one of the reasons they don't feature largely in official art history before the more overtly feminist critiques of the 1960s and 70s promoted alternative media as worthy of respect.[19]

Constrained as it was by poverty, ill health and lack of opportunities, the world of Madge Gill can seem a world away from that of the Carlines, Edna Clarke Hall or Elsi Eldridge. Nevertheless, certain challenges were shared by women artists of the period, whatever their background: the success they enjoyed depended on finding a space, be it mental or physical, in which they could make their work.

Opposite Madge Gill displays a 4.5-m (15-ft) calico drape mural in her London home, 18 August 1947.

Chapter 5

ALTERNATIVE ARRANGEMENTS
life, art and sexuality

While homosexual acts between men remained against the law until 1967, same-sex relationships between women were not illegal in Britain in the early twentieth century and, indeed, have never been so. In 1921 a Scottish Conservative MP proposed criminalizing acts of 'gross indecency between female persons' in case they threatened the birth rate, and because they were thought to cause neurasthenia and insanity, but his suggestion was thrown out by the House of Lords on the grounds it would only bring the subject to the ears of those who would otherwise never have heard about it.

Many artists during the period covered by this book were engaged in reshaping the concept of 'home' around a non-nuclear idea of the family that embraced relationships between people of different sexual orientations while trying to combine life with art. Both Vanessa Bell and Dora Carrington entered relationships with homosexual men that, while emotionally problematic, were ultimately rewarding. Vanessa Bell, who as her son, Quentin Bell, put it[1] was in the advance guard of liberated women, found the intellectual hegemony of men debilitating, writing of members of the New English Art Club (NEAC) that they 'seemed somehow to have the secret of the art universe within their grasp, a secret one was not worthy to learn, especially if one was that terrible low creature a female painter'.[2]

Professor Henry Tonks once mistook a painting by Duncan Grant for one by Vanessa, saying to Roger Fry, 'what a pity it is that women always imitate men';[3] the truth was that in many ways Vanessa Bell was more ferociously modern than any of her male peers. She never toed anybody else's line: in a letter about a painting she made in 1914

Vanessa Bell, *Bathers*, 1911. Oil on canvas. The naked standing woman may represent Bell among her extended family. The scene shows the influence of *Baigneuses, Plage du Pouldu* (1899) by Maurice Denis, as well as of paintings by Degas, with figures disappearing off the picture's edge as in a snapshot. Bell photographed her children running naked and free, shocking the somewhat prudish local chemist who developed the negatives.

that was inspired by a gift of oranges and lemons from Duncan Grant, she pointed out '[it is] against all modern theories.... I mean one isn't supposed nowadays to paint what one thinks beautiful. But the colour was so exciting that I couldn't resist it.'[4]

Bell's pictures of Studland Beach, painted in 1911 and 1912, were left out of Roger Fry's 'Second Post-Impressionist Exhibition'; the first of them, painted the same year as Laura Knight's *Daughters of the Sun* (see page 21) caused shock because it showed naked bathers of both sexes, including children, alongside figures in modern dress. An added element to the perceived indecency of the image was that its creator was named as Mrs Bell, as was customary, identifying her as a married woman. Her later version of the same scene was more radically formalist and stark.

Of *The Tub* (1917), Bell wrote, 'I have been working on my big bath picture...I've taken off the woman's chemise and in consequence she

Vanessa Bell, *Madonna and Child*, c. 1915. Glazed ceramic.
While in the Western tradition the *vesica piscis* is often referred
to as 'fish-shaped' and is used as a Christian symbol, in the
East it is more often seen as representing a woman's vagina.

is much more decent.'⁵ Around the same time she made a fascinating
small glazed pottery object that she called *Madonna and Child* shaped
like a *vesica piscis,* an ancient symbol made up of two arcs sometimes
used to denote a halo on Christian saints. It bears a strange resemblance
to a woman's shoe. With this ceramic piece she appears to combine a
celebration of sex, fertility and motherhood in a single small image.

In social situations Vanessa Bell tended to be quiet and reticent,
while the men around her were often confident and ebullient; however,
her serious affair with Roger Fry provided considerable support – it was
a relationship based around art and ideas characterized by great mutual

respect and influence. Fry was not nearly as talented as a painter as she was; some critics have expressed regret that their affair ended because of her passion for Duncan Grant, whose work seemed eventually to shake her confidence. It is amusing to realize that the more formal painting of *Studland Beach* from 1912 that hangs in Tate Britain is painted on the *back* of one of Duncan's canvases; *his* image, of male nudes, faces the wall.

Bell wanted to live simply, somewhere she could be herself, but survival at Charleston (see page 38) was tough, at least at first. Despite the support of the domestic help usual to the upper-middle-class milieu, documented so interestingly in Alison Light's book about Bell's sister, Virginia Woolf,[6] she seemed to have been at the centre of a whirlwind of domesticity. 1916 was the year of her first solo exhibition at the influential Omega Workshops. She went on to exhibit at the London Independent Gallery in 1922 and then internationally in Paris, Zurich and Venice. Quentin Bell suggests[7] that her habit of self-deprecation was to guard against the sin of pride: he mentions the influence of the Quaker austerity that emanated from Roger Fry, influencing the women around him. Her grief over her son Julian's death in the Spanish Civil War and her sister Virginia's suicide in 1941 further disturbed her equilibrium.

It might seem ridiculous to suggest that the public reception of Bell's work has been overly affected by the phenomenon of 'Bloomsbury' when she was such a major part of it, but a solo exhibition in 2017 showed how useful it is to re-evaluate her on her own painterly terms,[8] including her early radicalism and constant experimentation. More private paintings, including later pictures of her grandchildren, are often criticized as being 'domestic', a coded form of disparagement for women artists. Her portraits of Fry, and of Duncan Grant shaving, are equally tender without the loss of any aesthetic appeal. *Duncan Grant in Front of a Mirror* (c. 1915–17)[9] references Velázquez's *The Rokeby Venus* (c. 1947–51), playing with the idea of mirrors and the male gaze. She makes a point of painting herself with paintbrushes in her hands.

If 'Bloomsbury' sometimes overwhelmed Vanessa's work, Dora Carrington, often portrayed as a victim because of her early suicide after the death of Lytton Strachey, always tried to rise above it. Known by her surname, as was the fashion for women at the Slade, Carrington was often dissatisfied with her own paintings and rarely exhibited them, frequently painting over her canvases, though as much for reasons of

economy as from any feeling of failure. A highly independent person, born into a middle-class and restrictive family, Carrington picked up feminist ideas through her friendship with artist Christopher R. W. Nevinson's radical family; his suffragette mother held regular soirées in her house in Hampstead that were also attended by Nina Hamnett, Daphne Charlton and Hilda Carline. Carrington tobogganed wildly on Hampstead Heath and rode a motorcycle around Regent's Park during the war; despite her demure and slightly hesitant appearance, she also knew how to have fun. The death of her father in 1918 led to a small annual income and financial independence. In 1921 she married Ralph Partridge, but it was an arrangement of convenience, in order that Strachey didn't feel she was too dependent on him. Strachey paid for the wedding and went with the couple on their honeymoon.

Carrington's life in the years before the outbreak of the First World War was complicated by the intense relationships among her friendship group at the Slade that included John and Paul Nash, Mark Gertler and Nevinson. Her passionate involvement in discussions with the group about art and life, combined with her air of physical reticence and determination to remain sexually unavailable only increased the fascination she held for them all and drove Gertler, in particular, half-crazy. The pain and complications arising from rapidly changing sexual politics affected men of their generation as much as women: Nevinson wrote to Carrington that 'men also worry about losing their freedom, mind, soul and ambitions on marriage just as women do, especially artists.'[10]

Nevinson and Gertler tried to steer Carrington and her friend Dorothy Brett away from their received opinions, pointing out the prejudices of their class and upbringing. 'So many mistakes and miseries have been caused through this foolish innocence that girls are compelled to have or pretend to,' Nevinson wrote. He suggested that sexual knowledge would give Carrington 'a much keener insight as to people as they really are and even pictures, books and plays will mean more to you'[11] – a cunning line of seduction, with some truth in it. The breaking up of her tight group of friends after they went off to war may have been beneficial in allowing her more space to try out her own ideas. Even Fry undermined her confidence at the Slade and she didn't enjoy the routines integral to art education.

Dora Carrington, *Frances Penrose*, c. 1930. Oil, ink and silver foil on glass. Popular glass paintings made in the 1920s and 30s were sold at Birrell and Garnett bookshop in Bloomsbury – a hive of intellectual discussion about sexual diversity and much else. Francis Birrell, who owned the shop with David 'Bunny' Garnett, edited a series of books about Representative Women.

Like many of her group, Carrington was influenced by the Italian Primitives that could be seen in the National Gallery: Sassetta, Giovanni di Paolo and even Botticelli. She liked their craftsmanship, soon to become a dirty word for the vorticists, who suggested all Old Masters should be thrown out and burnt. Her landscapes reveal her own particular vision. She was also influenced by popular art, making her own

glass paintings, tinselled pictures, woodcuts and painted signboards for breweries and shopkeepers, telling writer Gerald Brenan she found it 'more of an honour than becoming a member of the London Group'.[12] These arts all needed particular painting skills and their flat perspectives and colour schemes in turn fed back into her paintings.

Carrington made art from what she most loved. Her tinsel pictures, made from sweet wrappings and oil paint, reveal her fascination with colour and fugitive light; Mexican votive offerings are combined with the Cockney tradition of pearly kings and queens and etched glass in Victorian pub windows. Her oil painting *Tidmarsh Mill* (1918) shows her interest in reflections. She lived at the mill, in Berkshire, displaying popular engravings and seascapes alongside her own work there. She was ahead of her time in her appreciation of popular art, treasuring objects that Barbara Jones, Olive Cook and Enid Marx (see chapter 9) would be collecting in twenty years time. She had different aesthetic tastes to the Bloomsbury set,[13] and liked narrowboats, circuses and fairgrounds. Fry was encouraging his students to look at art from Africa, but not at art that came from outside the 'High Art' canon closer to home.

Carrington was criticized for 'wasting her time' on craft activities when she could have been painting – as if only oil painting counted as real art that mattered. She decorated her own furniture and designed rooms for Dorelia John at Fryern Court, Hampshire, also working for the owners of other large country houses, but always continued painting, making portraits and frankly erotic drawings of women that hinted at her bi-sexuality. When she did exhibit her work it was not well received. After a critical review in 1920, when she showed with the London Group, she wrote: 'there is arrant bilge written in this week's *Nation and Athenaeum*.... No one can just enjoy with their eyes simply, they must argue and reason and criticize.'[14] As Michael Holroyd points out in his foreword to Jane Hill's monograph about Carrington, 'her work was not generally known or seen until the end of the 1960s – when her first retrospective was opened in 1970 Arts Minister Lord Eccles actually referred to her as a Sunday painter, to a howl of protest'.[15]

Artists can be just as dismissive of each other. In a letter to Lytton Strachey, Carrington complains that Vanessa Bell and Duncan Grant liked her painting of Tidmarsh Mill, but 'not what I tried for, but for something else.... They tend to want you to be like them, and not like

yourself – which is really the only thing it's worth anyone's while to be.'[16] Ironically, Bell had said herself that viewing the 1910 post-impressionist exhibition had enabled her to 'say things one had always felt instead of trying to say things that other people told one to feel'.

Women can be dismissed so easily when they don't conform to the standard preoccupations of the day – and Carrington was gloriously herself. Lytton Strachey, Carrington says, 'was the only person to whom I never needed to lie, because he never expected me to be anything different to what I was'. The novelist Rosamond Lehmann thought she was 'one of the most un-boring people' she ever met.[17] It is important Carrington is neither defined by her relationships, which were all limiting in their various ways, nor by her death. The film *Carrington*, made in 1995 and directed by Christopher Hampton, focuses on the tragedy of her shooting herself, days before her 39th birthday and it is that event that is too easily remembered about her.

Relationships often transcend definitions, yet we are still too quick to employ categories, even when priding ourselves on our broadmindedness. Many women artists and designers during this period set up home together – Betty Rea and Nan Youngman, Phyllis Barron and Dorothy Larcher, Enid Marx and Margaret Lambert among them – remaining reticent about their private lives. Marx and Lambert, for example, were a hard-working couple who shared a home as well as a passion for the same ideas and art practices, working in a symbiotic, creative partnership. Other women were more flamboyantly alternative, but the term 'lesbian' should be used with caution; many would not have used it themselves, and not for reasons of shame. The writer and artist Djuna Barnes always insisted, 'I was never a lesbian, I only loved Thelma Wood.' Nan Youngman similarly disliked the term. Vita Sackville-West and Virginia Woolf concealed their thoughts about each other in *romans à clef*.

Women were experimenting with a variety of relationships and disliked being categorized; many felt that Freud, Krafft-Ebing and Havelock Ellis had pathologized homosexuality. Radclyffe Hall's *The Well of Loneliness* wasn't published until 1928, when it was banned as obscene in Britain, although pirated copies were easily available in France.

Before the First World War, 20 per cent of women never married and 17 per cent of marriages remained childless; after the war, male

mortality rates meant only one in three women found a husband; the classier magazines ran practical self-help features and promoted self-sufficiency, alongside articles that described wild partying and socializing.

As always, wealth granted a greater degree of control in life; Ethel Sands and Anna 'Nan' Hudson reinvented the French female-led salon tradition (as Ottoline Morrell and Vanessa Bell did elsewhere), providing space for intellectual conversations between writers, artists and intellectuals of both sexes. Walter Sickert enjoyed their company as well as their financial and social support. At his house, of course, women were still put in charge of serving tea to his guests and potential buyers. Sickert told Nan Hudson about his first meeting with Ethel Sands, that 'it was refreshing to find someone spiritually and intellectually on the slightly higher level for which I have always had a sneaking snobbish and perhaps pedantic hankering'.[18] Hudson and Sands painted each

Cecile Walton, *Romance*, 1920. Oil on canvas. Possibly representing a married woman artist's dilemma, there is irony in the title of this piece, which shows an array of male stereotypes from a woman's point of view. The reclining woman's pose is ambiguous: is she enjoying her freedom to be semi-naked, or is she a martyr taking leave of her offspring? There are disquieting elements: the nurse, petals on the floor, an apple suggesting The Fall.

other's portraits, Sickert offering them painterly advice, which they quietly ignored. Sands, with her rather aristocratic friendship group, free of the modernist pretensions of the Bloomsbury Group, favoured a rather a chintzy, eighteenth-century style of decor, keeping her paintbrushes well out of sight. She wasn't totally divorced from the real world, however; she nursed wounded soldiers in France during the First World War, subsequently working in a factory making overalls in London.

Sands and Hudson acquired the work of other important modern artists, displaying it creatively in carefully designed domestic spaces for England's cultural elite to view. Vanessa Bell found Sands's work, inspired by French painter Edouard Vuillard, full of a 'fatal prettiness' and probably warned Fry against inviting them to join the Omega Workshops. Writing in the *Nation* about Sands and Hudson's joint solo exhibition at the Carfax Gallery in 1912, Roger Fry dismissed the whole show as 'frankly feminine'.[19]

Hannah Gluckstein only ever wanted to be known as Gluck, and is now possibly best known for *Medallion*, her double portrait of herself and Nesta Obermer, which was used for the cover of the Virago Classics edition of *The Well of Loneliness*.[20] Gluck always referred to it as *YouWe* and painted it in 1936 to commemorate her 'marriage' to her new lover after finishing her relationship with Constance Spry. Obermer was a socialite, already married for convenience to an American businessman, and stayed with Gluck until 1944, when she complained she had become too possessive. The image was designed to comment on the difficulties of living a lesbian life.

In 1918 she wrote to her brother: 'I am flourishing in a new garb. Intensely exciting. Everybody likes it...it is old masterish in effect and very dignified and distinguished looking. Rather like a catholic priest.'[21] Aiming to shock, she sometimes dressed as a very convincing young male dandy – she went to the best gentlemen's outfitters and bootmakers – and sometimes in exotic dresses by Elsa Schiaparelli, around the time Coco Chanel was making androgyny fashionable. Captions in the press always pointed up when a work was by a female artist and Gluck had fun causing confusion.

Gluck was born into a wealthy Jewish family – her uncles were the founders of Lyons & Co., who set up tea shops around the city, charging economical prices, very popular with women as clean, safe spaces

to meet with friends. An instinctive prejudice against wealthy women artists was still present in 1936 when Gluck wrote to her mother: 'When you come to the show, tell no-one you are Mrs Gluckstein. Just tell them you are my mother. You will help the sale of my pictures more than you know, because then I will not be labelled "rich amateur".'[22] Her society friends were wealthy and could afford to court controversy. She knew Romaine Brooks, who painted her as *Peter, a Young English Girl*,[23] but they didn't get on and a large, reciprocal portrait of Brooks by Gluck was not a success – Gluck thought herself a better artist and Brooks refused to sit for the required amount of time. Paris, where Brooks mostly worked, was much more relaxed about women's behaviour than London, although outside the French capital any extravagant dressing or behaviour was less likely to be tolerated.

Not a feminist in the way we would understand the term today, Gluck regarded strength and genius as male attributes she identified with, and was obsessive in her quest for technical perfection. She changed her art style with each new lover, sometimes burning all traces of previous work. Some of her portraits have, like some of Nina Hamnett's, an almost Neue-Sachlichkeit intensity, in tune with the new post-war realism. She got on well with important men, who enjoyed having their portraits done by her. During the First World War she had painted soldiers playing snooker and a fire warden on the home front. After the war she painted racing scenes, as well as boxing matches, a subject Nina Hamnett and Laura Knight were also attracted to.

Although she was unconventional in her lifestyle, Gluck painted in quite a traditional manner. Her four-year relationship with floral designer Constance Spry inspired many of her flower paintings of the 1930s; in return Gluck sometimes suggested adding red cabbage leaves or curly kale to Spry's arrangements. Gluck's flower paintings (see pages 84 and 85) did not represent any acceptance of woman's traditional association with nature – they were to do with social prestige and interior design. Artificially arranged in vases against a simple empty background, they had nothing in common with the works of Winifred Nicholson and little with those of Ithell Colquhoun.[24]

Gluck designed and patented a kind of frame that, either painted or covered in the same wallpaper, completely integrated a painting within the wall; Oliver Hill, an architect who designed for the minor aristocracy,

Documentary photograph of Gluck, exhibition at the Fine Arts Society, Bond Street, 1926.

used both Spry's and Gluck's work for the society interiors he created. Although severe and formal, Gluck's flower arrangements were painted in a very sensual and sexual way – she described herself as like a bee, 'penetrating them for their sweetness'.[25]

Gluck had originally lived in Lamorna, in Cornwall, where Dod Procter and Laura Knight encouraged her to take her art seriously and to paint portraits. In a vigorous pencil portrait of Gluck by Alfred Munnings, made before she left home and cropped her hair, her free-flowing locks, strong profile and the pipe she is smoking make her look like a Romany. She liked to say she 'ran away' but her family, although highly disapproving of her way of dressing and living, were quietly outraged by this, as they always remained supportive, paying for her to attend the St John's Wood Art School and setting her up with a trust fund when she was twenty-one.

By 1935 she had bought a Georgian house in Hampstead and commissioned a modern studio from the fashionable architect Edward Maufe[26] for the garden. In Hampstead society, women who wore men's

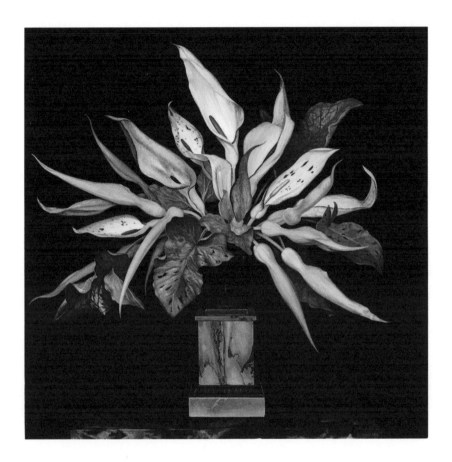

Above Hannah Gluckstein (Gluck), *Lords and Ladies*, 1936. Oil on canvas. Georgia O'Keeffe's flower paintings, made at a similar time in the USA, were interpreted by later feminist critics as sexualized. While O'Keeffe insisted this was not her intention, Gluck enjoyed challenging the public, and was likely making deliberate sexual statements.

Opposite Hannah Gluckstein (Gluck), *The Devil's Altar*, 1932. Oil on canvas. Devil's trumpet was one of Constance Spry's favourite flowers. While her work represented 'bourgeois mediocrity' for some critics, Spry's highly original vegetable and flower arrangements had an enormous impact on middle- and lower-income families between the wars: ordinary people could now design their own floral works of art, which were cheaper than paintings.

clothes were not commented upon. For over a decade she expended a lot of energy battling with artists' colourmen to develop the perfect paint. She didn't need money, and regarded her paintings as her children, only selling them to look professional, then buying them back later if she could. Gluck's reputation in London fell after the war – a new spirit of austerity and egalitarianism meant there was less enthusiasm for paintings of elegantly arranged flowers. She sold her Hampstead studio to Ithell Colquhoun, and moved to Steyning in Sussex, burying herself in the countryside. Gluck disliked abstraction and believed in objective observation, feeling any deviation from this path was intrinsically dishonest. Although she carried on painting, she would have found any idea of sharing her aims and ideas with a wider group of artists constricting. She never wanted her work to be seen as in any way related to her gender.

Chapter 6

WOMEN ON TOP
influence in the art world

Despite the male-dominated structures within the art world in the first half of the twentieth century, certain women – whether as writers, gallery owners or patrons – were able to bring their influence to bear.

On seeing an exhibition of contemporary art in the Arts Club in Mayfair in 1930, when she was a student at Oxford, Myfanwy Evans considered becoming an artist herself, but settled on a career as a writer. A close friend of fellow student and curator Nicolete Gray, she travelled regularly to Paris from the mid 1930s, where she became friendly with Jean Hélion, and also met Mondrian, Jean Arp and Sophie Taeuber-Arp. In 1935, she set up and edited the influential magazine *Axis*, a journal about abstract art, with financial support from writer Geoffrey Grigson (see page 88). It sold through Zwemmer bookshop in Charing Cross Road, London. Barbara Hepworth was the only woman included in the first issue and later issues carried articles by European artists such as Hélion, Picasso, Kandinsky, Klee and Jan Tschichold. English contributors included Herbert Read.

A precursor to *Axis* was *Unit One*, set up by Paul Nash in 1933. It accompanied exhibitions introducing his old students Barbara Hepworth, Ben Nicholson and Henry Moore to the British public. *Unit One* was designed to represent a contemporary spirit; its title referred to a 'unit', meaning an individual artist, committed to the 'one' common social ideal. Nash wanted Britain to break with its insularity and compete with Paris as a centre for the arts. The magazine didn't last very long, due to internal disagreements; Frances Hodgkins, for instance, soon became disillusioned with it. *Circle: International Survey of Constructivist Art*, edited by Naum Gabo, Ben Nicholson and architect Leslie Martin, with a layout done by Sadie Martin and Barbara Hepworth, would founder for the same reason in 1937.

Axis: A Quarterly Review of Contemporary 'Abstract' Painting & Sculpture,
No. 1–8 (a complete set).

Weary of all the infighting that threatened to undermine the spirit of the modern movement, Evans was determined to try to ensure *Axis* would last longer. She was pragmatic about differences of opinion because she felt that the ideological purism surrounding abstraction was leading to something resembling an ugly totalitarianism. She advertised the 'Abstract and Concrete' exhibition in *Axis*, but believed that art that reflected its own time must, by its own nature, be able to cope with change and rapid development. As a feminist she had doubts about Le Corbusier, who promoted modernism as a move against the 'feminizing of art and culture'; she saw this as as a dangerous path to follow. Politically to the left, she met her old school friend Peggy Angus again in 1936 and they immediately bonded over their discussion of communism. By 1935, when *Axis* was founded, the Artists International Association (AIA) was already making an impact in its campaigning

against fascism; social realism was being enforced in Russia, and within another two years Hitler would stage his first exhibition of 'Degenerate Art' – this was no time to adopt a rigid attitude to what should or should not be painted.

Myfanwy Evans saw art as a healing power. In her essays Virginia Woolf spoke of the world as a work of art, of wholeness and her own personal, creative energy, and also of the 'cottonwool of daily life'[1] – the monotony of unthinking chores, arguably more dominant and irksome in the lives of women than men and linked to their psychological wellbeing. Such matters, as well as the broader issues of artist's responsibilities, were touched on by Evans in her editorials for *Axis*.

In the 1930s, one subject of (hot) debate was whether artists should work cooperatively or as individuals. Intellectually supportive of the theories of the abstract artists, Evans nevertheless felt a strong need to see varied work in very different exhibitions 'for itself – not as a commitment to a line of behaviour'.[2] She agreed with John Piper, who she was living with from 1934, that 'the point is fullness, completeness: the abstract qualities of all good painting together with the symbolism (at least) of life itself'.[3] *Axis* survived for eight quarterly issues in 1935–36 before it too sadly foundered, but it established Evans as a voice to be respected.

She next edited an anthology of artists' essays entitled *The Painter's Object*,[4] which included one of the photographs taken by Dora Maar of Picasso's painting *Guernica*, still wet and propped in his studio – the first time it was seen in reproduction in England. The anthology was a response to *Circle*, reacting against its aestheticism, suggesting a more accessible, pragmatic approach, supporting a new synthesis that avoided rigid orthodoxy, using both formalism and symbolism to make sense of the world, rather as Picasso had done. It suggested a position that could tolerate change, as the moment dictated.

The outbreak of the Second World War brought new soul-searching for many, including Evans and Piper, and a retreat into neo-romanticism as the decade wore on. Evans went on to write libretti for the operas of Benjamin Britten, a notable pacifist, and became a close friend of Kenneth Clark, who disliked abstract art and saw no value in it.

Artists' reputations were increasingly dependent on where and how often they exhibited. Before 1939 there were only a handful of private galleries showing contemporary art, which is why the exhibiting

opportunities presented by artist groups were so vital to artists of the period. Later, most big reputations were made by dealers working with international markets, and particularly with the United States. Between 1950 and 1960 the number of private galleries dealing in contemporary art doubled. British Council shows, Biennales and promotions through the newly formed Arts Council were also important and largely run by men in positions of power: it became really important who you knew and were supported by. As Winifred Nicholson wrote to a friend in 1951, 'if we are to survive as painters we must find public bodies for our patrons; the private individual can no longer support us'.[5]

The Design and Industries Association was formed in 1915 to update Arts and Crafts ideals by allying industry with creative artists in order to reach all parts of society. By the 1920s and 30s, design had become as important as painting. The London gallery shop Dunbar Hay Ltd, founded by Cecilia Dunbar-Kilburn[6] with Athole Hay, the registrar at the Royal College of Art (RCA), became the focus of design work for industry, specializing in china and glass, and interior decorations and furniture. 'Every year a great deal of excellent work is done which falls into obscurity between gallery and shop. The gallery is altogether too formidable; the ordinary shop is too commercial and wants quantity for cheapness,' Dunbar-Kilburn explained. She preferred the term 'shop' to gallery.

Dunbar-Kilburn was in the same RCA student intake as Angus and Enid Marx and had studied sculpture. She commissioned work from her friends; Eric Ravilious designed her trade card and she was responsible for introducing him to Wedgwood & Sons. Marx contributed stunning fabric designs, Edward Bawden his wallpapers and Tirzah Garwood her marbled papers. Alan Powers describes the shop as having 'an ambience of lightly modernized English history and tradition'.[7] Full of integrity and enthusiasm, Dunbar-Kilburn was also fierce and sometimes tactless; she promoted new young artists that she liked, although she disliked some of the austerity of modernism, as in Marion Dorn's textiles and the work of Eric Gill. The shop folded in 1940 due to wartime shortages and bomb damage.

Muriel Rose was the pioneering owner of the Little Gallery, just off Sloane Street in Chelsea, which opened in 1928 and flourished until the

Opposite Enid Marx, textiles swatches.

beginning of the war in 1939. She had studied at St Martin's School of Art and was an exhibiting painter herself, teaching painting and ceramics most of her life. Like many of the RCA artists she wanted to break down the barriers between art and craft and educate the public through exhibitions where they could see how things were made and learn from the people that made them. She was also a devotee of folk art, travelling widely to collect and preserve examples, researching traditions and skills. She was passionate about maintaining the highest standards in craftwork and everything stocked in her shop was her personal selection.

Together with Margaret Turnbull, Rose made displays of textiles, embroideries, lace, pottery and papers, trying to present them in a natural domestic setting, as part of life rather than as art objects. Profits from sales went to support impoverished communities of handworkers that existed alongside more profitable concerns such as the Wedgwood factory and the established studios of potters like Norah Braden and Katherine Pleydell-Bouverie. She showed the textiles of Phyllis Barron and Dorothy Larcher, Ethel Mairet and Enid Marx alongside the quilting work of miners' wives from Durham and Wales. Artists including Barbara Hepworth, Ben Nicholson, Henry Moore and even Francis Bacon made forays into design and textiles in the 1930s, trying to introduce the new modernist aesthetic to a wider audience, but Rose disliked their abstract work, preferring the figurative work of artists like Peter Peri, a refugee from Nazi Germany in 1933 and later a neighbour of Peggy Angus at Camden Studios.

Phyllis Barron and Dorothy Larcher were both painters and among the leading hand-block printers of textiles during the 1920s and 30s, part of a reaction against historical reproductions of designs that lacked vitality. Barron had been to the Slade and then became inspired by traditional block printing in India and the textile designs of French peasants; Larcher favoured more organic images derived from plant forms. At first they used natural dyes. Ethel Mairet encouraged them to set up their own studio in London, where they attracted influential clients, but after 1930 they moved to Gloucestershire, where they employed several assistants and continued printing until wartime shortages encouraged them to turn back to painting.

If you couldn't run a gallery you could still support artists and their work in other ways. Mary Behrend and her husband were patrons of

Stanley Spencer at Burghclere, as well as of Frances Hodgkins, Stella Steyn, Anne Redpath and Frances Richards. Margaret Gardiner, a philanthropist, peace activist and founder member of the Institute of Contemporary Arts (ICA), bought new work and later went on to found the Pier Arts Centre in Orkney in 1979.

Nicolete Gray had collected artworks by Paul Nash, Eric Gill and Barbara Hepworth from an early age, using money saved from her dress allowance. She and her older sisters Helen and Margaret were the daughters of the scholar and critic Laurence Binyon, who encouraged them to have wide-ranging artistic tastes. A great supporter of David Jones, she later wrote an important book about his idiosyncratic inscriptions. A practitioner herself, she was a historian of letterforms as well as a critic, becoming the first female member of the Double Crown Club, the club for printers, publishers and all those involved in the graphic arts. She curated the 'Abstract and Concrete' exhibition in collaboration with *Axis* in 1936, at the same time as she was doing her research on popular Victorian typefaces that would influence John Piper and John Betjeman and some of the signage created for the Festival of Britain: a typical instance of modernism positioned side by side with romantic populism and nostalgia.

Helen Sutherland was a patron of both David Jones and the Nicholsons, a collector of avant-garde art who also supported the Pitmen Painters, working men who were trying to integrate art with their working life. Pitmen Painters often refused to attend life classes on moral as well as ideological grounds – they felt that images of nude women added sex and sensuality to artwork and they objected to the fact that this increased its 'value'; there may still have been an element of innate working-class prudery about nudity and sex in their make-up, which baffled their upper-class patrons. They used terms like 'religious', 'spirituality' and 'inspiration' in reference to their work, language with which sophisticated critics and patrons were uncomfortable; and they didn't actively seek remuneration for their work, which was confusing. Sutherland liked the work of Oliver Kilbourn so much that she wanted him to take up her offer of a regular stipend in return for more pieces, but he did not want to be seen as 'professional' and was suspicious her offer was merely to validate and increase the worth of his work in her collection. 'We hadn't any desire really to become artists,' he was

to recall. 'That was entirely foreign to our way of thinking.'[8] While Sutherland enjoyed the 'vitality and energy' of the modern work she collected, she seemed to equate it with sexual and specifically masculine energy, of which she wrote: 'women may not have it...it's an excess of energy too great for ordinary life'.

Art monographs were far less commonly published between 1910 and 1960 than they are now, and were therefore an important barometer of success. When Penguin, advised by Kenneth Clark, brought out the cheap and accessible Modern Painters series in 1944, the first four volumes featured Duncan Grant, Paul Nash, Henry Moore and Graham Sutherland, each suggested by Clark. Surrealist John Banting wrote a response to these, illustrating some of the deep personal, class and ideological antagonisms that seethed just below the surface of post-war Britain. 'They are very artistic,' he wrote, 'probably have no adventures even in their sleep, and most likely to go out of doors to make pre-arranged visits to other painters and their patrons, a list of which pillars of society and (cleaned up) culture is given in each book.'[9] Women artists would have reason to agree with Banting about the way the dice fell in terms of fame and fortune. Frances Hodgkins was the only woman represented in the series, posthumously, in 1948, with a text by Myfanwy Evans.

Women who found themselves able to become gallery owners did not necessarily support other women as a matter of course. Most were driven by a passion for the sort of art they believed in. Dorothy Warren ran a gallery for a while with her husband Philip Trotter, but it was temporarily closed by the police after a complaint by a member of the public about her exhibition of D. H. Lawrence's 'erotic pictures' in 1929, described by a judge as 'gross, coarse, hideous...and in their nature obscene'. Lawrence enjoyed upsetting the bourgeoisie. Warren went on to show embroidered seascapes by Norfolk fisherman John Craske, which were collected by Sylvia Townsend Warner; the early work of the young and unknown Henry Moore; and paintings by Patricia Preece and Dorothy Hepworth.

As the wife of a wealthy shipping magnate, Lucy Wertheim could support her interest in modernism, and particularly the 'primitivism' of Christopher Wood and Cedric Morris. She, too, was interested in the Pitmen Painters and lent work by Alfred Wallis and other outsider artists from her collection to their exhibitions. She founded the short-lived

Twenties Group for artists under thirty, and the women she championed included Barbara Hepworth, Frances Hodgkins, Edna Ginesi and the Irish painter Norah McGuinness, who represented Ireland at the 1950 Venice Biennale with Nano Reid. It was Frances who told Wertheim's husband to encourage her to open a gallery 'for us poor artists' – it is unclear whether she was referring to women or progressive artists generally. The gallery lasted from 1930 until the outbreak of war in 1939, with a sister gallery in Manchester existing for only a couple of years.

Peggy Guggenheim, who encountered misogyny wherever she went, had the resources to set up her own gallery in Cork Street called Jeune. It lasted for eighteen months before folding in 1939. Plans to set up her own museum of art, to be administered by Herbert Read, also foundered and her collection was eventually set up in Venice. The Second World War brought many opportunities for the British art scene to an abrupt end; in 1943, Guggenheim staged an exhibition entirely dedicated to work by thirty-one avant-garde women painters in New York. Noel Evelyn Hughes, known as Peter, who later became Lady Horton, ran the London Gallery in Cork Street until 1939 and later became a great supporter of the ICA. Ala Story, born in Vienna, worked with Wertheim and the painter Helen Lessore, later running a successful and fashionable gallery near the Royal Academy (RA) before moving to the USA.

Many female gallery owners had strong international connections. Lillian Browse, educated in South Africa, worked at the Leger Galleries in Bond Street in the 1930s before entering a partnership as a gallery owner in Cork Street, at Roland, Browse & Delbanco. She was affectionately known as the Duchess of Cork Street. During the war she put on important exhibitions of British contemporary painters, petitioning Kenneth Clark to allow her to use the National Gallery, newly emptied of its permanent collections. The war was actually quite beneficial for some contemporary artists: with valuable collections sent away for safety and international movement of artworks at a standstill, dealers and galleries needed something to sell. By the end of the war Cork Street was still shabby and the only other art establishment on the street was the Redfern Gallery. Browse & Darby, the current incarnation of the gallery, has survived the corporatization of the street and Lillian's retirement in 1981, when she donated much of her large collection to the Courtauld Institute.

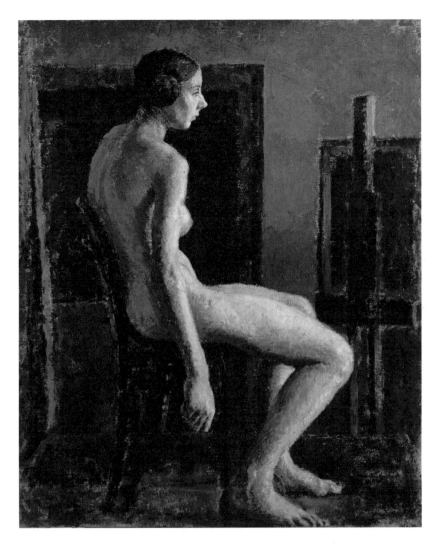

Helen Lessore, *Female Figure Seated*, 1927. Oil on canvas.

The painter Helen Lessore came from a cosmopolitan, part-Jewish family and was married to the much older sculptor Frederick Lessore. The Beaux Arts Gallery was originally an extension of his studio and Helen went to work there as a secretary in 1934. At the Slade in the 1920s she always questioned what made a work of art important from a European perspective; in her eyes this entailed a combination of intellect, emotion and observation, and philosophical questions about what it means to be human. Frederick Lessore's sister Thérèse[10] was the third

wife of Walter Sickert and a good painter in her own right, a founder member of the London Group. Helen preferred the directness of Sickert's painting style to the way she had been taught at the Slade. When the birth of two sons and administrative work interrupted her own painting career and her husband Frederick died in 1951, she took over sole management of the Beaux Arts, resuming her own artwork after the gallery closed in 1965.

Helen Lessore believed in what she called the 'Great Tradition', a form of humanism based on life drawing, and was determined not to be influenced by fashionable tastes like abstraction. The artists she represented painted mostly interiors, figures and landscapes. It wasn't the realism that was important but the artist's personal and positive response to the world at any one moment, and she liked David Bomberg and his students Frank Auerbach and Leon Kossoff. She had no interest in the increasing commercialization of the art world or in the emergent pop art; in any case, she couldn't afford to buy and show the work of established artists, even those she did like. Being an artist herself, she said, 'put me on the side of the artist, rather than anyone else'.[11] She might have liked Mark Gertler's remark to Carrington: 'The artists of today have thought so much about newness and revolution that they have forgotten art.'[12]

Lessore tried to provide an encouraging environment; the art critic Andrew Forge describes the Beaux Arts as being more like an artist's studio 'spruced up for visitors' than a gallery – no luxurious West End interiors here. However, her main stable of artists was mostly men, many of whom were habitués of Muriel Belcher's Colony Room club. Her gallery came to be associated with the Kitchen Sink School of realist painting, although the painter John Bratby found it 'a dry unhappy place, concerned not with the joy of life...but with the misery of the soul'. One of the few women she championed was Sheila Fell.[13]

The Hanover Gallery in Mayfair, founded by Erica Brausen[14] in 1949, was a very different kind of space. It had previously been the St George's Gallery, run by Lea Bondi Jaray, who had run a gallery in Vienna before being forced to flee to Britain in 1937 and who introduced many German expressionists to London during the war. Brausen was an extraordinary woman, who had been born in Germany in 1907. Living in Paris in the 1930s, a friend of Miró and Giacometti, she assisted Jewish

and socialist friends to escape from Franco's Spain during the Civil War. She arrived penniless in England in 1939 on a fishing boat and as a German national found it difficult to get work. A gay artist friend married her so that she could work legally at the Redfern Gallery. In 1949 she opened her own gallery with the help of an American banker and became Giacometti's main dealer in London. She was an early champion of Francis Bacon and also showed Lucian Freud, Duchamp, Matisse, Man Ray and Max Ernst. Her life partner Catharina Koopman, better known as 'Toto', helped her run the gallery and they lived openly as a couple. Toto had survived internment in Ravensbrück concentration camp after being caught spying for the Italian Resistance. The Hanover Gallery became a very important place for artists to exhibit and one of the most influential galleries in Europe. EQ Nicholson was offered a shared exhibition there in 1950, and Marlow Moss had solo shows in 1953 and 1958.

Outside London, the sisters Caroline Byng-Lucas and Frances Byng-Stamper set up the Miller's Gallery in Lewes in 1941, aiming to serve as a new regional centre of excellence, reviving all the arts in Sussex. Lewes had briefly housed the notorious private collection of Edward Perry Warren at Lewes House, including Eric Gill's *Ecstasy* and a cast of Rodin's *The Kiss*, which had scandalized the town during the First World War. A catalogue of 1987 calls Miller's an 'isolated centre of artistic production sheltering from the onset of a new dark age'.[15] In tune with the spirit of the time the sisters encouraged their painters to experiment with lithography and published a portfolio of various works that was exhibited as part of an Art for the People scheme. Born in the 1880s into an aristocratic family, the sisters were charming to those of their own class but otherwise snobbish and rather rude: hence their nickname, the Ladies of Miller's. They shared an affection for Duncan Grant, and supported the two notoriously alcoholic artists Robert Colquhoun and Robert MacBryde, eliciting from them some of their best work. Cedric Morris painted a double portrait of the sisters, but referred to them as the Upper Classes, so he was soon removed from their circle of enthusiasts.

Members of the Bloomsbury circle facilitated an entrée for the Byng-Stampers with the Council for the Encouragement of Music and the Arts,[16] who supported a '1,000 Years of Lewes' exhibition in 1941.

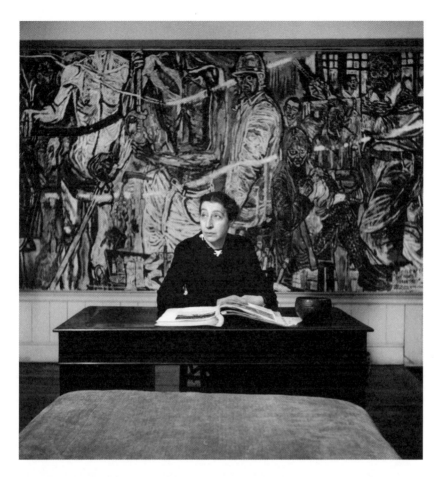

Helen Lessore, 1959. Square film negative. Photograph by Ida Kar. Ida Kar was the first photographer to have a retrospective exhibition in a major London gallery – the Whitechapel – in 1960, establishing photography as an art form. A Russian-born Armenian working in London from 1945 onwards, she specialized in recording avant-garde writers and artists, leaving an irreverent and yet deeply serious visual record of post-war cultural life.

Glyndebourne put on a song recital by Peter Pears and there was a ballet evening with Lydia Lopokova. Vanessa Bell lent some Julia Margaret Cameron photographs, and Ernest Duveen some important pictures from his collection. A 1942 show, opened by Bishop of Chichester, George Bell, included French 'modern masters' as well as sculptures by Moore and Hepworth. The Byng-Stampers owned a printing press and wanted to develop a printmaking atelier, teaming up with the Redfern Gallery and the Royal Society of Painter-Etchers and Engravers. They used the Chiswick Press and a master printer in Paris, paying scrupulous

attention to quality in their printing. Artists used transfer papers so that they could work in their own studios. Although known as rather mean landlords at the various properties they owned and for being bad at paying the tradesmen, they nevertheless paid the artists they commissioned up front. Caroline Byng-Lucas was a painter herself, exhibiting in London and abroad, and had studied sculpture with John Skeaping. She swept around Lewes in handwoven Ethel Mairet drapes made in nearby Ditchling and taught for a while at a local private girls school – the headmistress was a collector of contemporary art who had bought a Frances Hodgkins painting.

With Vanessa Bell and Duncan Grant, they set up a small painting school, and Vanessa considered reviving the Omega Workshops in Lewes. MacBryde and Colquhoun staged puppet plays and joined in enthusiastically with the traditional Lewes Bonfire celebrations; the sisters still supported them when they moved to Essex to live with George Barker. Miller's finally disbanded in the mid 1950s, when the sisters became too old to cope with the press; they died within months of each other in 1967. Their collection was sold and dispersed, and the town lost its role as a regional focus for art, something it has never regained. Despite their close association with Bloomsbury, they were little remembered until private research and a small publication and exhibition revived their story two decades ago.[17]

Nevertheless, overall there is no doubt that many women who were gallery owners, patrons, magazine editors and writers during the period had a profound influence on British art of the first half of the twentieth century.

Chapter 7

ON GROWTH AND FORM
modernism and abstraction

Modernism is a slippery term, often used loosely to imply that a certain way of thinking, living and making art can no longer be taken for granted. It is often thought of as embracing the new without any interest in tradition and is frequently associated with abstraction. For some artists it led to social radicalism, for others to a more detached aestheticism. Some artists pursuing personal forms of modernism failed to receive recognition. Katy Deepwell, the pioneering feminist art historian, has shown just how convoluted these discussions can be, citing the cases of Margaret Mellis and Wilhelmina Barns-Graham, who came to be marginalized by the vocabulary of the modernism espoused at St Ives (see pages 209–12). 'Their age was constantly at odds with the formula imposed on the narrative,' Deepwell writes. 'While they were too young in relation to the first generation, they were also excluded from the pivotal role of the second generation [as disciples] because of their association with the first generation.'[1]

The circle of friends around the artist Ben Nicholson had a major influence on public perception of culture between the wars; artists outside its orbit sometimes failed to get the recognition they deserved, even when they were unarguably 'modern'. Nicholson was very opinionated; charming and witty with people he liked, he could be savage to those with whose opinions he disagreed. Marxist critic Raymond Williams declared in one of his last lectures that the term 'modernism' stopped history dead, leaving some ideas stuck in the past and everything outside it fighting fruitlessly for attention: 'If we are to break out from the non-historical fixity of post-modernism, then we must search out and counterpose an alternative tradition taken from the wide margins of the century...to a modern future in which community may be imagined again.'[2] By 1972, the critic Robert Hughes would feel able to designate the avant-garde a 'period style'.

Marlow Moss, *White with bent cord*, 1936. Oil on canvas and rope.

The career of the painter Ethel Walker provides an example of an artist falling victim to being associated with the wrong 'ism'. Seen as a leading artist for a time, she was one of only five women included in John Rothenstein's *Modern English Painters* books in 1952, and was the

subject, along with Gwen John and Frances Hodgkins, of an important three-way exhibition after her death. However, as she continued to work until the end of her life in an impressionist manner she is little remembered today. The careers of artists of both sexes can founder if they are associated with a style that comes to be seen as out-dated.

By rights, the reputation of Marlow Moss should be up there alongside the big names of British modernism, but her work has been unaccountably neglected until recently. She is now regarded as one of Britain's most important constructivist artists. Born Marjorie Jewel Moss in 1889, she preferred the androgynous, ungendered name Marlow and always ignored the box asking whether she was 'Mrs' or 'Miss' at a time when the use of such titles was still usual. The daughter of a master hosier in London, she studied art at the Slade, against her parents' wishes, until some form of mental breakdown led to an abrupt flight to Cornwall, where she studied sculpture in Penzance. In 1926 she returned to London with a new name, masculine clothes – a cravat and jodhpurs – and very short hair. A year later she left for Paris, where she began a permanent relationship with the Dutch writer Antoinette Nijhoff-Wind, who wrote under the pen name A. H. Nijhoff. She studied under Léger and Ozenfant at the Académie Moderne, but the most profound influence on her work came through her meeting with Piet Mondrian.

While art history has largely consigned Moss to the role of a minor imitator of Mondrian's work, recent research[3] suggests that Mondrian may have been as much influenced by Moss as she was by him. She was a co-founder of the Abstraction-Création group, and may have been the originator of the mathematical justifications for the 'double line' in neo-plastic compositions, which she was employing herself, opening up a whole new area of spatial possibilities, before knowing of Mondrian's experiments in this direction. Along with Jean Hélion, she was also among the first artists to use coloured lines in neo-plastic compositions. By the 1930s she was making white reliefs, incorporating wood and rope.

Constructivism was an art movement based on mathematics and geometry; everything was arranged according to numerical considerations, rather in the way that D'Arcy Thompson's book of photographs *On Growth and Form*, published in 1917, had shown Pythagorean mathematics at work in nature. Mondrian and Kandinsky were also both interested

in Theosophy and other forms of mysticism, but their colleague, Theo Van Doesburg, under whom Marlow Moss studied, was not. Moss's philosophy seems to have been an existential Nietzschean atheism, which allied her closely with French intellectual thought; Myfanwy Evans's editorials, written for *Axis*, would probably have been too pluralist for her. For members of the British art establishment struggling to develop an identity for British art in the ongoing culture wars, Moss may have been too closely identified with the French scene for the good of her career, especially following the artistic community's return to parochialism after vorticism and the First World War. She was not included in Naum Gabo's *Circle* magazine of 1937, and Gabo was the mentor and friend of the modernist artists gathered at St Ives.

Vulnerable because of her Jewish heritage, she abandoned her Paris studio in 1939 and fled back to Cornwall. Much of her pre-war work was destroyed during the liberation of Paris in 1944. On her return she evidently hoped to join a community of like-minded artists in Cornwall, and wrote to Nicholson and Barbara Hepworth inviting them to her studio, receiving a very cursory, negative reply; this was doubly surprising as, like her, they were friends of Mondrian's and had found him a flat opposite theirs in Hampstead at the start of the war. After the war, Moss maintained her base in Cornwall, visiting Paris frequently and remaining close to Mondrian for the rest of her life. She joined the London branch of Groupe Espace and was included in their first exhibition in the Royal Festival Hall in 1955; she had solo shows at the Hanover Gallery in 1953 and also in 1958, the year of her death from cancer.

Her reclusive lifestyle, in the face of snubs by Nicholson and particularly Hepworth, whom she had met in Paris in 1927, may be one reason she dropped off the art-world map. There is no obvious reason for their attitude, although Nicholson was reported to have called her 'impure' – whether because of her class, her race, her sexuality or her diversion from Mondrian's strict principles is unclear. Her correspondence with her fellow artist Paule Vézelay shows how lonely and frustrated she felt because of the lack of interest shown in her work by any of the St Ives modernists, although she herself spurned friendly advances from Wilhelmina Barns-Graham. More conservative painters were nicer to her, and she knew Gluck, who took over her studio in Lamorna after she died. A painting of hers dating from 1956 was bought by the surrealist

performance artist Sheila Legge. Until the 1980s she was still considered a 'minor Mondrian imitator', but the recent re-evaluation of her work means it can now be seen in the collections of both the Tate and the Henry Moore Institute in Leeds.

Intellectual ideas about abstraction, put on hold by the First World War, resurfaced in the 1930s as part of a debate that framed art as a universal language transcending personality, a reaction to the social realism favoured by both Hitler and Stalin. However, such a position proved unpopular with the general public, particularly after the formation of the Arts Council in 1946; according to the popular press, abstract art was a waste of taxpayers' money. Royal Academicians, including Augustus John and painter and critic Alfred Munnings, were also vociferous disparagers of abstraction. In a catalogue to a 1949 exhibition of her drawings in Cornwall, Moss made a plea 'for the public to look at the work as free as possible from preconceived ideas', making analogies between her work, music and the beauty of form, platonic ideas that had much in common with Winifred Nicholson's approach to colour.[4]

It is hard to untangle the exclusions and the jostling for position that took place among artists of the period. In a letter to her friend Paule Vézelay, Moss refers to the 'miserable history' of abstract art and artists in England, and Vézelay gives an inkling of the tightness and insularity of the British art scene at the time when she remarks witheringly that 'they do not know enough about modern art; they know a few artist friends and that is about all'.[5] She was also caught in a crossfire of different allegiances, but she was a much more assertive character than Moss and perhaps overly optimistic about being welcomed back into the British scene.

Like Moss, Paule Vézelay had changed her name, having been born Marjorie Watson-Williams to a pioneering surgeon in Bristol. Briefly a student at the Slade, her first exhibitions showed colourful paintings of theatregoers and café society in Bristol and Paris. She was invited to join the London Group and met the Belgian brothers Gustave and Léon De Smet there, who were friends of the writer John Galsworthy. 'English art then bored me to tears,' she is reported as having said. Having exhibited with Gustave Smet in Brussels in 1920 she changed her name to Vézelay as a tribute to the Romanesque basilica in the town of the same name in Burgundy. Living in Paris until the outbreak of war she

fell in love with the surrealist André Masson and they came close to marriage. She abandoned figurative painting and began investigating her long-standing fascination with line. In France, Jean Cocteau was arguing that circus, jazz and music hall were the ideal new subjects for artists of the 1920s, injecting the fresh blood of popular culture into a tired tradition. The Cirque Medrano and tightrope dancers were already motifs in Vézelay's more figurative work. She was also drawn to surrealism, through Masson's ideas about automatic writing and the unconscious and freely drawn line as the root of creativity. In her case, it seemed, it was possible to be interested in surrealism and abstraction at the same time.

The wildness of Vézelay's affair with Masson eventually came to an end and she began a long working relationship with Jean Arp, the artist and poet associated with dada and concrete art, and his wife Sophie Taeuber-Arp, who sometimes worked on joint projects with him. This was an immensely happy and satisfying friendship and all three joined Abstraction-Création around 1931.

Arp's work was witty, his biomorphic shapes sensual and free, bridging a gap between modernism and the world of nature. Vézelay was more serious by nature and Arp's influence was good for her. Sophie Taeuber-Arp, an excellent artist, although her reputation was later overshadowed by her husband's fame, was also a dancer who had worked with Laban, interested in line and form and moving through space. She may have influenced Vézelay, who wrote that 'in 1935, I made my first constructions in three dimensions by using a small box in which I composed dried leaves, fishing lines and dry flies, sand and pebbles. This small and unimportant construction enticed me in 1936 to compose with white string stretched over canvas, and to make a collage with black-and-white forms on a black background, over which white cotton lines were stretched from point to point above the collage in the space beneath.'

Sadly, Taeuber-Arp died during the war, forcing Vézelay to return to England just as her career was taking off in France. Back in Bristol she made drawings of bomb damage and took striking photographs of barrage balloons, which mutated into threatening forms in her paintings. After the war Arp suggested marriage, but Vézelay decided this would upset their relationship and her work, and instead they remained very close friends. She, like Marlow Moss, lost all the work she had been forced to leave in her Paris studio.

Paule Vézelay, *Le Déjeuner sur l'Herbe*, 1931. Oil on canvas.

In London Vézelay was invited to form a branch of Groupe Espace by the president of the Paris constructivist movement, but there was little interest in post-war London in their activities. In 1955 she collected together a small group of artists of both sexes, including Marlow Moss, Ithell Colquhoun and Vera Spencer,[6] for an exhibition at the Royal Festival Hall[7] that anticipated the 'This is Tomorrow' exhibition of 1956. She earned her living by making textile designs for Heal's. Working on in a constructivist style, she was finally given a retrospective exhibition at the Tate Gallery in 1983, the year before she died. She was the first English abstract artist to have forged a reputation in France and she also exhibited at two commercial galleries in London, Gimpel Fils and Lefevre. Her career gives a picture of England's rather insular preoccupations.

Artists in Ireland and Scotland had a more cosmopolitan approach to seeking out European ideas, even if the work they brought home was seldom understood or appreciated. Like Staithes in North Yorkshire and Cornwall in the southwest of England, the west coast of Ireland had always been attractive to visiting artists from abroad, but there was a very limited art scene in Ireland generally, and therefore every reason to study overseas.

Born in Dublin, Evie Hone is now considered to be a major artist of the 1930s. The granddaughter of a viscount, she studied in London at the Byam Shaw School of Art, the Central School of Arts and Crafts and Westminster Technical Institute, where she attended classes given by Sickert and met her lifelong friend and fellow Irish painter Mainie (Mary Harriet) Jellett. They went on to study in Paris together at Atelier André Lhote and in 1921 more or less bullied the cubist Albert Gleizes to take them on as students; eventually they became more like collaborators with him in the move towards 'breaking up the picture plane', something Gleizes acknowledged after Jellett died in 1944, aged only forty-seven.

A bohemian way of life in Ireland was impossible, making escape to Paris essential; their privileged backgrounds (Jellett's father was an MP) made this financially possible. Both exhibited cubist pictures with the London Group and remained committed Christians. They belonged for a time to Abstraction-Création but few of Hone's paintings from the 1920s have survived. Back in Dublin the *Irish Times* merely reported Jellett was a 'late victim of cubism in some sub-section of this artistic malaria', but again her work has been reassessed in recent years and is now considered important in its own right. Theirs was a very poetic cubism, more like the work of Juan Gris than that of Picasso or Braque, and like many Slade students they were also inspired by early Italian and Byzantine art.

Evie Hone had a long-standing interest in the way that modern abstract art related to Celtic design and wanted to promote a national, Irish art. She was one of the co-founders in 1943 of the annual Irish Exhibition of Living Art; always interested in the spiritual aspect of aesthetics, she became a Roman Catholic in 1937.

Inspired by Georges Rouault, Hone studied stained-glass making with Wilhelmina Geddes, and was commissioned to make a glass panel for the Irish Pavilion of the 1939 New York World's Fair. Called *My Four Green Fields* after the folk song 'Four Green Fields', it depicted the four provinces of Ireland; since the 1980s it has been installed in the entrance hall of the Government Buildings in Dublin. A victim of polio in childhood, Hone was lame and often in poor health; Elizabeth Rivers, an English wood engraver living in Ireland, helped her work her designs up to scale. After the war, another of her stained-glass designs replaced the war-damaged east window of Eton College Chapel.

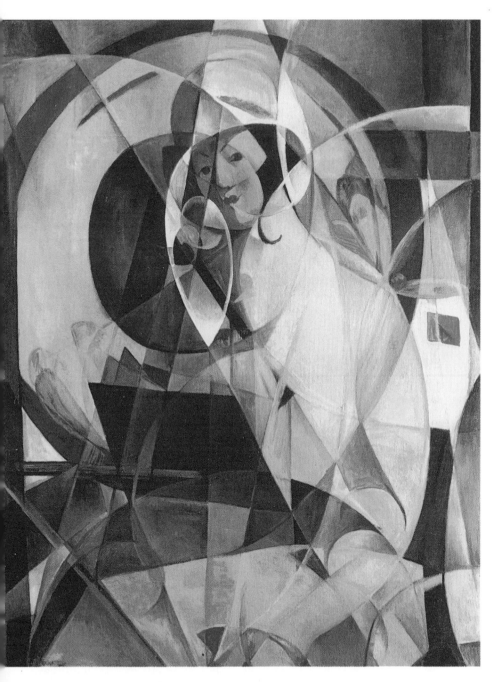

Mary Swanzy, *Woman with White Bonnet*, c. 1920. Oil on canvas. In Ireland, the fractured modernist image had a resonance for those whose lives were distorted by sectarian feuds and divided identities, as well as the huge differences between life in the city and the countryside. Mary Swanzy was one of Ireland's first abstract painters.

Mainie Jellett, *Decoration*, 1923. Tempera on wood
panel. This abstracted Madonna and child used
the gold leaf and tempera of a pre-industrial age.

Barbara Hepworth is the single most successful female modern-
ist artist of the period and is still seen as one of the most significant
women artists of the twentieth century. Much has been written about
her already. Giving a new direction and profile to sculpture in the way
that she did took a combination of talent, energy and ambition as well
as good fortune in her professional contacts. In the context of this book
it makes sense to focus on both her meteoric rise to success and her
attitude to having a family, discussed later.

Educated at Wakefield Girls' High School, the daughter of an
engineer, she was accepted at Leeds School of Art at fifteen, and at
sixteen won a county scholarship to the Royal College of Art (RCA).
Runner-up to John Skeaping for the 1924 Prix de Rome, she won a West
Riding Travel Scholarship that enabled her to travel in Italy. She married

Evie Hone, *Composition*, c. 1924–30. Oil on canvas. These bold
outlines could be easily translated into stained glass.

Skeaping in 1925, which allowed her to stay on in Rome, learning to
carve marble, before returning to London. Direct carving, previously
seen as inferior and artisanal, was associated with the so-called primi-
tive, non-Western art now becoming fashionable, of particular interest
to two of her old student friends: the artist Henry Moore and Richard
Bedford, soon to become a curator at the V&A. In 1929 she and Skeaping
had a son together but drifted apart, divorcing amicably after she met
Ben Nicholson in 1931.

So far Hepworth seemed to have led a charmed life: belonging to
a 'new movement' helped to give her career a good start and Bedford's
influence ensured an important collector bought her work. Moves
towards a purer abstraction culminated in her pioneering the 'pierc-
ing' of the block of stone and her experiments with collage and prints
maintained public interest in what she would do next. Her marriage to

Ben Nicholson, their contacts with the European avant-garde and their membership of Abstraction-Création, Unit One and Circle, combined to make them a force to be reckoned with. Together they formed a unit, influencing each other's work: she inscribed lines on Ben's pictures, they superimposed their own linocut profiles on top of each other, sometimes sharing a single eye, and shared exhibitions. They also took carefully choreographed photographs of themselves at work and compiled photo albums documenting their life together.

During the war they were evacuated from London to St Ives, the town with which Hepworth's name is now routinely associated, staying with Margaret Mellis and Adrian Stokes until they found a studio of their own. Hepworth's first major solo exhibition was in Leeds in 1943 but after the war she and Ben, together with Peter Lanyon, became prominent in the Penwith Society of Arts, attracting international attention. She contributed to the 1950 Venice Biennale and had two retrospective exhibitions, in Wakefield in 1951 and at the Whitechapel Gallery in London in 1954, which together with a monograph by Herbert Read that was published in 1952 confirmed her reputation. She started employing assistants on her larger commissions.

Throughout the 1950s, after her divorce from Nicholson in 1951, Hepworth's career continued to advance, seeing her become one of the few British women artists of the period to forge a truly international reputation. Two of her sculptures were included in the Festival of Britain site on the South Bank. She won the Grand Prix at the São Paulo Biennial in 1959, and installed her memorial to Dag Hammarskjöld, the secretary of the United Nations, in New York in 1964. Despite this level of success, her work was often compared unfairly at the time with that of Henry Moore. Moore had enjoyed a similarly meteoric career, and she was aware of the rivalry between them, which had been encouraged by critics since they were both students at the RCA. Her work was dogged by gendered criticism that spoke of her art in terms of pervading unselfconscious femininity, ultimate kindness and gentleness, and sheltering and embracing qualities. Hepworth was always quick to criticize such language, 'I have never understood why the word feminine is considered to be a compliment to one's sex if one is a woman but has derogatory meaning when applied to anything else.' 'Sculptors are workmen. They're not female, they're not anything. They're anonymous

Barbara Hepworth holding a chisel, St Ives, 1963. Photograph by Val Wilmer.

workmen.' However, she did identify herself with the land, claiming 'I the sculptor, am the landscape. I am the form and I am the hollow, the thrust and the contour.'[8] This may have been a response, whether conscious or unconscious, to Henry Moore, who was appropriating women's forms for his modernist sculptures in the landscape.

The neo-romantic movement, which emerged in the 1930s and 1940s, also made the landscape its subject but is usually represented by the work of a particular group of young male artists. How women had been instrumental in shaping the movement will be discussed in a later chapter.

Chapter 8

THE SUBVERSIVE EYE
surrealism and democracy

Surrealism was one of the few modern movements British women artists seemed able to turn to their own advantage. As feminist art historian and critic Frances Borzello has written, they 'were quick to see that because Surrealism was a movement in which technique was subservient to a poetic and imaginative vision it offered a level playing field to either sex.... They used the movement's hunger for powerful visual imagery to express their most complex – and shocking – thoughts and emotions.... As far as the public was concerned it was solar-plexus art, and in that sense truly democratic.... An image could go straight to the public psyche, and was not dependent on critical or institutional mediation for success.'[1]

Surrealist women were noisy feminists, adopting new tactics to raise their profiles. The artist Eileen Agar, while remarking in her autobiography that many of the male surrealists were good-looking, continued by pointing out that 'Surrealist women, whether painters or not, were equally good-looking...Our concern with appearance was not the result of pandering to masculine demands but rather a common attitude to life and style. This was in striking contrast to the other professional women painters of the time; those who were not Surrealist who were seen at all tended to flaunt their art like a badge, appearing in deliberately paint-spotted clothing. The juxtaposition by us of a Schiaparelli dress with outrageous behaviour or conversation was simply carrying the beliefs of Surrealism into public existence.'[2] This position remains contentious. Elsa Schiaparelli, a friend of Dalí and Cocteau, claimed to be a surrealist and her clothes suggested stories, myths and dreams: bright green gloves had fins on their fingers, a lobster appeared on an evening gown. Many artists could not afford a Schiaparelli dress. However, surrealist women were turning double standards to their own advantage.

Surrealism appeared to promote women's creativity as an antidote to decades of war; however, the vision of its leader and main proponent, André Breton, of perfect union with a muse was directed at expanding his own creativity, offering only a passive role for women, incompatible with the new freedoms *they* wanted. Breton[3] was indifferent to the artistic talent of his second wife, Jacqueline Lamba.[4] Male artists expected to enjoy their sexuality with complete freedom; however, when Lee Miller took lovers while living with Man Ray, it was seen as a different matter.

In 1931 surrealism formed the backdrop to Eileen Agar's declaration of a new age. 'In Europe', she wrote, 'the importance of the unconscious in all forms of Literature and Art establishes the dominance of a feminine type of imagination over the classical and more masculine order. Apart from rampant and hysterical militarism, there is no male element left in Europe, for the intellectual and rational conception of life has given way to a more miraculous creative interpretation, and artistic and imaginative life is under the sway of Womb-Magic.'[5]

However, some aspects of surrealism were problematic. Images that broke up the body questioned classical ideas of perfection, but some women began to question surrealism when it included violent assaults on female body images made by men. The painter Oskar Kokoschka, a regular visitor to Britain, painted self-portraits with dolls in the 1920s, and commissioned his notorious life-sized cloth figure based on Alma Mahler; he used it as a model for a series of paintings before abusing and ritually beheading it. German artist Hans Bellmer began constructing and photographing his disturbing, pre-pubescent *Puppe* (dolls) in the 1930s, fleeing to Paris in 1938, where he was welcomed into the surrealist group.

Mannequins had been used in avant-garde art and theatre to reflect the dehumanization of society since the end of the nineteenth century. Now they made ideal surrealist objects, leading a strange life of their own. They were often female. During the same period, much simpler shop-window mannequins had become an integral part of consumer culture, luring people into shops to buy clothes. Women felt uncomfortable about the way commerce had appropriated these representations of their bodies to sell an idealized and fetishized version of femininity. Mannequins had no sexual organs below their clothes of course, but in the International Surrealist Exhibition of 1938 in Paris, *La Resurrection*

Cover of *Surrealist Objects & Poems*, 1937, with
photograph of Eileen Agar's *Angel of Anarchy*, 1936.

des Mannequins featured a display of them, rearranged and dismembered,
resembling subjects of erotic violence, or, as Man Ray put it, 'the Eternal
Feminine subjected to the frenzy of the Surrealists...without any con-
sideration whatsoever for the feelings of the victims'.[6]

The International Surrealist Exhibition in London in 1936 had
been a much tamer affair. British surrealism was quite different from
its French counterpart, with a distinct approach to psychic reality and
the natural world. It was often an identification with the land and the
British romantic poets, rather than political or intellectual ideas that
led British artists to surrealism. A review of the first International
Surrealist Exhibition in Britain reported 'lovers of Lewis Carroll and
William Blake' flocking to the show, as if giving evidence of a general
tendency to madness and eccentricity lurking in the British psyche.

As late as 2008, in a preface to an exhibition catalogue of Agar's work, Andrew Lambirth still felt it appropriate to claim that 'a strain of divine madness has always run through our island art.... A native tendency towards unexampled invention and the wilder reaches of fantasy.'[7] Breton saluted the gothic writer Mrs Ann Radcliffe ('surrealist in landscape'), Jonathan Swift ('surrealist in malice'), 'Monk' Lewis ('surrealist in beauty of evil') and Lewis Carroll himself ('surrealist in nonsense') as the British ancestors of surrealism. But as artist and medical practitioner Grace Pailthorpe was to demonstrate, there was much to be learned from insanity.[8]

Eileen Agar was the only professional woman artist (apart from the mysterious performance artist Sheila Legge) to be included in the 1936 Surrealist Exhibition, her place possibly the result of the fact it was organized by her lover, Paul Nash. Legge appeared as *The Phantom of Sex Appeal*, wandering through Trafalgar Square in a long, white satin dress, her face obscured by paper roses with pigeons perched on her arms.

Agar came from a well-off professional family, had studied at Leon Underwood's school and at the Slade, where she used to beg her chauffeur to drop her off out of sight of other students because she was embarrassed about her background. In 1928 she had studied with a Czech cubist and her London flat was decorated along modernist lines influenced by Le Corbusier, so the term 'surrealist' covers only some of her interests.

Agar's life partner was the Hungarian writer Joseph Bard. They married in 1940 and stayed together through frequent infidelities on both sides; her passionate affair with Paul Nash in 1935 was inspired by a shared love of the extraordinary topography of the Dorset coast, which for her held childhood memories. Like Nash she began taking photographs of found objects and landscapes with megaliths and stones: 'It was as if nature had arranged a show of sculpture in the open air by the sea just to show these mortals what she could do,' she wrote.[9] Her extraordinary imagination and creativity inspired Nash, her freedom and playfulness often making his own work based on similar themes look rather intense and cerebral.

The Autobiography of an Embryo (1933–34), now in Tate Modern, was her first really important painting, representing animal and vegetable life in almost molecular form. She was fascinated by fossils, made drawings

in the Jardin des Plantes Natural History Museum in Paris, and for a while kept a fish tank in her apartment, intrigued that a foetus goes through a period when it has gills like a fish. Having children did not fit in with the male surrealists' vision of the world; an early notebook suggests Agar welcomed the idea of children at first but later adopted Malthusian arguments against procreation.

She found the publicity surrounding the 1936 Surrealist Exhibition and her sudden celebrity overwhelming, but enjoyed a summer spent with Picasso, Dora Maar, Lee Miller and Paul and Nusch Eluard on the beach at Mougins in the South of France, where she made flotsam from the beach into extraordinary surrealist objects, the sea and marine life often being uppermost in her imagery.

The exhibition of her work in 2008 at Pallant House Gallery in Chichester revealed her debt to abstraction and cubism, suggesting her reputation suffered by being too closely associated with surrealism.[10] Her collages were fragmented in a surrealist way but structured in a totally conscious manner, as she herself liked to point out. Exhibition reviews always commented on her wit. Her *Hat for Eating Bouillabaisse*, made from cork, shells and dried seaweed picked up on Riviera beaches, photographed well for the press, but had serious intent as well as popular appeal. In the popular imagination it rivalled Schiaparelli's 'Shoe-Hat', made in collaboration with Salvador Dalí, in which the heel of the shoe fitted onto the head with the toe forming a half brim at the front and the shocking pink stiletto heel pointing cheekily up to the sky.

In his book *Surrealism in Britain*, Michel Remy writes that 'deformation, elongation, condensing of the human form, turn Eileen Agar into a magician or benevolent witch, especially as she wore a pointed hat. And it is true that there was always something intrinsically supernatural in that unabated freshness of inspiration which never left her.'[11] Lee Miller made a collage of her, which includes her black silhouette in an acorn-shaped hat. The traditional ideas and images of witches (with pointed hats or otherwise) date back as far as classical texts, but a classical vision of life was being torn up by modernist movements. Surrealism was a balancing mechanism to the utopian idealism of pure abstraction.

Leonora Carrington read *The White Goddess*[12] by Robert Graves when it was first published in 1948, and approved. 'The Rights were there from the beginning; they must be Taken Back Again, including The Mysteries

which were ours and which were violated, stolen or destroyed, leaving us with a thankless hope of pleasing a male animal, probably of one's own species'.[13] She disliked 'masculine' intellectualizing, welcoming the operation of chance, and like Ithell Colquhoun turned esoteric traditions inside out to suit her own vision.

Born in England to a wealthy family, Carrington is often associated with Sussex: with Edward James at West Dean and Lee Miller at Farley Farm House. Her mother was Irish and she was influenced by Irish folklore, as well as Celtic mythology and magic. When fleeing to Spain in 1939, Leonora visited the Prado. Here she saw paintings by Hieronymus Bosch, playful, direct references to whom sometimes occur in her work. Her interest in alchemy and the use of egg tempera as a medium, with its laborious mixing and grinding and almost magical transformation of material earth pigments and an egg into works of art, led to inevitable references to cooking and rituals. One thinks again of Agar's Womb-Magic, women seizing control of Breton's idea of woman as passive receptacle of mystery, magic and creativity. Magic is not a topic much discussed in art criticism related to the surrealists, but the occult was a major fascination for many of the original members of the movement. In England, Aleister Crowley, a friend of both Nina Hamnett and Ithell Colquhoun, is frequently mentioned in the press throughout the period.

Hamnett's autobiography *Laughing Torso* mentions her friend Betty May, whose husband Raoul Loveday died in 1923, almost certainly from drinking infected water at The Abbey of Thelema, home to the remote and unsanitary commune Crowley founded on a mountainside above Cefalù in Sicily. Hamnett's account also mentions dead cats, a missing baby, a goat and blood, and Crowley unwisely decided to make a claim for libel, saying the book suggested he practised black magic. He lost, but the proceedings did none of the litigants any good: Crowley was made bankrupt and Hamnett never really recovered her *joie de vivre* after the stress of the drawn-out court case.

By 1932 Crowley was nearing fifty and a new generation of women was breaking away from all kinds of authority. Ithell Colquhoun was banned from many of the occult organizations she tried to join for refusing to accept the authority of male tradition. As a painter and writer she was developing a modern concept of magic through revolutionary

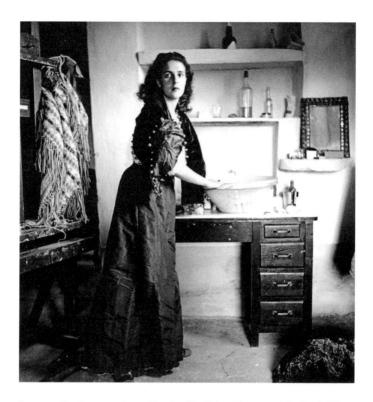

Leonora Carrington at Saint-Martin-d'Ardèche. Photograph by Lee Miller. In 1939 Leonora began a relationship with Max Ernst, whose influence moved her painting from satire to the magical and nature-bound. Following the war, which brought Ernst's internment and her psychological breakdown, she became a pioneer of the Women's Liberation movement in Mexico.

sexual imagery and deep identification with the land, many years before the ecological paganism and feminist practices of the late twentieth century. A student at the Slade a little later than Agar, her first paintings – *Judith and Holofernes* and *Susanna and the Elders* – featured strong and definitely non-subservient women. Colquhoun was inspired by Artemisia Gentileschi's paintings of violence against, and by, women – she had a reputation, particularly among male reviewers, for being 'strident' in her youth.

She joined some occult groups while still at the Slade, where Henry Tonks seems to have respected her individuality and her sense of design. As part of a long correspondence with her he wrote, 'the only danger in your development is that with your active and curious mind you may be led to run after stranger objects; you go out to gather strawberries

and come back with two strange beetles and a spider instead'.[14] Early on she painted erotic themes and flower paintings featuring exaggerated close-ups of their sexual organs. She saw sex as a biological force deep within the cosmos and portrayed the magic of nature in fertility and cycles of creation and destruction.

Women have traditionally been taught to keep their eyes downcast and not to stare, a stance that would be a problem for any artist. Such regulations are a classic method of restraint; even young males in many devout religious faiths are exhorted to keep their eyes down. Still occupying public spaces as unequal citizens in a variety of ways, women of the period did not have the automatic right to scrutinize others from a position of security. This has particular resonance when considering Colquhoun's work, remarkable for her unflinching gaze. Her ideas about androgyny and identity suggest she may have known of some early twentieth-century feminist theosophists who, long before artificial insemination developed, imagined that one day it would be possible to reproduce by parthenogenesis, without the need for men or genitalia. *Scylla*, painted in 1938, shows two phallic legs emerging from what could be a bath, but the body is female according to the carefully placed piece of seaweed in the groin area and there is a landscape beyond.

Some of her later works – *Double Coconut* (1936) and *Sardine and Eggs* (1940) – portray castration and male impotency, themes that may either be related to the mythology discussed in James George Frazer's *The Golden Bough*, or generally reflect her attitude to men. Her novel *The Goose of Hermogenes*, published in instalments in the *London Bulletin* from 1938, is about the completion of the Great Work by a hermaphrodite magician who transcends gender. It was based on the works of the seventeenth-century mystic Thomas Vaughan, popular with the neo-romantics. She wasn't against sex, depicting it positively with diagrams of men and women entwined in tantric sex, and of two women together, which may have differed from other similar occult imagery of the time. It was probably unusual for a woman in the 1940s to be depicting explicit sexual activity and she was asked to remove *The Pine Family* (1941) from the Leicester Galleries in London in 1942 as it was seen as pornographic. The painting shows a male and a hermaphrodite, both castrated, and a female whose leg has been chopped off. According to Remy and Richard Shillitoe,[15] the title is a play on words: *pine* is

French slang for 'penis', and the label reading '*l'hermaphrodite circoncis*' refers to an ironical nickname given by French surrealists to George Sand, for changing her name to a male one. The picture also refers to classical mythology. Attis, also referred to on a label, was born from a hermaphrodite and eventually castrated by the gods. Like a complex surrealist crossword puzzle about Eros and Thanatos, *The Pine Family* hints at an impending end of family life. The artist was briefly married to surrealist Toni del Renzio but chose not to have children, possibly because of her preoccupation with her own psychic development.

Colquhoun subverted authority from within. She was expelled from the formal surrealist movement for being an active member of several occult societies; Breton forbade membership of organizations that conflicted with the freedom of the surrealist way of life. She moved to Cornwall after the Second World War and her books *The Living Stones: Cornwall* and *The Crying of the Wind* (about Ireland), published in 1957 and 1955, mix folklore, paganism and herbal remedies with descriptions of archaeological sites and local flora and fauna. The first fed into latent Cornish nationalism and both are precursors to alternative 'earth mysteries' movements in the second half of the century.

Colquhoun ignored the traditional alchemical principle of 'wholeness', to introduce the idea of greater inherent powers for the female principle. In one piece of writing, Landscape and Woman combine in creative energy; the 'water of life' is conjoined with menstrual blood, a traditional source of occult power. It sounds faintly ridiculous until put in context with the shock caused by Lee Miller appearing as an identifiable woman in an advertisement for Kotex[16] in 1928, or Tirzah Garwood[17] – who could always be relied upon to speak frankly – recounting in her memoir how even doctors in the 1930s referred to menstrual pains as imaginary. Shock is a powerful weapon. It wasn't until 1978 that *The Wise Wound*,[18] by the poets Penelope Shuttle and Peter Redgrove, would discuss menstruation, a topic largely ignored by male-dominated science and medicine, in the context of anthropology and literature.

Colquhoun's technical experiments, with their complicated names described in 'The Mantic Stain'[19] in 1949 – automatism, entopic graphomania, decalcomania, fumage, frottage and parsemage – have been described as a form of modern witchcraft, endeavouring to reproduce

Ithell Colquhoun, *Tree Anatomy*, 1942. Oil on wood panel. Beyond more obvious connotations, one thinks of Picasso's rendition of Dora Maar's weeping face, Munch's *The Scream* or Bacon's open mouths. Lamorna Cove in Cornwall was still a particularly beautiful area and Colquhoun lamented the gradual destruction of its trees.

Grace Pailthorpe, *Ancestors*, 1935. Ink on paper. At the height of their fame, Herbert Read likened Pailthorpe and Mednikoff to super-realists, alongside William Blake and Lewis Carroll. They were expelled, however, from the surrealist movement by André Breton in 1940, perhaps as the result of the publication of Pailthorpe's article 'The Scientific Aspect of Surrealism', published in the *London Bulletin*, no. 7, December–January 1938–39.

the dark secret voice of the subconscious. She maintained that the methods of John Dee, the Elizabethan magus, were more scientific than Breton's modern automatic writing or the dream studies of Freud. Her work on Tree Alphabets acknowledges the influence of Robert Graves's *The White Goddess*.

The Tate houses the bulk of Colquhoun's archive, but refused to accept much of her 'magical' material, which is now irrevocably dispersed, irritating female researchers who want to take back the language of witchcraft on their own terms. Calling herself 'a poet in words, collages, paintings and constructions', she also admired Marcel Duchamp and Kurt Schwitters. Much of the work she made from rubbish has disintegrated, thereby recycling itself.

Unlike Grace Pailthorpe and Reuben Mednikoff, who were influenced by the therapeutic uses of automatism first suggested by French

psychiatrist Pierre Janet, Colquhoun's automatic drawings were done to gain spiritual understanding – a self-centred aim, it could be argued, compared with their interest in the public good.

Pailthorpe hadn't trained as a painter but came to believe that art had a vital psychological function. She studied medicine in London, qualifying in December 1914, before serving in the French and British Red Cross and as a surgeon in several different hospitals in France between 1915 and 1918. After the war she travelled to Australia and New Zealand, where she worked as a General Practitioner, before returning to England to study criminal psychology. In 1928 she founded the Institute for the Treatment of Delinquency, which later became the Portman Clinic.[20]

Before discovering surrealism, Pailthorpe wrote a book that would gain her international recognition in her field: *What We Put in Prison*[21] further developed ideas she had developed in a Medical Research Council special report called *Studies in the Psychology of Delinquency*, published in 1932. She did not see conscious and unconscious desires as warring factions locked in an inevitable repressive struggle, but argued for assisting their reintegration, maintaining that mental health professionals could learn from children, the insane and the delinquent, a viewpoint similar to that expressed by psychologist R. D. Laing several decades later. There were also strong similarities in her thinking to the maxim Aleister Crowley maintained lay beneath the whole of his social and spiritual philosophy, Thelema: Do what thou wilt shall be the whole of the Law.

In 1935 she met a young painter, Reuben Mednikoff, who had studied at St Martin's School of Art and worked briefly in advertising. At twenty-eight he was nearly half her age; they began, quite impulsively on his side, what she saw as a scientific experiment, well aware of probable gossip and misinterpretation. Mednikoff is supposed to have suggested to Pailthorpe, who was a large and masculine-looking figure, that she was confused about her identity as a woman. The couple eventually married and she also adopted him as her son. Mednikoff had serious psychological problems, mainly centred on his relationship with his mother. With Pailthorpe as his analyst, he embarked on an extraordinarily intense series of physical therapeutic sessions, involving sex and sadomasochism, risk and trust that they both recorded meticulously

Emmy Bridgwater, *Budding Day*, c. 1940. Oil on panel.

in their artwork and writings. Pailthorpe was of course crossing many boundaries, not least those of her profession, by having sex with and eventually marrying her patient.

Pailthorpe wrote in one of her first letters to Mednikoff, 'If what I am aiming for comes off, we shall not only both of us have benefited ourselves, but we shall have made a contribution to progress however small or great that may prove to be; and this, in my opinion, is the greatest privilege to which man and woman may attain. To give anything to the world that makes life for those that come after us one tiny a bit richer a experience, carries its own reward in the increased pleasure it brings to those who give.'[22] For Pailthorpe, the purpose of both surrealism and psychoanalysis was to liberate the individual psyche; while male surrealists were too closely involved with art history and tradition to make truly unconscious work and engage in automatist practices, women had often come through a much less structured education. Pailthorpe

and Mednikoff, their aims not limited to making works of art, were the ones acting in a truly surrealist spirit.

Edith Rimmington, and Emmy Bridgwater, who joined the British Group of Surrealists in 1937 and 1940 respectively, are two further examples of British surrealist artists making radical images of growth and metamorphosis. Both came from humbler backgrounds than Agar, Carrington or Colquhoun. According to Michel Remy, Bridgwater's emergence on the British scene was 'of the same importance to British surrealism as the arrival of Dalí in the ranks of the French surrealists'.[23] She was particularly fascinated by birds, which she saw as mediators, flying between different spheres. Like Rimmington, she also painted eggs and eyes, sources of the origins of life and of seeing. Born in Birmingham into a modest Methodist family, Bridgwater worked as a secretary to pay for her studies at Birmingham art school. The Birmingham Group of Artists, to which she belonged, had a strong surrealist contingent that included Conroy Maddox, who introduced her to the London Group. The 1936 Surrealist Exhibition in London impressed her so deeply that she enrolled at the Grosvenor School of Modern Art in London; her relatively humble background may explain why she felt uncomfortable there. At the school she began to work in a quite different way; she became friends with Rimmington and had a brief affair with surrealist artist Toni del Renzio. She had already decided she would never marry or have children as there was a genetic condition in her family she had no wish to pass on to another generation.

Del Renzio wrote of Bridgwater's work in the surrealist magazine *Arson*: 'We do not see these pictures. We hear their cries and are moved by them. Our own entrails are drawn painfully from us and twisted into the pictures whose significance we do not want to realise.'[24] Art critic Robert Melville described them as 'dreamlike in their ambiguity they are realistic documents from a region of phantasmal hopes and murky desires where few stay to observe and fewer still remain clear-sighted'.[25]

During the Second World War, as well as trying to promote a new aesthetic, British surrealists were committed to personal imagination as a way of understanding the roots and implications of conflict. Bridgwater and most of her fellow British surrealists were destined to remain outsiders; from their perspective, artists like Humphrey Jennings, Henry Moore, Herbert Read and even David Gascoyne had sold out to the

establishment.[26] As Angela Carter wrote in 1978, 'Surrealist romanticism is at the opposite pole from classical modernism, but then, the Surrealists would never have given Pound or Eliot house room on strictly moral grounds. A Mussolini fan? A high Tory? They'd have moved noisily, but with dignity, to another cafe.'[27]

Bridgwater maintained a strong sense of humour – her interests ranged from Emily Brontë to the Marx brothers – but her work is spiky and very physical. Her profile was raised when she had a one-woman show in London in 1942 and Breton chose to include her work in the Exposition Internationale du Surréalisme in Paris in 1947, but her output was gradually affected by having to look after her mother and a disabled sister. She never complained. By the mid 1980s she was beginning to be rediscovered and appreciated, but by this time she was too frail to continue working.

Bridgwater had shown how the shape of an egg is like an eye, and an eye is like an egg, finding a unity of place where an image begins; both she and her close friend Rimmington attempted to create new thought processes out of apparently strange content, deliberately keeping their work enigmatic in order to defy narrative interpretation.

Rimmington, who was born in Leicester but studied at Brighton School of Art, moved to London in 1937, where she met Belgian artist E. L. T. Mesens and the London Surrealist Group, becoming, as Bridgwater had done, close friends with the artist John Banting. Like Eileen Agar she loved the sea and moved to Bexhill-on-Sea on the south coast in later life, not far from Edward Burra, who lived in Rye; they admired each other's work. In a letter to Banting in 1971 she described the sea 'as a vast waterbrain...[it] seems to hold all the secrets'. Plunging into the sea is frequently seen as a metaphor for plumbing the depths of the subconscious.

Like many women artists, Rimmington found making art difficult during the war;[28] in the post-war years she exhibited in major surrealist exhibitions and contributed a large number of drawings and writings to surrealist publications, before turning increasingly in the 1960s to photography, demonstrating once more the porous boundaries between imagination and reality.[29]

Edith Rimmington, *The Oneiroscopist*, 1947. Oil on canvas. An oneiroscopist is an observer of dreams. One thinks of Dalí in his diving helmet in 1936. The head is slightly tilted – what does it see? The eye, ubiquitous in many surrealist works (and easily parodied subsequently), represents the impossibility of really seeing or knowing, alluded to also by the fragmentation and destruction of any system of perspective.

Chapter 9

ART FOR LOVE
Neo-Romanticism

Although a particular group of male artists come to mind when think-ing of British art of the 1930s and 1940s – Graham Sutherland, John Piper, John Craxton and the photographers Bill Brandt and Edwin Smith among them – women played an important role in shaping the art of the period. As with the surrealist movement, the literary influence on the visual artists involved in neo-romanticism was strong and in some cases it is literature that most clearly shows the effects of pre-war tension and wartime anxiety.

Neo-romanticism was closer to an underlying feeling than a coher-ent art movement, the term itself principally serving as art-historical shorthand. Alexandra Harris's more nuanced term 'Romantic Moderns' is also the title of her important book,[1] which dissects the art of the period with its intertwining patterns of nostalgia and modernism. Neo-romanticism was grounded both in a sense of place and a feeling of insecurity about the future. While the look of English post-war culture was much influenced by female artists of the period, it was primarily women authors, rather than painters, who were using topography as their inspiration.

Elizabeth Bowen's short stories about London evoke the heightened context and slightly gothic strangeness of the neo-romantic sensibility, some passages the verbal equivalent of a painting by Sutherland or John Minton. In the postscript to her collection *The Demon Lover and Other Stories* she wrote: 'It is a fact that in Britain, and especially in London, in wartime many people had strange deep intense dreams.'[2] If neo-romantic imagery incorporating the moon and moonlight can now appear hack-neyed, this may be because we have forgotten the particular significance of natural light in blacked-out, wartime London. The following extract gives something of that context:

'Full moonlight drenched the city and searched it; there was not a niche left to stand in. The effect was remorseless; London looked like the moon's capital – shallow, cratered, extinct.... However, the sky, in whose glassiness floated no clouds but only opaque balloons, remained glassily silent. The Germans no longer came by the full moon.'[3]

In the novels of Mary Butts,[4] written in a modernist style as innovative at times as that of Gertrude Stein, mythical events are re-enacted in the contemporary period and a very particular place. Mary's great-grandfather was Thomas Butts, the friend and patron of William Blake, and her stories, all based in Dorset, draw on the story of the Holy Grail, which also provided inspiration for Jessie Weston's study *From Ritual to Romance* in 1920 and T. S. Eliot's epic poem *The Waste Land*, published in 1922.

The novels of Mary Webb, popular throughout the 1930s and 40s, feature the land itself as a character, drawing comparison with the works of Thomas Hardy. The film version of her 1917 novel *Gone to Earth*, made by Michael Powell and Emeric Pressburger in 1950, despite being an American co-production was shot largely on location in Shropshire, using locals as extras in many scenes. The book had emphasized the idea of female innocence versus male culture and was savaged hilariously by Stella Gibbons in her parody *Cold Comfort Farm*,[5] published in 1932.

Archaeologist Jacquetta Hawkes's intense and visionary non-fiction book *A Land*, published in 1951, the year of the Festival of Britain, was another bestseller, predating but bearing comparison with Ithell Colquhoun's *Living Stones*.[6] Writer Robert Macfarlane has described *A Land* as 'Roger Fry on Rocks...a geological prose-poem; a Cretaceous cosmi-comedy; a patriotic hymn of love to Terra Britannica...a lusty pagan lullaby of longing; and a jeremiad against centralisation, industrialisation and "our" severance from the "land".'[7] It was a precursor of the environmental movement that emerged in the early 1960s, influenced by such works as Rachel Carson's powerful denunciation of pesticides, *Silent Spring*, published in 1962.

In the introduction to *A Land*, Hawkes says of Britain, 'I see a land as much affected by the creations of its poets and painters as by changes of climate and vegetation.' She wrote the script for *Figures in a*

Olive Cook, *Untitled*, c. 1950s. Pastel on paper.

Landscape, the documentary film about Barbara Hepworth made by the British Film Institute in 1953, and was friendly with both Paul Nash and Robert Graves, with whom she discussed *The White Goddess.*

The novels of Daphne du Maurier, in which the topography of Cornwall plays a significant role, were made into films shortly after publication and influenced the popular imagination. Du Maurier's younger sister Jeanne was an artist who trained at the Central School of Art under Bernard Meninsky and joined the St Ives Group at the same time as Dod Procter, with whom she became romantically involved. In the 1940s Jeanne du Maurier's work was well regarded and sold for good prices – her first solo show was at Helen Lessore's Beaux Arts in 1950 – but her career suffered when she was forced to dedicate herself to looking after her mother.

Naomi Mitchison's *The Corn King and the Spring Queen* of 1931,[8] illustrated by Susan Einzig, is underpinned by a strong feminist ideology reaching far beyond the comparatively 'bourgeois values'[9] of Virginia Woolf's *A Room of One's Own* of 1929. Mitchison, born Naomi Haldane,

was a forceful intellectual voice in the 1920s and 30s, speaking out on the topics of patriarchy, poverty, sexual freedom and birth control, as well as the seemingly incompatible aims of socialism and feminism. After criticism she received from the established church on all these grounds, supported by letters of protest in the press accusing her of communism, she agreed with pride that indeed women *were* potentially culturally dangerous people. One Catholic rector, writing to the *Middlesex County Times* in 1931, suggested that 'as Mrs Mitchison does not apparently believe she has a soul or a hereafter, let her go right ahead, and wait and see', to which Mitchison replied that the Catholic church, not being able to burn her as it had once burned witches, proposed simply now to send her to hell.[10]

1939 saw the first film adaptation of Emily Brontë's *Wuthering Heights*, filmed wholly in the United States despite its Yorkshire setting, with a craggy-looking Laurence Olivier playing Heathcliff. The British sense of the gothic it played to goes back to Mary Shelley and her novel *Frankenstein* (1818), through Ann Radcliffe and *The Mysteries of Udolpho* (1794) and Jane Austen's parody of the genre, *Northanger Abbey* (1817). Each has a strong, specific landscape setting.

The Sitwell siblings – the writers Edith, Osbert and Sacheverell – were a family with arguably many gothic characteristics. Their family seat, Renishaw Hall. was huge and reputedly haunted – without electricity and with miles of corridors and creaking stairs. When they commissioned John Piper to paint the house, he discovered that when in residence, Edith[11] spent most of her time in bed to keep warm, drinking alcohol, knitting and listening to a wind-up gramophone to fight off bouts of despair. Even Edith's appearance was romantic, her eccentric costumes hinting at an earlier Elizabethan age.

A very different sense of place and local distinctiveness underpinned the work of artist and writer Olive Cook and her husband Edwin Smith, particularly in their work for *The Saturday Book*. Published annually from 1941 to 1975, each volume of *The Saturday Book* was a literary and artistic miscellany of British life and popular taste. Cook was an intellectual, a contemporary of Jacquetta Hawkes at Cambridge, where she studied French and German. She had then studied under Cedric Morris at the East Anglian School of Painting and Drawing. Her first job was as art editor for Chatto & Windus; during the war she was supervisor of publications at

the National Gallery, working with Kenneth Clark, where she got to know Thomas Hennell, Eric Ravilious and Stanley Spencer, all of whom were commissioned as war artists. The watercolours she was commissioned to make for the Recording Britain project are now held by the V&A. Her portrait of Edwin Smith is in the National Portrait Gallery and she exhibited with both the London Group and Leicester Galleries. Better known as a writer, she considered herself first and foremost an artist.

Although he also considered himself primarily a painter, Edwin Smith is now known principally for his photographs, in which he tried to capture his vision of an England that was slipping away. Olive called him elitist but they both had a warm humanity, sceptical of the State but believing strongly in community. Nonconformist, without religious belief, they believed in social concern, but not in being told what to do. An early environmentalist, Cook was concerned with the future of the planet and the preservation of the countryside, campaigning vociferously against the building of Stansted Airport.

She was interested in puppet plays, magic lantern shows and early projections that preceded the invention of cinema, writing an important survey of the subject called *Movement in Two Dimensions* in 1963. Her contributions to *The Saturday Book* enriched British visual culture. The first volume had few images but included wood engravings by Agnes Miller Parker. By the time Olive and Edwin joined the team for volume 4, inset photo pages documented a quirky selection of etched pub glass, Victorian religious mottoes, shop signs, popular ceramics, taxidermy extravaganzas and a huge variety of ephemera. These were usually compiled by Olive using Edwin's photographs, 'a brilliant conjoining of authoritative information and emotional intensity',[12] her short descriptions and longer articles demonstrating her expertise as a critic. Olive Cook wrote, 'There is something miserly about serious collecting...if an object moves us by its own grace that should suffice.'[13] The images in the miscellanies mirrored the sort of things found in their own home, where extraordinary objects were displayed with a surreal abandon. She was an endless source of hospitality and enthusiasm, like many of her circle, generous to the point of recklessness. She disliked the uniformity of modernism – what should matter was the particularity of wherever you happened to be, which lay in detail, decoration and the popular arts, all anathema to the modern purist.

Olive and Edwin were chiefly responsible for the increasingly quirky look and content of the books, as editor Leonard Russell[14] was the first to admit. Olive's selection was prompted by her amusement at the continual small follies of individuals and societies. Curiosities featured included lovingly made objects that expressed remembrance, heroism, grief, mourning or jubilation; valentine cards, greetings cards, commercial signs and exuberant decorations; and the stuff of everyday life – the sort of things her great friend Peggy Angus was fascinated by and called 'Art for Love'.

Cook used collage in her own art, picking up discarded scraps and weaving them back into a seamless web of existence, a record not only of how things looked at a certain moment, but also how it felt to be there. Sent as cards or small gifts to friends and acquaintances, they re-entered the chain of ephemera that would have to take its chances on whether it would be passed on to posterity or end up in a bin – the fate of a lot of work done by lesser or unknown artists, skewing the record

Spread from *The Saturday Book*, contributions by Olive Cook and Edwin Smith (Hutchinson, 1955).

of what people were actually doing at any given time. Her creativity was relentless, but she wasn't prepared to change her principles or her nature in order to gain recognition as a serious artist. Peggy Angus's trip to Bali in 1960 crystallized ideas for them both. In Bali, a lot of 'artwork' was burnt during religious festivals, or in the case of lovingly crafted, coloured mountains of symbolic food, eaten. 'How marvellous in this materialistic age...to be so profligate with expressions of the spirit as to make art to burn,' wrote Peggy. 'What confidence in their limitless energy...in this world so cluttered up with PAPER and CONCRETE, consumable art like cakes and bonfire effigies have much to recommend them.'[15] Such art, it could be argued, was ecologically sound.

Another person with boundless energy was Barbara Jones, one of Cook's main rivals when it came to being 'a snapper-up of unconsidered trifles', Shakespeare's phrase later used as the title of a monograph on her work.[16] David Mellor writes in *Recording Britain*[17] that 'Enid Marx, Barbara Jones, Olive Cook and Edwin Smith particularly favoured Louis Meier's antique shop in Cecil Court as well as the second-hand book-sellers of Farringdon Road, but the pursuit of the vernacular was competitive; if one of the group saw something piquant in a junk-shop "you couldn't tell Barbara or she'd be there ahead of you".'

Barbara Jones's attitude differed from Cook's, and was more bright and breezy – 'Forgive yourself', she wrote in an article 'Tat Hunting',[18] 'for an occasional rather sweet/jolly/comic/childhood-memory/might-be-useful-you-never-know- and what-can-you-buy-for-six-pence-now-a-days-anyway.' She later ran a stall in the antiques and bric-a-brac market at Camden Passage in Islington in the 1960s. Her house, another cornucopia of exciting visual stimuli, provided inspiration for her drawings and publications and she delighted in having it professionally photographed for publicity articles about herself and her work. A decade younger than Cook, Jones was highly professional and liked to be paid properly, preferring to be called a jobbing painter rather than 'an artist'.

Having trained in mural decoration at the Royal College of Art (RCA) in the mid 1930s, after a spell at Croydon School of Art, she worked usually to commission, and enjoyed responding to a brief. Although she sometimes made uncommissioned paintings she rarely bothered to exhibit: she was more interested in making ephemera and

Barbara Jones, *A Jumping Cat*, 1957. Oil on wood.

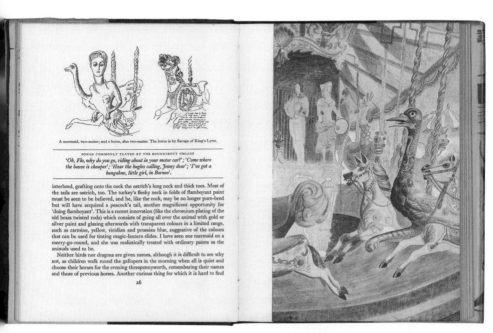

Barbara Jones, spread from *The Unsophisticated Arts* (The Architectural Press, 1951).

posters than in having shows in West End galleries. At the RCA she was a contemporary and great friend of another very good painter, Malvina Cheek; they later lived near each other in Hampstead, where Jones drew pictures of the fun fair on the Heath. Olive Cook and Edwin Smith lived nearby, before they moved to Saffron Walden in Essex in the early 1960s.

Illustrating book jackets, making exhibition designs and murals – completing twenty-nine commissions for various public and private patrons – Jones was also an inspiring teacher, augmenting her income by lecturing at Hornsey and at Leicester School of Art. She provided thirty-one watercolours for Recording Britain, the project's first and most prolific contributor, also becoming involved with an offshoot of the project called 'The Londoner's England'. This was subsidized by brewing companies and went for populist appeal; Jones created seven images, four of which depicted pubs. She had a tremendous sense of fun and enjoyed modern life; her drawings included telephone wires and other traces of modern technology, all of which she felt had their own beauty.

Her book *The Unsophisticated Arts*, commissioned by Nikolaus Pevsner, collected articles she had written over a number of years for *The Architectural Review* and was published in 1951. Originally to be called *English Vernacular Art*, it included fairground baroque, canal boat decoration, seaside architecture and amusement arcades, alongside tattooing, taxidermy, automata and simulacra, artisan signs and mementoes of death. Edwin Smith provided the photographs. Humorous without being facetious, it was well reviewed; John Steegman in the Cardiff *Western Mail* noted that it avoided being 'patronizing, nostalgic, arch, whimsical or folksy',[19] which given its subject matter was quite an achievement.

At the same time, Jones was preparing 'Black Eyes and Lemonade', an exhibition of British popular and traditional art, staged at the Whitechapel Gallery as part of the Festival of Britain. She and her partner Tom Ingram acquired a converted London taxi for a road trip around Britain to seek out unusual items. Others were borrowed from friends and enthusiasts. The committee of the Society for Education through Art (SEA) had originally wanted Enid Marx and Margaret Lambert to be in charge, but Barbara's mural designs for 'Britain Can Make It' and 'Design Fair' meant her expertise was now recognized. She was anxious to avoid rigid academic categories, preferring the judgments of makers, collectors and consumers to those of connoisseurs and design

Enid Marx, *Staffordshire Dogs*, 1960. Linocut.

reformers. Powerfully assertive, she was good at fighting her corner to defend what others at the time saw as rather peculiar tastes: for instance, her fine collection of taxidermy and mementoes of death, which mainly interested her for their visual qualities rather than through any introverted, morbid fascination.[20]

Jones had the curiosity of an historian or anthropologist and was highly intelligent, but enjoyed confrontation. The SEA was expecting a display of traditional folk art rooted in pre-industrial ways of life to prove the value of art education and craft training, rather than things that were machine-made or contemporary. In its view, Jones's approach was too wild and uninhibited; the committee worried she was having too much fun and not including enough educational material in her very personal selection.

Most people were won over by the sheer exuberance of the show, although the *Daily Worker* disliked the inclusion of work made for profit or commerce, as did John Berger, who claimed in the *New Statesman* that 'industrial capitalism has now destroyed the standards of Popular Taste and substituted for them standards of gentility, Bogus-Originality and competitive cultural smartness'. The huge popular success of the

exhibition led to an invitation to join the Council of Industrial Design to oversee the standard of souvenirs for the Coronation, an appointment that added to Jones's fame and notoriety, publicity she welcomed. She went on to write *Follies and Grottoes* in 1963, *Design for Death* in 1967 and *Popular Arts of the First World War* in 1971 with Bill Howell. She could justly be called a true precursor and enabler of pop art; Peter Blake, who attended the Whitechapel exhibition aged nineteen, called her 'one of the more important things that happened to me, and helped form the way I work'.[21] She died of cancer in 1978.

Although Jones stated that 'the museum eye must be abandoned', she was closer in outlook to Enid Marx and Margaret Lambert than Olive Cook or Peggy Angus. All knew each other but there was not a lot of communication between them, revealing their rivalries and differences of attitude. Marx, for example, disapproved of both Angus's romantic left-wing politics and Jones's sensationalist commercial opportunism, but agreed with Angus that 'folk art' was a term best avoided, given its appropriation by Hitler with his distorted ideas of the *Volk*. Margaret Lambert, a historian, was well placed to recognize early on the excesses of the Stalinist purges in Russia and be horrified by them; Marx and Lambert tended towards political conservatism. Marx had no worries about Barbara Jones's entry into the field, secure in the great success of her own two books about popular art, written with Lambert and published in 1946 and 1951.

The Festival of Britain in 1951 celebrated the native distinctiveness of a country emerging from a war that had threatened to change its landscape disastrously. The Festival was set up as a mainly middle-class extravaganza of colour and fun after wartime austerity, an invitation to visit the unique history of 'This Island Race'.[22] It combined a neo-romantic aesthetic with a new and practical modernism. Many of those working inside the pavilions were women, while most of the organizers and architects of the spaces and pavilions were male; women who worked in partnership with their husbands fared better than single women in finding themselves in positions of influence. Although by 1951 nearly a third of the workforce in England were female, the Festival still concentrated on representing women in the home, while at the same time glamorizing them like Hollywood stars; usherettes and guides were selected for their looks and put in cute Hardy Amies uniforms. 1951 was

also the summer of the first Miss World Competition in London, the beginning of a strangely mixed decade for women, after the flowering of new freedoms and possibilities in the previous decades.[23]

The social ideology of the Festival was regarded with suspicion by many, and the incoming Conservative government in 1951 could not wait to make sure that most of the pavilions and their contents were taken away and destroyed as soon as possible; Churchill called the whole exercise 'three-dimensional socialist propaganda'. However, Peggy Angus was involved with what was called a Live Architecture Exhibition in the East End of London. Poplar Fields, now renamed Lansbury after George Lansbury, the social campaigner and former leader of the Labour Party, was being rebuilt and regenerated after extensive damage during the Blitz. The Live Exhibition was both something that would last and that visitors could witness in progress.

Peggy Angus, *John Piper*, 1937. Crayon and wash. Angus and Piper had long discussions and correspondence about art, religion and politics – his interest in medieval art, ideas about who art was for, and his rejection of modernism. She sent her children to stay with the Pipers at Fawley Bottom, Buckinghamshire, for a while during the war, and they were lifelong friends.

Angus is an example of an artist who slips backwards and forwards between realism, modernism and Romanticism. Originally, with a self-confessed penchant for Hogarth and the work of Victorian narrative painters like William Powell Frith, and an admirer of Percy Horton,[24] she wanted to 'paint like Michelangelo'; realism seemed the obvious path for a left-wing political animal like her. Her brief marriage to the architectural historian James Richards,[25] however, introduced her to different viewpoints among the many modernist architects with whom she became friendly; she was particularly involved with Russian-born Serge Chermayeff and his family.

Angus had transferred to the Design School at the RCA in order to learn skills that could enable her to earn her living; war, teaching and divorce eventually turned her into an industrial designer almost by chance, when architect F. R. S. Yorke saw work she was making with schoolchildren and encouraged her to start designing tiles. Yorke had a more pragmatic approach than some of the more hard-line modernists, and Peggy's designs humanized many of the new concrete buildings being put up at great speed after the war.

Commercial tiles that were available – illustrative Victorian motifs laboriously hand-painted onto tiles by teams of badly paid women – were now completely unsuitable.[26] Angus devised her own technical process for transferring her simple geometrical designs with the firm Carters in Poole, and modernist architects greatly admired the way that as units they could be built up into different, more complex designs, or even murals, depending on how they were arranged.

In the Susan Lawrence Primary School in Lansbury, the large expanse of wall in the foyer was filled with her bright grey and yellow patterned tiles to convey a feeling of peace and jollity. They remain in place today. The commission was well reviewed and Angus was particularly pleased that James Richards, by then her ex-husband, wrote an appreciative article in *The Architectural Review*: 'The use of tiles has the dual advantage of allowing the enrichment to be conceived as an integral part of the wall itself', he wrote, 'and of using industrial as distinct from handicraft techniques.'[27] Her later designs for hand-printed wallpaper, developed out of her work on tile designs, could be seen as less modern in that they favoured craftwork, but like William Morris she believed in people having control over their technology. Her wallpapers,

Tile mural by Peggy Angus for the Brussels Exhibition for the Council of Industry, 1958. Photograph by Sam Lambert. The architect for the British Pavilion was James Gardner. This photograph shows a man in front of the mural, touching it proprietorially.

she believed, were aesthetically far superior to attempts to replicate them commercially.

Angus embraced the idea of being an industrial designer; when at Gatwick Airport she worked with glass cladding, devising her own method of transferring her designs onto glass with a small firm in Limehouse.[28] The images she created were like cosmic frost patterns on the glass, translucent by day and twinkling at night. The buildings were later destroyed during redevelopment and few photographs survive. Her later wallpaper designs used imagery from the natural world and she lived close to nature in both Sussex and the Hebrides, a 'Romantic Modern' at heart.

The Festival of Britain was supposed to begin to break down the old professional barriers between architects and designers, but change was slow in coming. In 1958, when Angus designed another tile mural

for the British Pavilion of the Brussels Exhibition for the Council of Industry, it was again well reviewed, but she was not invited to the grand opening alongside the architects.

The painter Prunella Clough[29] was also linked to neo-romanticism, although any connection was more social than artistic, as she moved during her career from realism towards abstraction, navigating her own path through the terminology. Born into an affluent family in Knightsbridge in 1919, her studies at Chelsea were interrupted by the war – she was conscripted to be a draughtsman engineer and cartographer and had little time for painting until 1945. Her career was encouraged and promoted by Erica Brausen, with an exhibition at the Leger Gallery in 1947. It drew the usual gendered criticism, being described as 'delightful' with 'gentle and feminine colour' her work likened to that of Paul Nash (who had died the year before) and Robert Colquhoun. She would have particularly hated this vocabulary as her work was an attempt to break away from anything that might be labelled traditionally 'feminine' and she hated what she called 'prettiness'. She may have been intrigued briefly by Nash's surrealism and she knew Colquhoun from the Colony Room (see page 224), where she met other artists as a welcome escape from her family and the conventional widowed mother she supported. Her mother's sister, however, was the internationally known modernist designer Eileen Gray.

Around 1949 she began making paintings of Lowestoft fishermen and lorry drivers in working environments. Art historian Frances Spalding suggests her move away from painting moody landscapes with bones and beach detritus and her fascination with the landscape at Southwold, Suffolk, signalled a gradual shift from neo-romanticism to realism during the early 1950s. Clough now wanted to show human beings 'without benefit of religious or mythical content'. Although a socialist and a close friend of John Berger, she rejected the idea artists had any social function, doubting whether art could in any way be validated as useful, a classical position dating back to Plato. Working environments were attractive subject matter formally but she denied painting 'abstracts', saying all her work was inspired by things she had seen. She was 'saying a small thing edgily', as she put it in an interview for *Picture Post* in 1949.

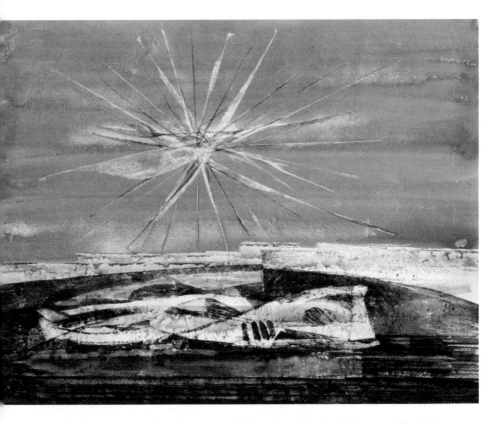

Prunella Clough, *Nocturnal Landscape*, c. 1946. Watercolour. Clough called pictures like this 'urbscapes' – pictures of a rather desolate post-war Britain that she sometimes made in the studio from drawings, memories and sensations rather than *en plein air*. The 'star' looks more like a snowflake; she often portrayed England in a cold, grey light.

Her personal reticence and hesitancy at categorizing her work were ways of evading definitions. Her early interest in materiality and mark-making may relate to French artists like Jean Dubuffet and Jean Fautrier, as well as to the scrap metal constructions of César Baldaccini, but her later experiments with a variety of unconventional materials – nail brushes, potato-mashers, pot scourers and junk from the rubbish tip or the beach – were purely done for fun. While she moved closer to abstraction, it all derived from her excitement about industrial land-scapes, textures and patterns.

Clough was friendly with artists Mary Fedden and Gertrude Hermes, and Bryan Robertson promoted her work alongside that of another friend, Mary Potter (see page 199), at the Whitechapel Gallery.

Modernist architects like Ernö Goldfinger and Denys Lasdun bought pieces from her. She sometimes stayed at Eagles Nest, the Cornish home of the painter Patrick Heron, who championed the way her paintings changed the way the world was perceived; they were, he wrote, 'machines for seeing with'. By 1960 she was also experimenting with printmaking with Stanley Jones at the Curwen Studio. She painted, stretching her own canvases, up to the end of her life, dying aged eighty in 1999 at the end of a long and successful career, and was well known for her personal generosity and donations to charitable causes.

Chapter 10

EDUCATION THROUGH ART
women artists as teachers

For many twentieth-century artists teaching was, of necessity, a major part of their working lives. Despite the teaching diplomas introduced in the 1920s, there were fewer women teaching in art schools before 1945, the limited number of jobs available meaning that men got first pick. Married women were excluded from working by the marriage bar that operated until the 1960s in many professions; however, this was lifted for teachers in 1944, and the gender balance among tutors at art schools began to change after the end of the war.

Teachers play a key role in shaping the way that art develops. Men like Herbert Read, who wrote *Education Through Art* in 1943, were strong on theory, but it was often women who were developing and putting ideas into practice at ground level. This chapter looks at some women artists who were particularly associated with educational ideas: Peggy Angus, Evelyn Gibbs and Nan Youngman, who mostly worked with school children; Helen Binyon and Rosemary Ellis, who taught at Bath Academy of Art, Corsham; and Betty Swanwick, at Goldsmiths College, London.

At the Suffrage Atelier, set up in 1909 by Clemence and Laurence Housman and Alfred Pearse, women had met and modelled for each other in life classes, bypassing the restrictions in art schools. Women who had already trained elsewhere gave classes and set up exhibitions at the Atelier, which paid them for their time, so that working-class women (and some men) could be included among the teaching staff. After 1918, Manchester School of Art and the Central School of Arts and Crafts in London offered free evening classes and Goldsmiths provided courses for workers who wanted to study part-time. Not for these aspiring artists the years in Parisian ateliers enjoyed by wealthy Edwardian women!

Grace Oscroft, *St Clement's Hospital, Bow Road*, undated. Oil on canvas. The annual exhibitions at the Whitechapel Gallery were open to all, and catalogues show artists from the East London Group exhibiting in 1928 alongside established artists like Vanessa Bell, Frances Hodgkins and Winifred Nicholson, and in the French-themed show with Degas, Gauguin and Picasso.

Artists who came from poorer backgrounds, like Peggy Angus, benefited from the scholarships to schools and colleges that were granted to girls from families that had lost husbands and sons during the war. Many of the scholarships to the Royal College of Art (RCA) stipulated that a teaching course also had to be completed so that artists could earn a living; it is therefore not surprising that so many women went into education. The primacy of the Design School over the painting course at the RCA occurred at a time of high unemployment in the 1920s, when the distinction between 'fine' and 'commercial' artists was becoming hard to maintain. Angus transferred to the Design School after her first year with an eye on future employment, but also because she preferred drawing life models who had their clothes *on* in the illustration department, finding models in active poses preferable to the traditional static nudes in the Painting School.

In the 1920s art classes were set up in the East End by John Cooper, Phyllis Bray and William Coldstream, which people could attend at the

Margaret Brynhild Parker, *Windy Day on Marine Parade, Southend, c.* 1931.
Oil on canvas. The daughter of an artist, Parker won prizes at the Slade
and taught art for a while at Letchworth Grammar School in Hertfordshire,
becoming a member of the East London Group. During the war she started
illustrating Picture Puffins for book editor and designer Noel Carrington
to make a living.

end of their working day. The East London Group, which lasted until
1936, gave practical instruction and lectures to workmen and labourers;
several of those attending were women, including Lilian Leahy and two
shop girls, Grace Oscroft and Flora Jennings. Oscroft, the daughter of an
ironmonger, recalled she was often so tired after work she could barely
think. Walter Sickert tutored and mentored the group, and wealthy
philanthropists like Joseph Duveen[1] contributed funds for materials
and framing, which many of them would otherwise not have been able
to afford. The Tate bought paintings for a special exhibit at Millbank,
including *The Aviary Victoria Park* by Flora Jennings and *A Garden in Bow*
by Grace Oscroft. Critics liked the sincerity of their work and the *New
Statesman*[2] wrote that encouraging individuals was better than perpet-
uating styles in traditional art schools.

This new spirit of egalitarianism fed directly into the rise of the
Artists International Association (AIA) from 1933 onwards. The
Ashington Group, miners painting in North East England, was founded

in 1934, associated with the Workers' Educational Association (WEA).[3] Questions of 'professionalism' were beginning to be challenged, often by small instances of insurrection as the decade progressed; for example, Nan Youngman invited a workman from the Whitechapel High Street to officially open the AIA exhibition 'Art for All' at the Whitechapel Gallery in 1939.

Teaching art in schools was in the process of being reinvigorated throughout Europe. Paul Klee was introducing mark-making and exercises to free up the imagination at the Bauhaus, and many artists and teachers – including Peggy Angus – flocked to see Professor Čižek's *Kunstgewerbeschule* (School of Arts and Crafts) in Vienna. Čižek believed in allowing children to develop at their own rate, with encouragement but a minimum of adult interference. Wilhelm Viola published a book about his approach in English, but the British were reluctant to abandon regulation and formal exams, keen to equip students with the practical skills and qualifications that would enable them to teach or work in industry, an ongoing legacy of the Arts and Crafts movement.

Women involved with children's art education were often inspired by the work of Marion Richardson, who used child-centred techniques that encouraged free expression and her own special method of 'visualization'. She didn't expect children to try and imitate 'adult art'. Children closed their eyes and waited for images to arrive in their mind's eye, sometimes with the added stimulation of stories being told to them, developing their inner imagination. In 1930, Richardson was appointed Inspector of Art for London County Council (LCC), running courses for teachers and organizing a large exhibition of children's art at London's County Hall in 1938.

Nan Youngman studied under her at the London Day College for Teacher Training, and helped with the 1938 exhibition. She had put on her own exhibition of children's art at the Lucy Wertheim Gallery in 1931, which inspired Herbert Read, and continued to use visualization techniques in her classes after the war. Youngman had studied at the Slade and was a joint prize-winner there in 1926, along with Helen Lessore. A rather reserved visionary, her own work often combined sympathy with wry amusement and a trace of surrealism; she admired the work of Dora Carrington. Undergoing teacher training and then entering the profession were financial necessities. She was later to say

Nancy Mayhew (Nan) Youngman, *Steelworks, Ebbw Vale*, 1953. Oil on board. Too busy during the war with administrative, political and child-minding duties to get much painting done, Youngman made some of her best paintings of the industrial landscape of the Welsh Valleys between 1950 and 1965 – a historic record of a landscape and people under threat, which she got to know intimately through her association with a Welsh painter and AIA member.

that teaching 'threatened at times to interfere with painting, but never for long. I certainly wouldn't have done the teaching without the painting and I don't think I could have painted entirely without the teaching'.[4]

Although she came from a comfortable background, Youngman was very down to earth and found the theorizing of Herbert Read too high-minded and overly academic; 'he was a sweet man but his ideas led to the slosh era', she would say.[5] She was the editor of *Athene*, the journal of the Society for Education through Art (SEA),[6] founded in 1940, an organization closely involved with the AIA. An amalgamation of the previous art teachers' associations, it believed 'specialized art training is too confined in its conceptions...it depends too exclusively on the specialized good taste which is the dead aftermath of only one of the great traditions'.[7]

Evelyn Gibbs, *c.* 1947. Photographer unknown.

During the Second World War she and Betty Rea, a figurative sculptor and educationalist,[8] looked after the children of a woman who had died in childbirth when their father, a fellow communist, went away to fight. Afterwards she continued to paint while working as County Arts Advisor for Cambridgeshire for a decade; like Peggy Angus, she believed art teachers should always be practitioners themselves. In 1947 she initiated the Pictures for Schools scheme with Brenda Rawnsley, through the SEA, enabling local education authorities to buy contemporary art at reasonable prices to hang on the walls of schools, providing inspiration for children.

Born in Liverpool, Evelyn Gibbs won a scholarship to Liverpool School of Art and a further one to the RCA Design School in 1926, where, among her contemporaries, she made friends with Frances Richards and Elisabeth Vellacott. Later she got to know Gertrude Hermes and Mary Fedden. She was a fine draughtswoman with a particular interest in etching, which at the time was enjoying a great revival. She was given a Rome Scholarship to pursue her engraving in 1929, but the Wall Street Crash demolished the fine-print market, leaving her with no option but to teach. Working for the LCC as a teacher for children with disabilities,

her ideas did not always accord with Marion Richardson's – she believed her students required practical tasks and strong guidance. She developed a highly praised system, described in her book *The Teaching of Art in Schools* that was published in 1934, predating similar books by both Nan Youngman and Herbert Read, as well as Richardson's own *Art and the Child*, which was published posthumously in 1948.[9]

Gibbs became great friends with Nan Youngman, but in some ways her teaching ideas were much closer to those of Peggy Angus, involving potato prints and paper cutting, pattern-making and collage. These tasks were demanding for inexperienced or disabled children, but this was where good teaching came in. Both Gibbs and Angus believed in showing children how to do things through simple tasks, encouraging them to learn from each stage and then experiment further.

When Gibbs left her teaching post in 1934 to become a lecturer at Goldsmiths' College on the strength of her growing reputation, her position was taken over by her good friend Elisabeth Vellacott,[10] who later joined Youngman on the Cambridge Examination Board. On the

Evelyn Gibbs, *Canteen Counter*, 1942. Oil on canvas. This was not the result of a WAAC commission but was exhibited at the AIA show, 'For Liberty' in London in 1943.

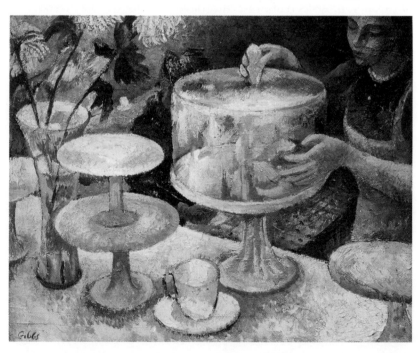

outbreak of the Second World War, Gibbs was commissioned by the War Artists Advisory Committee (WAAC) to make drawings of war work on the domestic front. Like Angus, she also ran practical and art appreciation classes for servicemen on leave. Evacuated to Nottingham along with Goldsmiths teacher-training students and tutors, she organized an AIA exhibition in 1943, borrowing works by high-profile painters from the London 'For Liberty' show, along with the work of local Midlands artists. The exhibition drew a certain amount of ill-informed and hostile responses from both the press and the public, showing how much this sort of exposure was needed in the provinces. A committed, practical idealist, she founded the Midland Group and Laura Knight became its patron. After the war the AIA continued to support regional initiatives and artist groups that operated outside London, and Gibbs remained in Nottingham after the war with her new husband until they moved back to London in 1960. She had no children due to her late marriage, for her a matter of some regret. In the 1950s she made a series of striking book covers for the novels of Hilda Lewis, and continued to extend her painting and printmaking activities until her death in 1991.

Artists often faced problems when they tried to raise the profile of the arts; projects had to be introduced carefully if they weren't to look patronizing. Peggy Angus took her educational ideas further than most; she wanted to educate children by using them as apprentices, rather like a medieval guild system. She saw letting children decorate their own schools as a huge educational opportunity, advising head teachers not to 'waste their almost limitless imagination and capacity for designing'.[11] Her ideas, put to work in somewhat limited form at North London Collegiate School where she taught art, were championed by Quentin Bell in *Athene*; he thought continually repainting walls would encourage aesthetic awareness, 'treating the work of former generations with all the exuberant callousness with which Julius II treated Piero della Francesca'.[12] The work of the children she taught continually gave Angus fresh inspiration for her own projects.

Angus always had faith in the future. Her personally devised History of Art syllabus not only examined the Western tradition but also spanned continents and eras, including all forms of popular art, from tattooing to cake decoration, as well as traditional art from across the globe. Members of the Schools Inspectorate Committee thought

highly of her teaching methods and ideas. Colin Sorensen remembered 'she was the most inspirational person in the art world.... She showed how a charismatic personality with wide technical ability can transform people, even girls without the benefit of much natural talent, giving them confidence – which is the real purpose and achievement of good teaching – to transform their world, beginning at a simple domestic level.'[13]

Herbert Read believed in 'personality', but like Eric Gill, who thought nothing could be expressed except through the making of something, Angus felt it denied children their human rights to leave them to their own devices: teaching *skills* gave children a sense of worth and importance. She always had severe reservations about any whiff of 'psychological funny business' and ran her classes with a strong sense of egalitarianism; believing, like Gill, that everyone is an artist, she clamped down on any signs of egotism. For Read, the purpose of educational reform was not to produce better works of art but better people and a better society; however, Angus thought he had a poor opinion of teachers. He once unwisely wrote to Wyndham Lewis, saying that most of them were 'rather dumb creatures and generally reactionary in so far as they are conscious of modern art'.[14] Angus was probably in touch with far more teachers around the country than he was and found such views terribly condescending.

Her good friend Helen Binyon[15] was teaching at the Bath Academy of Art at Corsham Court, near Bath, after the war, where sadly an almost medieval ethos of master-pupil relationships did not survive the Coldstream Report and subsequent reorganization of art education in the 1960s. At Corsham Court the students were exposed to very contemporary ideas; while the walls of the big house were covered with eighteenth-century paintings by Joshua Reynolds and Thomas Gainsborough, the teaching was all about contemporaries Mark Rothko and Jackson Pollock. The children of Barbara Hepworth and Winifred Nicholson all went to study at Corsham.

The first presidents of the college were Clifford and Rosemary Ellis, who worked collaboratively on the much-admired covers for the Collins New Naturalist series (see page 156). Clifford Ellis, who had been trained by Marion Richardson, used to say, 'Don't many of the better art teachers owe their sensibilities more to their great-grandmothers

Book jacket of *Wild Flowers of Chalk & Limestone* by J. E. Lousley (Collins, 1950), illustrated by Rosemary Ellis (with Clifford Ellis).

than to their official education?'[16] Rosemary Ellis ran the education course, transferring ideas into practice with seemingly boundless energy. She looked after a small menagerie of animals, which she brought into classes as models, in line with her own enthusiasm for drawing animals for her freelance work. Ecology and the protection of the environment were important to her. The idea that art was a process of discovery rather than an object to be exhibited was prevalent at Corsham.

Helen Binyon taught on the education course full time, living in a little row of weavers' cottages just outside Corsham Court, taking her students home with her to continue conversations. Binyon had done illustration work after leaving the RCA, and watercolours as preparation for copper and wood engravings, a love of which she shared with Eric Ravilious. After working for a time in Paris and New York she kept up close relationships with her RCA group, drawing Percy Horton's garden, staying at Furlongs (see page 191) during her affair with Eric Ravilious, having affairs with John Nash and James Richards, and sharing a love of marionettes with the Freedmans (see page 228). She was always searching for a husband more exciting than those on offer from her own upper-class background, but never seemed to find a suitable candidate who was also unattached.[17]

Puppets were Binyon's main enthusiasm and she taught shadow puppetry at Corsham; her book *Puppetry Today,* published in 1966, was dedicated to her students; together with *Professional Puppetry in England* (1973), it formed a major part of her professional legacy. She founded Jiminy Puppets in the 1930s with her sister Margaret (Peg) Binyon; Peg wrote the words and music for their shows while Helen carved the wooden puppets and designed the sets. Reviews of their puppet shows were full of praise for their artistry; in 1938 they were performing a one-act play called *Old Spain* twice nightly at the Mercury Theatre in Notting Hill, featuring a verse libretto by Montagu Slater and music by Lennox Berkeley. A little-known composer called Benjamin Britten played the piano; Ravilious helped supply wood for the puppets; the Freedmans, Hortons and Peggy Angus all came along to see shows, as did Enid Marx, who was a good friend of the puppeteer George Speight. Helen's *Puppets for Spain* were featured in the sculpture section of the AIA exhibition at the Whitechapel Gallery in 1939.

Helen and Margaret Binyon rehearsing with Benjamin Britten (left) and Lennox Berkeley (right) at the piano, 1938. Photographer unknown.

The importance some artists attached to puppetry was perhaps a precursor of artists' huge interest in animation today. From 1938 onwards televisions entered many homes, with the first news bulletin broadcast, boat race and football cup final screened that year, by the end of which nearly ten thousand new sets sold. Helen's puppet show may have been among the first to be broadcast that year, although TV was then suspended throughout the war. Annette Mills's *Muffin the Mule* programme was first aired in 1947 and the educational possibilities of puppets in children's broadcasting were utilized from then on.

Since the time of Heinrich von Kleist[18] marionettes were always more intellectually respectable on the Continent, where they were appreciated as a serious art form. Kleist believed marionettes would become an antidote to bourgeois values: all their limbs followed a simple form of gravity with a purity denied to any human actor; they existed in a rare state of innocence, something the surrealists considered made them the ideal surrealist object. Offering a very direct method of communication, puppetry was used to subtly subvert the status quo under repressive regimes. At the Bauhaus in Dessau, Germany, marionettes were particularly associated with Sophie Taeuber-Arp and Oskar Schlemmer. The teaching at Bath Academy after the war drew on Bauhaus principles and Helen Binyon's lessons fitted in well with the prevailing ethos of unity in all the arts.

Francis Bacon has explained why a painting is the complete opposite of illustration: 'It lives on its own like the image one is trying to trap; it lives on its own and therefore transfers the essence of the image more poignantly.'[19] Similarly, an actor *represents* an idea, but the puppet *is* that idea – it must create the illusion of reality, not reality itself, a very modernist idea. During endless debates about high and low culture and the role of entertainment, puppetry remained outside the binaries – an age-old, global method of communication in which humour exists side by side with satire and challenging comments on the status quo.

Until the 1960s, puppetry and marionettes were often included in the English art curriculum. Betty Swanwick, who taught at Goldsmiths' College from 1936, turned the annual puppet play into an institution, with other artists, including Olive Cook, coming to performances. It is not too far-fetched to consider Swanwick's early illustration and poster work in the context of this aesthetic, in which anthropomorphism and caricature are used not just for whimsy or ephemeral amusement but also for satire and social comment in the eighteenth- and nineteenth-century traditions of George Cruikshank or James Gillray. But Swanwick also believed in Fun – the development of the puppet plays with the students was always a memorable experience, a celebration of joy in creation. The annual productions from 1943 to 1964 were a collaborative project, teaching students how to find within themselves the practical and imaginative talents they needed along with the responsibilities of a commission and the possibilities offered by different materials.

Swanwick's depictions of anthropomorphic animals tapped into intuitive exposure of human social dynamics. She had faith in how animals reacted to people, without guile and with senses more acute than our own. She had an amusing personal entourage of cats, dogs and a grey parrot that ruled her household, initially suggesting eccentricity but which actually served as a foil for a complicated and deep-thinking personality. Born in Essex, she went to Goldsmiths aged fifteen, a fellow student of artist Carel Weight and writer and painter Denton Welch – she was the inspiration for characters in at least two of his books.[20] While at Goldsmiths, she began a long, discreet affair with Clive Gardiner, the principal of the college, who shared her passion for toy theatres. She was one of the few staff members who remained on the London site

throughout the war, teaching without full pay in order to make sure the college survived at a critical point in its history.[21]

Edward Bawden had been her tutor in 1930 and they remained lifelong friends. After the Second World War, when even the Royal Academy (RA) was beginning to accept changing attitudes to print-making, they became the first two 'draughtsman' members of the RA, a category previously excluded even though many Academicians had been illustrators. A prodigious draughtswoman, she was given commissions for book illustration, commercial packaging and posters for London Transport.

Despite exhibiting at the Leicester Galleries and becoming a founder member of the Society of Mural Painters in 1950, Swanwick always prioritized her teaching, very possibly for financial reasons. 'I have always felt an outsider and not belonging anywhere and my funny old drawing is in the same boat. Not quite acceptable!'[22] Like Clive Gardiner, who also willingly sacrificed his painting career, she loved teaching and rarely signed her own artwork. It was a huge personal blow to both of them when the new national guidelines began to be introduced into art education, sweeping away 'old-fashioned ideas' like the puppet theatre and what they believed was much of the humanity of the ethos they had lived and taught by. A series of heart attacks led to Gardiner's resignation in 1958. As Head of the Design School at Goldsmiths, Swanwick found the new regime that followed inimical to the proper teaching of illustration. She started introducing figures rather than animals into her work, in order, she said, to be taken more seriously.[23]

Figurative work and certain traditional skills are useful for aspiring artists of many kinds. Students at art school during the period benefited from a wide choice of options, alongside the healthily various enthusiasms of their particular tutors. Although a 'new broom', Mary Martin was an excellent teacher at Goldsmiths throughout the 1950s, introducing students to mathematical, biological and architectural ideas. However, plaster casts that had been smashed could not be unsmashed again; it was a denial of the pendulum between romanticism and classicism. Peggy Angus described the avant-garde in late capitalist society as a cynical cycle of novelty and assimilation, continually demanding fresh blood, with frequent changes of direction conferring moral

Betty Swanwick, *Remember Ye These Things*, 1963. Watercolour. 'Drawing from Life' was abandoned at Goldsmiths after 1958 and Swanwick was ostracized by the incoming regime. In this response, a group of decrepit old men work in front of a female model, who exudes life and vitality; three of the men fly triumphantly out of the window, clutching their abstract works – the epitome of fashionable new ideas. Time smiles.

superiority to those who stayed ahead of the game. When criticized for appearing to want to keep the artists in places like Bali 'backward and uneducated', she replied that on the contrary, 'unless we all learn from them we will all go mad'.[24]

In Swanwick's archive is a heavily reworked version of an article for a magazine,[25] with a final paragraph that she eventually left out – feeling perhaps that publishing her real views was too risky:

> Watching the discontent and confusion that seems to result
> from this wilful destruction of many (gifted) artists has
> made me more & yet more certain that I and others, hold

my faith in visual art...in bringing back some sort of normality to what may lead to complete obliteration of something that is necessary to keep the art world sane.

What rankled most for Swanwick was the unseemly haste with which many of her older colleagues were prepared to cave in to save their own positions; she preferred to stick to her own ideas rather than jump on any bandwagon. Utopias, and new orthodoxies especially, need anarchic individualism to reinvigorate them. She taught again at Goldsmiths from 1973 to 1978, although she had resigned as a senior lecturer in 1970. After 1965 she developed her own painting with a particularly personal vocabulary, using New Testament stories in some of her work; although not a conventional practising Christian herself she thought 'Christ was the biggest rebel who had ever lived'.[26] The contemporary artists she most admired were Edward Burra and David Jones. A regular exhibitor at the RA Summer Exhibition, people still came to see her because her teaching had been so inspirational. Like so many women artists of her generation, she found teaching of vital importance, even if it left less time for her own artwork, not least because it stimulated her own ideas while encouraging discussion and dissent.

Chapter 11

PROLETARIANS AND PAINTERS political women

The rise of fascism in Europe during the 1930s, particularly the attack on the democratically elected Republican government in Spain by Franco's Nationalists, galvanized artists, intellectuals, workers and the wider public to unite in a common cause; many artists, whether or not they held particularly strong political views, were prepared to contribute work to Artists International Association (AIA) exhibitions at the very least. With the end of the Second World War, artists who had been motivated by left-wing ideals in the 1930s in many cases reverted to a more apolitical stance. Communist Party memberships were revoked; the AIA ceased its large-scale campaigning in favour of promoting wider access to arts activities; and several artists moved into the establishment, taking up positions on education committees and other bodies. With the election of a Conservative government in 1951, the pendulum swung against the ideals that had brought Labour to a landslide victory in 1945. Nevertheless, the ideas of earlier figures like William Morris and Charles Robert Ashbee continued to hold influence in some quarters.

Ethel Mairet,[1] who had worked with Ashbee, consistently challenged established practices and gender roles in art, craft and industry. She saw weaving as a form of engineering, requiring mastery of machinery and scientific knowledge of dyestuffs, rather than as part of a feminine world of colour and design. For Mairet, working at home meant living at her workshop, not engaging in domesticity; weaving, despite its industrial roots, was an art and not a craft, blending tradition with modernity. Ironically, many of the weavers she trained were middle-class women who, unlike her, had no need to earn their living.

In the 1930s it was common to see anti-fascist graffiti on buildings in North London where Marx and Engels had once lived. Ships

sailed from the Thames near London Bridge to Leningrad twice a week and women had good reason to want to experience life in the Soviet Union, where daycare for children, gender equality, communal medical provision and a classless society were championed. Artists who visited the USSR witnessed the full ideological force of the Five Year Plan. Museum displays seen by Peggy Angus and Pearl Binder (see page 168) at the Hermitage showed art and social history as equally part of the momentum of revolutionary history, moving towards a Golden Age. Meanwhile, England was still mired in complicated class distinctions and social connections. Without the benefit of hindsight, who wouldn't have wanted to feel involved in the Soviet project?[2]

Doris Hatt was one artist who remained overtly political; born in 1890 in Bath, she was initially excited by cubism and the machine age. After attending the Royal College of Art (RCA), where she was influenced by the romanticism of Paul Nash, she studied under Fernand Léger in Paris who introduced her to communism. Exhibiting alongside Wyndham Lewis, Duncan Grant and Vanessa Bell at the Royal West of England Academy in 1921, her work stood out for its originality and was praised by artist Albert Rutherston (brother of William Rothenstein), who spoke of her 'curiosity and conscience'.[3] Today it can be found in several major collections. She also exhibited in London – at the Redfern and Leicester Galleries – but never had a London dealer, so her work is only now becoming better known. Although radical, her paintings, linocuts and carvings retained a dark romanticism. She lived in a modernist house built to her own design in Clevedon, which she shared with her partner, Margery Mack Smith.[4]

A strong feminist, committed to improving the lot of the working class, from the 1920s onwards, Hatt was a member of the Independent Labour Party, founded by Keir Hardie, standing as a Communist candidate for Clevedon in 1946. Her friend Dr Peter Millard recalled, 'Doris Hatt's communism was gentle and kind, and suffused with solid middle-class virtues'. She remained a communist until her death in 1969.

The radicalizing effect of the Spanish Civil War affected even the very young. Ursula McCannell, the daughter of the painter Otway McCannell, principal of Farnham School of Art, was only thirteen in 1936 when she went to Spain to stay with a school friend for the Easter holidays. When the Civil War began in July she followed its progress in *Picture Post*, avidly collecting pictures and press cuttings, not as a school

Peggy Angus, *Woman Reading The Nature of Capitalist Crisis*, 1935. Watercolour. We don't know the model but it could well have been a fellow AIA member. The book was written by John Strachey, a friend of Angus's and later Eric Ravilious and Tirzah Garwood's landlord. First published in 1935, the book was hot off the press. Films shown at the Workers' Film Society, which Angus regularly frequented, gave a romantic view of Russia at this time.

project but as a result of her own passionate involvement with the cause. At the same time, with the encouragement of her father, she was developing as an artist. Her striking paintings deliberately referenced Picasso's early period as well as the work of Spanish Renaissance painter El Greco, and were possibly influenced by Augustus John; at the age of sixteen in 1939 she was given a show at the Redfern Gallery, attracting much press attention. She was the youngest member ever elected of the Woman's International Art Club, as well as the youngest exhibitor at both the New English Art Club (NEAC) and the Royal Academy (RA) in 1940 and she remained an artist for the rest of her long life.

The AIA[5] believed art was achievable by all and should be affordable for all to buy – one of the reasons it promoted printmaking through its Everyman Prints and autolithographed Pictures for Schools. With artwork drawn straight onto the plates, the prints cost one shilling for

Doris Hatt, *Fish Stall, South of France*, 1951. Oil on canvas.

black-and-white prints (at a time when a Penguin paperback cost half that at sixpence), and one shilling and sixpence for colour. Sometimes sold directly over the counter in shops like Marks and Spencer, and produced in large numbers, they bypassed the gallery system. The AIA was also attempting to become a trade union for artists, an idea *Artists Newsletter*[6] tried to revive three decades later. After the shock waves of the Wall Street Crash such an aim was hugely popular with those struggling to earn a living. It brought artists together in working units similar to the Suffrage Atelier (see page 147).

Given its enthusiasm for printmaking, it seems appropriate that the first AIA meeting was hatched at an evening class in lithography run at the Central School of Arts and Crafts by James Fitton, and attended by several women, including cartoonist James Fitton's wife Margaret, Peggy Angus and Pearl Binder. It was 1933 and Fitton, James Boswell and James Holland were trying to 'revive the great age of the satirical political cartoon' in accord with the aims of social realism: 'We feel we have broken away from the middle-class and infantile code of good taste

Ursula McCannell, *Family of Beggars*, 1939. Oil on board. This was one in a series of immensely strong images of beggars and fleeing families, continued throughout the early 1940s. McCannell chose to focus on the frightening effects of war on displaced women and children, and the plight of the aged. In 1943 she began taking drawing classes at the RCA with the artist Percy Horton, a Quaker pacifist.

Above left Pearl Binder, *Chalking Squad*, 1935. Printed in *The New Left Review*.

Above right Peggy Angus, *What a Splendid Way of Dealing with Cranks*, 1930s. Printed in the *Daily Worker*. Angus was always proud to announce that she sat at 10 Downing Street making cartoons for the woman's page of the *Daily Worker* because of her close friendship with Isabel MacDonald, social hostess for her widowed father Ramsay while he was prime minister. She often arrived off the train from Furlongs in need of a hot bath.

which has reduced English cartooning to emasculated illustration and religious hysteria.'[7]

Pearl Binder encouraged the group to all go and hear artist Cliff Rowe speak at architect and designer Misha Black's studio, where the AIA had begun (see page 172). Binder, usually known as Polly, had had a solo exhibition at the Museum of Modern Western Art in Moscow and contributed to the Russian literary magazine *Krokodil* from 1934 to 1935. The AIA exhibition catalogue from that year calls this a 'signal honour'. 'One of the attractions that Russia held out for the graphic artist was the sheer amount of work available,' it wrote,[8] but Binder's daughter, who has access to her diaries and notebooks, says that her mother found it difficult to get paid work. Binder was born in Salford and her father was a naturalized Russian Jew, a rather unsuccessful jobbing tailor. Having lived in London's East End since 1931 in Spread Eagle Yard, Whitechapel, she explored and drew everyday scenes that she used to illustrate *The Real East End*, a book by the Poplar writer and publican Thomas Burke published in 1932, and her own book *Odd Jobs:*

Stories and Drawings in 1935. Binder always had tremendous empathy, particularly for women and the dispossessed – her moving depictions of a 1939 evacuation programme and her dark lithographs teem with life, humour and eloquent social comment.

After her failed marriage to the anthropologist Jack Driberg,[9] Binder met Frederick Elwyn Jones, a socialist lawyer, through the anti-fascist interests they had in common and they subsequently married. She kept up her close ties with the East End once her husband became Labour MP for Stratford East, where he served for twenty-nine years, maintaining them after he became Lord Chancellor and a life peer. During visits to Moscow she amassed a collection of Soviet children's books, admiring their illustrations. When she showed them to the publisher and book designer Noel Carrington, he used them as inspiration for his design of the Puffin Picture Book series for children. The first volume in the series was published by Penguin in 1940 and in the following decades they were illustrated by many AIA artists, including Binder herself. After the war she continued to work as a graphic artist and writer and on two occasions designed costumes for theatre director Joan Littlewood as part of Littlewood's circle at the Theatre

Book jacket for *The Real East End* by Thomas Burke (Constable & Co, 1932), illustrated by Pearl Binder.

Royal Stratford East. It was through this that she met A. L. Lloyd, the folk singer and collector of English folk songs. She illustrated his children's book *The Golden City* in 1960. Like her close friend Peggy Angus, she loved 'popular' art, collecting pieces on her travels, and she wrote books on the subject, including *Magic Symbols of the World* (1972) and *The Pearlies: A Social Record* (1975). Her last lithographs, of punks, were made in the early 1980s.

Looking back on the 1930s, Misha Black said that 'a lot of the artists in the AIA were proletarian in the sense that they came from proletarian backgrounds, but as soon as they became painters, the proletarian background ceased to have any major contribution to their make-up and they soon became the dispossessed intellectuals which they always are'. Angus and Binder somehow managed to defy the inevitable by the sheer force of their independence; their political views never mellowed.

Among Pearl Binder's many friends was the Austrian photographer Edith Tudor-Hart. Born Edith Suschitzky in Vienna, she trained in photography at the Bauhaus, where she studied under László Moholy-Nagy. Arrested as a communist sympathizer in Vienna in 1933 she escaped imprisonment by marrying Alex Tudor-Hart, a British surgeon from a radical and artistic family who had practised as a GP in mining villages in Wales. In Britain she took documentary photographs for *The Listener* and *Design Today*, depicting working-class life and poverty in Wales and North East England as well as refugees from the Spanish Civil War. Shown in the AIA exhibition of 1935 (see page 172), they were designed to provoke a reaction.

Edith was shocked by the extent of working-class deprivation in Britain. She used her camera as a political weapon, targeting child poverty, unemployment and homelessness, creating unsentimental images that nevertheless showed how she felt. Photojournalism was popular and she was notable for always trying to preserve her subjects' dignity. She separated from Tudor-Hart in 1936, after his return from the International Brigade in Spain, and with an autistic son to support set up a photographic workshop. Immediately after the war her pictures of a school for children with learning disabilities were published in a special issue of *Picture Post* and for a while she was able to earn her living more easily.

Her strong social conscience and emotional identification with her subjects, together with the loss of her family in Auschwitz, subjected

her to huge strain, eventually resulting in a breakdown. The pressures she was under were exacerbated by the attention she had from MI5 as the result of her friendship with members of what would later be known as the Cambridge spy ring. This taint meant her work was often denied publication later in her career, as she was suspected of being a Comintern agent; her great friend from Austria Litzi Friedmann had been married to the double-agent Kim Philby.[10] Under suspicion since 1951, Philby was dismissed from MI6 a year later and finally defected to Moscow in 1963. Unlike Philby and Anthony Blunt, Edith had openly been a member of the Communist Party, as many artists were in the 1930s, never concealing her political views or restricting her attendance at demonstrations. Her actions sprang from idealism and a desire for a better world and, although she was always hard up, she never received any payment – something reiterated by ex-KGB agents interviewed for the documentary film *Tracking Edith*, released in Britain in 2018. But in the climate of the 1950s her working life became too difficult and she eventually gave up photography for good, destroying many negatives out of fear of prosecution. Tragically her images, which speak for themselves, were neglected for years.[11]

Another pioneering and innovative photographer who was determined that her pictures make a difference was Helen Muspratt. She founded a photographic studio in Swanage, Dorset, in 1929 and made striking portraits of Paul Nash and Eileen Agar, posing dramatically with her mass of sculpted hair. After an expedition to the Soviet Union with the Left Book Club in 1936, photographing farmers and peasants along the River Volga, she made images of unemployed Welsh miners in the Rhondda and also of Basque children who had arrived in Britain as refugees from the Spanish Civil War. Helen escaped overt censure despite the fact that, together with Lettice Ramsey, she photographed Guy Burgess, Donald Maclean and Anthony Blunt, whom they knew through Cambridge intellectual circles.

The political nature of some art in the late 1930s was a novelty for Britain. At the 1936 International Surrealist Exhibition, Herbert Read had insisted surrealism would inspire revolutionary action, but this was hotly debated. Reportage photography and the graphic arts combined with striking slogans were what the situation demanded. Felicity Ashbee was one artist who put her graphic skills to the service of

the cause. Her posters about the situation in Spain were unsentimental and direct: three she made in 1937, each with the same main title *They Face Famine in Spain*, used photomontage techniques to show the results of Nationalist bombing raids of civilian targets. In one image, bombs labelled 'Disease', 'Hunger' and 'Desolation' fall on a mother and child. Governed by urgency rather than aesthetics, the posters were pacifist in intent; however, they were judged both too shocking and too political to display on the London Underground. Ashbee, one of Charles Robert Ashbee's daughters,[12] had been a Communist supporter since 1930 and made anti-war cartoons for the weekly magazine *Time and Tide*. She trained at the Byam Shaw School of Art, made textile designs briefly and worked on codebreaking at Bletchley Park during the war, eventually becoming a charismatic art teacher.

The original Artists' International group founded by Misha Black was driven by a Marxist agenda, but by 1935, when it changed its name to the Artists International Association and held the exhibition 'Artists Against Fascism and War', the AIA had already moved to a less doctrinaire position. There was much debate among the artists involved about the validity of social realism versus the 'negation of content' associated with avant-gardism. The sculptor Betty Rea, who edited the book *5 on Revolutionary Art*, published in 1935 and including contributions from Herbert Read, Eric Gill and A. L. Lloyd among others, dared to support the latter.

The AIA's move towards the arts establishment continued. It was influential in forming the Council for the Encouragement of Music and the Arts (CEMA) in 1940, with the aim of helping and preserving British culture. In 1946, CEMA was renamed the Arts Council. In 1955 Betty Rea organized an exhibition called 'Looking at People', and John Berger was one of the sponsors for a touring exhibition of panels made by two Japanese artists showing the horror of Hiroshima. Three years later, despite the AIA's radical origins, the only truly political works in the exhibition held in 1958 to mark the twenty-fifth anniversary of its founding were by the Italian Renato Guttuso and the Frenchman Edouard Pignon.

It remained for women artists to be the true radicals, redefining the role they played both in wartime and in the peace that followed.

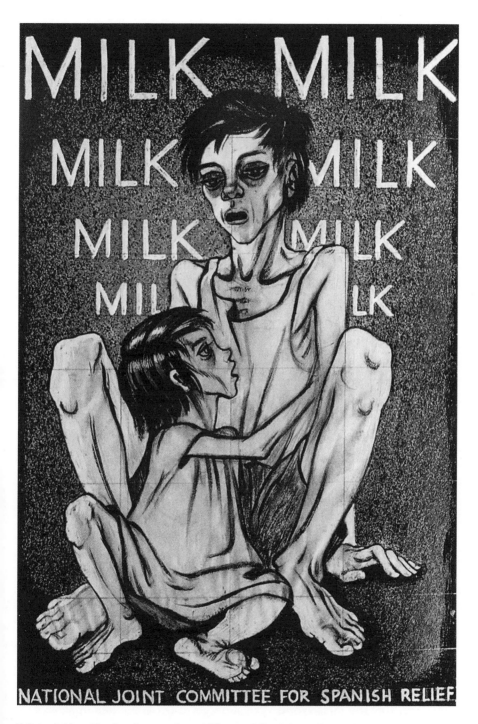

Felicity Ashbee, *They Face Famine in Spain: Milk*, 1937. Offset lithograph on paper.

Chapter 12

THESE THINGS
THAT WAR HAS MADE
art of the world wars

Many women artists found it challenging to make art during wartime. Vanessa Bell retreated to Charleston in East Sussex in 1916 to get away from a conflict that the Bloomsbury Group didn't believe in. In a different way Eileen Agar was one of many of her contemporaries who found their impulse to paint dried up with the outbreak of the Second World War in 1939; the fact she was working as a fire watcher by night and at a canteen catering to bombed-out civilians in Savile Row during the day may have had something to do with it.

Painter Maeve Gilmore, the wife and biographer of writer and artist Mervyn Peake, put her crisis of conscience into words: 'At times too I feel that one cannot stay outside events that are passing in Germany,' she wrote in her diary; 'the multitudes of homeless people – can one just say "I am a painter" and leave it at that? I can think of no practical way in which I can help such unthinkable multitudes of wanderers.'[1]

Picasso is reported by Lee Miller as saying in 1945 that the idea of war artists was 'psychologically wrong' after she had tried to explain to him about the war artist scheme.[2] Official war artists had to be commissioned by government, and unofficial drawings of the war effort were discouraged and in many cases banned; many everyday scenes such as barrage balloons over London streets sketched by passing women artists in the Second World War bear official stamps representing tiresome bureaucracy and prohibitions, or were made in secret. However, many women did find ways to make official work in both world wars, from a variety of motivations.[3]

During the First World War, suffragette artists painted images of women at work in factories, emphasizing the fact that conflicts were

won on the home front as well as on the battlefield. Lucy Kemp-Welch was commissioned by the British Parliamentary Recruiting Committee to paint a recruitment poster in 1914, *Forward! Forward to Victory Enlist Now*, showing a mounted soldier charging with a drawn sabre, which became an iconic image. Her chief interest was in portraying horses and many of those she depicted in training didn't survive service on the Western Front.[4] An artist of a previous generation, Elizabeth Butler had already established a reputation for her paintings of battles in the Napoleonic, Crimean and Boer wars, but she painted some memorable scenes from the First World War, including *The Royal Horse Guards Retreat from Mons* (1914).

Vorticist Helen Saunders's semi-abstract pictures, based on images of struggle and machinery, although not overtly images of the 1914–18 war somehow tell us how the war *felt* rather than how it looked to observers. Women's distress was frequently underestimated, particularly if they had no obvious reasons for anxiety such as husbands, brothers and sons in the fighting. After 1918, many men felt changed – considering themselves older and wiser – while women were often regarded even more than previously as 'hysterical', or 'innocent, silly creatures', without acknowledgment of how the war had changed them and their ideas too.

During the Second World War, Paule Vézelay got permission to record bomb damage in her hometown of Bristol, arguing that her modernist style was appropriate to drawing the twisted iron girders of the wrecked buildings. Work by lesser-known women artists often didn't emerge until years later. When Margaret Abbess donated a series of drawings she had made while working in a munitions factory during the Second World War to the Imperial War Museum in 1995, a curator asked her why she didn't see herself as a war artist. Abbess replied that Henry Moore's shelter drawings were 'lovely in themselves' while hers 'weren't done with enough care, not really meant for posterity, they were on scrappy bits of paper'.[5] The interviewer insisted that they had immediacy and were useful documentation, attributes highly valued today.

Only two women received government commissions to work overseas during the Second World War: Laura Knight, whose reputation ensured she was seen as a safe pair of hands, and Mary Kessell, who benefited from being one of Kenneth Clark's intimate friends. Even Kessell wasn't sent to Germany until the war was over, where she recorded the

Mary Kessell, *Notes from Belsen Camp*, 1945. Sanguine crayon on paper. Doris Zinkeisen and Lee Miller were at Dachau and Buchenwald respectively at the moment of liberation. Kessell was at Belsen four months afterwards but still found it extremely distressing. She made more optimistic images of women and children being repatriated and of this frail woman being assisted to medical and practical help.

life of refugees in Germany and the aftermath of the allied bombardment of Hamburg and Berlin. The role of the war artist did not end when fighting stopped and many pictorial records were made of ruined towns and devastated landscapes following the German surrender.

Kessell witnessed the camps set up to accommodate prisoners from Belsen. Months after the camp was liberated its former inmates were still a pitiful sight, and in her wispy chalk drawings it seems as though she can hardly bear to commit the ghostlike figures to paper, in case they don't survive. She wrote of the experience: 'tears poured down my face.... Remember forever these things that war has made.' Stella Bowen had similarly powerful emotions when she was commissioned to paint a group of airmen, *Bomber Crew* (1944): she made the initial sketches but only one of the men returned alive to see the portraits she was obliged to complete; she said it was like painting ghosts.[6]

The sisters Doris and Anna Zinkeisen were both commissioned as artists during the Second World War by the Red Cross. Anna painted a portrait of the plastic surgeon Archibald McIndoe at his centre in East Grinstead, where he treated badly burned RAF pilots. During the war she worked in the casualty department of St Mary's Hospital in Paddington in the mornings before using a disused operating theatre to paint in the afternoon. Before the war, she had painted murals on ocean liners, including the *Queen Elizabeth* and the *Queen Mary*. Doris drove an ambulance in London during the Blitz and witnessed the liberation of Belsen; she never recovered from the shock and had nightmares for years afterwards. It was all a far cry from their work in the 1920s and 1930s, when they were well known for their London Transport posters and the stage designs they created for the director Edward Gordon Craig.

Doris Zinkeisen, *Human Laundry, Belsen: April 1945*, 1945. Zinkeisen wrote that '[t]he shock of Belsen was never to be forgotten.... The stable was used to wash any living creature down before sending them into hospital to be treated. Each stall had a table on which to lay the patient – the German prisoners did the washing. The church was used as a hospital for those that were alive.'

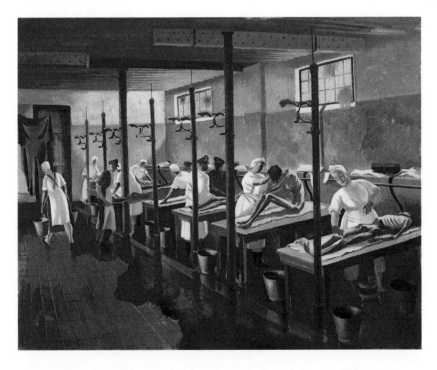

Images such as *Human Laundry* showed that women could not only face all the horrors of war, but also, as traditional washers and layers out of the dead, were only too aware of its impact. The images of war produced by women artists, sometimes illicitly, were shocking and often ignored the government's prohibition on negative propaganda that might sap morale. For some, bearing witness was a way to process what they had seen psychologically. It didn't always work. Olive Mudie-Cooke,[7] artist, ambulance driver and interpreter for the Red Cross in the First World War, painted many sombre watercolours of her daily tasks and of cemeteries in France once the war ended. She returned to Cornwall in 1920 and continued painting, but took her own life in 1925. It is impossible to say whether seeing things at such close quarters pushed her to this decision.

For many women in the Second World War, the devastation was all around them. In London, where one in six people lost their homes and more than 60,000 civilians died in bombing raids, the juxtaposition of destruction and domesticity was particularly upsetting, with homes torn apart by bombs opened to public view. Ethel Léontine Gabain, commissioned by the War Artists Advisory Committee (WAAC) to produce lithographs recording the evacuation of children from London, sometimes had to explain to initially hostile communities why documenting their experience was an important contribution to morale. She was unusual as a woman artist in relying entirely on making a living from her work, so her contract to record the home front was vital.

In her almost photorealist style, Gabain faithfully recorded women's activities, including in the Women's Voluntary Service (WVS). In terms of form and content it could be argued that her exquisitely executed lithographs represent an idealized vision of order and optimism, but male war artists of the time were not producing anything as revolutionary in form as the vorticists did during the First World War. Born in France but living and working in England after attending the Slade, she was a founder member of the prestigious Senefelder Club of master lithographers, together with her husband John Copley. She ignored modernist influence at the Slade, and pursued her vision of recording women's experience with superlative technical skills. Like Laura Knight, she painted portraits of well-known actresses in the 1930s. In old age, suffering from arthritis, she continued working with a paintbrush strapped to her wrist.

Ethel Gabain, *Bombed Out, Bermondsey*, 1940. Lithograph on paper. A scene following an enemy bombing raid, showing grief but also grim resilience in the poses of women and children. Gabain said she wanted to show women's courage in carrying on with daily chores – 'the milk girl who goes on with her delivery during raids' – as well as daunting clearing-up operations, sorting debris for building materials for re-use.

Portraiture is often an act of commemoration and photographs of paintings were sometimes sent as mementoes to widows. Gabain made portraits of Pauline Gower, a pilot in an all-women RAF flying team, fifteen of whom were killed on active service; of Sir Alexander Fleming, whose drug penicillin was having a revolutionary effect on reducing fatalities; and of nurses demonstrating new techniques for treating burns. Laura Knight painted Corporal Pearson, the first woman to be awarded the George Cross for pulling a wounded pilot from a burning plane.

American photographer Lee Miller was still writing for the fashion press, but her Second World War reporting was down to earth and unromanticized, providing a clear report of the horrors she felt should be known about in England, including the plight of civilians, horrible scenes of slaughter and one of the first air strikes using napalm. Her apparently unshakeable confidence that she would survive depended on

regular intakes of alcohol. She reported on the liberation of the camps and suffered afterwards. Her articles in *Vogue* reported scarcely credible heaps of skeletal corpses: 'I implore you to believe it,' she asked her readers. In the photograph of herself in Hitler's bath, taken by fellow photographer David Scherman, she was washing off the dust of the camps, and something more that she would never really wash away.[8]

Her earlier photos, published in *Grim Glory: Pictures of Britain Under Fire*,[9] turned bombed buildings and objects into surreal compositions, without losing touch with her empathy and compassion. Although they showed the madness of war, they were used as propaganda to try and encourage the USA to intervene. Beyond the artistry of her images, in her written work she spoke in an unflinchingly humane voice of the suffering and the dead, including a Nazi commander's daughter who had killed herself. Her partner, the British artist Roland Penrose, was serving as a camouflage instructor. He used a naked Lee as a model, covering her in green patterns using a newly developed cosmetic cream, applying the principles of cubism to the optical disruption of form, a subject he had studied in Italy. 'Apart from this brief taste of action at the front I remained a homebound instructor throughout the war', he wrote, 'which gave me a sense of inferiority when I compared my own efforts to the daring exploits of Lee.'[10] He reveals little of what happened when Miller finally returned home to Penrose's secluded Sussex farmhouse, in a state of clinical depression that nobody at the time understood. When she became pregnant and finally married Penrose, she kept her black sense of humour, telling him 'There is only one thing – MY WORK ROOM IS NOT GOING TO BE A NURSERY. How about your studio? Ha Ha.'[11]

Miller took up cooking at Farley Farmhouse and concocted extraordinary surrealist meals, confessing to a friend that she only refrained from suicide because she knew her husband and son would be quite happy without her. She was terrified of being considered mentally ill. Doctors insisted there was nothing the matter with her, one telling her 'we cannot keep the world permanently at war just to provide you with excitement'.[12] The military ignored post-war stress in front-line journalists of both sexes; recent analysis suggests that over a third of them may have needed treatment for their symptoms.[13] Her work only has the level of recognition it does today because her family worked tirelessly to rescue her reputation from neglect.

One artist whose political convictions led her to choose military service over the life of the artist was Felicia Browne. A contemporary of William Coldstream at the Slade, and a great friend of Nan Youngman's, she witnessed the rise of Nazism while working as a stone carver in Berlin in 1928. She visited the USSR, Hungary and Czechoslovakia before returning to England in 1936 where she joined the Communist Party and the Artists International Association (AIA). A male contemporary of Browne's at the Slade cruelly described her as a 'rather plain, dumpy young woman in horn-rimmed spectacles and a black hat. She was a showy but competent draughtswoman and a great talker – a bit of a gas-bag but with a saving sense of humour.'[14] Her obituary in the AIA also emphasised her funny side, but rather more positively called her 'painfully truthful and honest, immensely kind and generous, completely humane…and as capable of enormous humour as she was deeply serious.' Through a friend, Edith Bone, who had contacts at the *Daily Worker*, she enlisted in the International Brigade at a communist militia office and was eventually sent to help blow up a munitions train. She was killed trying to save a comrade from fascist snipers. Although her body was lost, her sketchbook was saved and sent back to England to be sold to raise money for Spain. The first British volunteer to die in the Spanish War, her death led Nan Youngman to join the AIA: 'I began to be aware of living in history, aware of what was happening in a way I had never done before,' she recalled later. 'I was 30 but I was a child.'[15] Nan Youngman organized Felicia Browne's memorial exhibition in October 1936.

While many, including Vanessa Bell's son the author and poet Julian Bell, followed her example and embarked for Spain, other artists felt it more useful to use their skills at home for propaganda purposes in aid of the Republican cause, producing publicity, posters and leaflets and organizing exhibitions from which all the proceeds went to providing money for food, ambulances and medical supplies. Julian Bell died driving an ambulance in 1937, after being in Spain little more than a month; his mother thought his death a great waste of a life. Another artist who became an ambulance driver, although in her case she served during the London Blitz, was Elizabeth Watson,[16] a great friend of both Felicia Browne and Nan Youngman. An ex-Slade student, Watson wrote an illustrated memoir, showing in graphic terms the horror and carnage

Felicia Browne, *Sketch of Women and Children*, date unknown. Graphite on paper. In a letter to Elizabeth Watson, Browne wrote: 'You say I am escaping and evading things by not painting or making sculpture', responding that she would do so '[i]f painting and sculpture were more valid and more urgent to me than the earthquake which is happening in the revolution.'

wrought by wartime bombing. In one incident, when an explosion covered everything in a blue dust, she wrote, 'I just avoided stepping on a blue arm and then noticed a Prussian blue head in the gutter.' Her bomb-shelter drawings, less monumental than Henry Moore's, reveal a more realistic and domestic aspect of people's suffering.

Evelyn Dunbar[17] was the only salaried woman war artist in the Second World War and had over forty works accepted by the Imperial War Museum; other works by her remained hidden for years. As a Christian Scientist, she saw only truth and love as reality; she looked beyond the destruction and despair that surrounded her in an effort to seek out and document examples of compassion and regeneration. When she records life on the home front – even such banal scenes as a women's knitting group making scarves and blankets for the forces in her mother's drawing room – what she depicts takes on a new significance as a result of her unusual perspective. Peggy Angus wrote after Dunbar's death in 1960 that she was 'an outstanding painter, imaginative and sensitive – THE BEST of all the war artists'.

Dunbar was apolitical, although Nan Youngman had persuaded her to join the AIA and later facilitated the purchase of her painting *Joseph's Dream* (1938–42) through the 1948 Pictures for Schools exhibition by Cambridge County Council. The painting was seen by one critic as a 'problem picture in a surrealist style', but R. H. Wilenski, an important modernist critic of the time, was much more favourable, comparing it to the work of Stanley Spencer. In fact, Dunbar had met Spencer and his brother through her tutor Allan Gwynne-Jones and admired his work, exhibiting at the Goupil Gallery with them. At the Royal College of Art (RCA), principal William Rothenstein considered her work and personal vision equal to that of her tutors Eric Ravilious, Barnett Freedman and Percy Horton, but her self-effacement and the end of her relationship with her ex-tutor Charles Mahoney in 1936 estranged her from the RCA circle for a time. The murals she worked on with Mahoney and Elsi Eldridge at Brockley School for Boys still survive, and are increasingly written about,[18] works done with love for little financial remuneration. For Dunbar, art was so personal she disliked money being involved and the Goupil Gallery's further interest in her work was not pursued. She survived financially with the help of family legacies and through her marriage in 1942.

Her commissioned war work included images of nursing scenes and of the evacuation of St Thomas's Hospital using clever 'split-screen' compositions that were inspired, like Stella Bowen's work, by Quattrocento religious painting. She often worked with the WVS and the Land Army, producing brilliantly designed and beautifully painted scenes of routine chores, such as the pruning of apple trees, milking practice with artificial udders or a canning demonstration; the WAAC may have missed her feminist intent. Her only solo show in 1953 included both her personal and her war work; the Tate bought her painting *Winter Garden* (*c.* 1929–37) in 1940. Hers was a celebratory art, her identification with the natural world a form of self-healing. Topographically, she worked in the Weald of Kent and the North Downs, the Garden of England, which formed her own Garden of Eden. In beautiful paintings made just before the war you can almost smell the potting compost and the rich smell of growth. Percy Horton criticized some of this early work for being 'petit-bourgeois' in its outlook, but Christian Scientists believed that by gardening you were nurturing God's creation. It seems sad but fitting that she died, quite suddenly from a coronary atheroma, when gathering pea sticks for her garden, at the very young age of fifty-four. Half her work disappeared into storage, not reappearing until 2013.

Dorset seems an image of relief after the trauma of war – the land has survived. In *A Life in Painting*,[19] Christopher Campbell-Howes explains that the woman in the picture is specifically based on Anne Garland from Thomas Hardy's *The Trumpet-Major* (1880), gazing out to sea with her hands in a protective framing gesture, watching HMS *Victory* rounding the headland, bound for Trafalgar – on board is her suitor Bob Loveday, who survives the battle that saves England from invasion.

Stella Bowen worked as a war artist throughout the Second World War. While many of her friends were pacifists – 'war's purpose was destruction, which appeared to be the opposite of our function as would-be artists, or as women' – as a single woman with a young child her commissions provided a welcome source of income. Born in Australia, she moved to London in 1914, studying with Walter Sickert at Westminster School of Art. In 1918 she met Ford Madox Ford, twenty years her senior and still shell-shocked from the Somme. She devoted herself to his recovery while he wrote *Parade's End* (1924) – even their small daughter lived elsewhere with a nanny to give him the peace

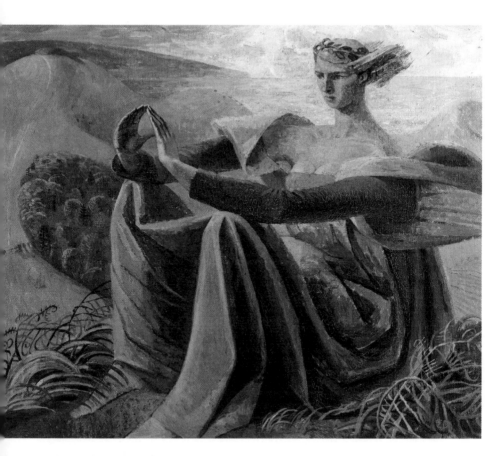

Evelyn Dunbar, *Dorset*, 1947–48. Oil on canvas.

he needed. His short affair with Jean Rhys[20] ended their relationship. Living for ten years in Paris and London, and mixing with literary modernists including Gertrude Stein and Edith Sitwell, she painted landscapes and still life, and portraits of T. S. Eliot, Aldous Huxley, Stein and Naomi Mitchison among others; she was always experimenting. Her painting of repatriated Australian prisoners was inspired by a Fra Angelico fresco she had seen in Italy, *The Nine Ways of Prayer,* providing a technical solution for a multiple-view composition. Other work has a psychological intensity that overtakes its documentary nature. In *Embankment Gardens* (see page 186), the almost anthropomorphic trees act out poses of tension, alarm and anxiety at what might be about to happen. Sadly, Bowen died of cancer just as her career was taking off again after the war.

Stella Bowen, *Embankment Gardens, London*, c. 1938. Oil on composition board. Only three small dark figures venture out in the unusually empty gardens, with their spookily empty bandstand, against the backdrop of the misty Thames Embankment. Cleopatra's Needle stands perpendicular in the river's foreground, and in the distance is the dome of St Paul's, which was to become a symbol of defiance as it survived the bombing around it.

The artist Gladys Hynes was a pacifist, but also a supporter of the Republican government in the Spanish Civil War and the nationalists in Ireland in the 1920s, sympathizing with women who were badly treated in Ireland by the British Army.[21] *Crucifixion*, from 1939, which now hangs in the RAF Museum, shows a young airman splayed across the fuselage of his plane above a landscape. Hynes always seems to be commenting on gender. *A Private View* from 1937 records the posturing of mannishly dressed women and effeminate men, none of them looking at the paintings. A drawing made during the First World War called *The Railway Carriage* (1917) shows an exhausted war widow sleeping with children in her arms next to a similarly exhausted soldier coming home on leave.

Laura Knight's competent realism meant she received several commissions to paint women doing essential work on the home front,

intended to encourage women to work in weapons production; the enthusiasm to teach women engineering skills seemed to decline after the war was over. Knight was allowed to document barrage balloons being raised, whereas non-commissioned artists were forbidden to draw such routine daily events, which was extremely frustrating for those with an instinct to record such extraordinary scenes. Knight was sent to document the Nuremberg trials, an emotionally harrowing assignment; eventually she blended her images of the men seated at the hearings with a vision of a burning townscape, a visual expression of her own intense feelings that was quite unlike her usual style.

Even without an official commission, no artist could be prevented from producing work from her imagination. Priscilla Thornycroft[22] was an active AIA member, having joined as a Slade student. Her grandparents had been friends of Eleanor Marx and George Bernard Shaw. A pacifist, she had produced anti-fascist posters during the Spanish Civil War, and helped Nan Youngman and Betty Rea paint murals on a street hoarding. She made drawings of raids on Camden Town from

Gladys Hynes, *Crucifixion*, 1939. Oil on cardboard. Now in the RAF Museum, the picture suggests her sympathy for young recruits.

a specifically working-class point of view, which she kept hidden until after the war. As late as 1979 she painted an image she remembered from 1944 of a very old lady sitting on a pile of rubble clutching a cup of tea – she had been in a basement when a bomb fell and kept repeating over and over 'I was very lucky'. She also painted a shocking image of a horse that had stampeded and ended up impaled on some railings.

Murals in workspaces and public buildings contributed greatly to general morale. Olga Lehmann[23] made a series of such works for the RAF during the Second World War in her late art deco style, painted straight onto the brick walls of the canteens at Spring Quarry, near Corsham, Wiltshire, where the Bristol Aeroplane Company manufactured parts for bomber and fighter planes. Her official war drawings are now owned by the Imperial War Museum. She would probably have been amused to think of herself as a kind of jobbing artist, never receiving the recognition she deserved for her extraordinary career, which included working for Hollywood films and for the *Radio Times*. After the war she always maintained that having a good time was an essential part of an artist's life.

In 1971, Barbara Jones and Bill Howell published *Popular Arts of the First World War*, which examined trench art, embroidered postcards, sentimental posters and china, and all the wartime toys and board games that gave such an unrealistic impression of the first war while somehow also showing the fears, emotions and circumstances of people of the time. Their hope was that enough time had passed for it to be possible to take a more anthropological approach to the era, reminding us that the popular arts can convey just as much about a period as oil paintings in the classical canon. One thing that emerges from any study of the art of the period: in multiple ways, women were central to recording the impact of the wars of the first half of the twentieth century.

iscilla Thornycroft, *Runaway Horse in an Air-raid Alarm, Autumn 1939*, 1955. Oil on board. In 1948, Thornycroft oved to Berlin with Hans Siebert, a German resistance fighter and painter whom she married during the r, and their two daughters, born in 1943 and 1946. She moved to Dresden, East Germany, in 1952, where is painting was made. She continues to live and paint there still.

Chapter 13

THINKING IN COMMON
topography and creative clusters

For masterpieces are not single and solitary births; they are the outcome of many years of thinking in common, of thinking by the body of the people, so that the experience of the mass is behind the single voice.

Virginia Woolf, *A Room of One's Own*, 1929

Being located in a specific place can affect the career of an artist, their inspiration and the recognition they receive just as much as partaking in the shared outlook of an artistic group. This chapter examines the effects of topography, tracing patterns of friendship, mutual support and rivalry across the southern half of England amid clusters of creative practitioners in Sussex, Essex, East Anglia, Hampshire, Dorset and Cornwall.

Between the wars, those who shared an aesthetic outlook shaped by their socialist beliefs decided to locate themselves among ordinary working people in the countryside in an attempt to find a 'New Arcadia' in which to live the simple life. Artists like Ethel Mairet and Eric Gill for example: Gill relocated to Ditchling in East Sussex in 1910 and in 1919 Mairet built her house Gospels there, as both a home and a workshop where she could take on apprentices, including young women from the village.

Attitudes to the countryside were undergoing great changes during this period. It might be argued that the Recording Britain project, which combined art with the kind of immersive fieldwork championed by Pearl Binder's friend Bronisław Malinowski, the Polish anthropologist, was metropolitan in its outlook. However, when artists started doing farm work, either as conscientious objectors or when they were conscripted

as land girls during wartime, different worlds began to intertwine. Artist and illustrator Evelyn Dunbar, who lived alongside women working on the land, produced her study *A Book of Farmcraft* with Michael Greenhill in 1942. Today her role would probably be described as 'artist educator', but who was educating whom? Dorothy Hartley was an artist, illustrator and social historian who had worked in a munitions factory during the First World War. Perhaps best known today for her book *Food in England* (1954), her publications are particularly interesting, as she includes herself in photographs of the people in small communities she is studying, showing them relaxed and chatting, relating to and in some cases working alongside her.

Raising a family away from the London smog was appealing. Many artists chose to move to the countryside to access cheap housing that came with a landscape attached and allowed room to work. Career-wise it could be a risky strategy: for those without good connections, moving out of London could mean losing touch with galleries and customers. Peggy Angus's first job on finishing her teaching diploma in 1926 was in Nuneaton, Warwickshire; she was in despair – it felt to her like being banished to the back of beyond. It took her four years before she was able to find a teaching job in Eastbourne, in East Sussex, within an hour and a half of London by train.

For some women, the friendship groups formed during their student days were strengthened by working together in the Artists International Association (AIA). As they took on different employment it was necessary to share childcare and sometimes during the war to send children to the country to stay with artist friends. As the children of these artists were brought up in almost familial proximity to each other, it led to a sense of dynastic belonging that in some cases continues to this day. They became associated with a specific place, just as wealthier artists like Augustus John and those associated with the Bloomsbury set had established their territories earlier in the century. Some of these locations, like St Ives in Cornwall, subsequently took on a mythical dimension, burnishing the reputations of the artists associated with them and by extension excluding others from the canon.

In 1932, Peggy Angus settled as an illegal sub-tenant in Furlongs, an estate cottage outside Glynde in East Sussex, although she always tried to keep a studio base in London. Furlongs soon became a social centre

Charlotte Epton, *Eric Townsend*, 1932. Oil and gouache on canvas.

for her group from the Royal College of Art (RCA) and her architect friends – Moholy-Nagy, who visited while taking a series of photographs in Brighton, and Serge Chermayeff, who used it as a base while building his modernist home Bentley Wood in nearby Halland. A few miles further was Muddles Green, Chiddingly, where from 1949, Roland Penrose and Lee Miller lived at Farley Farmhouse, and entertained a succession of famous visitors including Picasso and Miró. Their relations with the inhabitants of Furlongs were cordial but sporadic. Although Angus taught alongside Quentin Bell for a while in Lewes after the war

and both she and Bell were stalwart AIA members, there continued to be little fraternizing between Furlongs and Charleston Farmhouse, only 6.5 km (4 miles) away, where the conscientious objectors of the Bloomsbury Group had escaped prosecution by supposedly working the land. Andy Friend notes in *Ravilious & Co*[1] that Virginia Woolf would have passed Furlongs' gate when she cycled from Rodmell to visit her sister Vanessa.

Great Bardfield in Essex became something of an outpost of the RCA as early as 1931. Essex-born artist Edward Bawden was the first to move there, along with fellow RCA student Charlotte Epton, and in 1932 they rented Brick House jointly with Eric Ravilious and Tirzah Garwood. Evelyn Dunbar, who shared their passion for gardens and horticulture, was an early visitor. Epton had already had a successful career as a potter working with both Bernard Leach at St Ives and Michael Cardew at Winchcombe Pottery in Gloucestershire, but Great Bardfield eventually took over her life. Happily abandoning her artistic career to support Bawden, their two children and other artists in their group, Charlotte went on to become a magistrate and a serious supporter of the local Women's Institute. Bawden always believed that a woman's place was in the home and, according to Tirzah Garwood, he was jealous of Charlotte's painting skills.[2]

The painter John Aldridge and his wife Lucie Leeds Brown arrived in Great Bardfield in 1933, moving into Place House; Aldridge, Bawden and Ravilious commuted into London to teach, until they were called up during the war. Other artists moved into the village seeking sanctuary from the Blitz; they included Diana and Kenneth Rowntree, who had been forced to abandon their bomb-damaged flat in Lawn Road, Hampstead. Diana Rowntree was an architect who worked in Jane Drew's all-woman architectural office in London, designing fake factories to confuse enemy bombers. Later, Rowntree became *The Guardian*'s first woman architecture correspondent, helping expand newspaper coverage of the visual arts after the war.

The artist Duffy Rothenstein moved to Great Bardfield with her husband, the painter and printmaker Michael Rothenstein, in 1941. Living in the very English village suited her while she was having her family. Michael Rothenstein was the son of William Rothenstein, the principal of the RCA, and the brother of John Rothenstein, the director of the Tate Gallery, so he maintained more international connections

than most of the group, making him temperamentally distinct from his neighbours. Duffy Rothenstein[3] was a figurative painter and portraitist who usually painted women, using reds and patches of strong bold colour. In 1955 she split from her husband and moved back to London, marrying the typographer Eric Ayers, the director of Editions Alecto, in 1957. This move reinvigorated her career and she continued painting into her old age, dying, aged 102, in 2017.

Tirzah Garwood, considered by Oliver Simon of the Curwen Press the best marbler in Europe, is always associated with Great Bardfield, although her stay there was short. Charlotte Epton (now Bawden) helped her to make hand-marbled papers that they sold to Harold Curwen and to Dunbar Hay and the Little Gallery, either as single sheets or made up into stationery or lampshades. From a respectable, well-to-do family, Garwood had studied wood engraving under Eric Ravilious at Eastbourne School of Art, and then at the Central School of Arts and Crafts in London. She exhibited with the Society of Wood Engravers (SWE) and was commissioned by the BBC and the *Radio Times*, as well as making book jackets for Golden Cockerel Press and patterned borders

Duffy Rothenstein, early 1950s. Photographer unknown.

Duffy Rothenstein, *Portrait of Tirzah Garwood*, 1944.
Olive Cook described Duffy as having 'a keen and
penetrating gaze for both the outer details and inner life
of her subjects'. Tirzah's portrait is one of Duffy's best.

for Kynoch Press and the Curwen Press, to which she was introduced
by her husband-to-be. After an SWE exhibition, her *Four Seasons* (1926)
was praised in *The Times* in the same breath as work by John and Paul
Nash.[4] Lively and experimental, as Andy Friend has written, she 'almost
instantly became an adept peer of her already accomplished teacher –
and during 1927 began to exert an influence over his own approach'.[5]
She and Eric Ravilious both loved quirky oddities and her engraving
may have spurred him on in a slightly competitive way. Ravilious had
originally been drawn to her when she was his student because her work
was 'personal and didn't imitate his own'.[6] After her marriage in 1930
she stopped engraving so much, concentrating more on her papers.
A plan for her to do twelve engravings for Oliver Simon was abruptly
withdrawn and this may have affected her confidence; it coincided with
a general decline in private press opportunities. Supporting Ravilious

Tirzah Garwood, marbled papers. According to Olive Cook, Garwood 'quickly mastered the volatile medium and produced patterns the like of which had never been seen, delicate repeating designs which had nothing in common with traditional marbling. The motifs are nearly always based on natural forms: on leaves, frail flowers and grasses, and the freedom and unpredictable character of the medium imbue them with a tremulous, poetic sense of life.'

practically by painting the Morecambe mural with him in 1933 meant Garwood had even less time for her own work, but she made some embroidered pictures as clever and quirky as her paintings. Around this time Ravilious began his affair with Diana Low, but Garwood liked Low and maintained it did not upset her unduly. Later, when she was ill, she said that burying herself in a task was her way of escaping reality.

Garwood had always been very critical of the scale of values attached to certain kinds of painting and artwork, demanding, for instance, 'why should watercolour, which is a much more difficult medium than oil, be less valuable?' She was her typically outspoken self in criticizing the motives of 'stockbrokers and businessmen' who collected etchings like 'postage stamps', referring to the price paid for etchings in comparison with wood engravings. Her particular enthusiasm and skill became making three-dimensional paper models of local buildings: between 1947 and 1950 they were exhibited at the V&A, and in 1948 at the Tate Gallery and the Whitechapel Gallery. Nan Youngman wrote to Olive Cook about Garwood from Cambridge, probably after reading Cook's article about her in *Matrix* magazine in 1990: 'There was a butchers shop in which the blinds could be pulled up and down.... They often topped the bill for the children's favourite.... It is strange that Tirzah is so little known when everyone responds to her work.... That period hasn't really been written about and it is time it was, Muriel Rose and all.'[7]

Preoccupied with her three children and the impact of having a mastectomy, Garwood only started working in oils in 1942, making over twenty paintings in the last year of her life, when she was frequently in pain; it was, she said, the happiest year of her life.[8] Some were of miniature buildings set within slightly primitive landscapes, like her amusing view of Furlongs surrounded by a toy train and tractors; others were of rather surreal animals. The pale woman in *Spanish Lady* (see page 198) under a threatening sky was inspired by a piece of pottery, her cracked neck somewhat reminiscent of a Frida Kahlo self-portrait: it was probably her last piece of work. She died of breast cancer in 1951.

Many artists in this chapter trained in London but happily returned to their home territories afterwards. Elisabeth Vellacott was born in Essex and spent her childhood in Cambridge. At the RCA Painting School, Thomas Monnington encouraged her to look at early Italian frescoes,

Tirzah Garwood, *Spanish Lady*, 1951. Oil on canvas.

and she was a fellow student of Cecil Collins and Evelyn Gibbs and a good friend of Nan Youngman. Her feeling for abstract form and design was developed by hours spent looking at Diaghilev ballet performances and works in museums: Russian icons, Indian miniatures and applied arts in the V&A. She studied Matisse, Morandi and Giacometti in order to reduce figures in landscapes to their essentials. After graduating she worked as a textile designer and printer in Cambridge with her friend Gwen Raverat, making sets and costumes for university productions, and at the Old Vic in London with Lilian Baylis. Vellacott often said half jokingly that making textile designs got abstract art out of her system,[9] people were what was important; and drawing – which was done outside – was a completely different activity from painting in a studio.

The war drove Vellacott further afield: she was conscripted to do land work and was billeted near Huntingdon, Cambridgeshire, with Lucy Boston,[10] who wrote the Green Knowe series of children's books. Her

Elisabeth Vellacott, *Figures under a Tree*, 1951. Brush and ink on tracing paper.

gallery contacts were disrupted and all her work was lost during an air raid on Cambridge. After the war, Boston's son built Vellacott a studio of wood and glass on a very tight budget and she returned to painting and drawing while eking out a living as a teacher. She became an examiner, with Betty Rea, and did not have her first solo show until she was sixty, encouraged by Bryan Robertson, who was then working at Heffer's Bookshop and Gallery in Cambridge and went on to be director of the Whitechapel Gallery, London. Robertson was an early champion of women and less well-known artists, including Nan Youngman; *Studio International* described him as the 'greatest director the Tate Gallery never had'. Vellacott's work was also bought by Jim Ede for Kettle's Yard in Cambridge and she enjoyed a quiet, late-flowering recognition.

Born in Kent, Mary Potter[11] studied at the Slade with Winifred Knights, leaving with a clutch of prizes. She had already established

herself as an artist in London when she moved with her husband, the writer and broadcaster Stephen Potter, to Essex during the war and then to Aldeburgh in Suffolk in 1951. A member of the 7&5 Group (see page 43) briefly in 1922 and an admirer of the work of Frances Hodgkins, she had her first exhibition at the Bloomsbury Gallery in 1932 and shared another with Edna Clarke Hall at the Redfern in 1934. At the Slade, Henry Tonks had warned her never to get married but Potter was no bohemian and was totally dedicated to her work; her high-powered husband was a distraction but not a permanent one, although the birth of her two sons contributed to a period of ill health.

After her divorce in 1955, Potter developed a close friendship with composer Benjamin Britten and his partner, the tenor Peter Pears. Born near Lowestoft, Britten felt very strongly that an artist should be part of his community and moved to live in Aldeburgh in 1947. Pears was enthusiastic about collecting contemporary art, buying from artists even when their work was not particularly good or to his taste, to be supportive. He greatly admired Potter's work, however, which features largely in the collection now held at the Red House, Aldeburgh.

Experienced at fulfilling commissions in order to earn her living, Potter painted portraits of Britten, Pears and composer Imogen Holst. In the 1940s she began painting the sea and seaside promenades, using spare modern shapes and light tones, and over the years her work became increasingly abstract. Affected, like Elisabeth Vellacott, by the east coast light, she achieved a luminous quality in her paintings, experimenting by mixing beeswax into her paint. Potter and Prunella Clough admired each others' work; Margaret Mellis was another admirer when she lived in Southwold. Potter was also friendly with Britten's librettist Myfanwy Evans.

Britten's home Crag House, right on the seafront, became too publicly accessible as his fame grew, and in 1957 he swapped houses with Potter when her sons left home, moving to her house on the edge of town. At Crag House she painted seascapes from the windows, until it became too large for her as well, and Britten and Pears built her a studio in her old garden at Red House that she used until she died. She became part of the composer's family, holidaying with them abroad and helping with the entertainment of Aldeburgh Festival guests and the organization of exhibitions.

Mary Potter, *East Coast Window*, 1959. Oil on canvas. Later versions of this view from Crag House became less representational and even more fluid.

Kenneth Clark was a go-between for Aldeburgh Festival and the Arts Council so she kept up good contacts, becoming one of Clark's favourite women friends. Bryan Robertson encouraged her to make large paintings for Whitechapel Gallery exhibitions in the mid 1950s, although few sold. In the catalogue of her 1965 Whitechapel exhibition, Clark wrote that her works 'exist in the domain of seeing and feeling; we know that they are exactly right in the same way that we know a singer to be perfectly in tune...enchanting moments of heightened perception.' She resisted becoming a completely abstract painter and had a major exhibition at the Tate in 1980 (a year before she died).

Potter taught weaving at Bryanston public school in Dorset, where her friend Peggy Rankin[12] was also employed. Born in East Sussex to a gentleman farmer, and used to country life and freedom, Rankin seems to have had an unhappy struggle with her talents and her vision. She studied at Bolt Court School of Photo-engraving and Lithography, then at the RCA, where her fellow students included Cecil and Elisabeth Collins and Mary Martin, who made a sculpted head of her in the

1930s. She was dissatisfied with the lack of tuition she felt she received at college. In 1936 she married fellow RCA student James Allardyce (a cousin of Betty Swanwick's) and they spent their married life in Blandford Forum, Dorset.

Rankin was inspired by Odilon Redon, Marc Chagall and Edvard Munch, and was very interested in the writings of Carl Jung and Sigmund Freud. She painted colourful, narrative, almost autobiographical paintings and specialized in creating murals, but seemed to lose confidence in herself. She trained without much enjoyment as a teacher and was equally frustrated by her continuing attempts at tempera painting, which she felt were technically unsuccessful. In her diary she describes her struggles with her vision. 'But what I get is nothing.... I do not want to paint for money, for other people's pleasure – for fame or for a profession. I want to paint for myself, paint this thing out and have done with it.'[13] It is hard to be not as good as you want to be and brave to face the reality of it. Already fragile, deeply affected by the early death of her brother, Rankin carried on painting, but was always reluctant to sell her work, although Edward Bawden had one of her paintings and kept it in his bedroom. Richard Bawden, Edward Bawden's son, remembers her house as chaotic but full of lovely things, more aesthetic than practical, with paintings by Mary Fedden and Katharine Church on the walls.[14]

Katharine Church[15] and EQ Nicholson, also associated with Dorset, were both excellent painters. Katharine, known as Kitty, was a free-spirited student, who found the life-drawing rooms at the Royal Academy (RA) depressing, and facilities at the Slade not much better; nevertheless, life drawing was what gave structure to her energetic lines and she was soon exhibiting at the Lucy Wertheim Gallery. She admired Ivon Hitchens and both she and Myfanwy Evans modelled for him, on an occasion when Myfanwy first met John Piper, who fell for her skinny-dipping in the sea. Hitchens encouraged her to be confident and to work *en plein air* – although Church said the most important thing about painting was that it always involved your own sense of discovery.

Church inherited money and always had good connections – her parents were friends of the Betjemans and lived in Highgate. Her youngest sister Margaret was the first woman to be elected to the Royal Institute of British Architects and married Berthold Lubetkin; they

Peggy Rankin, *Daphne and the Kettle*, 1933. Tempera. 'Daphne' was Rankin's lifelong RCA friend Daphne Reid, who for a while looked after Eric Gill's daughters at Pigotts, near High Wycombe, Buckinghamshire, in the 1930s. Both Rankin and Reid belonged to a pacifist community near there for a while.

Katharine (Kitty) Church, *Brick and Flint Wall, Tarrant Hinton*, 1950. Oil on canvas.

were both part of the Tecton Group who designed Highpoint One and Two, also in Highgate, where they lived in a penthouse flat until the outbreak of war in 1939.

Church visited Varangéville in northeastern France, with the Pipers in 1938 and 1939, along with EQ and Peggy Angus, and became influenced temporarily by John Piper's collages. She exhibited vigorous portraits, landscapes and interiors with vibrant colours in solo shows at the Lefevre Gallery from 1937, with supportive comments from Frances Hodgkins.[16] Despite having maintained she would remain single, she was married to Rebecca West's son Anthony West between 1936 and 1950. He was a painter to begin with, but deferring to Kitty, turned to writing instead. During the war they moved to a small farm in Dorset, where they took in some evacuated children from the Isle of Dogs, whom she painted, revealing their state of shock at being out of London for the first time. Two children were born during the war, although Kitty, like Peggy Angus, wasn't particularly motherly: after the birth of her second child in 1944 she wrote to Peggy at Furlongs, 'I think we will all have to

be far more tolerant of each other's children in the future, don't you? I can't see the days of nurses ever coming back.'

She was invited to contribute to a Contemporary Art Society exhibition at the Tate to celebrate the Coronation, from which pictures were to be bought for public collections, along with Prunella Clough, Mary Fedden and Sandra Blow (see page 280). Fedden, a close friend, told author Vivienne Light, 'Kitty was very committed and in a way rather sure of herself.... Kitty always painted standing up, I always paint sitting down. She thought I was much too neat.'[17] John Piper called her personal style: 'dashing, generous, linear'.[18] She always had a base in London but by the 1960s she was fed up with the London art scene and in 1963 she bought her own art gallery in Blandford Forum, running it successfully until 1984.

Elsie Queen Nicholson (née Myers) came from a highly cultured background and married into a painting dynasty; nevertheless, she maintained her own, strong individuality. Her father, the novelist Leo Myers, was painted by William Rothenstein, her American mother by John Singer Sargent; the family knew Virginia Woolf and the writer Frances Partridge[19] was a distant relative. Winifred and Ben Nicholson were frequent visitors to parties in her parents' plush London home; they had bought one of Ben's paintings. David Jones also visited and rather fell for Elsie – always known as EQ – although her daughter Louisa reports that 'his attentions were scornfully rejected'.[20] EQ spent three weeks at the Slade in 1924, but she didn't like the teaching and soon found herself dismissed by Professor Tonks.

Her parents knew plenty of artists who could help her. Sculptor Frank Dobson had used her as a model when she was a child and through him she had spent a few months working in the studio of the sculptor Betty Muntz when she was still sixteen. She developed a passion for design early on and went to Paris for a year to learn batik at a college of decorative arts. On her return she worked as an assistant to Marion Dorn, a successful textile artist making wall hangings and papers, carpets and rugs for modernist British interiors. The experience persuaded EQ to start thinking about making her own designs.[21]

Her parents moved from London to Leckhampton House in Cambridge, which became her first project as an interior designer. It was in Cambridge that Ben Nicholson introduced her to his brother

Kit and EQ Nicholson, *c.* 1930. Photograph by John Somerset Murray.

Christopher, known as Kit, who was teaching at Cambridge School of Architecture; they married in 1931. EQ and Kit collaborated on a number of projects, including a hangar and clubhouse for the London Gliding Club on Dunstable Downs, Bedfordshire, for which EQ designed the interiors, featuring modernist furniture by Breuer and Alvar Aalto. Kit also designed Augustus John's modernist studio at Fryern Court in Hampshire.

EQ liked her sisters-in-law Winifred Nicholson, and Barbara Hepworth, but she had perhaps most in common with Nancy Nicholson, sometime wife of Robert Graves (see chapter 16), a similarly strong and stubborn woman.[22] Nancy, a typographer and textile designer ran a successful hand-printing business in London called Poulk Press. After the birth of her two daughters, EQ began making hand-printed linocut fabric designs and worked with Nancy Nicholson on and off from around 1936 to 1950, helping out after the war with sales for a while, after Nancy's all-night printing sessions. They had a similar sense of humour and their shared love of plants and gardens inspired many of their prints.

During the war, while Kit was serving in the RAF, EQ had three small children under the age of four to care for; she was not used to isolation or the simple life. Initially she lived in Dorset, but in 1941 she

rented Alderholt Mill near Fordingbridge in Hampshire, along with a family friend, the artist John Craxton,[23] a refugee from the London Blitz. Interior design commissions had dried up but Craxton, pronounced unfit for war work, helped to decorate the house and brought along a supply of jazz records. American soldiers billeted nearby taught them to jitterbug, and EQ introduced Craxton to modern classical music. They had long conversations about art and EQ returned to painting, taking as her subject whatever she could see in the house or the garden: jugs and jars that came to hand and her images of plants and flowers with elaborate seedpods expressing her delight in natural forms.

Her work veered between the modernist influence of Ben Nicholson and the neo-romanticism of Craxton (he hated the term), but the result was definitely her own synthesis of strong lines and good design – lively, witty and unsentimental; she moved forms around with complete abandon to create unusual spatial connections. Craxton later said that she helped him find himself as a painter. 'She'd be playing with the children and I'd be painting away,' he wrote. 'Painting seemed as natural as being alive and EQ, who had an infectious *joie de vivre*, was

EQ Nicholson, *The Black Jug*, 1946. Gouache, ink and collage on paper.

the catalyst.'[24] Craxton later took his friend Lucian Freud to see EQ at Alderholt Mill, where he made drawings of her donkey.

She used simple and unconventional water-based materials to make her pictures – coloured ink washes and pen drawing. A great friend of Peggy Angus, EQ wasn't so political and democratic – she was generous to people she knew and liked but she could form a hostile opinion about someone new within seconds and never deviate from it, rather like her brother-in-law Ben Nicholson. Nicholson was particularly sniffy about Peggy Angus as an artist – he considered her far too messy and craft-based to be a proper artist but he liked EQ for her toughness and irreverence. Peggy was in no doubt of EQ's abilities as an artist. 'Grasswidowhood definitely suits some folk,' she wrote to Myfanwy Evans, after staying with EQ at Alderholt Mill in 1942, 'some really lovely pictures. Drawing some real things seen with her inward eye.'[25]

Kit Nicholson, obsessed with flying, like his fellow-artists Peter Lanyon and Paul Nash, survived the war only to be killed in a gliding accident in Switzerland in 1948. His death left EQ both devastated and financially insecure. Olive Cook and Edwin Smith often stayed with her, taking photographs and sketching. EQ and Peggy met up regularly after Kit's death and Peggy's divorce, as they both had children at school at Frensham Heights in Surrey. EQ's children often accompanied Peggy and hers on camping trips to Scotland; they had a plan to run art and craft studios together in Lewes, although this never came to fruition.

In 1950, John Craxton introduced EQ to Erica Brausen, who offered her an exhibition at her Hanover Gallery in Mayfair; this was to be her only big painting show as she had started concentrating on making wallpaper designs for Cole & Son. Some of her original hand-printed fabric designs, such as Black Goose, were later screen-printed by Edinburgh Weavers. She had a good eye for turning natural forms into designs; Kit Nicholson's former student Hugh Casson selected her design Runner Bean for furnishing fabrics in the Royal Yacht Britannia.

In the 1960s, EQ became involved with the esoteric teachings of George Gurdjieff and P. D. Ouspensky and her art became less important to her, although she still enjoyed designing interiors. Her work in gouache, crayon and collage was all filed away in plan-chests and not rediscovered by her artist children until years later. In the 1980s there was a remarkable revival of interest in her work, both in her

paintings and drawings and also in her activity as a designer; she reworked several of her earlier designs and went on to collaborate with her son Tim, producing tufted rugs. Richard Morphet, writing her obituary in *The Independent*, noted that 'the warmth of the response [her work] received pleased but also astonished her – she never seemed quite able to believe in it'.

Dorset's thriving artists' colony was much less written about than the one based at St Ives in Cornwall. For sculptors, the stone quarries of Purbeck and Portland had always been a magnet and by 1918 women accounted for nearly 40 per cent of the new intake into the profession. Two women sculptors worked in Dorset all their lives. Betty Muntz, the first woman freeman of the Ancient Order of Purbeck Marblers and Stonecutters, and a founder member of the Guild of Memorial Craftsmen, had been a member of the 7&5 Group briefly, showing frequently with the London Group; she taught at Bryanston public school in Dorset. Mary Spencer Watson, trained at the Slade and inspired by studying carving with John Skeaping at the Central School, absorbed the new 'truth to materials' ideas and used direct carving techniques, like Barbara Hepworth. Mary Spencer Watson's mother was a dancer and mime artist, a disciple of the theatrical practitioner Edward Gordon Craig; Mary and her sister Hilda were part of a colony of artists who settled at Corfe Castle in Dorset. They danced like Isadora Duncan and posed in exotic tableaux in art deco Egyptian costumes for photographer Helen Muspratt.

Many modernist artists moved to Cornwall during the war to escape bombing in London, but by the late 1940s there was an acrimonious split in its art community, which was highly competitive and notorious for its rivalries and jealousies. This split is often seen as the beginning of its relative decline in importance within the modern movement, but possibly it also added a frisson of notoriety to its public image. Given this potentially fractious dynamic, belonging to a particular topographical or ideological group could become something of a curse, as Wilhelmina Barns-Graham was to find. Born in Scotland into an old, but not overly rich, landed family – an austere and unemotional background – she had studied at Edinburgh College of Art. Not naturally assertive, she suffered from ill health and was prone to depression, but inspired by the Nicholsons and Naum Gabo she moved

Wilhelmina Barns-Graham, *End of the Glacier, Upper Grindelwald*, 1949. Gouache and pencil on paper.

to St Ives in 1940, three years after she graduated. When she became a founder member of a breakaway alternative to the conservative St Ives Group after the Second World War, her reputation began to suffer from marginalization. Her work was perceived as similar to Ben Nicholson's and she was therefore considered a 'follower', even though her work developed, diverged and showed different concerns. The new Penwith Society of Arts was rapidly becoming the 'Ben and Barbara group'. Separation, and eventual divorce, from her modernist husband David Lewis did not help.

After she inherited some land in St Andrews she tried dividing her time between Cornwall and Scotland but found little support for her work in Fife. Always inspired by the shapes of natural landscapes, she started visiting the Grindelwald Glacier in Switzerland in 1949, developing her own personal way of portraying forms, attempting 'to combine in a work all angles at once, from above, through, and all round, as a bird flies, a total experience'.[26] She produced some extraordinary work.

Surprisingly, she didn't receive wide recognition until well towards the end of the twentieth century and may have felt justifiably annoyed when a Tate exhibition about St Ives in 1985 gave far more precedence to

the works of male artists. Bitterness was certainly not visible in her work, however, which became increasingly joyful and free. Awarded a CBE in 2001 three years before her death, she left behind a charitable trust providing grants and bursaries for new young art students and her legacy is now acknowledged and celebrated.

One of Barns-Graham's great friends was the artist Margaret Mellis, who had been a fellow student at Edinburgh. Taught by Samuel Peploe and W. G. Gillies, Mellis had started off as a colourist and then became a modernist, marrying the critic Adrian Stokes. They fled London for St Ives during the war, where Mellis started making small reliefs and collages inspired by fisherman-painter Alfred Wallis. It was thanks to the couple's hospitality that many of the other St Ives artists moved to Cornwall, including the Nicholsons and Naum Gabo, who encouraged Mellis's collage and abstract work; in this way they changed British art history. Mellis had an emollient personality and could often smooth over the artistic scraps and rivalries; nevertheless, even though she was the first to befriend the 'primitive' artist Alfred Wallis, once Ben Nicholson

Margaret Mellis, *Blue Lighthouse*, c. 1952–54. Oil on canvas.

had adopted him as his inspiration she still felt it judicious to inform Nicholson whenever she was going to visit him.

After her marriage broke down in 1946, partly due to her refusal to keep house in what her husband saw as a proper manner, her painting returned to being more representational for a while; she had at one point been part of the Euston Road School along with William Coldstream and Victor Pasmore. All her work was subject to her emotional states of mind and life became hard after her former husband married her sister. She left St Ives seeking isolation and space to pursue her own vision, moving back to abstraction. After the war she lived briefly in France with artist Francis Davison, before marrying him and moving first to Walberswick in Suffolk in 1950 and later to the countryside near Diss in Norfolk, where they ran a small self-sufficient farm growing fruit and vegetables, as well as herbs to keep her painful rheumatoid arthritis at bay.

In 1976 they moved to Southwold; Mellis began making work out of driftwood, gaining belated acclaim and becoming a kind of mentor to a young Damien Hirst when he sent her a fan letter in his teens, serving as a bridge between one generation and another. Her relationship with Davison was a symbiotic artistic collaboration, and they continued to produce paintings and collages until his death in 1981. Only a few friends were allowed to interrupt her work, among them Mary Potter and Mary Newcomb (see pages 264–65).

In 2009, Jules Hussey, who had made a documentary film about Mellis, wrote a letter to *The Guardian* as a corollary to her obituary, which epitomizes much about what made her such a unique figure. 'She never conformed or bowed to pressure of galleries or critics,' she wrote. 'She recounted how, in 1939, Barbara Hepworth had the idea of camouflaging the power station chimneys in Hale, near St Ives, Cornwall. Margaret, Ben Nicholson, Bill Coldstream and Adrian Stokes each made a design, but Margaret was the one hauled up in a tiny home-made rope cradle, swinging in the sea breeze and burning her knees on the chimneys as the famous artists shouted directions to her. Her fearlessness, stubbornness and independence spilled over into her art.'[27]

Chapter 14

SIGNIFICANT OTHERS
artists' partnerships

This chapter looks at how the careers of women artists were either helped or hindered by the romantic partnerships they entered, as well as examining the artistic collaborations that took place within such relationships, in many cases unacknowledged in critical reception. Male artists often felt uncomfortable and competitive if their female partners were the main breadwinners, as this could be seen as indicative that they were producing the better, or at least more commercially success-ful, work. Women were most likely to be left holding the baby when relationships ended, as equal custody was unheard of. Regrets about lost opportunities often surfaced at the end of a woman artist's long career – but then men could feel dissatisfied too.

Women often have a wry take on the matter. Known best for her wood engravings, Agnes Miller Parker married Scottish artist William McCance. Part of Naomi Mitchison's circle, they moved to Powys in Wales, along with Gertrude Hermes and Blair Hughes-Stanton, where McCance worked as a typesetter at the Gregynog Press. After they divorced in 1955, Naomi Mitchison declared that 'Mac' was 'something of a phoney, demanding to be taken as a D. H. Lawrence-type genius; his wife, who in fact provided the family income and was a far better artist, was forced into practising mousemanship' – a fitting term in the circumstances.[1] It is not surprising that fellow students often married; frustratingly, we rarely hear much about artists' wives, despite the support they provided or the influence they may have had. In many cases their stories are ignored even when they were good artists themselves.

Lilian Holt was born into a poor East End family and worked at the Prudential Assurance Company while attending Putney School of Art and evening classes at Regent Street Polytechnic. Passionate about drawing since childhood, she married the art and antiques dealer Jacob

Agnes Miller Parker, wood engraving for *The Return of the Native* by Thomas Hardy, 1942. As wood engravers, women worked on relatively equal terms with men, their work popular with both public and publishers. Miller Parker's best work included illustrations for *Aesop's Fables* and the novels of Thomas Hardy.

Mendelson, thereby gaining first-hand access to works by artists, including Walter Sickert, Jacob Epstein and Jacob Kramer. Eventually feeling exploited by working long hours in his shop she divorced him in 1928. She later embarked on a relationship with the artist David Bomberg, whom she met at Borough Polytechnic, marrying him in 1941. She was among the founder members of the Borough Group, centred around Bomberg, which lasted from 1946 until 1951.

Holt believed in Bomberg's ideas and never regretted prioritizing his career through the financial and emotional support she provided. Men like Bomberg, it seemed, who had suffered in the trenches in the First World War, needed a special kind of nurture. He

died, penniless and unappreciated by the art market in 1957, although Helen Lessore had been trying to persuade him to exhibit with her before his death and Winifred Nicholson had also tried to help. Holt reverted to her maiden name and continued to paint while working tirelessly to promote Bomberg's legacy; on both counts her work matters. She rescued his early pieces from storage where they had lain since 1914, helped in her efforts by her daughter from her first marriage Dinora, who also became an artist.

Bomberg often treated women dismissively, despite their loyalty to his then-unfashionable ideas. His former student Edna Mann was thrown out of the Royal College of Art (RCA), where Bomberg's ideas were unpopular with the tutors, losing her scholarship money by

Lilian Holt, *Nude*, 1947. Oil on board. Bomberg believed artists should be totally immersed in a scene, like actors inhabiting a part, recording the mood of a place beyond its topography and mere appearance. He influenced Lilian's work but hers was excellent in its own right; she had always been an excellent draughtswoman.

insisting on continuing to belong to the Borough Group; ironically Bomberg asked her to resign from the group after she became pregnant for a second time. She continued to paint and exhibit regardless. He disapproved of women artists being mothers, something he considered 'unprofessional', although he was delighted to have a daughter, Diana, with Lilian in 1935. Having children proved no impediment to Holt becoming an accomplished painter.

Dorothy Mead, like her friend Lilian Holt, was another neglected but excellent artist. She studied at the City Lit and at Borough Polytechnic under Bomberg, and eventually went to the Slade as a mature student in the late 1950s, becoming the first woman president of the annual exhibiting society. A radical feminist, as well as a well-respected artist – with perhaps a better reputation abroad than at home – she always said she would have succeeded much better if she had not been a woman.

Edna Mann, *Flowers in Vase*, c. 1950. Oil on board.

Dorothy Mead, *Portrait of Dinora*, 1947. Oil on board.

A very different group of women – Nancy Sharp (later Spender), Nicolette Macnamara and Elinor Bellingham-Smith – arguably led easier lives, married to fellow Slade students who made good, continuing to paint with varying degrees of success. Nancy Sharp came from a conventional family, the daughter of a doctor. Sharp both by name and by nature, she did not intend to let marriage or the birth of her children disrupt her painting or her bohemian lifestyle. Her first husband was William Coldstream and they had two children together. Before her marriage she shared a studio with author and artist Nicolette Macnamara who went on to marry fellow student Anthony Devas. (Macnamara's sister Caitlin later married Dylan Thomas.) In her memoir of her early life, *Two Flamboyant Fathers*,[2] Macnamara wrote of Sharp: 'Nancy was a long-legged bouncing girl with a lively intelligence who seemed to carry the zest of her native Bude sea breezes in her blood.... We lived in squalor. The beds were like old dog baskets. Our dirty washing and laundry piled up in a corner for weeks.... We were terribly happy.'

London was a good place to attend parties even if you were poor, and Macnamara had an entrée to Bloomsbury through her family.

Once Nancy Sharp was married to Coldstream and living in Hampstead, the group looked for support from another Slade friend, Elsie Few. Few was an heiress from the West Indies who decided early on to devote her life to prioritizing the career of her husband Claude Rogers, a member of the Euston Road School of painters. In the early days the Rogers' always had more money than the Devases and the Coldstreams and often bailed them out financially. The partying fizzled out among the group when they had no money for alcohol; Sharp provided meals for Coldstream's male friends and was annoyed when return invitations would come back just addressed to him. The couple had a tempestuous relationship; once, when Coldstream needed a canvas, he painted over one of hers, illustrating the casual attitude some men had to their wives' work.

Both William Coldstream and Nancy Sharp painted in the figurative, realist manner encouraged by the Slade. At first, somewhat reluctantly, Sharp let her career take second place to his, but she exhibited with the London Group and at the Royal Academy (RA), using her maiden name. Coldsteam became distracted from painting when he began working at the GPO film unit with W. H. Auden; apparently it was Sharp who rescued his portrait of Auden that he would have otherwise discarded and encouraged him to continue working as a painter. Auden, a homosexual, jokingly considered having an affair with her, 'but just in time I remembered that all women are destructive'. He encouraged her affair with his fellow poet Louis MacNeice, on the grounds it was 'keeping Nancy happy while Bill got on with his painting'.[3] Auden didn't take her painting seriously either, although he was aware she designed covers for some of Benjamin Britten's sheet music.

The war disrupted work patterns for women artists and left many in financial hardship. Sharp divorced Coldstream in 1939, after she met and fell in love with Michael Spender, an explorer and RAF squadron leader, the brother of the photographer and artist Humphrey and the poet Stephen Spender. They married in 1943 and had a son. Leaving her children with her mother, Sharp enlisted as an ambulance driver, working courageously through the Blitz. Following Michael Spender's death in a plane crash in May 1945, she became an art teacher through

Nancy Sharp, *Portrait of Louis MacNeice*, c. 1936. Oil on canvas. Sharp went to the Outer Hebrides with MacNeice and illustrated his 1938 book *I Crossed the Minch*, along with his second book of poems, *Zoo*. She became something of a muse for him, the catalyst for some of his best love poems.

necessity and her painting career slipped through her fingers. It was only after retiring that she took up painting again seriously, undeterred by lack of commercial success. Her portrait of Trevor Huddleston is in the National Portrait Gallery, while that of architectural historian Sir John Summerson, with whom she had a sustained relationship after the war, hangs in the Sir John Soane's Museum in London.

Perhaps Sharp's decision to stick with a realist and figurative style was also unhelpful to her career, although it didn't seem to impede those of the male artists who became tutors, or in the case of Coldstream, principal at the Slade. An important retrospective exhibition of Euston Road School painters organized by the Arts Council that toured Britain in 1948–49 omitted all the women artists who had been members of the group, including Elsie Few, Sylvia Melland and Thelma Hulbert.

Thelma Hulbert had not benefited from a formal art education but was a great friend of Victor Pasmore and had worked as a secretary at the Euston Road School, picking up teaching jobs through Henry Moore's wife Irina Radetsky at St Albans School of Art and Craft, then at Camden School for Girls and the Central School of Arts and Crafts. An inspiring teacher, she exhibited at the Leicester Galleries, and had a one woman show at the Whitechapel Gallery in 1962.

Sylvia Melland studied at Manchester School of Art and the Byam Shaw School of Art in London before arriving at the Euston Road School as a mature student in 1937–39, turning her for a period into a strongly realist painter. Pre-war exhibitions provided money for travel across Europe and she returned to her previous imaginative and lyrical style. She studied printmaking as a way of meeting other artists and escaping domesticity, making work that became increasingly abstract towards the end of the 1950s, joining the Munich Group of Printmakers in 1961.

Nicolette Macnamara[4] was one of the most colourful of the former Slade students of the period. Part of the aristocracy of Bohemia, she was the eldest daughter of an eccentric landed Irish family who had fallen on relatively hard times. Abandoned by her father, she had become part of Augustus John's entourage at Fryern Court in Dorset, where the young people ran wild and semi-naked, communing with nature, and there was little formal education but a lot of fun.

Many of the students at the Slade came from more conventional homes than hers and were excited about breaking rules that she had never known existed. She in turn ignored their bourgeois rules of social etiquette. She described the courtship displays on the main steps at the Slade, which sound more predatory than the relationships formed at the RCA: 'There was a proportion of a quarter men to three quarters women. Those women who had asserted a priority for the "pecking order" with the men formed a privileged coterie and the competition was ruthlessly

primitive.'[5] Her husband-to-be among the fellow students was Anthony Devas, who like her was still only sixteen; while other students were impressed by her family connections with Augustus John and Stanley Spencer, Devas didn't yet know who they were.

Macnamara made painting her career for some time after leaving art school. 'In later years I was bewildered by those students who had never shown any talent at the Slade', she wrote, 'and after they left made a success of their talent. And equally bewildered by those so full of promise and who failed.' She and Anthony thought that talent was less important than drive, discipline, character and determination to exploit what gifts you had. She had no time for those who complained of being hampered by a job, marriage or children and thought the creative urge should take priority over everything else. Often critical of the wild behaviour of her sister Caitlin and Dylan Thomas, she claimed 'the untidiness inside me was tidied up in my painting'. After 1945, it was her own choice to take up writing rather than continuing to paint. Her marriage survived until Anthony died in 1958. She married another fellow Slade student, the painter Rupert Shephard; their house in Chelsea became a gathering place for artists where the traditions of upper-class bohemianism would be maintained.

Her great friend Elinor Bellingham-Smith[6] was a much more serious painter, the daughter of a London surgeon who had collected paintings. She had studied at the Royal College of Music and given up ballet dancing after an injury, before deciding to transfer to the Slade, where she was older and wiser than Nicolette and saved her from the squalor of lodging with Nancy Sharp. In return Nicolette introduced her to Fryern Court – Elinor was very keen to be part of the 'right set' and indeed on forming her own. With a good sense of humour, she was attractive and fun – 'in moments of exuberance she would turn a cartwheel on the Slade lawn'. She soon netted the romantic-looking half-Spanish Rodrigo Moynihan and they married in 1931 when Elinor was already pregnant with their son John, borrowing Nancy Sharp's wedding ring for the ceremony. Despite motherhood, Elinor was serious about her painting; fortunately, they could afford a governess for John as well as a cleaning lady. She mostly painted landscapes and children, often making painting trips to East Anglia and the Fens, as well as doing illustrations for Faber & Faber, *Harper's Bazaar* and later for Shell.

Elinor Bellingham-Smith, *Low Tide, Putney, c.* late 1940s. Oil on canvas.

All her friends from the Slade demonstrated in the anti-fascist marches in London as the 1930s progressed. Their relationships tended to be stormy. Nicolette Macnamara had an affair with Moynihan that was interrupted by the war but Elinor's marriage survived for another twenty-five years.

Bellingham-Smith was very friendly with Daphne Charlton, an ex-Slade student who was now one of the Hampstead set and who was having an open affair with Stanley Spencer, who already had his two 'wives', Hilda Carline and Patricia Preece. Their social circle accepted this liaison with amusement and little comment – her husband George Charlton was a tutor at the Slade and kept his head down out of trouble.

The confident and predatory Charlton had previously been one of Spencer's students and he painted a portrait of her in a fetching hat. On one occasion Bellingham-Smith and Moynihan saved Spencer from being beaten up by drunken Canadian soldiers on the tube – they thought he looked 'queer', with his long hair and floppy fringe. No one else came to their assistance and Bellingham-Smith staved off their

assaults on Spencer with her handbag. Charlton could be amusingly rude about Spencer when they both stayed with the Moynihans on their way to or from Cookham.

Another of their group at this time was Anne Olivier Popham – always known as Olivier – who was one of the first intake of art history students at the Courtauld Institute. During the Second World War she worked to prevent Nazi thefts of works of art and to protect the National Gallery collection from bomb damage. Rodrigo Moynihan painted a portrait of her looking 'pensive and stoical' as did her lover and first fiancé, the South African painter and journalist Graham Bell, whose portrait of her is in the Tate Collection. Graham Bell died in an air crash during the war and Olivier went on to marry Quentin Bell, Vanessa Bell's son, in 1952. She helped Bell research his biography of Virginia Woolf and herself edited the five volumes of Woolf's diaries, becoming deeply involved in saving Charleston Farmhouse for the nation and in the preservation of the legacy of the Bloomsbury set. The work she and her colleagues did during the war to prevent art being stolen by the Nazis and to return works to their rightful owners was memorialized in the film *The Monuments Men,* directed by George Clooney in 2014.

In 1951 the Festival of Britain commissioned sixty artists to make large paintings that were to be distributed to public buildings, including schools, libraries and hospitals, awarding five prizes to the works it judged the best. Elinor Bellingham-Smith's painting, *The Island,* won second prize. Well-known author and critic David Sylvester wrote that she was 'one of those English landscape painters who paint the weather... an equivalent on canvas of her experience of being alone in a flat country under a great canopy of sky.' Other reviewers described her work in terms of its lyrical elegance, commenting on its enjoyable melancholy; the public found it adventurous and unusual. In 2008 Grayson Perry chose *The Island* from the Arts Council Collection for the exhibition 'Unpopular Culture' that he curated at the De La Warr Pavilion. The exhibition showed work from a time before British Art became fashionable – work that was often poetic and understated rather than what Perry, in the press release, called 'shouty advertisements for concepts or personalities'. Bellingham-Smith's paintings sold well through exhibitions at the Leicester Galleries, as well as to fellow artists, including Prunella Clough and Elisabeth Frink, and to the writers Elizabeth Smart and Elizabeth Taylor.

Situated within a few minutes' walk of the Chelsea Arts Club, the Moynihans' house became an informal artists' salon; Rodrigo Moynihan was part of a very all-male gang of RCA tutors and became Professor of Painting there from 1948. The notoriously conventional Alfred Munnings, who became president of the RA in 1948, also visited and was an admirer of Bellingham-Smith's work. Moynihan himself was caught up with his teaching and doing society portraits – in 1946 he painted the young Princess Elizabeth, a commission that necessitated several royal visits to the house for sittings, causing gawping bystanders to gather outside. Elinor had to provide hospitality to the Queen Mother, who thought she was a housekeeper of some kind, but she took this sort of thing in her stride.

The Moynihans were habitués of Muriel Belcher's private drinking club the Colony Room in Dean Street, Soho, where they paid for generous rounds of gin and tonic. Founded in 1948, the club was frequented by London's sexual and artistic demi-monde, including Francis Bacon, Lucian Freud, model and bon viveur Henrietta Moraes, novelist Christopher Isherwood and jazz singer and painter George Melly. Bacon said he respected Bellingham-Smith's painting, and she also gained a reputation for her clever pornographic drawings. A painting of her by Lucian Freud portrays her looking haggard. She was a close confidante of the painter and illustrator John Minton but they fell out when she had a liaison with one of his coterie of beautiful young male friends.

As the 1950s progressed, both Moynihan and Bellingham-Smith experimented with abstraction, but their marriage was under strain. The bibulous Scottish artists Robert Colquhoun and Robert MacBryde were particularly supportive after the breakdown of the Moynihans' marriage – Elinor was eventually worn down by Rodrigo's infidelities, including his infatuation with Henrietta Moraes; they separated in 1957 and divorced in 1960. After a failed attempt to kill herself, Bellingham-Smith left London for Suffolk, where she continued to paint landscapes until her death in 1988.

The stories of bohemian loucheness that surround Bellingham-Smith's early life are hard to reconcile with her calm landscapes peopled with slightly mysterious groups of figures, many presumably painted under the influence of terrible hangovers. Her grandson remembers Elinor as a rather wacky grandmother, still very physical with a strong

Mary Adshead, *Portrait of Daphne Charlton*, c. 1935. Oil on canvas. Adshead's portrait probably gives a more accurate impression of Daphne than Spencer's pictures of her made four years later, in which she wears an elaborate hat, including a rose and black veil.

Enid Marx, *Clowns*, 1927. Pen and ink, pencil and watercolour.

grip and always painting in her living room at an easel. Although she remained prolific, the quality of her work had probably peaked by 1960.

Mary Adshead studied at the Slade a little later than Macnamara, Sharp and Bellingham-Smith, and was a contemporary of Rex Whistler. She maintained a disciplined professionalism in combining her work with marriage and the bringing up of three children. It helped that her father was an architect and town planner and her husband was the painter Stephen Bone, son of the war artist and supporter of young artists, Muirhead Bone. Stephen Bone's more painterly work went out of fashion faster than hers, but they were both part of the established London art scene.

Adshead found her chief success as a mural painter. Her first commission in 1921 for Shadwell Boys Club in Wapping, was arranged by Henry Tonks and she executed it together with Rex Whistler, who went on to paint the famous mural in the Tate Britain Restaurant. More

commissions followed: for Bank Station on the London Underground (subsequently lost); for Lord Beaverbrook's Newmarket house; for the auditorium on Victoria Pier in Colwyn Bay, together with Eric Ravilious, in 1934; and for Oliver Hill's British Pavilion at the World Fair in Paris in 1937. Thanks to the unflagging support of Kenneth Clark, she was able to continue making murals throughout the war; one she completed in 1950 for the fourth-floor restaurant at Selfridges was destroyed in 1967.

What of the women at the RCA during the 1920s, a period their former tutor Paul Nash recalled as being 'remarkable for an outbreak of talent'? RCA students were far less aware of European artistic developments than Slade students[7] and many found alternatives to painting. One exception, Enid Marx, from a cosmopolitan Hampstead background, failed her diploma, refusing to conform to the required realism of the tail end of the Arts and Crafts movement – Eric Ravilious proved her ally in continuing her RCA education by proxy, passing on what he had learnt and sneaking her into the engraving room after hours. With many enthusiasms in common they trawled East End bookshops and Benjamin Pollock's Toy Shop to find good children's books and patterned papers, and learned from watching women hand-colouring printed sheets.

Marx painted but had always known she wanted to be a designer. Her work was very experimental; her diploma piece showed her interest in cubism and her designs have been described as 'more jazzy, risk-taking and lively than those of her male friends'.[8] Her first job was at Barron and Larcher fabric designers in Hampstead as an apprentice and she soon had her own primitive studio nearby, making her own block-printed designs. Mostly abstract and geometric, these soon became sought after at the Little Gallery and Dunbar Hay, and were used by publishers including Chatto & Windus and the Curwen Press, and later by London Transport and Shell. She always felt she was held back by being a woman, but her career developed steadily, aided by her long collaboration with her partner Margaret Lambert on books and exhibitions about 'folk art'.[9] In the 1950s she had an exhibition in Rye with potter Katherine Pleydell-Bouverie and Trekkie Ritchie Parsons, Leonard Woolf's lover after the death of his wife Virginia; Leonard gave Marx a Siamese kitten.

Two more female RCA alumni who married fellow students and settled in London were Claudia Guercio and Edna Ginesi. Ginesi had

Edna Ginesi, *Encounter at Queens Square Crawley*, 1963. Oil on canvas. The picture shows a traditional figurative painter moving with the times and painting a New Town development.

met Raymond Coxon at Leeds College of Art and they married in 1926 after leaving the RCA, where they had been part of the self-confident 'Leeds Group', along with Henry Moore and Barbara Hepworth, and Phyllis Dodd, who had studied first at Liverpool School of Art. Moore had been in love with 'Gin' (Ginesi's nickname) since they met at college in Leeds in 1921, but she and Coxon were already engaged and they all remained friends. Ginesi won a West Riding Travel Scholarship to Italy, as Hepworth did, and was a member of Lucy Wertheim's Twenties Group; she exhibited with the London Group and had a one-woman show at Zwemmer Gallery in 1932. She taught at Chelsea School of Art part-time and made designs for the Camargo ballet and theatrical groups. Illustrator Michael Parkin wrote of Ginesi and Coxon that 'they boasted a resilience and bluntness that epitomizes the friendliness of the North...Gin's influence on Raymond was as strong as his love; a good painter herself, she was always prepared to push him forward to his advantage.'[10] She died three years after him, in 2000.

The marriage of Enid Marx's friends Claudia Guercio and Barnett Freedman was a secret at first – Freedman was an East End Jew of Russian extraction and Guercio was a High Church Anglican, although

Edna Ginesi, Henry Moore and Barbara Hepworth in Paris, 1922.
Photograph by Raymond Coxon.

her parents' concern was mostly about Freedman's earning capacity.
Guercio's father was Sicilian, an exporter of citrus fruit to Merseyside,
and her mother came from a shipmaster's family in Brixham, Devon;
she was born in Liverpool but spent much of her childhood in Sicily.
Guercio's work was well respected enough for her to be invited to illus-
trate *A Snowdrop*, a poem by Walter de la Mare, part of the Ariel Poems
series of pamphlets published by Faber & Faber and illustrated by artists,
including Paul Nash, Eric Ravilious, Gertrude Hermes, Celia Fiennes,
Althea Willoughby, David Jones, Eric Gill and Barnett Freedman. Other
projects included vignettes for Cochrane's *Review of Reviews*, Shell

Claudia Guercio, Shell Valentine drawings, 1938. Shell Valentines could be thought a kind
of popular art, and are now collected as examples of twentieth-century advertising art.

Valentines and cartouches for Shell newspaper advertisements, as well
as floral greetings cards for the Post Office.

Guercio's work was overshadowed by her husband's but they some-
times worked on books together – she contributed title page designs
and decorated endpapers. Freedman designed a decorative alphabet for
Baynard Press in 1935 named after her, Baynard Claudia – a lithographic
font, it was never cast in metal type. In 1939 Guercio was commissioned
to make another font, Baynard Flora, with initial letters infilled with floral
decoration, something that became one of her specialities after the war.
She worked happily on the kitchen table, along with a tea tray and a
pet rabbit.

Illustration work was hard to get during and after the war. Despite
Freedman's success they had never been really well off, but both
considered themselves serious graphic artists; when he died in 1958,

'commercial art' had become a term that was rarely used, its slightly derogatory ring a thing of the past. By the extraordinary quality of the work he produced and his own high standards, Freedman had greatly increased the fee that designers could now expect. He would have been the first to say that it was all art. There were excellent painters in the RCA Painting School, but it was often those from the Design School who made their names.

Henry Moore's wife Irina Radetsky was an RCA student not long after arriving in London from Paris. Born in Kiev, Ukraine, she had been abandoned on the streets as a six-year-old when her mother fled from the Russian Revolution. Seemingly aloof, some said she had reacted to childhood starvation by becoming more voluptuous. She soon caught the attention of Henry Moore; she was his model in the early days of their marriage but soon got caught up in his 'empire', as his master printer Stanley Jones used to call it. Her daughter recalls she would sometimes say she had sacrificed everything for art, but believed her parents complemented each other completely – Moore gregarious and charismatic and Radetsky more solitary and 'entirely the moon to my father's sun'.[11] He always relied on her good judgment and criticism.

Phyllis Dodd married the dashing Scottish painter Douglas Percy Bliss. She specialized in strong, perceptive portraiture after graduating and settled in London before Bliss became Director of Glasgow School of Art in 1928, prompting a move to that city, where they remained for many years. She also made highly competent etchings. It was Dodd who persuaded Bliss to take up painting again after decades of critical and illustration work. Dodd's mother had made a point of telling husband-to-be that her daughter must be able to continue to paint after marriage.

Frances Clayton left the RCA in 1925 after specializing in tempera and mural painting; she came from a Potteries family and had trained at Burslem School of Art. Like many of her generation, including Winifred Knights, she admired early Italian painters and continued to work in tempera on a small scale. At the RCA she met and later married the Welsh artist Ceri Richards. Afterwards she became a part-time teacher at both Camberwell School (later College) of Art and Chelsea School of Art. Her work was less influenced by her husband than by William Blake and her friend and contemporary David Jones, whom she corresponded

Phyllis Dodd, *Bath in the Nursery*, *c.* 1935. Oil. This warm study shows perhaps how seductive domesticity could be. Both Dodd and her partner Douglas Percy Bliss were fine painters with different styles, occasionally sharing the work on details of a painting together.

with and continued to visit until his death. Clayton and Richards greatly respected and supported each other's work, and both were inspired by poetry. Clayton's work was characterized by a transforming, visionary modernism and she was completely assured in the rightness of what she was doing, a self-belief confirmed by her sell-out exhibitions. Art historian and author Mel Gooding, who became her son-in-law, has written that 'for over fifty years her own quiet formalized figurative art was unaffected by her daily closeness to the extravagant and some-times violent drama of Richards' painting.... She had a marvellous visual insight and a formidable intelligence. She had no doubts as to Richards' genius and a precise understanding of its nature.'[12]

She made drawings for Arthur Rimbaud's *Les Illuminations* (1973–75) for Curwen Studio and for *The Revelation of Saint John the Divine* (1931) for Faber & Faber, a project commissioned by T. S. Eliot. She exhib-ited frequently using quiet and unfashionable media – tempera and

Frances Clayton, *Angels on the Mountaintop*, c. 1943. Her haunting monoprints are expressive but not personal, something more deeply existential – the long path, the lonely path, rooted perhaps in her passion for Blake. Her stitched pictures were like none made before.

extraordinary collaged, embroidered pictures – at the Redfern, Hanover and Leicester Galleries in London. Not part of the Hampstead set championed by Herbert Read, she and Ceri Richards were friends with Victor and Wendy Pasmore, Elinor Bellingham-Smith, Edna Ginesi, William Scott, Julian Trevelyan and Mary Fedden. Patrick Heron and Francis Bacon greatly admired her work.

Another mutually supportive couple were the Martins. Mary Balmford studied at Goldsmiths and then at the RCA from 1929 to 1932, where she met and married fellow student Kenneth Martin in 1930. Their names and work are usually linked as they discussed ideas and worked towards abstraction together. Even her first major exhibition was a joint one with her husband at Heffers Gallery in Cambridge in 1954. Their work was notably different from each other's, however, even though both were inspired by the same utopian aims of 1930s

modernism, fed via their friendships with ex-Bauhaus students such as Max Brill and international links stretching back to Theo van Doesburg.

It was a relationship of equals and Kenneth Martin was happy to describe his wife's work as better than his. They had two sons born in 1944 and 1946. They believed in democratic accessibility and used work-aday modern materials: concrete, steel and plaster, as well as the new industrially produced hybrids Formica, Perspex, plywood and hardboard. They believed that designs based on mathematics and the golden section introduced balance and order into modern domestic life; as Mary put it, 'the end is always to achieve simplicity'.[13] They, too, were friends with the painter Victor Pasmore, with whom they had been associated in the Euston Road School and London Group in the 1930s.

During the Cold War it was harder to find out about constructivism and Mary called her work 'constructive abstract art'. She painted her first abstract painting in 1950, eventually abandoning painting completely to work with reliefs and constructions. She exhibited in the 'This is Tomorrow' exhibition at the Whitechapel Gallery in 1956,[14] in 'Konkrete Kunst' ('Concrete Art') in Zurich in 1960 and in 'Experiment in Constructie' ('Experiment in Construction') at the Stedelijk Museum in Amsterdam in 1962. She died in London in 1969, the same year she was joint winner with Richard Hamilton of the John Moores Painting Prize at the Walker Art Gallery, Liverpool.

Opposite Mary Martin, maquette for 'This is Tomorrow', 1956. Hardboard and wood, painted.

Chapter 15

THREE SALUTARY TALES
careers and conflicts

This chapter is about three very different women: Diana Low, Kathleen Hale and Isabel Rawsthorne; none of them married fellow artists, but the circumstances of their partners' lives profoundly affected their careers.

Diana Low was a highly talented painter, an upper-middle class girl whose career, despite an auspicious beginning, suffered later through her geographical isolation. Her story is typical in pointing up the difficult choices faced by women who want to pursue an artistic career but who fall in love and decide to start a family. Born in London into a wealthy family, she was taught by Charlotte Epton at Cheltenham Ladies' College and then studied in Paris before attending the Slade.

Competence in art was common among women of her class in that more leisured age. The Slade was full of middle-class girls whose mothers painted landscapes, flower-pieces and still lifes – Low's mother, married to a surgeon, painted very good watercolours that she exhibited and sold to discerning patrons, and she was happy for her daughter to study art. Such tacit support may have been unfortunate, however, for those who faced opposition often broke free and ran wild, with interesting results. Low's revolt was of a slightly different order. Her mother commissioned the established painter William Nicholson to paint her four children – including a portrait of Diana and her sister Margaret in 1926 and one of Diana on her own in 1933. When she was twenty, Nicholson suggested he gave Low tuition; despite the forty-year age difference between them they soon began a relationship, allowing her to escape the restrictions of the dark, bourgeois family home in Harley Street for 'sittings' at which she acted as both lover and pupil. Nicholson's tuition had a highly beneficial effect on her painting, in contrast to Henry Tonks's regime of life drawing using HB pencils, with charcoal forbidden in case it made a 'bad' drawing look better, persuading her to leave the Slade prematurely.

Much more of a painter than a draughtsman, Low made a portrait of Nicholson that was long in gestation and remained unfinished until 1936; it shows the artist lying reading in a cream shirt and trousers on a cream sofa, and now hangs in Wolverhampton Art Gallery.

In 1934, aged twenty-three, she rushed into a marriage with Richard Clissold Tuely, an architecture student two years older than herself, whom she met at the Architectural Association where her sister was studying. In what might have been a bid to escape the confines of her family, they eloped without their parents' blessing. Low's father, who considered Tuely feckless and impractical, had suggested waiting a year and didn't speak to him again after the marriage, a standoff that continued until Tuely's death. After two or three years of married life in London, Tuely decided to abandon architecture and become a farmer. An artist friend of Low's suggested that Romney Marsh in Kent would be a good place to live and paint. They bought a farm complete with apple orchards and a primitive Georgian farmhouse, where Low eventually had a studio. Although she exhibited textiles at the 1937 World's Fair in Paris, her artistic ambitions were somewhat overwhelmed by the demands of raising three children in wartime.

Nevertheless, she carried on painting, now concentrating mostly on landscapes, selling work to friends and through the Rye and Tenterden

Diana Low, *Street Scene in Loches*, 1948. Oil on board.

Galleries, as well as to the New English Art Club (NEAC) and through the Royal Academy Summer Exhibition in London. One or two pieces were accepted by the fashionable Leicester Galleries. Her husband was supportive of her work and rather proud of her previous relationship with Nicholson, even tolerating her later affair with Eric Ravilious; as a former pupil of Edward Bawden's wife Charlotte Epton, Low had visited Brick House while Ravilious was there and begun a short affair with him, which was revived again before the war; according to Tirzah Garwood, her free brushwork and strong colours influenced his work for a period.

Low was a very good painter in oils and would have liked to do more portraits, but she was no longer moving in the right circles for opportunities to occur. Her sister Margaret had married Humphrey Spender in 1937 and had an architectural practice, but she died in 1945 from Hodgkin disease. The chances for meeting up with other contemporary artists and discussing ideas of the day just weren't there in their rural location. Going out on painting expeditions with local artists didn't appeal to her. Her work, still influenced by Nicholson, was good but beginning to look rather old-fashioned. An oil sketch she did of Loches in France while on holiday in 1948 looks surprisingly timeless, considering the war was still a recent memory. William Nicholson, who died in 1949, was often criticized for producing work that appeared to be 'outside history'; his son Ben liked to imply that he was just an amateur compared with Ben's own revolutionary modernity, and these views were becoming more and more dominant.

None of us gets to see the results of the paths not taken in life. It is difficult to know, therefore, to what extent Low sleepwalked into obscurity, or whether it was her own choice, through lack of confidence in facing the cut and thrust of other artists' comments. After the war there was no serious market for small tasteful oil paintings done in the English style. There had been a suggestion that she should be apprenticed to Ben Nicholson, but it was soon very obvious they didn't get on.

Before the war, like so many others, she had hand-printed linocut designs onto fabric, making them up into clothes; she knew Nancy Nicholson (see page 247) and they shared a stall selling their fabrics briefly at Central Hall Westminster. She exhibited at the Little Gallery and there was an article about her in *The Studio* magazine, but coming from a background where women weren't expected to work she had

absolutely no experience of how to go about getting a job or setting her design work on a more professional footing. Later it was suggested she might work for the John Lewis store but the logistics of commuting from Kent as the mother of three young children were prohibitive; their apple-growing business meant there was no question of moving back into town. After the war when the children were grown she thought about a career designing wallpapers, but without proper advice it all came to nothing. She went to Hastings School of Art to learn lithography and hired someone to come and help her set up a press at home, but lithography is best done with assistants in a professional studio. In the 1960s she adopted a more contemporary style of painting – landscapes with figures and beachscapes around Rye – which were exhibited and sold; she died in 1975 with possibly some regrets as to how things turned out for her work.

Kathleen Hale is a different case study, a painter who turned into a reluctant illustrator, partly by accident and again because of her own choice in approaching marriage and motherhood. Her career is recounted at some length because it exemplifies many of the topics discussed in earlier chapters.

Hale was a rebel from her youth and cropped her long hair short in a bob like Dora Carrington and Dorothy Brett while still at school. Of the same generation as Hilda Carline (but not a Slade girl) she had to forge her own path. Born into a wealthy professional family who fell on hard times, sending her off to relatives who enforced a strict religious regime, she had good reasons for running a little wild. She went to Manchester School of Art, where she was a contemporary of L. S. Lowry, before taking up a scholarship at University College, Reading. At Manchester, women were allowed to draw from male models, and tutor Pierre Adolphe Valette, who had known the impressionists, was insistent on the importance of painting *en plein air*. After Hale's experience at Manchester, Reading felt stuffy and disappointing and she couldn't wait to escape to London and be independent; in 1917 she found a job with the Ministry of Food.

Her boarding house near Baker Street included a colourful collection of prostitutes and artists' models who introduced her to the Café Royal set, where the reigning beauties included Betty 'Tiger Woman' May. At the Studio Club she became romantically entangled with a

young artist called Frank Potter who had decorated the walls there with murals in 1914. Her first art commission was a theatre poster for a musical. In her spare time she drew London street scenes, people in cafés and the animals at Regent's Park Zoo, all valuable research for her later life as an illustrator. She survived in a series of rackety lodgings, 'carapaced in suburban virginity' as she put it, until as a pacifist she joined the Land Army in 1918, working for a year in a market garden near Hammersmith where she enjoyed working with the carthorses.

Back from the war, Frank Potter continued her education, taking her to see post-impressionist work and the Chinese T'ang horses and Tanagra figures at the British Museum. Ten years older than her, his war service provided him with a post-war scholarship to the Slade, where he had an interesting take on some of his fellow students, whom he described as 'young Ladies, many of whom were sent to the Slade only for a final gloss on their education. These girls lived with "Mummy and Daddy", had plenty of pocket money, four good meals a day and regular hot baths'.[1] Potter was still forced to live with his parents in Islington, then very different from the gentrified area it is today. After a year they became lovers, but Hale wasn't ready for marriage. A friend from the Studio Club found her work designing book jackets for W. H. Smith. It was at the Studio Club that she met Augustus John and was offered the job of being his secretary, with a room in his Chelsea house thrown in. Excited by the chaotic abandon of their lifestyle she became entranced with Dorelia, and Augustus – with whom she had much innocent fun and one experimental session of sex. At their country home she enjoyed the close contact with all their animals – ponies, donkeys and cats, including a Siamese that was then a novelty in England.

After eighteen months, Hale left London to join Potter in the French port of Etaples, a popular location for impecunious artists, where they shared a studio and paid grateful locals who posed as models. W. H. Smith sent work to her by post. The cracks in their affectionate relationship became clear when someone suggested her artistic success was undermining Potter's fragile state of mental health; in fact, he was still suffering from shell shock. Encouraged by Augustus John, she exhibited her folio of French drawings at the NEAC, where they sold well. She moved back to Fitzrovia – Omega Workshops territory – where she did some marbling designs for interiors; Duncan Grant was very helpful,

teaching her colour mixing, and she decorated the walls of the Wembley Exhibition Centre with Nina Hamnett and a group of Slade girls. She was introduced to Richard Carline and met the Nash brothers at one of his parties, alongside 'scientists and a happy sprinkling of eccentrics'.[2]

She knew she wanted a real family, with children and a steady father figure for them, to make up for her own fatherless, unhappy childhood. When she met the young medic Douglas Maclean, a socialist intellectual, she realized she'd found what she was looking for. Love came later, after their marriage in 1926, Maclean's father becoming the father she longed for herself. Douglas never stopped her from working; as she put it, he was just 'a very moderate man'. They kept their working lives separate but many of her friends thought she had made a wrong move and some now faded from her life. One told her, 'When you married your light went out.'[3]

Inspired by Alexander Calder, she began making metal mobiles and three-dimensional pictures, selling them at the Lefevre Gallery, where they were very popular. The Leicester Galleries wanted to exhibit them alongside Vanessa Bell's paintings but Bell refused to agree. They sold at Heal's and Fortnum & Mason and were reproduced in *Vogue* and *Picture Post*, but with the outbreak of the Second World War metal became scarce, putting an end to the enterprise. The couple's two sons were born in 1930 and 1933 and the family moved to a large Victorian house in Hertfordshire. It was here she began writing and illustrating the children's books that made her name, based on the character of Orlando the Marmalade Cat. She started the books partly to recreate the sense of a childhood she had never had and also because she wanted to provide comfort to wartime children, many of whom were being uprooted and evacuated from bombed-out streets. She also wanted to produce something that adults would enjoy reading as well.

Noel Carrington, editor at the publisher Country Life, was impressed by Hale's graphic skills. He was becoming hugely influential in the world of illustrated books towards the end of the 1930s and was a passionate advocate of good book design. The brother of Dora Carrington, he was inspired by Soviet children's books brought back from Russia by artists like Pearl Binder and Peggy Angus. At the same time, Geoffrey Smith of W. S. Cowell in Ipswich wanted to develop his lithographic printing works in tandem with a publisher. Autolithography

Top Spread from *Orlando the Marmalade Cat: A Seaside Holiday* by Kathleen Hale (Country Life, 1938). The beach scene of 'Owlbarrow' shows all the principal sights of Aldeburgh in Suffolk.

Above Kathleen Hale, drawing with anthropomorphic figures, *c.* 1930s.

was cheaper than the standard three-colour process, especially if the artists drew their own plates – something for which they were often not paid. The first Orlando books commissioned by Carrington were printed in 1938 and 1939, with a Cowell's artist recreating Hale's illustrations for the first one; after that she drew them herself. The printers at Cowells were helpful and friendly and taught Hale the rudiments of the process. She was supposed to join a union in order to work at the press but as a woman was unable to do so.

Despite her success, Hale was conflicted. 'Though obsessed with Orlando, I was always creating on a lighter level of consciousness than if I had devoted myself to painting, with its despairs and exultations,' she wrote in her autobiography. 'To me painting is deeply fundamental, giving a freedom from all sense of time. This side of me was inevitably starved as I worked on Orlando.'[4] She was commissioned to write an Orlando serial for the British government's propaganda programme, to be sent out to the Middle East in the form of a monthly magazine. Orlando became 'mish-mish', Arabic for 'apricot', as there was no Arabic word for marmalade. At home, the marmalade cat was an institution and she was earning a lot of money, taking the family finances into a super-tax bracket that was not approved of by her socialist husband. During the war she worked at an American hospital near her home, giving art classes and making portraits of the patients that they could send home to their families. Again she felt ambivalent: her carefully painted portraits were folded and crammed into envelopes and yet, like Orlando, they gave such pleasure.

The Orlando books were a document of her life, friends and acquaintances regularly appearing as characters, thinly disguised, with always the slight worry that she would be sued for libel. The setting for *Orlando: His Silver Wedding* (1944) was based on The Pound, Cedric Morris and Arthur Lett-Haines's private art school in Suffolk, where she was a regular visitor; John Skeaping's black marble torso sculpture there was replaced in the book by a stone Madonna-cat and kittens. Aldeburgh became Owlbarrow-on-Sea in *Seaside Holiday* and a neighbour appeared as Mr Cattermole, the owner of the cat's shop. *Orlando: The Frisky Housewife*, published in 1956, is full of social comment about poverty and takes a position against the killing of animals for fashion furs. At one point, Grace the cat says, 'We don't like money – it doesn't smell nice and we can't eat it.'

Hale loved her husband but the strain of their different natures began to take its toll. She had become very friendly with Morris and Lett-Haines when they were neighbours in London and she frequently visited them in Suffolk on her own, feeling herself 'back in the magic world I had to abandon when I married Reason and Moderation'.[5] Among their house-guests she gained a reputation for wild dancing. Her psychotherapist suggested she have an affair to kick herself out of her nervous crisis and kick-start her marriage and, pragmatic as ever, she did so with the bi-sexual Lett-Haines; they always continued to be the best of friends, he remaining devoted to Cedric Morris and she to Douglas Maclean. She continued to write and illustrate Orlando books until 1972 but never stopped painting animals and landscapes, exhibiting at the Whitechapel Open and in a bookshop near Selfridges where her pictures sold well for years. She lived to the age of 101, having published eighteen Orlando books and received an OBE in 1976.

Isabel Rawsthorne[6] always remained a serious painter, but her career has been overshadowed by the great names she associated with, her profile perhaps further obscured by her own frequent changes of surname as she took the names of the three men she married. She was born Isabel Nicholas, the daughter of a merchant seaman in Liverpool, whose early death left the family penniless. Winning a scholarship to the Royal Academy Schools after attending Liverpool School of Art, she found it 'snooty and affected'; she soon ran out of money and left after six months, getting a job modelling for Jacob Epstein, who shared her admiration for Rodin. It was the beginning of a wonderfully bohemian life as a model, mistress and painter in her own right; she recalled that Epstein was actually very strict and that even after she became his lover, she and his daughter had to be home from the Café Royal by 10pm sharp.

She was a striking woman, lithe and feline, with dramatic slanted eyes (there were some Asian genes in her family), and as a model she suggested new forms and structures, but she was also a highly intelligent bon viveur, engaging in philosophical discussion with her partners. After a period as a general dogsbody in Epstein's studio she left for Paris, where she was painted by Derain and Picasso and became a lifelong intimate of Giacometti, one of the inspirations for his long, etiolated figures. In Paris she became interested in ethnography and phenomenology, writing articles herself and becoming involved with

the existentialist group, getting to know Simone de Beauvoir, Jean-Paul Sartre and Georges Bataille as well as becoming friends with Dora Maar. In wartime Britain there was a new interest in the seventeenth-century metaphysical poets Thomas Vaughan, Francis Quarles and John Donne, who inspired Paul Nash, Stanley Spencer and Graham Sutherland, contrasting with the existentialists who saw the world as essentially absurd; influenced by both she developed her own cosmopolitan way of thinking.

Sefton Delmer, a correspondent for the *Daily Express*, fell in love with Epstein's portrait bust of Isabel before he even met her in Paris. They married in 1936 when she was still only twenty-four and travelled together to Spain, where he was reporting on the Spanish Civil War. During the Second World War they both worked for the Political Warfare Executive making 'Black' propaganda, outrageous stories that were broadcast to Germany in order to sap morale. Isabel was a lifelong socialist and remained engaged in political activities into the 1950s. Unsurprisingly, she didn't have much time for artwork until 1945, when she and Delmer parted.

After the war Giacometti became a great influence on British art, inspiring Bacon, Paolozzi and Elisabeth Frink among others. Isabel found herself the main conduit for his ideas in London. Giacometti had been friendly with Winifred Nicholson and Barbara Hepworth and had exhibited in London in 1936, and the leading art patrons Robert and Lisa Sainsbury visited Paris and began collecting his work. In her own work Isabel strived to create a modern form of representational art – a sort of figurative avant-garde, alongside artists she admired like Derain and Balthus, who had resisted being caught up in surrealism or abstraction. Later she met Bacon at Erica Brausen's gallery in London, where they were both exhibiting, and he painted many significant images of her, adding to her reputation in the art world. Her involvement with progressive artists and politics challenged notions of what it meant for a woman to be both a model and an artist; however, her connections with such famous names may have overshadowed her own artistic achievements.

She painted the young dancer Margot Fonteyn, who had been madly in love with the composer and conductor Constant Lambert since he became conductor at Sadler's Wells. However, it was Isabel who married Lambert in 1947, providing her with an introduction to

the innovative world of British dance, where she soon became involved with designing stage sets and costumes. She made designs for Frederick Ashton's controversial ballet *Tiresias*, with its scandalous topless dancers and striking score by Lambert. Tragically, her husband died a month after the ballet opened, in 1951. He had been alcoholic and diabetic for many years; Isabel had accompanied him on champagne sessions at the Colony Room with Dylan Thomas, for weekends at the Sitwells' and to Lord Berners's Faringdon House in Oxfordshire, and to the George in Great Portland Street, which in the 1940s was the equivalent of Les Deux Magots or the Café de Flore in Paris – crowded with intellectuals discussing philosophy and looking for jobs.

With exhibitions at important galleries like the Marlborough and the Hanover, Isabel's work was well respected. She named her artistic credo 'Quintessentialism'. She didn't draw dancers in the way Laura Knight or even Degas did, but with an approach more like Giacometti's, showing an acute interest in form and structure – she saw the skeleton and organs beneath the skin. Her interest in reflections, deceptive appearances and doubles led to her using mirrors and constructing misty refractions, as though everything was seen through water.

After Lambert's death she married his friend the composer Alan Rawsthorne and they moved to a thatched cottage in Essex, near to the Ayrtons, where she lived for the last forty years of her life. Along with many of her generation she was affected by the publication of Rachel Carson's *Silent Spring* in 1962, which led to her growing interest in environmentalism. She loved wildlife and had ponds full of frogs and newts and a garden attracting birds of all kinds. She remained resolutely undomesticated to the end and never wanted to have children – as she put it, 'how could one afford the time?'[7]

While she is often included in exhibitions related to Bacon and Giacometti, a reassessment of her work on its own terms is long overdue, along with that of many other women artists in this book, the circumstances of whose lives have obscured the importance of their own practice.

Chapter 16

IN THE SERVICE OF ART
visions of the muse

The *Oxford English Dictionary* defines a muse as the 'inspiring goddess of a particular poet'. In the context of the mid twentieth century, with the dominance of the life model on the wane, such ideas might seem fanciful; nevertheless, the concept of the female muse was alive and well, played up by the press and enlarged on in Robert Graves's highly influential study of the roots of poetic myth *The White Goddess*, published in 1948. An artist in the act of creation was thought of as possessed by an inspiration beyond his control, a feeling similar to the irrational state caused by love. For the ancient Greeks, poets and artists were just the mouthpieces of the feminine muses, who bestowed the gift of creativity but could also take it away. Far from being passive creatures, the muses were actually the ones with power, connected to the source, bringing about new influences and new ideas.

In 1932, Kenneth Clark had commissioned a 140-piece dinner service of 'celebrated females' – 12 queens, 12 actresses and dancers, 12 'beauties' and 12 writers – with 12 serving dishes decorated with nude goddesses by Duncan Grant and Vanessa Bell. He played all this down in his memoirs as it came to seem too frivolous.[1]

By the 1930s, English artists were more likely to be in love with the landscape than their model, as Ronald Blythe has pointed out in *First Friends*,[2] but in 1948 the admittedly eccentric Graves was still writing that a woman was 'either a muse or nothing.... She must inspire the poets by her womanly presence...impartial, loving, severe, wise'. It is possible he bit off more than he could chew when he met the American writer Laura Riding – this particular goddess was undomesticated and definitely the perpetual 'other woman'. The question of how far Graves's ideas were borne out in his own life has been undermined by his biographers' treatment of his first wife, the artist Nancy Nicholson, whom

on the whole they choose to ignore. Nancy was a woman of 'fierce principle and abundant passion, a probity forged in prickly opposition to hypocrisy of all kinds'.³ Born in 1899, a committed socialist, she was represented by Graves in his memoir *Goodbye to All That* (1929) as an uncompromising feminist, proselytizing for contraception (having had four children in three years herself), equal pay for women and the benefits of goat's milk and a healthy vegetable diet. When they married in 1918, she kept her maiden name, insisting that her two daughters also remained Nicholsons, allowing only the two boys to be named Graves. Her children were encouraged to go barefoot, thought of at the time as a marker of poverty, and she sent them to village schools. She accepted living in a *ménage à trois* with Laura Riding until Riding's attempted suicide in 1929 and Graves's departure with her for Mallorca. After the end of the marriage, Nicholson took sole responsibility for the children. Sadly, it is Riding who most intrigues the biographers.

Meanwhile, in France André Breton flirted with the surrealist idea of the *femme enfant*, an identification of woman and nature dating back to nineteenth-century Romanticism, in which the muse is a passive receptacle of mystery, magic and creativity. Breton, too, ignored the artistic creativity of his second wife, the painter Jacqueline Lamba.

Women surrealist artists chose to emphasize how their experience differed from Breton's, seeing the muse instead as located inside themselves and accessible only to them. Leonora Carrington said in 1983: 'I didn't have time to be anyone's muse...I was too busy rebelling against my family and learning to be an artist.'⁴

As for artists' models, Henrietta Moraes was a life model as well as a painter, the sometime muse of Lucian Freud and Francis Bacon, who worked from pornographic photographs of her by John Deakin. She also modelled for Maggi Hambling, with whom she had a long relationship, both the photographs and the relationship representing very twentieth-century developments.

A very different image of a muse is provided by the aristocratic society hostess Ottoline Morrell, who had an interesting take on the idea. She offered refuge and hospitality to the Bloomsbury set at Garsington Manor, outside Oxford, and was a loyal supporter of artists, poets and novelists, despite the sometimes cruel depictions of her that appeared in subsequent literary works. She excused her own sexual infidelities,

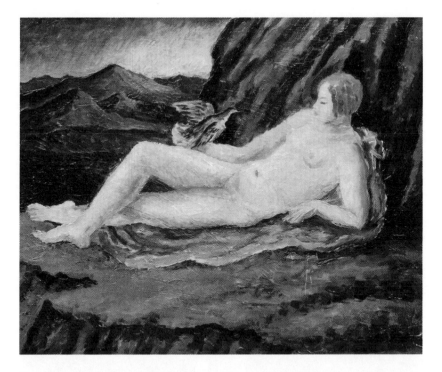

Dora Carrington, *Reclining Nude with a Dove in a Mountainous Landscape (portrait of Henrietta Bingham)*, 1920s. Oil on canvas. In a letter to Alix Strachey, c. 1924, Carrington wrote: 'I am very much more taken with Henrietta than I have been with anyone for a long time. I feel now regret at being such a blasted fool in the past, to stifle so many lusts I had in my youth for various females.'

claiming that 'any physical indiscretion on her part was in the service of Knowledge and Art, one of the minor, unspeakable duties of a muse'.[5]

Being a muse could be inhibiting, tiring and generally vexatious, and the subject of veneration often had little control over how they were perceived. Dora Carrington remained an *idée fixe* for John Nash, who tried in vain for many years to push their relationship beyond intense friendship before he married Christine Kühlenthal. Carrington's fellow Slade student Christopher Nevinson was also infatuated with her. She did eventually find happiness through her relationship with Lytton Strachey, who lived with her and her husband Ralph Partridge – none of the other men around her took her work seriously, for all their stated ideas about freedom, emotional space and progressive relationships. She committed suicide following Strachey's death from cancer in 1932. Mark Gertler was another artist who was preoccupied with her; he

Still from *Blood of a Poet*, 1930. Motion picture by Jean Cocteau. The Poet, played by Enrique Rivero, approaches the Statue, played by Lee Miller. The hideously taxing filming process involved the application of thick white make-up, with Miller's arms strapped down to make her into a Venus de Milo.

killed himself in 1939, partly as a result of his unrequited passion for her, although there were other contributory factors to his death.

Partridge told novelis Rosamond Lehmann that Carrington 'was an obsession to me – once she got into anyone's blood she was ineradicable'.[6] The suggestion was that she courted her air of inaccessibility and that her behaviour was deliberately provocative. She did have affairs with Gerald Brenan and with female partners. She gained an unwelcome celebrity after Gilbert Cannan published his novel *Mendel* (1916) based on the tangle of her relationships, at a time when she really wanted to be left on her own to get on with her own work. She also featured in several other novels of the period by men and women: D. H. Lawrence's *Women in Love* (as Minette Darrington); Wyndham Lewis's *The Apes of God* (as Betty Blythe); Rosamond Lehmann's *The Weather in the Streets* (as

Anna Cory); and Aldous Huxley's *Crome Yellow* (as Mary Bracegirdle). Lawrence predictably said of her: 'she was always hating men, hating all active maleness in a man. She wanted passive maleness'. He caricatured her as the gang-raped Ethel Cane in a short story *None of That*, a kind of revenge for Gertler's death.

Being a muse in the twentieth century did not prevent many of these women acting just like a wife, looking after their men devotedly in the domestic sphere until the end of their lives, as Carrington did with Strachey – even in the most bohemian of settings, women looked after the day-to-day running of life. Roles may have been more equal when women set up with other women.

Lee Miller could arguably be said to be one of the last iconic muses of the twentieth century. Her father, Theodore Miller, an amateur photographer, had been in the habit of taking pictures of his daughter since she was a child, in a way we might now find questionable. However, he had been enlightened enough to give her chemistry sets alongside her brothers and had taught her rudimentary photographic skills. She seemed to have a very comfortable relationship with him and her son Antony Penrose says he was the man in her life she loved the most. For some time she was best known for the images of her taken by Man Ray, for whom she became an obsession. Skilled at turning the tables on men and advancing her own career, Miller took the initiative and became Ray's assistant, learning advanced techniques in photography and inadvertently developing the first 'solarized image'. Ray took the credit for seeing the possibilities to which the process could be put, but at least they ended up working as a partnership; her goal was always to earn her own living independently.

It's an unsettling, and one might say surreal, take on the idea of the artist and his muse to see a photograph taken by Man Ray of his twenty-four-year-old lover curled up naked on her father's lap, a father who was still in the habit of taking pictures of her in the bath.[7] There were iconic photographs of her in *Vogue*, after she was 'discovered' when an editor saved her from being run over in the street; and she was the Statue in Cocteau's surrealist film *Blood of a Poet* in 1930.

Miller was also subjected to the surrealist practice of taking images of women to pieces in order to create startling and violent images. Man Ray used her body parts combined with other objects, her eye on the

metronome in *Object to be Destroyed* (renamed *Indestructible Object*, 1958) alternately destroyed and reappearing, her lips floating over the gardens in *Observatory Time*. Later, her face was reconstructed by Picasso; the artist's biographer John Richardson suggests she was offered up by her partner Roland Penrose as a friendship offering in a primitive fashion, in Penrose's eagerness to cement his relationship with the master. When Penrose introduced her to the surrealists she joined the movement on her own terms. There is no doubt about the quality of her work, which is quite different from Man Ray's and totally her own, combining quirky observation, humour and intellectual insight in a potent combination.

She survived being a muse by being serially unfaithful and taking other lovers herself, rather than being a passive participant. Her appearance in a Kotex advertisement in 1928 horrified America. It is tragic that she was arguably able to do this by putting her mind and her body into two different boxes, possibly as a result of being raped by a family member when she was seven years old, leaving her with a venereal disease that required painful treatment.

Artist Maeve Gilmore was an inspiration for Mervyn Peake, triggering an explosion of images of her after they met. Press reports liked to play on the idea that she was his muse, but also talked up their 'rivalry', showing photographs of them sitting drawing each other. Her son Sebastian writes in *A Child of Bliss*: 'My father's catalytic and singular influence gave her the moment and the security to expand from the shy cocoon of an Irish Catholic upbringing into the wholly original woman that she became. She loved my father with a partisan fanaticism with which a genius is sometimes rewarded.'[8] For some, the artist–muse relationship could be one of mutual benefit.

After the Second World War, the exhibitions staged by the newly formed Arts Council and British Council were still primarily curated by men who sidelined women's work. In response, one male artist wrote articles and small publications that championed the idea of female creativity in an increasingly technological world. Cecil Collins taught alongside Mervyn Peake at the Central School of Arts and Crafts throughout the 1950s; his artist wife Elisabeth Ramsden was his muse and he very consciously painted her as such. Collins met Ramsden at the Royal College of Art (RCA) and they married while still both students in 1931. She was a down-to-earth Yorkshire girl, from a wealthy

Halifax family that was horrified by both her decision to go to art school and her choice of a husband: Collins came from a humble family that had hit hard times and they thought she had married beneath her. The couple's first home was a cottage in Buckinghamshire, near Eric Gill's home Pigotts farmhouse at North Dean. Gill introduced them to the writing of Jacques Maritain, which influenced Cecil Collins's essay *Vision of the Fool,*[9] in which the figure of the fool is a symbol of the purity of consciousness; all Gill's discussion of ideas was directed at Cecil rather than Elisabeth.

The couple lived the simple life, but the allowance Elisabeth received from her family made it considerably easier. Influenced by Larionov, Chagall and Kandinsky and their roots in Russian folklore, a subject that had been made topical by Diaghilev's Ballets Russes, Elisabeth was arguably more open to different artistic ideas than her husband. However, she decided early in the marriage to downplay her own work in order to support Cecil. He was like a child in many ways, including his lack of sophistication in the practical ways of the world and in his single-minded pursuit of his own work. Elisabeth didn't have a child because, as she put it, 'she had Cecil'. The fool is even less linked to

Elisabeth Collins, *Fool Thinking in a Landscape, c.* 1938. Gouache on paper.

economic concerns than clowns and gypsies and Cecil campaigned for an official Fools' Day every 1 April. The fool inspired a major cycle of images for Cecil, and Elisabeth continued to paint clowns and strolling players all her life.

Elisabeth and Cecil Collins, like Olive Cook and Edwin Smith, were a unit, a symbiotic partnership; some of their paintings seem like part of a conversation between them. It was Elisabeth who made the first drawing of 'the fool', which inspired so much of Collins's writing and drawing, and it was always her face in his pictures. In *The Artist and His Wife* (1939) Collins portrays his partner holding a chalice full of the waters of inspiration, although the painting is also meant to show the balance of male and female features in each of them. A romantic figure, the fool could also be a seditious one. Writing about the state of Britain in 1948, historian David Kynaston notes the long-standing popularity of the comedian Norman Wisdom, 'a seeming simpleton...The Gump, that most unwittingly subversive of post-war figures, ensuring without apparently meaning to that the best laid plans of his social superiors never came to fruition'.[10] The Collins's support for the idea of a 'Fools' Day' mirrored the idea that, as Kynaston puts it, in a still rigidly stratified society 'every now and then the underdog would have his day', when the world would be temporarily turned upside down for a short period of alternative reflections.

When Cecil Collins became director of the Art Studio Workshop at Dartington Hall in Devon in 1939, Elisabeth was released from many of the everyday chores she had been responsible for and entered a fruitful period in her own practice, mostly producing works on paper. She had become friendly with the American painter Mark Tobey who taught at Dartington until he went back to the USA in 1938, attending his classes and sharing his interest in eastern mysticism. Her drawings were exhibited in Cambridge when they moved there in 1943, some of them under the name Belmont, as if she wanted to dissociate herself from her husband's work for a time. Later they shared a house with the poet Kathleen Raine in London, where for a time Winifred Nicholson lived in the basement. The house became a meeting place for artists and for Collins's steady stream of students, making it hard for her to concentrate on her own work.

Elisabeth started painting again in earnest after Cecil's death, discovering her old drawings and reworking them, and making new

small-scale gouache paintings. She had always considered his work 'better' and more important than hers; at his Tate exhibition in 1989, just before his death, the curators were initially reluctant to include her work alongside his, which was hardly encouraging. After her own show at Jane England's gallery in 1996, the Tate finally did buy four of her works, showing how critical reception can change over time; she said, 'if I'd known my paintings would sell like that and people liked them so much, why did I ever give up?'.[11] Her work is now increasingly admired. Her explanation of why she stopped painting for so long differed, depending on who she was talking to and when. According to Mary Fedden,[12] Elisabeth told her that Cecil didn't like her paintings, which differed quite a lot from his in the 1930s. She was always more critical of her own work than he was of his: he had great faith that he was a genius and didn't shy away from saying so.

Her friends talk of her as being serene, calm and beautiful – she took care of her appearance and wore splendid clothes and hats – but her own comments imply it was not always easy being the muse for Cecil Collins's representations of angels; in her old age she said guardedly, 'it was not a gloriously happy life, but there is interest in it clearly'.[13] Did she, like so many women artists of her generation, have regrets towards the end? And was there an enigmatic significance to the title of the painting she called *Carrying the Prince*?

Chapter 17

THE KITCHEN SINK
domesticity and the making of art

Domesticity was a new concept at the beginning of the twentieth century, associated with a growing separation between work and home for the middle classes, along with an increase in leisure time and time spent as a family. For the better off, the concept of 'home' meant a more isolated unit than the communal terraces, tenements and apartments of the working poor. While Victorian dwellings tended to be dark, full of ornaments and claustrophobic, new evidence showed that light and a lack of dust resulted in better health – all the more reason to avoid clutter in new, streamlined houses, which Le Corbusier would come to call 'machines for living in'.

In 1910, modernist architect Adolf Loos delivered his lecture 'Ornament and Crime', later published as an essay, which suggested that the more refined a human being became the less he would feel the need to decorate his environment. While the domestic interiors in Arts and Crafts houses included elements of decoration, the polemicists for modernist ideals who increasingly dominated architectural discourse in the 1930s became prescriptive in their zeal for abstraction and purity. The phrase 'avant-garde' came from a military term. 'Home' was a term still associated with women. The vorticists had seen defence of homemaking as 'sentimental hysteria', the result of women 'sapping male virility'. Those associated with the Bloomsbury set had arrived at a radical new idea of the home in terms of relationships; however, there was still little attention paid to the needs of children in such unconventional but affluent bohemian settings, where domestic servants, nannies and boarding schools were the norm. Women artists from less-well-off backgrounds faced a variety of practical problems in pursuing their careers once they had a family.

One particular group of artists found a new and effective way of combining the domestic sphere and their careers. The Bardfield artists,

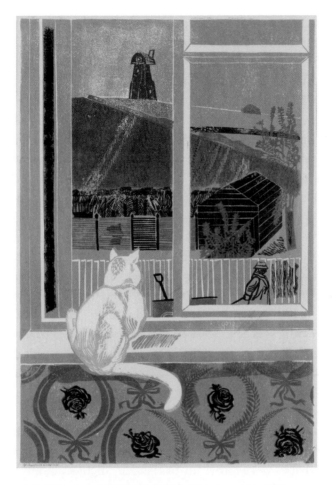

Sheila Robinson, *Great Bardfield Windmill*, 1958–59. Colour linocut.
One of Robinson's hand-printed wallpapers is visible below the
windowsill; her collection of unusual textiles and painted crockery
regularly appeared in her illustrations.

based in Great Bardfield in Essex, although highly professional, worked
at home rather than in dedicated studios, often for financial reasons. All
interested in design, they were rather competitive about their houses,
with several of them designing their own wallpaper; the objects they
collected often appeared in their artwork. They had moved to the coun-
tryside because they needed affordable spaces in which to work: now
they needed to bring the buying public to them.

The 1951 Festival of Britain promoted the idea of artists exhibit-
ing in their own homes and the novelty of the concept was picked up

by glossy magazines as well as the local and national press, resulting in thousands of visitors flocking to Great Bardfield. It was Charlotte Epton who, ignoring her husband's natural reticence, did much of the work arranging the publicity that put the Bardfield artists on the map. 'Visitors will not only be able to stroll round their sitting rooms and studios but meet the artists and their families as well,' the *Daily Mail* reported in June 1955.[1] Special trains and buses were laid on and the artists helpfully provided an artist-designed plan of the village street. The press came from far afield, excited by the colourful interiors on display that provided different photo opportunities to the cool purity of modernism.

George Chapman's etchings showing his wife Kate naked and pregnant were rare reference to traditional images of the nude in the artistic community, which more usually favoured family-friendly local scenes populated by people with their clothes on. Even Duffy Rothenstein, who admired Francis Bacon and Lucian Freud, had no enthusiasm for nudes and used clothing as abstract shapes. Chapman's nudes contributed to the villagers' slight mistrust of their new neighbours, who were described by *The Tatler and Bystander* of 1958 as 'the Montmartre villagers', their rural isolation overcome through the reach of the new mass media. 'Television has put these artists on the map', said *The Times. Art in London* felt it important to point out that 'few of the Artists are decidedly Left Wing', providing reassurance for local people's obvious concerns; the artists' activities were rather un-British and slightly alarming, even if the village stores benefited from the influx of visitors they attracted.

The *Art News and Review* article about Great Bardfield in July 1958 concentrates mostly on male artists, but it ends: 'the surprise in [John Aldridge's] house was the patchwork cope and colourful rugs made by his wife. Theatrical costume by Audrey Cruddas, textiles by Marianne Straub and gay designs by Sheila Robinson complete the varied fare.' Were the women added in last because their work was 'applied art' or just through everyday sexism? Either way, women artists were gaining valuable exposure even if their male colleagues were still getting the lion's share.

Lucie Aldridge's designs, once presumed to be by her husband, are now thought to be her own. Trained as an artist and already experienced in producing costume designs and fabrics in London before she arrived

in Great Bardfield, Lucie was involved with the 1930s revival of rag rugs, further promoted through the wartime austerity movement of 'Make Do and Mend'. Her work was well liked by artists at Charleston Farmhouse in Sussex, while Olive Cook thought her rugs 'transformed a humble popular craft into a rich and original work of art'.[2] Her love of gardens, domestic life and interiors was not a specifically female preoccupation but shared by many of the male artists in the village. Oskar Kokoschka noted in his introduction to Edwin Smith's 1944 exhibition catalogue, 'being a foreigner here I soon realised that the English nation has in its blood the love for cats, but not that lust for art that was common abroad'. However, it existed at Place House, then Lucie's home; before all hanging space filled up with John's own paintings there were several by Frances Hodgkins on the walls. They used big kitchen dressers to display unfashionable Victorian china, waxworks, beadwork, baskets and stoneware lions, all later championed by Olive Cook and Edwin Smith in the *Saturday Books*; some of the Aldridge's domestic china and other objects are now in the V&A. A hive of creativity and a work of art in its own right due to Lucie's good taste, Place House reverted to being a more ordinary country house when the marriage broke down and she left the village in 1960.

A younger generation found the village suited them well. Sheila Robinson, a former student of Edward Bawden, married fellow Royal College of Art (RCA) student Bernard Cheese and moved to Great Bardfield in 1952, both in search of affordable housing and because they wanted to become part of the community; Robinson immediately made four woodcuts of village cottages for their owners. She came from a very modest Nottingham background and had left school at fourteen just as the war started, continuing her own education through extensive reading. At art school in Nottingham she studied calligraphy, bookbinding and puppetry; after a further four years at the RCA she became more confident and felt the world was open to her.

Robinson had helped Edward Bawden make the mural decorating the Lion and Unicorn Pavilion for the Festival of Britain while she was pregnant with her first child Chloe. After her arrival in the village, seeing her printing linocuts by standing on them, Bawden let her use his press, and his influence can be seen in her early work. Following his example, she combined fine art and commercial commissions, designing

advertisements for Kia-Ora and Schweppes as well as posters for London Transport, which helped pay for her house. Later, at the same time as exhibiting at the Royal Academy (RA), she experimented with new materials like fibreglass for Blackpool's 'Noah's Ark' fun fair ride, and she eventually became one of the first women to design a postage stamp, an image of Westminster Abbey in 1966.

The Bawdens continued to look after her professionally, particularly after her divorce in 1958. There was still a lot of stigma to being a single parent – locals were socially conservative, critical of broken marriages, new-fangled divorces and 'wayward husbands' in the decade that followed, as indeed Bawden was himself. Nevertheless, once on her own Robinson could concentrate on her work; with her mother's help she was able to enjoy motherhood as well as work as a professional artist. She used her RCA contacts to get work for *BBC Books, Time and Tune, Television Club* and *Making Music*, television being the new up-and-coming thing. Is the recent revival of interest in the artists' community at Great Bardfield because it is an example of Rural Modernism or is it all just nostalgia? The discussion is now enriched by the insights of Grayson Perry, often himself sounding like a reincarnation of Peggy Angus, and by the work of Tracey Emin, which has done so much to revive interest in sewn and 'domestic' artwork.

Women artists who paint at home surrounded by their children automatically suggest a degree of domesticity. Barbara Hepworth had four children, so questions about her domestic life were inevitable, but she was always careful to be photographed with her work and her materials, preferring to be shown with her chisel in her hand rather than in a domestic setting. Both she and Ben Nicholson controlled publicity photographs of themselves very carefully and she had good feminist reasons for doing so. She is very amusing about the birth of her triplets in 1934, but one wonders how much she conceals behind the carefully written accounts for public consumption, such as *A Pictorial Autobiography*, first published in 1970.

Despite being hard up early in her career, Hepworth showed great skill in juggling family life, both practically and psychologically. She always insisted her children enriched her life, intensifying her 'sense of direction and purpose', and she included in *A Pictorial Autobiography* the sound advice to always do a little artwork each day, 'even a single half

hour, so that the images grow in one's mind'. She had the benefit of a number of support systems in caring for her children, including nannies and eventually boarding schools when the philanthropists and educationalists Leonard and Dorothy Elmhirst gave the triplets scholarships to Dartington Hall School at the end of the war. It was extraordinary how much she managed to achieve, but by 1951 family life was bursting apart at the seams and she admitted Ben Nicholson was growing resentful as he found it difficult to work over the noise made by the children and her sculptural activities. Their cramped conditions may have contributed to the couple's divorce; they certainly did to her move in 1949 to Trewyn Studio, now the Barbara Hepworth Museum and Sculpture Garden, in which she worked until her death.

In later life, Maeve Gilmore, Mervyn Peake's wife, had a somewhat different outlook. 'I always seem to have been able to paint when there is intense life surrounding me', she wrote, 'despite the eternal meals, the fights of one's children, and the constant demands of domesticity...it is now with more time and less friction I find it harder';[3] several other women have also remarked on the same phenomenon. Gilmore also mentions a downside of working at home alongside domestic chaos – once, after a children's party, a child's mother saw her canvases stacked round the walls and said, 'yes I used to dabble too',[4] a careless comment from someone not involved with Gilmore's artistic world but that exposed her hidden insecurities and sapped her confidence. Her decision to stop painting after Mervyn Peake's death was not just because of the demands of promoting his legacy; what really stopped her was the feeling of working in a complete vacuum, as well as in a figurative tradition that was no longer seen as relevant or interesting. When she did start painting again it was to experiment in a completely different style.

How did paintings as objects now relate to domesticity? Peggy Angus always maintained that historically they had not been designed for homes, but were more likely to be one form or another of public art: wall paintings in churches were a way of teaching bible stories to a non-reading congregation, for example. Easel painting developed later, to be sold to private secular patrons. Post-war abstract expressionist paintings were huge – suitable only for very wealthy patrons or art institutions. But many artists had always created primarily for

themselves, their work an end product of a process, sometimes of little interest once it was done.

Mary Fedden was a Slade artist who studied stage design with Vladimir Polunin and began her career painting sets at Sadler's Wells in London. After the war, during which she worked with the Land Army, the Women's Voluntary Service (WVS) and overseas the Navy, Army and Air Force Institutes (NAAFI), she returned to easel painting, often of still lifes and flowers. She admired the work of Winifred Nicholson and Anne Redpath. While Prunella Clough used to compare painting with throwing herself in the sea to learn how to swim, a phrase she took from Manet, Fedden's description was more tranquil: 'each of my paintings is a mixture of things that I'm looking at, and my thoughts and imagination'.[5]

A straightforward woman, she was evidently not bothered by what anyone else thought and would be the first to say that there was little cerebral about her approach. Hearing David Jones's epic war poem *In Parenthesis* on the radio in 1946 and reading T. S. Eliot's *The Waste Land*, both works infused with Grail stories, inspired her to make some images of chalices, but her subjects were really still just everyday mugs and jugs. In 1951, Fedden married the painter Julian Trevelyan, who encouraged her love of Matisse and Braque but more importantly encouraged her to fully inhabit being an artist and have confidence in herself. They were a generous-spirited, mutually supportive couple, working in different corners of the same studio in Durham Wharf in Hammersmith, although she said at times she felt overwhelmed, being in the shadow of a better-known artist. She often used bits of Trevelyan's abandoned prints as collage material in her own work.

Although Fedden married into a life of travel and influential friends she was serene by nature; little disturbed her equilibrium. Trips to the USA and to Russia seemed to have no outward affect on her work whatsoever. The couple were always exceptionally generous to others less fortunate than themselves. Like others in Britain in the late 1930s they adopted a child refugee from the Spanish Civil War but were quite relieved when his family were located and eventually took him back. Fedden wasn't particularly interested in politics, although during the war she made propaganda murals, using her talent for stage design. She wasn't searching for 'reality' so much as for a kind of poetry. Making a virtue of the limitations of her domestic life, her imagery was not

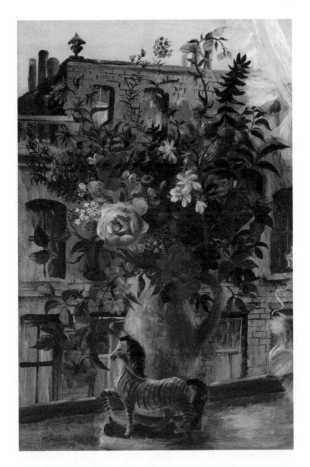

Mary Fedden, *Still Life with Staffordshire Zebra (Redcliffe Road)*, 1946. Oil on canvas. Early on, Fedden was interested in how to relate things near with those far away.

overloaded with too much import, the everyday experienced with delight rather than as a psychodrama of the kitchen sink. Combining shape and pattern with pleasure in the specificity of birds' wings, eggs and flowers, her work was both beautiful and popular.

Fedden's work can easily be mistaken as 'naïve' but she knew exactly what she was doing. She was one of the first women tutors at the RCA when Robin Darwin, brother of Trevelyan's first wife Ursula,[6] was rector. Her students included David Hockney, Patrick Caulfield and Allen Jones; she and Hockney shared a delight in the physicality of paint and the process of painting. In the 1950s there was little critical interest in her work and she sold it very cheaply, mostly to private customers.

At the Durham Wharf Open Studio people queued around the block to grab a watercolour for £15 that would later be worth thousands, a situation she hated. Late in life she still gave her work away to friends and visitors quite randomly.

Work like hers can suffer from being too closely associated with its reproduction on gift items and greetings cards; diluting the colour and texture of the original image, such items associate the work explicitly with good taste and, by association, with domesticity. One can only despair at the need to generate revenue that drives even serious curators to tolerate this situation; it would be nice to be able to appreciate work without being influenced by memories of the RA shop, where many of the couple's images are on sale. Fedden and Trevelyan had spurned the RA for many years after Alfred Munnings's outburst against contemporary art in 1949 but must have relented at some point and given permission for their work to be reproduced.

Mary Fedden liked the work of another younger artist, Mary Newcomb, who had little formal art training in painting but a fiercely observational eye trained by birdwatching and nature observation. Ben Nicholson also admired her work, which, with its convoluted and wordy titles such as *These Sheep Find it Necessary to Cross the Bridge*, and *Some Bees do not Die but Remain on their Backs Confused*, provided an amusing, wry and individual take on the world, both poetic and concise.

Newcomb was influenced by the poetry of John Clare, Andrew Marvell and Ted Hughes; she, in turn, was admired by writers including J. G. Farrell and Ronald Blythe, with whom she collaborated on a book of essays. Winifred Nicholson once said of the painter Christopher Wood that 'his work is only cared for (and maybe understood) by people like myself who enjoy the regions between poetry and art'.[8] This is also perhaps where the art of Mary Newcomb and Mary Fedden is situated. When Newcomb started a diary in 1986, the first entry was the following statement: 'I wanted to say these things to record what I have seen to remind ourselves that – in our haste – in this century – we may not give time to pause and look – and may pass on our way unheeding.' Her words seem to echo the quotation from Virginia Woolf's 'Women and Fiction', which introduced this book, in which she claims a woman writer's task might be to change established values and 'make serious what appears to be insignificant to men, and trivial what is to him important'.

Mary Newcomb, *The Shadow of an Aeroplane Passing over an Insect*,
undated. Watercolour and pencil.

Today I was looking at a striped insect
as it paused in the sun on the terrace.
The hoverfly shadow it cast
was deep and long,
stretching ahead from the proboscis.
At that moment a large noisy aircraft
flew over as they are wont to do here.
Its shadow immediately covered
and extended that of the insect,
so that it appeared to have
an aeroplane for a shadow
a moment in time – there it is – or was

I drew it quickly.'[7]

In the late 1950s Newcomb was 'discovered' by, and began exhibiting at, the Crane Kalman Gallery in London's Brompton Road. A Hungarian by birth, Andras Kalman's interests lay outside traditional British art categories; he had shown L. S. Lowry, another artist who was seen as outside the mainstream in the 1950s before becoming extremely popular, in his first gallery in Manchester. Kalman liked quiet, contemplative work that moved the viewer, as well as the direct emotion found in the work of 'naïve artists'. Some say that Newcomb's and Fedden's pictures were bought by a moneyed and metropolitan class who yearned for a certain kind of simplicity; be that as it may, it doesn't detract from the artists' intentions. The Tate owns one work by Newcomb dated 1983 and twenty by Mary Fedden. Newcomb's obituary in *The Guardian* placed her in the tradition of British visionary artists like William Blake and Samuel Palmer, as well as more recent figures including Winifred Nicholson, Elisabeth Vellacott and Mary Potter.

Domesticity in different forms encompassed the life and work of Anne Redpath. Her husband was a successful architect and for some years they lived on the French Riviera in the grounds of a palatial house

Anne Redpath, *The Indian Rug (Red Slippers)*, c. 1942. Oil on plywood.

owned by an American millionaire for whom her husband was working. Wealthy clients provided an exotic and cosmopolitan milieu while she looked after three sons. The daughter of a tweed designer, she was a brilliant student at Edinburgh College of Art and won a travelling scholarship on leaving but did very little painting after she married a year later. She never regretted her fifteen years of marriage and child-rearing, remarking that decorating a home, preparing good food and enjoying good company were not worth sacrificing, even for art; as far as she was concerned, 'the experience went back into art when I began painting again'.[9] She started working seriously after separating from her husband in 1934, while still travelling extensively, gathering up images in her mind to draw on, feeding an intense interior life.

Her painting *The Chapel of St Jean, Tréboul* (1954) shows a small chapel with a rich lace altar cloth, potted plant and busy attending angels; somehow it is as domesticated as the paintings she produced of her own home. Much of her later work was finished in the studio from memory – images of flowers, altarpieces and exotic interiors with paint encrusted like jewels, as well as of cities and landscapes. Her intimate domestic interiors were often compared with Vuillard and Matisse. By 1948 she was holding soirées in Edinburgh as an important Scottish artist and was recognized on both sides of the border. She was awarded an MBE in 1955. A Fellow of the Royal Society of Arts from 1952, she was the first Scottish woman to be elected a Royal Academician in London in 1960. By the 1970s and 80s her work was being reassessed and increasingly appreciated.

A very different picture of life and its domestic dramas emerges in the painting of Jean Cooke. Born in Blackheath, London, the daughter of a grocer, Cooke experimented with different media at the Central School of Arts and Crafts, Goldsmiths, Camberwell School of Art and then at the RCA as a postgraduate, before settling on becoming a painter. Seemingly indomitable, she survived a series of tragedies, the first of which may have been marrying John Bratby, the artist most associated with what David Sylvester termed the Kitchen Sink School of painting. Bratby, who had studied painting at the RCA, locked her in his lodgings until she agreed to marry him, an inauspicious beginning to twenty years of cycles of violence, which she and others who should have known better insisted contributed to her creativity. She lost a lot of work in

Jean Cooke, *Self Portrait*, *c.* 1954. Oil on canvas. Cooke's style became familiar from RA Summer Exhibitions, and she was made a full Royal Academician in 1972.

a fire at her home in London. When her cottage near Birling Gap in Sussex fell into the sea through coastal erosion she merely moved into the house next door. The real tragedy was that she genuinely loved her husband, although they finally separated in 1977. She once remarked that she found women 'treacherous', perhaps thinking of her husband's many affairs.

Virginia Woolf was one of the first to suggest that the idea of the artistic genius led people to think they could be allowed more liberties than 'ordinary people'. In the case of the Bratbys, many think Cooke's work was better than her husband's, but it was he that took the liberties, resorting to physical violence on many occasions in their long relationship. She was only allowed to work for three hours in the morning; he slashed her paintings if he disapproved of them and commandeered them if he needed a fresh canvas. John Berger remarked, admiringly, that he painted 'as though he sensed he had only one more day to live',

yet Bratby seems to have felt threatened by Cooke's creativity, annoyed that she had a reputation before he did, which continued after his own had dwindled.

Cooke was a tiny woman with a huge character, who painted vigorous landscapes and searingly objective self-portraits, finding beauty in a variety of unusual places. Her friends thought Bratby made her look old in his pictures, so she painted herself 'how she wanted to be'. When newly married, he made her sign one of her self-portraits as 'Bratby' – she 'belonged' to him now. Later, she always used 'Cooke'. It is telling that at the time of her separation she called another self-portrait *Et Jamais Je ne Pleure et Jamais je ne Ris* (1972), a line from Baudelaire meaning 'And never do I cry and never do I smile'. She started showing work in group exhibitions from 1956, with her first solo show in 1963. She eventually became a lecturer at the RCA and a regular exhibitor at the RA. When she was invited as one of only three women artists, along with Ithell Colquhoun and Anne Redpath, to contribute a self-portrait to the Ruth Borchard Collection at half her usual fee, she responded: 'Dear Miss Borchard, I am not a feminist but to have only three women painters out of 91 makes rather poor odds so 21 gns it is. Are you going to come and pick up the painting? Yours

Jean Cooke at home with her children, *c.* 1960. Photographer unknown.

sincerely, Jean E Bratby.' She had four children, most of who went on to be artists, too. Her friend Nell Dunn wrote after her death that she had a wonderful sense of humour and saw herself as a 'comic character in a comic world' – with the only serious thing in it being painting.[10]

Patience Gray, Women's Editor of *The Observer* from 1958 to 1961,[11] was friendly with both Olive Cook and Peggy Angus, and often criticized the way women were represented in contemporary art. She particularly hated French painter Bernard Buffet for depicting women as 'like hatchets. Hard as brass bedsteads, plucked hens drooping like desiccated rubber plants. This is hatred etched.'[12] She berated Bratby similarly for representing his wife as 'haggard, grey and melancholy'.

While abstract expressionism was being promoted by one art camp and social realism by another, headed up by John Berger, the reality of life in 1950s Britain could be quite bleak. The image of the heroic male artist in his mythical garret persisted and was implicitly critical of women. Colin Wilson's novel *The Outsider* was published in 1956, suggesting to many a young male artist that angst and desolate loneliness were a necessary requisite of genius, but 'the day-to-day struggle for intensity that disappears overnight, interrupted by human triviality and endless pettiness' that the novel describes were surely more often applicable to women's lives.

Male artists of the Kitchen Sink School who represented Britain in the Venice Biennale of 1956, and those who would be termed the School of London twenty years later, enjoyed being photographed amid painterly squalor. Critics and public alike tend to fetishize, with a kind of morbid attraction, images of walls covered in daubs of paint or an unwholesome morass of clotted matter on the floor, as in the studios of Francis Bacon and Lucian Freud. Women living in squalor could expect to attract different kinds of epithets. It came as a relief therefore when Andy Warhol deliberately had himself photographed with his mother as an act of both defiance and challenge. While Gay Pride was stirring, helping to confuse and break down categorizations, pop art was reasserting the domestic. When Robert Rauschenberg used bits of fabric among the ephemera in his pictures, the commentators saw it as a statement about gender[13] – there are as many stereotypes attached to homosexuals as to women. The RA had always stipulated that 'no needlework, artificial flowers, cut paper, shellwork, or any such

baubles should be admitted' to its exhibitions. Over a century earlier, the very popular artist Mary Linwood, who made 'needle paintings' – embroidered pictures that were versions of oil paintings – was always excluded from the Academy's Summer Exhibition and it took a long time for things to change.

One result of encouraging the avant-garde was that it led to an obsession with new techniques and practices in order to stay ahead of the game, even the reviving of old ones that had been scorned, such as the use of sewing, stitching and collage, previously associated with outsider artists or women. At the same time, some men had begun to take over domestic space in a new way, inspired by Hugh Hefner, the

Prototype for a book by Olive Cook, 1959. An extended photo-essay, this original mock-up included shapes cut out of the pages and holes through which to catch glimpses of images. Like the Palais Idéal, which she considered an outstanding work of art, her book would aspire to 'impose the pattern and character of a vision on the chaos of life'.

American editor of *Playboy* magazine. Hefner redefined the modern home as a bachelor pad with futuristic gadgets worthy of James Bond; its prime purpose was seduction, with a dormitory of bunny-girl slaves on the top floor, coerced into all forms of domestic 'service', including supplying food, drink and sex. The avant-garde architect Reyner Banham[14] claimed that *Playboy* magazine justified itself by being a purveyor of excellent articles on good design and intelligent literature.

In an era of utopian architectural ideas it is perhaps not surprising that one of Olive Cook's grand projects in 1959 was called The Dream Palace. She wrote at length about the so-called outsider artist Ferdinand Cheval, the French postman, and the thirty-three years he spent building his Palais Idéal, an 'extravaganza of stone and concrete which beggars all description and defies classification...a vision of the brotherhood of all people, a symbol of the bond which makes all men and all nature, one and which unites past and present'. Over the door of the Palais he had engraved the words *Ou le songe devient la réalité* ('where dreams become

Book jacket for *A Portrait of Dorset: The South-East* by Rena Gardiner, 1960. First using an old mangle and the facilities at the local art college for grinding her aluminium plates, Gardiner acquired type and an Adana press, graduating to much larger machines.

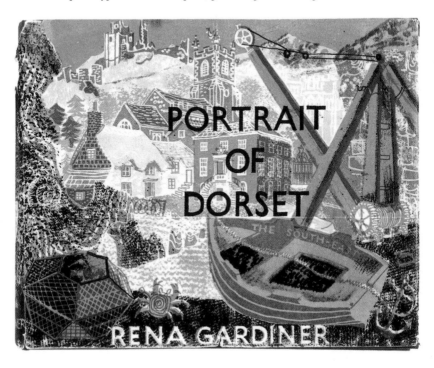

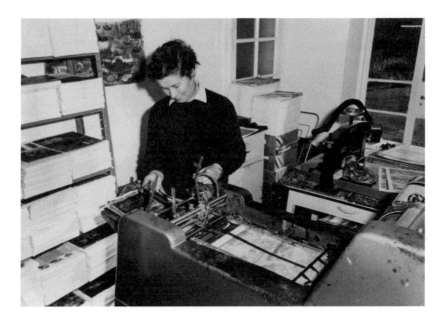

Rena Gardiner printing in her kitchen, late 1960s. Photographer unknown. The printing machine is a larger Gestalt 201 press and a bookbinding press is visible on the table beyond it. By the late 1960s she had given up teaching and concentrated solely on her books.

reality'). Cook could relate to the way this particular man had made his art his home, or even his world, into which he could retreat. She might also have known about (surrealist) Frederick Kiesler's *Endless House* (1951), which opposed modernism's prescriptive desire for rationalism in its own way. Kiesler described it as 'sensuous, more like the female body in contrast to sharp angled male architecture', its continuous surfaces and cell-like pods easily attached or removed to make flexible spaces that met both emotional and physical needs.[15]

In the everyday world of the British high street there was a move towards popularizing DIY (Do It Yourself), using new, safer materials; the authority of designers and professional decorators was irrelevant when shops sold paints that could be mixed in-store to any shade on demand and new magazines offered practical instruction. Labour-saving devices meant more leisure time for the housewife. Peggy Angus encouraged the customers visiting her studio in the early 1960s to enter into the spirit of creation and design their own wallpapers for her to print, inspired perhaps by the ideas of Muriel Rose, who helped found the Crafts Study Centre in the 1960s.

Rena Gardiner developed a continuation of the autolithographic process championed by Noel Carrington from her thatched cottage in Dorset, bridging the gap between commercial and fine press production. Her first book came out in 1954 in an edition of thirty-three copies; by 1960 she was starting to produce editions in the hundreds, using a commercial offset press instead of a hand-press, adding and adjusting colour as the printing process went along, so that each copy was slightly different, each a work of art. Using extraordinary overlays of colours and textures, Gardiner documented buildings and landscapes around Dorset, working directly onto aluminium plates until the image seemed 'right'. She did all the research, writing, calligraphy and typography herself, as well as collating, folding and stapling the books – she said it wouldn't feel her own work if she had an assistant. Influenced by the Puffin Picture Book series, Gardiner's books were never precious expensive productions, although they sell for quite a bit more than a shilling now. William Morris would have approved of the way she appropriated technology and worked in her own home.

None of the artists included in this chapter are diminished by having continued their practice in settings that could be termed domestic; their achievements challenge the negative connotations of the word head-on. Meanwhile, in 'gallery-land' in Britain's major cities, the tendency was towards the staging of big blockbuster shows promoting the latest avant-garde tendencies, structured around just one artist or group and ignoring the quieter flowering of creativity elsewhere.

Chapter 18

THIS IS TOMORROW
signs of change

The 1950s was a strange decade during which Britons tried to pick up the pieces after the huge trauma of the Second World War, which had brought the idealism of the grand project of modernity to such an abrupt end. Theo Crosby, a member of the Independent Group, wrote of the 'contradictory paths and personal preferences'[1] the decade offered artists. Clinical neuroscientist Raymond Tallis has since defined art as a way of 'expressing one's universal wound – the wound of living a finite life of incomplete meanings'.[2]

The United States had become the new focus of the art world; many artists from Europe had moved there as refugees either before or during the war. Unbeknown to many at the time, the first conference of the Congress for Cultural Freedom in Berlin in 1950 and the 1952 International Exhibition of Twentieth-Century Arts in Paris were part of a covert propaganda offensive initiated by the CIA to lure intellectuals and artists away from communist ideas.[3] In 1954, nine painting galleries at the National Gallery were still out of use because of damage sustained during the war and it was difficult to see much European art in London. The first Dubuffet show at the Institute of Contemporary Arts (ICA) was in 1955, the year an ex-art student from Goldsmiths', Mary Quant, opened Bazaar, her first boutique on the Kings Road, making clothes for a newly vocal, visible and financially independent young clientele. The same year, *Everybody's Weekly* reported that Royal Academy (RA) artists were complaining the hourly rate for life models had gone up and they were now unaffordable; a generation of younger artists were less interested in life drawing. The Tate's first exhibition in its newly restored galleries was held in 1956, the year of the Suez Crisis and the Soviet invasion of Hungary; 1956 also saw the first production of *Look Back in Anger* at the Royal Court – whose creator, John Osborne, was

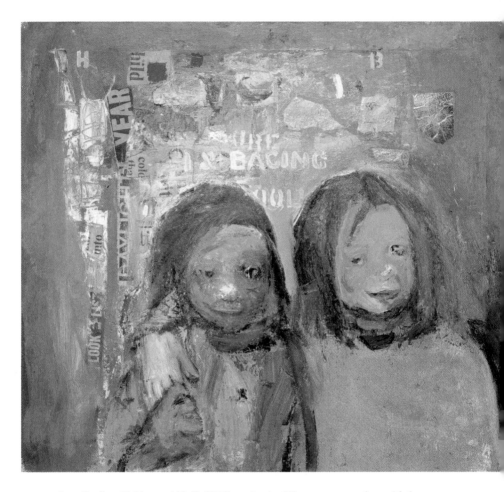

Joan Eardley, *Children and Chalked Wall 3*, 1962–63. Oil, newspaper and metal foil on canvas.

anti-establishment and anti-royalty, but also used misogynist rhetoric on occasion. By 1958, even the Artists International Association (AIA) was reduced to mostly being an exhibiting organization rather than a politically active campaigning group.[4]

At the RA, women were still not allowed to go to the annual banquet even after having been made Royal Academicians – Edith Granger-Taylor, a member of the Society of Women Artists, made an image of women crouching hidden under the tables, ready to upset the feast. Women artists were still under-represented on the kind of committees that gave the power to choose or veto selections for institutional purchases or commissions. The Tate was trying to build

up its collections in the 1950s and 60s and male artist trustees often donated their own work: Barbara Hepworth, the Tate's first woman trustee, wasn't elected until 1965. It was not until the 1970s that more work by women artists began to be acquired – by Mary Potter, Vanessa Bell, Eileen Agar, Wilhelmina Barns-Graham, Ithell Colquhoun and Prunella Clough. Dora Carrington wasn't represented until her brother donated one of her paintings in 1987; Winifred Knights was not shown until 1989.

Younger British women artists who were newly in the limelight included Joan Eardley, Sheila Fell and the women of the Independent Group. Joan Eardley, born in Sussex, had a Scottish mother and lived in Glasgow to escape the Blitz, eventually attending Glasgow School of Art. She spent half her time in the fishing village of Catterline on the east coast of Scotland, south of Aberdeen. On a steep bluff above a raging sea, the village was austere and remote; Eardley's small cottage had an earth floor and was without electricity or running water. She loved the sea, revelling in the coastal weather. She expected the artist's life to be tough, always running towards a storm, immersing herself completely, the wind and rain affecting her mark-making, which appeared almost expressionist – except that she rejected such comparisons and had particularly resented what she called the oppression of the French masters while at college.

Eardley was interested in ordinary people – farmers and fishermen on the coast and workers in one of Glasgow's poorest slums, Townhead, where she rented a studio in the 1950s and painted the children with an honesty reflecting their own grit. A lesbian with no children of her own, she managed to find a way of presenting children in their own environment without condescension or sentiment.

Glasgow was permeated with a left-wing aesthetic promoted by artists like Jankel Adler and Josef Herman, who had arrived there as refugees during the Second World War. Eardley liked the openness of the backstreets and the uninhibited lifestyle of their inhabitants; she befriended the Samson family, buying them clothes and coal, and giving the children pocket money. In her paintings she always included the graffiti behind the children, which was their own way of enlivening their environment, done on walls due for demolition. Around this time the Opies were collecting children's rhymes and playground games,[5] while

anthropologists were looking at the influence of the new mass media.

Eardley could be placed alongside Prunella Clough, arguably occupying the same space between abstraction and social realism, between the mid-decade Kitchen Sink School and tachisme in Europe. Eardley tended to be ignored by John Berger – for not being realist enough – and by the Tate, where Alan Bowness judged her 'unsuccessful' because she didn't 'go all the way' like Peter Lanyon, with whom her emotional response to the landscape was compared. Eardley felt that maintaining some sense of realism rather than abstraction was more 'visceral', a view shared by Francis Bacon and Lucian Freud. She was never a mere clinical observer of her subjects – the children she painted enjoyed being part of her painting process as her photographs of them and their families show. Out daily in all weathers, painting compulsively and with reckless urgency, she was diagnosed with breast cancer in 1962 but refused any treatment that would prevent her from working. She died aged only forty-two. Before her death she had already gained a strong reputation in both Scotland and England.[6]

Sheila Fell was another of the small group of women artists gaining national recognition in the 1950s. Born in 1931 in Cumberland, the daughter of a coal miner and a seamstress, she studied at St Martin's between 1949 and 1951, exhibiting at the 'Young Contemporaries' the following two years running. She had her first solo show with Helen Lessore in 1955 and by 1958 was teaching at Chelsea School of Art, having previously supported herself by modelling and waitressing. She made powerful paintings of her home landscape and her Beaux Arts show was a sell-out. L. S. Lowry bought two paintings, the first of many he later donated to galleries at home and abroad. He became a good friend and mentor, as did Frank Auerbach, who she worked beside at David Bomberg's classes in Borough for a while; she was also promoted by the critic David Sylvester.

Raised in a secure and supportive working-class family, Fell found herself suddenly thrust into the heart of London's bohemian scene and often felt homesick. Small and reticent, but looking very poised in the documentary television news clips of the time, she returned to Cumberland on painting expeditions, on her own or with Lowry. One of a new generation of women, she would have hated being thought of as a 'woman painter', and might well have refused to be part of this

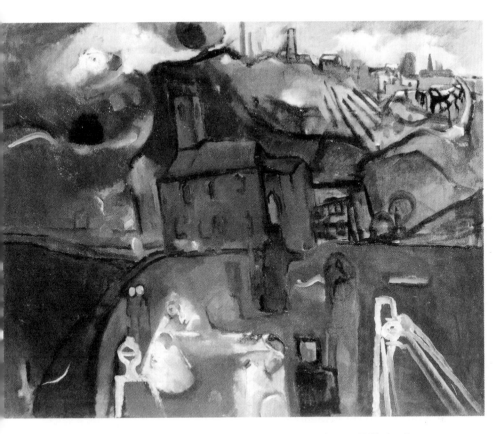

Sheila Fell, *Wedding in Aspatria II*, 1958. Oil on canvas. 1958 was the year Fell's daughter Anna was born – her father was a Greek sculptor. Aspatria is the small market town between Skiddaw and Solway Firth where Fell was born, its streets and panoramic views the only subject she found worked for her, although she was more preoccupied with colour and form than any likeness.

book, an important issue to be noted in this last chapter, pointing as it does towards a new era. In 1973, Bridget Riley was to write of Women's Liberation that 'artists who happen to be women need this particular form of hysteria like a hole on the head'.[7] Fell's father and Lowry died in the same fortnight in 1976 and she was greatly affected by the double loss. She herself died three years later, accidentally of alcohol poisoning in her London flat, aged only forty-eight. She had recently told an interviewer from *The Sunday Times* that she intended to live to 104 to finish all the paintings in her head.[8]

Magda Cordell[9] was the only non-British artist included in the Independent Group, an important contributor who brought a welcome

infusion of the continental scene. Born Magda Lustigova in Hungary, she emigrated to Palestine in 1938, where she became a translator and met her first husband; they were both working for British Intelligence. Back in London at the end of the war she was soon taken up by Erica Brausen's Hanover Gallery. In the 1950s she did some of her best work. She had a very physical approach to painting as an activity, making innovative experiments with new materials – plaster, pure pigments, oil, wax and ink, alongside modern acrylics, resins and polymers – generating extraordinary, visceral colours. Lawrence Alloway likened the layering in her work to a tapestry being woven, with no derogatory or sexist intention, and she preferred this interpretation to the label 'art brut' that was applied to artists in France working around Dubuffet. Sandra Blow, born a few years after Cordell in 1925, should be mentioned briefly here, too, as she also used new and 'unorthodox' materials – liquid cement, polymers and so on – in the spirit of arte povera; Blow exhibited at the Venice Biennale of 1958.[10]

The Independent Group had no fixed dogma but was against snobbery and rigid division between high and low culture, a revolt against the ethos of the Slade by some of the young men who had recently studied there. The Euston Road School had lapsed after the war, but Coldstream still promoted traditional skills at the Slade in order to provide a sense of professionalism and as a way of validating art to 'ordinary people', in the same way that he later caved in and recommended that artists should study for a degree. The Independent Group was also critical of Roland Penrose and Herbert Read, even though both were closely associated with the ICA, where much of the Independent Group activity took place. The group embraced, with partial ambivalence, the new culture coming from the USA and had a slightly romantic enthusiasm for technology. If it had an aesthetic it was about mobility and change, in the way Myfanwy Evans had suggested in *Axis*. The group was fascinated by advertising materials, science fiction and popular art in the spirit of Barbara Jones's exhibition at the Whitechapel Gallery.

Magda Cordell made monoprints and collages from magazines and ephemera, digested and reconstituted into very primal, painterly images, much more powerful than those made by male artists, who seemed less inclined to obliterate the images of cars and pin-up girls in their own assemblages. Artists in the group all enjoyed the livid colour

of cheap sci-fi magazines and after the austerities of the war years and years of rationing there was an excitement in the air about the sudden feeling of plenty. They included images by Hannah Höch in their exhibitions, a woman artist working in collage well known for breaking down stereotypical gender roles, both in her life and her dada work from the 1920s. She had only found recognition because of the success of her husband, Raoul Hausmann, who had threatened to withdraw if she wasn't included in the dada fair of 1920.

Cordell was reclaiming the female figure, parodying the 1950s emphasis on nurturing and domesticity, promoted alongside the corseted fashions and plastic Barbie dolls just being introduced. Replacing stereotypes with something more powerful, by the mid 1950s she was making images of women with an almost neolithic sense of form, concentrating on breasts, bellies and thighs. This period was a time of anxieties about the nuclear arms race, the effects of Nagasaki and Hiroshima on pregnant women and their children, and on new genetic discoveries. Although referring to 'organic self-repair' and 'regenerative embryos', her images went beyond any particular polemic. They were a challenging interpolation into a technological age.

She liked the way that Eduardo Paolozzi treated the mass culture of the USA like that of a primitive society, to be used as material for art objects in the spirit of a surreal ethnography. Roland Penrose, founder of the ICA, and Humphrey Jennings (co-founder with Tom Harrisson of Mass-Observation) had both been involved with surrealism, and Kathleen Raine, Paolozzi's landlady for a time, considered that their passion for documenting ephemera was a 'manifestation of the collective imagination'. Critic Reyner Banham documented his ambivalence about using American pulp culture while being politically on the left. John McHale, whom Magda Cordell eventually married, told her ironically, 'if we go on voting Labour we shall destroy our own livelihood',[11] but the Independent Group's main objections to the aesthetics of Fry and Herbert Read were that they used redundant terms that made the work of art disappear into an excess of aesthetic distance. In contrast, their own definition of culture was simply 'what a society does', which was what many women had been trying to suggest for some time. The group's defence for seemingly aiding and abetting the dominance of American culture was that the English scene seemed so dispiriting and flabby.

Woman in Art: From Type to Personality by Helen Rosenau, 1944. Three views
of the Willendorf Venus are shown on this cover.

Cordell's images were overwhelming assertions of female presence,
threatened but unbowed by both consumerism and atomic dust; 1958
saw the first CND march. They presented an ambiguous inside/outside
viewpoint – felt from within, represented from without – an antidote
to both pin-up-girl material and the writings of John Bowlby, psycho-
analyst and promoter of attachment theory, who seemed to be trying
to reinforce the importance of the nuclear family. Cordell never had
any children herself.

American pin-ups were slightly shocking to a prim and proper
1950s Britain, quite apart from any feminist critique, but the ethos of
the Independent Group was generally positive for women. Alloway
later ruefully remarked that they must have had a chauvinist streak
because all the women in the group were wives or girlfriends, but Cordell
makes a point of saying how collaborative an enterprise it was, and
that working as a group they all achieved more than they could have as
individual artists on their own. Architect Peter Smithson had a light-
ning-bolt revelation after his first child was born: 'this weird business
of a transformation of a girl into a mother...one is astounded by their
competence. Men are shits...[I was] thoughtless taking her for granted
just not thinking about it...bringing up children and doing a job.'[12]

Cordell and Terry Hamilton[13] sourced a pile of images for Richard
Hamilton's well-known collage *Just what is it that makes today's homes so*

Magda Cordell, *No. 12*, 1960. Oil on canvas. This work glows with colour, evoking blood, the force of nuclear fission, an X-ray, hallucinatory light – is it a maternal figure or an embryo? In 1957 a fire burned for three days at what was then known as Windscale, now Sellafield. It was the worst nuclear accident in British history and contamination spread across Europe. 'I was filled with pain and I hoped for a better world,' Cordell recounted later.

different, so appealing?, and came up with the American Tootsie Pop sucker, which was just the right size for the muscle-man's hand. It is good to have this artefact as a visual aid that embodies the idea of collaboration, something usually ignored or downplayed by art history and criticism, traditionally more comfortable with the idea of individual genius. It was an important image, tackling the issues of sex and commerce and the use of body parts in advertising imagery. Popular culture was, of course, the traditional home of male/female stereotypes and at this point in time there was often too much fun to be had playing around with these to stop and pursue a thorough feminist critique.

Mary Banham,[14] a critical essayist, calls all the women in the group 'highly aware and exceptionally strong personalities', playing more than just a supporting role. She was annoyed by the Arts Council film titled *Fathers of Pop* shown at the ICA in 1979, later emphasizing that all the discussions took place in the homes of the group, where it was the women, many with small children, who were the most vociferous about ideas for a better tomorrow, including trying to re-establish a sense of internationalism now that the war was over. Several of the women had trained at the Courtauld. The second director of the ICA, 1951–69, was Dorothy Morland, an inspiring administrator who acted as a huge catalyst for the group, ensuring it flourished and encouraging its interdisciplinary approach, offering her home for meetings. A friend of Picasso and a promoter of European modernism, she was more politically savvy than some of the artists, always open to new ideas. The Banhams called her their 'guardian angel'.

Theodor Adorno[15] had typified museums as 'family sepulchres for works of art', whereas the ICA was supposed to function as a temporary exhibition space, full of life and creativity. The Independent Group embraced the ephemeral and throwaway, making art out of materials to hand. The seminal exhibition 'This is Tomorrow' of 1956, featuring the work of thirty-eight artists, challenged not only ideas about art, but curatorial practice, too – the way exhibitions were arranged and the use of space. It was supported by articles in the press by Monica Pidgeon, who liked the fusion of painting and sculpture with architecture.

Reminiscing in 2008, J. G. Ballard considered this exhibition to be the moment that Moore, Sutherland and Hepworth, associated with the Arts Council, were usurped from their positions as the respectable

avant-garde.[16] Paule Vézelay wanted the group to become a coalition of abstract arts but these were too closely associated with what the group was trying to get away from and she withdrew. Mary Martin and her husband worked in Group Nine of the exhibition. She didn't want her work to be seen as impersonal, writing later that the precision of her art was 'precision of choice, not dry academic precision...precision is the property of the hand rather than the machine'.[17]

Alison Smithson[18] was the other principal female figure involved in the Independent Group, together with her husband Peter Smithson. They had moved to London from Newcastle in 1950, inspired by photographer Nigel Henderson's pictures of life on the streets. They thought they knew about the realities of working-class life, convinced that their ideas about architecture were socially aware and informed. Their town planning was supposed to support urban community life after slum clearance – a plastic representation of the group's aesthetic ideas – with no formalist preconceptions. They believed in collaboration, although some would now say ideological and aesthetic considerations in their work trumped social realities.

Not included in the exhibition but part of the group was Lawrence Alloway's wife, the artist Sylvia Sleigh. Born in Wales she grew up in Sussex and trained at Brighton College of Art. Her first solo show was at Kensington Art Gallery in 1953, but not much attention was paid to her work in the 1950s. She painted *The Situation Group* in 1961, all fully clothed.[19] In her portraits of her group of friends, they often appeared quite naturally naked, emphasizing the bonds of friendship and affection between them. She later made images like *Working at Home* (1969), which showed herself painting at an easel in a comfortable sitting room with her husband working at a desk in the background, challenging the idea of the artist in the studio. She ignored conventions about minimizing imperfections or downplaying body hair, and painted without any sense of objectification, something she particularly hated. In 1949 she had painted an interesting portrait of Alloway entitled *The Bride (Lawrence Alloway)*, recently acquired by Tate Britain: he is portrayed posed as if in a Tudor portrait, a diamond held and displayed between finger and thumb, and in a white dress with strings of pearls at neck and wrist, conjuring up echoes of the then yet-to-be-produced film of Virginia Woolf's *Orlando*, with Tilda Swinton its eponymous hero.

Sylvia Sleigh, *The Turkish Bath*, 1973. Oil on canvas.

The Alloways moved to the USA around 1960, as did Magda Cordell and John McHale, who worked on futurological studies there with Alvin Toffler and Buckminster Fuller, writing books together about the social impact of technology and its effect on world resources. In the States, Sleigh became famous for her male nudes, painted in poses traditionally associated with women, suggesting works by Ingres, Titian and Velázquez and challenging classical ideas of beauty. Sleigh also co-founded an all-women gallery. Alloway, ten years younger than Sleigh, was known for his sympathy with women artists.

Sleigh made a series of paintings in the grounds of Crystal Palace – what had been the highlight of the 1851 World Exposition, now in ruins, a 'graveyard of Empire'. The departing classical figures signalled the end of a long period of Western artistic tradition – Barbara Jones had already said in 1951 that the time of allegorical figures was past: 'all those boring creatures are dead and we can forget them'.[20]

Ironically, here was a group at ease with the idea of domesticity just as a growing ecological sensibility gave even more new reasons for homes to be streamlined and less full of 'stuff'. They were right in

realizing that the world had always been a very complex place – or as Theo Crosby put it, one with no simple road to the future.

In 1957, Pauline Boty exhibited in a 'Young Contemporaries' exhibition alongside Bridget Riley, and later with Derek Boshier, David Hockney and Peter Blake. In 1961 she took part in one of the first pop art shows, at the AIA gallery – 'Blake, Boty, Porter, Reeve' – showing over twenty collages. In a Monitor documentary filmed by Ken Russell called *Pop Goes the Easel*, only the male artists were interviewed, but her work still made a big splash at the time. Hers was an exciting, early, intelligent feminist voice, silenced by her tragic early death in 1966.[21]

By 1961, Sylvia Pankhurst had died, but the pill was available on the NHS and Feminism with a capital F was inexorably on the rise. Soon a much noisier sort of art would be made by women alongside that made by those pioneers who acted as trailblazers and whose lives have been explored in this book.

Sylvia Sleigh, *Crystal Palace Gardens: The Departure*, 1957. Oil on canvas.

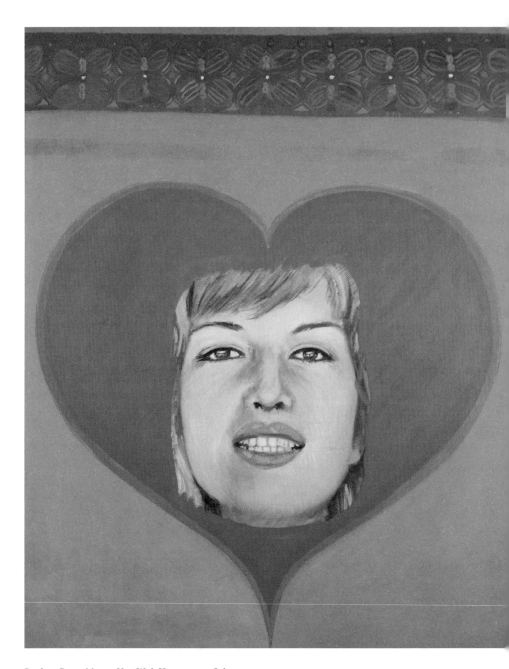

Pauline Boty, *Monica Vitti With Heart*, 1963. Oil on canvas.

ACKNOWLEDGMENTS

I would like to thank my early readers (of a much longer book!) Penelope Leach, George Craig, Jan Hunter, Kathy Whalen and Nancy Campbell; also, my development editor James Attlee, as well as Roger Thorp, Amber Husain and Maria Ranauro at Thames & Hudson. Many artists' families, dealers and galleries have been incredibly helpful and generous in providing information, images and permissions and supporting me in this project, and I am immensely grateful to them for making the book possible:

David Herbert, Victoria and Emma Gibson, Rose Knox-Peebles, Juliet Moller, Olwyn Bowey, Timothy Wilcox, François Matarasso, Pauline Lucas, Juliet Lamont, Ed Vulliamy, Charlotte Parsons, William Pryor, Rosalind Bliss, Prudence Bliss, Jovan Nicholson, Gail Clarke Hall, Henrietta Garnett, Julian Bell, Sarah Milroy, Louise Smith at Dulwich Picture Gallery, Alex Lewis, William Rea, Nick Rea, Martin Pel, Richard and Hattie Bawden, Chloe Cheese, Iris and Nigel Weaver, Colin Wilkin, David Oelman and all at the Fry Art Gallery, Rachel Rose Smith, Julian Francis, Christopher Whittick, Andy Friend, Alan Powers, Simon Lawrence at the Fleece Press, Jane Hill, Clem Vogler, Rhodri Thomas, Susan Fogarty of the RS Thomas & ME Eldridge Society, Helen Williams-Ellis, Tony Brown of the University of Bangor, Anne Thomson at the Newnham College Archive, Tony Raymond, Neil Jennings, Paul Liss, Sacha Llewellyn, Lou Taylor, Hope Wolf, Desdemona McCannon, Lottie Crawford, Simon Martin, Sarah Norris, Denys Wilcox, Jane England, Karen Taylor and Sara Cooper at Towner Art Gallery, Tom Edwards and Philip Athill at Abbott and Holder, David Wootton and Chris at Chris Beetles Gallery, Peter Vangioni, Airi Hashimoto and Jillian Cassidy in NZ, Jamie Anderson at Waterhouse & Dodd, Julia Carver at Bristol Museum & Art Gallery, Steve Swallow at Castlegate House Gallery, Martine Rouleau at UCL, Lucy Tann and Judy Aitken at Southwark Local History Library and Archive, John Peel at Manchester Art Gallery, Cheska Hill-Wood, Patrick Duffy and Gordon Cooke at the Fine Art Society, Victoria Lucas at Jerwood Gallery, Hastings, Annabel Niekirk at Piano Nobile, Ciara Phipps at Southend Museums Service, staff at the Tate Archive, Rob Airey and Geoffrey Bertram at WBG Trust, Conor Mullan and Richard Gault at the Redfern Gallery, Christine Hourdé at the Mayor Gallery, Gabriel Toso at Whitford Fine Art, Gordon Samuel at Osborne Samuel, Sarah Moloney at the Portland Gallery, Edna Battye at the Chappel Galleries, Tessa Newcomb and Sally Kalman, Kettle's Yard, Ami Bouhassane and Antony Penrose, Miranda Gray and Ashlyn Armour-Brown, Paddy Rossmore, John Russell, Sabrina Izzard, Alan Waltham, Marcus Rees Roberts, Christopher Campbell-Howes, James Folley, Julian Rothenstein, Anne Ravilious, Dennis Hall, Keith and Lucy Yarwood and the Rankin family, Tim and Catherine Nicholson, Vivienne Light, Paul Martin, Philip Trevelyan and Nellie Pryor, John Duncalfe, Tim Sayer, Jane Tuely, Philippa Price, Miles Tuely, Vincent Freedman, Leo Moynihan, Francis Ames-Lewis, Katya Marsh, Grant Waters, Rhiannon and Mel Gooding, Rachel Patterson, Jeffrey Sherwin, Cate Haste, Anna Fell, Helena Bonett, Christopher Catling, Brigid Peppin, Jeremy Parrett, Fintan Ryan at National Galleries of Scotland, Barbara Bartl at Newport Museum and Art Gallery, Michael Devitt and all at Little Toller Books, David Burnett at Dovecote Press, Veronica Watts.

PICTURE CREDITS

a = above; b = below; l = left; r = right

2 © The Estate of Eileen Agar/Bridgeman Images; 12 Photo Parliamentary Art Collection (WOA 5922) www.parliament.uk/art. © Estate of Sylvia Pankhurst; 15 © Estate of Dolores Courtney; 17 Private collection/Bridgeman Images. © Estate of Nina Hamnett/Bridgeman Images; 23 © Tate; 24 Illustrated London News Ltd/Mary Evans; 26 © Estate of Eileen Mayo; 30 Private collection/Whitford Fine Art, London/Bridgeman Images. © Estate of Gladys Hynes; 33 The Courtauld Gallery, Courtauld Institute of Art, London. © Estate of Helen Saunders; 35 © Tate; 36 National Portrait Gallery, London; 39 Private collection/Abbott and Holder, London/Bridgeman Images; 40 Private collection. Courtesy Liss Llewellyn; 45 Private collection. © Estate of Gertrude Hermes; 46 © Raverat Ltd, www.raverat.com; 50 Te Papa Museum of New Zealand, Wellington, New Zealand; 53 Private collection. © The Trustees of Winifred Nicholson, 2018, All rights reserved; 54 Bristol Museum & Art Gallery. © The Trustees of Winifred Nicholson, 2018, All rights reserved; 59 © Estate of Edna Clarke Hall; 63 © Estate of Mildred E. Eldridge; 66 © Estate of Dorothy Hepworth; 69 Photo Westwood/Paul Popper/Popperfoto/Getty Images; 70 Photo Paul Popper/Popperfoto/Getty Images; 73 Private collection. Photo Gareth Iwan Jones. © Estate of Vanessa Bell, courtesy Henrietta Garnett; 74 The Charleston Trust. Photo Matthew Hollow. © Estate of Vanessa Bell, courtesy Henrietta Garnett; 77 Private collection; 80 Scottish National Portrait Gallery, National Galleries of Scotland, Edinburgh. © Estate of Cecile Walton/Bridgeman Images; 83 Topfoto; 84 Collection of Royal Pavilion and Museums, Brighton and Hove. Courtesy Fine Art Society, London; 85 Private collection. Courtesy Fine Art Society, London; 88 Courtesy Bloomsbury Auctions; 90 © Estate of Enid Marx; 96 UCL Art Museum, University College London. Figure Painting, First Prize (Equal), 1927 (5347). © Estate of Helen Lessore; 99 Photo Ida Kar © National Portrait Gallery, London; 102 The Kröller-Müller Museum, Otterlo, the Netherlands. Gift from Ida and Piet Sanders, Schiedam. © Estate of Marlow Moss. All rights reserved; 107 Private collection. Photo England & Co, London. © Estate of Paule Vézelay; 109 Private collection. © Estate of Mary Swanzy; 110 National Gallery of Ireland. Bequeathed by Evie Hone, 1955 (NGI.1326); 111 National Gallery of Ireland. Evie Hone © DACS 2019; 113 Photo Topham/UPP. Reproduced courtesy Bowness; 116 Collection of Roger Thorp. © Estate of Eileen Agar/Bridgeman Images; 120 © Lee Miller Archives, England 2018. All rights reserved, leemiller.co.uk; 123 The Sherwin Collection, Leeds/Bridgeman Images. Reproduced by kind permission of the Noise Abatement Society. Ithell Colquhoun © Samaritans, © Noise Abatement Society & © Spire Healthcare; 124 The Sherwin Collection, Leeds/Bridgeman Images; 126 Photo England & Co, London. © Estate of Emmy Bridgewater/Mrs Z. A. Jenkinson; 129 Private collection/Photo Whitford & Hughes, London/Bridgeman Images; 132, 135 Collection of Carolyn Trant; 137a, 137b © Estate of Barbara Jones; 139 © Estate of Enid Marx; 141 National Portrait Gallery, London. © Peggy Angus Estate; 143 Photo Sam Lambert. © Peggy Angus Estate; 145 Victoria & Albert Museum, London/Bridgeman Images. © Estate of Prunella Clough. All rights reserved, DACS 2019; 148 Private collection. © Estate of Grace Oscroft; 149 Southend Museums Service, Beecroft Art Gallery, Southend-on-Sea, UK; 151 Reproduced with permission of the Newport Museum and Art Gallery (2003.583). © Estate of Nancy Mayhew Youngman; 152, 153 © Estate of Evelyn May Gibbs; 156 Illustration © Clifford and Rosemary Ellis/Courtesy The Friends of the Victoria Art Gallery for the benefit of the Gallery; 158 Press Association publicity photo; 161 Beetles Gallery, London. © The

Estate of Betty Swanwick/Bridgeman Images; 165 The Archive of Peggy Angus/Sussex Archive (PEG 9/21). © Peggy Angus Estate; 166 © Estate of Doris Hatt; 167 © Estate of Ursula McCannell; 168l Reproduction courtesy The Pearl Binder Archive; 168r The Archive of Peggy Angus/Sussex Archive (ESRO PEG 1/11). © Peggy Angus Estate; 169 Collection of Roger Thorp. Reproduction courtesy The Pearl Binder Archive; 173 © The Ashbee Family; 176 Imperial War Museum, London (Art.IWM ART LD 5747 b); 177 Imperial War Museum, London (Art.IWM ART LD 5468); 179 © Estate of Ethel Gabain; 182 Tate, London. Purchased by Tate Archive from Jim Sproule, Lin Sproule and Felicia France, November 2010 (TGA 201023/1/105); 185 Private collection. Photo Ben Taylor. © Evelyn Dunbar Estate; 186 Art Gallery of South Australia, Adelaide. Elder Bequest Fund, 1943 (0.1246); 187 Royal Air Force Museum, London (FA04334). © The Estate of Gladys Hynes; 189 Imperial War Museum, London (Art.IWM ART 17474); 192 The Fry Art Gallery, Saffron Walden, UK/Bridgeman Images. © Estate of Charlotte Epton; 194, 195; © Estate of Duffy Ayers; 196 © Estate of Tirzah Garwood; 198 Private collection/Bridgeman Images. © Estate of Tirzah Garwood. All rights reserved, DACS 2019; 199 Kettle's Yard, University of Cambridge. © Estate of Elisabeth Vellacott; 201 Tate. © Estate of Mary Potter. All rights reserved, DACS 2019; 203 Private collection. © Estate of Peggy Rankin; 204 © Estate of Katherine Church; 206 Photo John Somerset Murray. Courtesy The Estate of EQ Nicholson; 207 © Estate of EQ Nicholson; 210 © Wilhelmina Barns-Graham Trust; 211 Estate of Margaret Mellis. Courtesy Redfern Gallery, London; 214 Private collection; 215 Courtesy Waterhouse & Dodd Gallery, London. © Estate of Lilian Holt; 216 Courtesy Waterhouse & Dodd Gallery, London. © Estate of Edna Mann; 217 Courtesy Waterhouse & Dodd Gallery, London. © Estate of Dorothy Mead; 219 National Portrait Gallery, London. Accepted in lieu of tax by H.M. Government and allocated to the Gallery, 2003 (NPG 6628). © Estate of Nancy Sharp; 222 Wolverhampton Arts and Heritage. Gift from the Contemporary Art Society. 1950 (OP22). © Estate of Elinor Bellingham Smith; 225 Courtesy Liss Llewellyn. © Estate of Mary Adshead; 226 Collection of Roger Thorp. © Estate of Enid Marx; 228 Collection of Grant Waters. © Estate of Edna Ginesi; 229 Courtesy Bowness; 230 © Estate of Claudia Guercio. Courtesy Vincent Freedman; 232 Phyllis Dodd © Medici/Mary Evans; 233 Frances Richards © The Artist's Family; 234 Courtesy Annely Juda Fine Art, London. © Estate of Mary Martin; 237 Collection of Mr Sam Price. © Estate of Diana Low; 242a Collection of Roger Thorp. By permission of Penguin UK; 242b Collection of Roger Thorp. © Estate of Kathleen Hale/courtesy David Higham Associates; 249 Courtesy Bloomsbury Auctions; 250 Hulton-Deutsch Collection/Corbis via Getty Images; 253 Photograph England & Co, London. © Estate of Elisabeth Collins; 257 Fry Art Gallery, Saffron Walden, Essex/Bridgeman Images. © Estate of Sheila Robinson; 263 © Estate of Mary Fedden; 265 © Estate of Mary Newcomb; 266 National Galleries of Scotland, Edinburgh/Courtesy the Artist's Family/Bridgeman Images. © Estate of Anne Redpath/Bridgeman Images; 268 The Ruth Borchard Collection. Courtesy Piano Nobile, Robert Travers (Works of Art) Ltd. © Estate of Jean Cooke; 269 Courtesy Piano Nobile, Robert Travers (Works of Art) Ltd. © Estate of Jean Cooke; 271 Newnham College, Cambridge; 272, 273 © Estate of Rena Gardiner; 276 Scottish National Gallery of Modern Art, Edinburgh. © Estate of Joan Eardley. All Rights Reserved, DACS 2019; 279 © Estate of Sheila Fell; 282 Photo Wiedler; 283 Tate. Purchased 2013 (T13813). © reserved; 286 Smart Museum of Art, The University of Chicago, Purchase, Paul and Miriam Kirkley Fund for Acquisitions (2000.104); 287 Courtesy the Estate of Sylvia Sleigh; 288 Private collection, Paris, courtesy of The Mayor Gallery and Whitford Fine Art, London. © Estate of Pauline Boty

NOTES

CHAPTER 1

1 'Mr Bennett and Mrs Brown', in *The Hogarth Essays no. 1*, 1924 (London: Hogarth Press); in this essay Woolf also wrote on the idea of 'men of genius' and being heroic as bad for art.
2 Virginia Woolf, 'Old Bloomsbury', in *Moments of Being*, 1985 (New York: Brace Jovanovich).
3 Devised by curator Emma Chambers with the Emily Davison Lodge.
4 'Miss Richardson's Statement', *The Times*, 11 March 1914.
5 *Blast*, no. 1, 20 June 1914.
6 See Shirley Harrison, *Sylvia Pankhurst: A Crusading Life 1882–1960*, 2003 (California: Aurum Press).
7 *Ibid.*
8 *Ibid.*
9 Quotes are from the autobiography *Laughing Torso: Reminiscences of Nina Hamnett*, 1932 (California: Constable & Company, Ltd)
10 *Cambridge Magazine* article by Frederick Etchells, a painter whose sister Jessie, also an artist, worked at the Omega Workshops for a time before emigrating to Canada with her fiancé in 1914.
11 *Laughing Torso.*
12 Laura Knight, *A Proper Circus Omie*, 1962 (London: Peter Davies).
13 Laura Knight, *The Magic of a Line*, 1965 (London: Kimber).
14 *The New Age*, 21 July 1910, reprinted in Anna Greutzner Robins (ed.), *Walter Sickert: The Complete Writings on Art*, 2003. (Oxford: OUP).
15 Caroline Fox, *Painting in Newlyn 1880–1930*, 1985 (London: Barbican).
16 See chapter 18.

CHAPTER 2

1 Katy Deepwell, *Women Artists between the Wars: 'A Fair Field and No Favour'*, 2010, (Manchester: MUP).
2 Virginia Woolf, *A Room of One's Own*, 1929 (London: Hogarth Press).
3 Richard Cork, *Vorticism and Abstract Art in the First Machine Age*, 1976 (Virginia: G. Fraser).
4 *Ibid.*
5 *Blast*, no. 2, July 1915, p. 98.
6 *Vorticism and Abstract Art in the First Machine Age*, vol. 1, p. 148.
7 Lewis portrayed her in two works – *Smiling Woman Ascending a Stair* and *The Laughing Woman.*

8 Della Denman, 'Kate Lechmere: Recollections of Vorticism', *Apollo* XCIII, January 1971.
9 Finch married Norwegian artist Harald Sund, and both were early members of the London Group. Finch, a founder member, exhibited in London between 1907 and 1916. At the outbreak of war in 1914 the couple moved to Norway, after which she disappears from the record.
10 Reported by David Redfern on the London Group website.
11 See Alan Powers, *Bauhaus Goes West*, 2019 (London: Thames & Hudson).
12 See Lisa Tickner, in *Men's Work? Masculinity and Modernism*, 1992 (Indiana: Indiana University Press) and *Differences: A Journal of Feminist Cultural Studies*, vol. 4, no. 3.
13 Henriette Antonia Groenewegen-Frankfort, a Dutch archaeologist and an expert on ancient art, was married to Henri Frankfort, a well-known Dutch Egyptologist and Orientalist, who became head of the Warburg Institute in London in 1948.
14 A toy in one of Saunders's drawings made after 1914 is very similar to one of the first produced in Sylvia Pankhurst's Toy Factory. See Brigid Peppin, *Helen Saunders 1885–1963*, 1996 (Oxford: Ashmolean Museum).
15 *Vorticism and Abstract Art in the First Machine Age.*
16 Wendy Baron, 'Camden Town Recalled', Tate website.
17 Dismorr contributed abstract works to the exhibition.
18 Quentin Stevenson, *Jessica Dismorr & Catherine Giles*, 2000 (London: The Fine Art Society).
19 Richard Cork, Introduction to Brigid Peppin, *Helen Saunders 1885–1963*, I am grateful to Brigid Peppin for updating me with her latest research.
20 *Daily Graphic*, no. 97, CXXV, Tuesday, 8 February 1921.
21 *The Easel Chorus* by Charles K. Wilkinson shows her three rival competitors, Leon Underwood, James Wilkie and Arthur Outlaw, 'diminished by her presence'.
22 Possibly referencing the Silvertown munitions factory.
23 Henry Tonks trained as a surgeon but taught at the Slade from 1892, and became a professor

in 1918. Sometimes considered a misogynist, he could be sympathetic to women on occasion but definitely thought marriage for a woman was incompatible with being an artist.
24 Activist for homosexual rights, socialist poet and philosopher.
25 Letter from Ben Nicholson to art historian Mary Chamot, transcribed by Andrew Wilson in 'The Seven and Five Society: Modernist Activity in British Art, 1919–37', MPhil. thesis, University of Kent.
26 'Women and the 7&5 Society', *Art News*, 19 September 2014.
27 Douglas Percy Bliss, *A History of Wood Engraving*, 1928 (London: J. M. Dent) differentiated the new approach from its previous Victorian reproduction processes.
28 See later chapters for Agnes Miller Parker and Tirzah Garwood.
29 Angus thought the irregularities in her hand-printed wallpapers were more sympathetic to the eye; Gardiner added colour to her plates on a commercial printing press while it was in action, so that no finished copy of her book was exactly the same. See chapters 9 and 18.
30 A prize-winning student at the Slade 1910–14.

CHAPTER 3

1 Unless otherwise cited, the source for quotations from the writings of Winifred Nicholson in this chapter is Andrew Nicholson (ed.), *Unknown Colour: Paintings, Letters, Writings*, 1987 (London: Faber & Faber).
2 Hodgkins exhibited as part of the group 1929–34, Winifred Nicholson 1925–35.
3 Jovan Nicholson, *Winifred Nicholson: Liberation of Colour*, 2016 (London: Philip Wilson).
4 Letter to her mother, 17 February 1915.
5 Letter to Isobel Field, 1921.
6 See chapter 6.
7 Melvin Day, in *Ascent: Frances Hodgkins Commemorative Issue*, 1969 (Christchurch: Caxton Press).
8 Letter to Willie Hodgkins, 1942.
9 Avenal McKinnon in *Frances Hodgkins 1869–1947*, 1990 (London: Whitford and Hughes).
10 Poet for whom nature had a mystical significance.

11 Kathleen Raine, 'The Unregarded Happy Texture of Life', 1984, in Andrew Nicholson (ed.), *Unknown Colour*, 1987.

12 *Ibid*. Letter to student friend Edith Jenkinson, Banks Head 1925.

13 *Ibid*. 'The Flower's Response', 1969.

14 *Ibid*.

15 From an early unpublished draft of 'A Way of Life', cited in *Winifred Nicholson: Music of Colour*, 2012 (Cambridge: Kettle's Yard).

16 From her essay 'Liberation of Colour', first published in *World Review*, 1944.

17 'Radiance in the Grass', 1978, in *Unknown Colour*.

18 *Ibid*.

CHAPTER 4

1 Quoted in Alison Thomas, *Portraits of Women: Gwen John and Her Forgotten Contemporaries*, 1994 (Cambridge: Polity). Much of the information on Clarke Hall in this chapter comes from conversations and correspondence between the author and the artist's granddaughter Gail, and from an online memoir by Edna's son, the architect Denis Clarke Hall, https://sounds.bl.uk/Oral-history/Architects-Lives/021M-C0467X0023XX-0500V0.

2 See Helen Thomas, with Myfanwy Thomas, *Under Storm's Wing*, 1988 (Manchester: Carcanet), and Helen Thomas's memoir *World Without End*, 1931 (London: Heinemann).

3 For a full discussion, see Kathryn Emma Fleming Murray, 'Self-ordering Creativity and an Independent Work Space: Edna Clarke Hall's Poem Pictures in the Early 1920s', University of Birmingham, http://etheses.bham.ac.uk/3755/1/Murray12MPhil.pdf.

4 Born in Wimbledon, her father was a pawnbroker and later a jeweller.

5 From a letter to Alan Powers written by Elsi in the 1980s.

6 Many of the quotes are from her autobiographical notes in the Eldridge archive at Bangor University, currently being prepared for publication by Dr Tony Brown.

7 See above.

8 They moved to Eglwys-fach and then Aberdaron.

9 The author is grateful for discussions with Rhodri Thomas, Eldridge's grandson; Philip Athill at Abbott and Holder; Susan Fogarty of the RS Thomas & ME Eldridge Society; and Helen Williams-Ellis and her film for BBC Cymru. Byron Rogers, *The Man Who Went into the West: The Life of R. S. Thomas*, 2007 (California: Aurum Press) was also an invaluable resource.

10 Eldridge's included slate fences and Welsh chapels.

11 *The Man Who Went into the West*.

12 Canvases mounted on board.

13 I am indebted to Dr Tony Brown and his wife, whose presentation of all Elsi's known work really brought this home clearly.

14 Alan Powers, *British Murals & Decorative Painting 1920–1960*, 2013 (Bristol: Sansom & Co.).

15 Nancy describing Hilda in an interview with Martin Thompson in *The Telegraph*, January 1999.

16 *Ibid*.

17 See chapters 9 and 10.

18 Angus and Cook, in conversation with the author.

19 The RA had always restricted the sort of work acceptable for painting and sculpture; the Women's International Art Club, founded in 1900, made a point of admitting 'embroidery, enamel, jewel and leather work and all kinds of schools of painting without prejudice'.

CHAPTER 5

1 Quentin Bell, *Elders and Betters*, 1995 (London: John Murray).

2 Quoted in Frances Spalding, *Vanessa Bell*, 1983 (London: Weidenfeld & Nicolson).

3 Letter from Fry to Vanessa Bell 1920, quoted in B. J. Elliott and Jo-Ann Wallace (eds), *Women Writers and Artists: Modernist (Im)Positionings*, 2014 (London: Routledge).

4 Quoted in the labelling at the 2017 Dulwich Picture Gallery exhibition, 'Vanessa Bell (1879–1961); Design and Experimentation'.

5 Letter to Roger Fry, 1918, in Regina Marler (ed.), *Selected Letters of Vanessa Bell*, 1993 (London: Bloomsbury).

6 Alison Light, *Mrs Woolf and the Servants: The Hidden Heart of Domestic Service*, 2007 (London: Penguin Figtree).

7 *Elders and Betters*.

8 'Vanessa Bell (1879–1961)', Dulwich Picture Gallery, 2017.

9 This picture is in the New York Metropolitan Museum. When exhibited at the 2017 Dulwich Picture Gallery exhibition of Vanessa's work the curator's note added that Duncan 'first knew she was in love with him when he caught her looking in the mirror while he was shaving'.

10 Letters from Nevinson to Dora Carrington, 8 September 1912, held by the University of Texas, Austin, USA, quoted in David Boyd Haycock, *A Crisis of Brilliance: Five Young British Artists and the Great War*, 2009 (London: Old Street Publishing).

11 *Ibid*.

12 Letter from Gerald Brenan to Dora Carrington, 5 July 1921, quoted in Jane Hill, *The Art of Dora Carrington*, 1994 (London: Herbert Press).

13 Letter from Dora Carrington to Gerald Brenan, May 1923. *Ibid*.

14 *Ibid*.

15 *Ibid*.

16 Letter from Dora Carrington to Lytton Strachey, 22 July 1920, quoted in Jane Hill gallery guide to Barbican exhibition, 1995.

17 Quoted in Mary Ann Caws, *Women of Bloomsbury*, 1990 (London: Routledge).

18 Letter from Sickert to Nan Hudson, 1913, Tate Archive TGA 9125/5, no. 71.

19 Roger Fry, *Nation*, 1912.

20 The Virago edition was published in 1992.

21 Quoted by Bridget Elliott in 'Performing the Picture or Painting the Other: Romaine Brooks, Gluck and the Question of Decadence in 1923', in Katy Deepwell (ed.), *Women Artists and Modernism*, 1998 (Manchester: MUP).

22 Frances Borzello; *A World of Our Own: Women as Artists*, 2000 (London: Thames & Hudson).

23 1923–24.

24 Discussed later in chapter 8.

25 Quoted in Diana Souhami, *Gluck: Her Biography*, 1988 (London: Pandora Press).

26 Architect of Guildford Cathedral, the Runnymede Memorial and Morley College.

CHAPTER 6

1 *Moments of Being: A Collection of Autobiographical Writings*, 1985 (San Diego: Harvest Books).

2 Myfanwy Evans editorial in *Axis*, Summer edition, 1936.

3 John Piper/Geoffrey Grigson in *Axis*, Autumn edition, 1936.

4 Published in 1937.

5 Letter to Philip James, 22 February 1951 ACGB/12V953, in Andrew Nicholson (ed.), *Unknown Colour: Paintings, Letters, Writings*, 1987 (London: Faber & Faber).

6 See Simon Lawrence, *Dunbar Hay Ltd*, 2016 (Huddersfield: Fleece Press).

7 Alan Powers, 'Cecilia Sempill, Dunbar Hay: notes for a lecture', *The Decorative Arts Society*, no. 27, 2003.

8 Oliver Kilbourn, quoted in William Feaver, *Pitmen Painters: The Ashington Group 1934–1984*, 1988 (Ashington: Ashington Group Trustees).

9 Newspaper documents in Tate Archive.

10 Slade 1904–9, m. Sickert 1926.

11 Richard Morphet, obituary in *The Independent*, Sunday, 8 May 1994.

12 David Boyd Haycock, *A Crisis of Brilliance*, 2009 (London: Old Street Publishing).

13 See chapter 18.

14 Her niece Tess, b. 1937, became a painter and taught at the Slade 1968–99.

15 David Mellor (ed.), *A Paradise Lost; The Neo-Romantic Imagination in Britain 1935–55*, 1987 (London: Lund Humphries).

16 The Committee, later Council, for the Encouragement of Music and the Arts; first set up in 1940 by the government with financial backing from the Pilgrim Trust; it later became the Arts Council in 1946.

17 'The Ladies of Miller's: The Miller's Gallery and Press of Lewes in the 1940s and 1950s', Towner Art Gallery, Eastbourne, 1989. See also Diana Crook's article 'Bloomsbury in Sussex', in *Country Life*, 16 April 1987, and her limited-edition booklet *The Ladies of Miller's*, 1996 (Lewes: Dale House Press).

CHAPTER 7

1 Katy Deepwell (ed.), *Women Artists and Modernism*, 1998 (Manchester: MUP).

2 'When was Modernism?', lecture 27 March 1987, University of Bristol.

3 University of Plymouth, 2008, http://hdl.handle.net/10026.1/2528.

4 There seems to be little evidence of contact between Winifred, based in the north, and Marlow Moss.

5 Letter in the Vézelay Collection, Tate Archive, London.

6 Vera Spencer, born in Prague and living in the UK from 1936, trained at the Slade and Central School. She was very productive in the 1950s and hailed as a brilliant maker of collages at a Palais des Beaux-Arts exhibition in Paris. She also exhibited alongside Victor Pasmore and Kenneth Martin in the 'Artist versus Machine' exhibition at the Building Centre, London and at the ICA.

7 The first exhibition of the Groupe Espace of Great Britain.

8 Quoted by Herbert Read, introduction to *Barbara Hepworth: Carvings and Drawings*, 1952 (London: Lund Humphries).

CHAPTER 8

1 Frances Borzello, *A World of Our Own: Women as Artists*, 2000 (London: Thames & Hudson).

2 Eileen Agar in collaboration with Andrew Lambirth, *A Look at My Life*, 1988 (London: Methuen).

3 Married to Lamba 1934–43.

4 French artist trained at the Ecole des Arts Décoratifs.

5 'Religion and the Artistic Imagination', *The Island*, 1 June 1931.

6 Man Ray, quoted in Nicole Parrot, *Mannequins*, 1983 (New York: St Martin's Press).

7 Andrew Lambirth, *Eileen Agar: An Eye for Collage*, 2008 (Chichester: Pallant House).

8 See caption to *Ancestors*, p. 124.

9 See note 2.

10 Eileen Agar: 'An Eye for Collage', Pallant House Gallery, 2008, curated by Simon Martin.

11 Michel Remy, *Surrealism in Britain*, 1999 (London: Lund Humphries).

12 Published by Faber & Faber; see chapter 16.

13 Commentary from 1975, quoted in a review by Lorna Scott Fox in the *Times Literary Supplement*, 5 May 2017.

14 Letter in Tate Archive, 5 July 1932.

15 *Surrealism in Britain*; Richard Shillitoe, *Ithell Colquhoun; Magician*

Born of Nature, 2009 (Lulu.com).

16 Kotex was a manufacturer of early feminine hygiene products.

17 Artist wife of Eric Ravilious, see chapter 14.

18 Penelope Shuttle and Peter Redgrove, *The Wise Wound: Menstruation and Everywoman*, 1978 (London: Victor Gollancz).

19 *Enquiry* October–November 1949, vol. 2, no. 4; article later extended and renamed 'Children of the Mantic Stain', in *Athene*, 1952, no. 2.

20 Now the Tavistock and Portman Clinic, an NHS Foundation Trust in north London specializing in mental health.

21 Grace Pailthorpe, *What We Put in Prison and in Preventive and Rescue Homes*, 1932 (London: Williams & Norgate Ltd).

22 Tate Archive.

23 *Surrealism in Britain*.

24 Toni del Renzio, 'The Uncouth Invasion: The Paintings of Emmy Bridgwater', *Arson*, March 1942.

25 Robert Melville, 'Challenging Pictures at Coventry Art Circle Exhibition', *Coventry Standard*, 8 November 1947.

26 See John Banting quote about Modern Painters in chapter 6.

27 'Alchemy of the Word', *Harper's & Queen*, 1978.

28 See chapter 12.

29 Some of her 100 photos of the Sussex Coast were shown for the first time in a 2017 exhibition at Two Temple Place, London, called 'Sussex Modernism', curated by Hope Wolf.

CHAPTER 9

1 Alexandra Harris, *Romantic Moderns: English Writers, Artists and the Imagination from Virginia Woolf to John Piper*, 2010. (London: Thames & Hudson).

2 *Ibid.*

3 Opening paragraphs from Elizabeth Bowen, 'Mysterious Kor', in *The Demon Lover and Other Stories*, 1945 (London: Jonathan Cape).

4 1890–1937.

5 First published in 1932 in London by Longman's Green and Co.

6 Published in 1957 in London by Peter Owen Ltd.

7 *The Guardian*, Friday, 11 May 2012.

8 Originally published in 1930.

9 See Jill Benton, *Naomi Mitchison: A Biography*, 1990 (London: River

Orams Press/Pandora List).

10 H. Barton Brown, 'Catholic Rector's Reply to Mrs Naomi Mitchison, Middlesex County Times May 23 1931', quoted in *Naomi Mitchison: A Biography*.

11 Poet and critic.

12 Robert Elwall, 'A Cabinet of Curiosities', in *Matrix 27*, Winter 2007.

13 Quoted by Alan Powers in *The Art of Acquisition: Great Bardfield Artists Houses*, 2015 (Saffron Walden: The Fry Art Gallery).

14 Husband of Dilys Powell. From 1951 the book's second editor was John Hadfield.

15 Quoted in Carolyn Trant, *Art For Life: The Story of Peggy Angus*, 2004 (Oldham: Incline Press).

16 Ruth Artmonsky, *A Snapper Up of Unconsidered Trifles: A Tribute to Barbara Jones*, 2008 (London: Artmonsky Arts).

17 David Mellor, Gill Saunders and Patrick Wright, *Recording Britain*, 1992 (Newton Abbot: David and Charles).

18 Quoted in *A Snapper Up of Unconsidered Trifles*.

19 *Ibid.*

20 *Ibid.*

21 Quoted in Peter Blake's Introduction to Barbara Jones, *The Unsophisticated Arts*, new edition 2013 (Dorset: Little Toller Books).

22 Shakespeare's term, often appropriated by Winston Churchill.

23 See Harriet Atkinson, *The Festival of Britain: A Land and its People*, 2012 (London: I. B. Tauris).

24 Artist, pacifist, Quaker and fellow AIA member.

25 James Maude Richards; they had two children born 1938 and 1939.

26 See chapter 1.

27 *Architectural Review*, July 1951.

28 T. W. Ide.

29 Born Cara Clough-Taylor, she reinvented herself with a new name.

CHAPTER 10

1 British art dealer between the wars.

2 29 December 1928.

3 See chapter 6.

4 Quoted in privately printed birthday Festschrift.

5 Carolyn Trant, *Art for Life: The Story of Peggy Angus*, 2004 (Oldham: Incline Press).

6 Since 1984, the NSEAD – National Society for Education in Art and Design.

7 NSEAD literature in *Art for Life*.

8 Elizabeth Marion Rea 1904–1965. After a short-lived marriage and two sons she lived with Nan Youngman until her sudden early death from a brain haemorrhage. She was a founder member of the AIA.

9 See Pauline Lucas, in *Women's Art Magazine*, 1991; *Evelyn Gibbs Artist & Traveller*, 2001 (Nottingham: Five Leaves Publications); *Rediscovery & Restoration: Murals by Evelyn Gibbs at St Martin's Church, Bilborough*, 2015 (Nottingham: Shoestring Press).

10 See chapter 13.

11 *Art for Life*.

12 The journal of the SEA.

13 Quoted in *Art for Life*.

14 *Ibid.*

15 At the RCA 1922–26 with Angus, Hepworth, Ravilious etc.

16 UNESCO Seminar on the Visual Arts in General Education, Bristol, Summer 1951.

17 See Andy Friend, *Ravilious & Co.: The Pattern of Friendship*, 2017 (London: Thames & Hudson) for more details about Binyon's artwork, life and career.

18 German Romantic-philosophical poet, novelist and dramatist; author of essay 'On The Marionette Theatre' (1810).

19 Quoted in Gabriel Josipovici, *What Ever Happened to Modernism?*, 2011 (New Haven: Yale UP).

20 Betsy in *A Voice Through a Cloud*, 1950, and Fat Bertha Swan in *A Party*, 1951.

21 Letter to Ross Chesterman, warden of the college, dated October 1965.

22 Letter to Paddy Rossmore, August 1980, quoted in Paddy Rossmore, *Betty Swanwick: Artist and Visionary*, 2008 (London: Chris Beetles Gallery).

23 Barry Viney quoted in *Artist and Visionary*.

24 See *Art for Life*.

25 'The Living Reference File', *The Artist*, January 1970; I am grateful to Paddy Rossmore for showing me notes from Swanwick's archive.

26 *Observer Magazine*, 29 May 1977.

CHAPTER 11

1 Married for a time to Ananda Coomaraswamy.

2 See Kitty Hauser's biography of archaeologist O. G. S. Crawford, *Bloody Old Britain*, 2008 (London: Granta).

3 *ART* magazine, Winter 2012, 1 December, no. 11 – an RWA quarterly publication.

4 See forthcoming title by Denys J. Wilcox, *The Art of Doris Hatt*, 2019 (South West Heritage Trust in association with The Court Gallery).

5 Lynda Morris and Robert Radford, *AIA: The Story of the Artists International Association 1933–53*, 1983 (Oxford: Modern Art Oxford).

6 Now known simply as a-n.

7 Letter from James Holland to the Foreign Committee of the Moscow Union of Soviet Artists, 1935, quoted in *AIA: The Story of the Artists International Association 1933–53*.

8 *Ibid.*

9 Brother of British journalist and politician Tom Driberg.

10 Special Branch files released in 2003 reveal Edith was under constant surveillance. The subject of interrogations, accusations and harrassment, she was never convicted of anything. Although Anthony Blunt named her in his 1964 confession, it remains unclear what her true involvement – if any – was.

11 Until the exhibition 'Edith Tudor-Hart: In the Shadow of Tyranny' at the Scottish National Portrait Gallery, 2013.

12 Felicity Ashbee, who died in 2008, tried to keep the memory of her father's ideas alive and wrote a biography of her mother – *Janet Ashbee; Love, Marriage, and the Arts and Crafts Movement*, 2002 (New York: Syracuse University Press).

CHAPTER 12

1 Diary entry for 11 April 1945, quoted in Malcolm Yorke, *Mervyn Peake: My Eyes Mint Gold: A Life*, 2000 (London: John Murray).

2 Quoted in Antony Penrose (ed.) *Lee Miller's War*, 1992 (London: Thames & Hudson).

3 See Kathleen Palmer, *Women War Artists*, 2011 (London: Tate Publishing).

4 She is possibly best remembered for her illustrations for Anna Sewell's *Black Beauty* – republished in 1916 (originally published in 1877).

5 Imperial War Museum, *Oral History*, object 80029046.
6 Group No. 4600 in Lincolnshire; letter to her brother Tom, September 1944, quoted on Australian war memorial site.
7 One of very few official war artists in the First World War, and a VAD nurse.
8 Noted in talks given by her son Antony Penrose at Farley Farmhouse, Sussex.
9 Edited by Ernestine Carter, 1941.
10 Quoted in Antony Penrose, *The Lives of Lee Miller*, 1988 (London: Thames & Hudson).
11 Letter to Roland Penrose, cited in Carolyn Burke, *Lee Miller: On Both Sides of the Camera*, 2005 (London: Bloomsbury).
12 *The Lives of Lee Miller.*
13 Katherine Slusher, *Lee Miller and Roland Penrose: The Green Memories of Desire*, 2007 (London: Prestel).
14 F. Reynolds, *The Slade: The Story of an Art School 1871–1971*, quoted in Tom Buchanan, *The Impact of the Spanish Civil War in Britain: War, Loss and Memory*, 2007 (Chicago: Sussex Academic Press).
15 Conversation with Carolyn Trant, quoted in *Art For Life: The Story of Peggy Angus*, 2004 (Oldham: Incline Press).
16 At least two of her peacetime paintings are in the collection of Charleston in East Sussex.
17 Much of her work has only recently come to light again after years stored in an attic.
18 See Alan Powers, *British Murals & Decorative Painting 1920–1960*, 2013 (Bristol: Sansom & Co.); and Christopher Campbell-Howe, *Evelyn Dunbar: A Life in Painting*, 2016 (Brainerd, USA: Romarin).
19 See *Evelyn Dunbar: A Life in Painting.*
20 The author of *Wide Sargasso Sea* (1966).
21 See Ed Vulliamy's article about his aunt in *The Guardian*, Sunday, 27 March 2016.
22 Born in Golders Green, London.
23 Lehmann and her sister Monica Pidgeon were born in Chile, like their great friend Peggy Angus. Olga had a variety of skills, working in stage design and illustration. Monica Pidgeon was the champion of modernist architects. She became the editor of *Architectural Design* in the 1940s – however, the owners of the magazine insisted that two male architects' names, Ernö Goldfinger and Denys Lasdun, were prominent on the masthead to 're-assure readers and advertisers' that a sole woman was not in charge!

CHAPTER 13

1 Andy Friend, *Ravilious & Co.: The Pattern of Friendship*, 2017 (London: Thames & Hudson), pp. 153–54.
2 Anne Ullmann (ed.), *Long Live Great Bardfield and Love to You All: The Autobiography of Tirzah Garwood*, 2011 (Huddersfield: Fleece Press).
3 Elizabeth (Betty) Fitzgerald, one of a pair of identical twins – always known as Duffy.
4 *Ravilious & Co*, p. 82.
5 *Ibid.*
6 *Long Live Great Bardfield & Love to You All.*
7 Letter in Cambridge archive.
8 As quoted by Olive Cook in *Long Live Great Bardfield.*
9 Michael Harrison writing in a Kettle's Yard exhibition catalogue, 1995.
10 A writer for both children and adults who didn't write her first book until she was sixty.
11 Born Marian Anderson Attenborough.
12 See Vivienne's Light's *Circles and Tangents: Art in the Shadow of Cranborne Chase*, 2011 (Bridport: Canterton Books), for a fuller discussion of her life and career.
13 *Ibid.*
14 *Ibid.*
15 *Ibid.* and John Duncalfe, *Katharine Church 1910–1999: A Life in Colour*, 2015 (Chichester: Tillington Press).
16 See portrait, chapter 3.
17 *Circles and Tangents.*
18 Catalogue to her retrospective, 1988 (Harrogate: Duncalfe Galleries).
19 Wife of Ralph Partridge after the death of (Dora) Carrington.
20 *Ibid.*
21 From Helena Moore (ed.) *Nicholsons: A Story of Four People and their Designs*, 1988 (York: York City Art Gallery).
22 Third child and only daughter of William Nicholson and Mabel Pryde.
23 English painter who finally settled in Crete.
24 *Nicholsons: A Story of Four People and their Designs.*
25 Letter quoted in Carolyn Trant, *Art for Life: The Story of Peggy Angus*, 2004 (Oldham: Incline Press).
26 Quoted on the Barns-Graham Trust website.
27 Letter to *The Guardian*, 13 April 2009.

CHAPTER 14

1 Naomi Mitchison, *You May Well Ask: A Memoir 1920–1940*, 1979 (London: Victor Gollancz), p. 79.
2 1966 (London: Harper Collins).
3 'Nancy Spender's Recollections of Wystan Auden' (as recounted to Kathleen Bell), in *The W. H. Auden Society Newsletter no. 10–11: Biography and Memoirs Double Issue*, 1993.
4 See Nicolette Devas, *Two Flamboyant Fathers*, 1966 (London: Harper Collins).
5 *Ibid.*
6 She was a proficient ballet dancer and pianist.
7 Ray Coxon notes that unlike Slade students 'no Royal College students knew what was going on in France. The only student interested was Wilfred Blunt, brother of Anthony, who went round with a small monochrome Cezanne in his pocket', both brothers having been brought up in Paris. Henry Moore eventually read Roger Fry's *Vision and Design*, published in 1921, from the public library, as told to Carolyn Trant in a letter from Prudence Bliss; see also Malcolm Yorke, *Gargoyles & Tattie-Bogles: The Lives and Work of Douglas Percy Bliss and Phyllis Dodd*, 2017 (Huddersfield: Fleece Press).
8 Alan Powers, 'Enid Marx RDI', in *Matrix: A Review for Printers & Bibliophiles*, no. 18, Winter 1998, p. 187.
9 Alan Powers, *Enid Marx: The Pleasures of Pattern*, 2018 (London: Lund Humphries).
10 Michael Parkin, obituary for Raymond Coxon, *The Independent*, 18 February 1997.
11 Mary Moore, *Guardian* interview, 26 July 2008.
12 Mel Gooding, *Ceri Richards*, 2002 (Moffat: Cameron & Hollis).
13 These words of hers were used for the title of exhibitions about her at Huddersfield Art Gallery and Kettle's Yard in 2005.
14 See chapter 18.

CHAPTER 15

1 Kathleen Hale, *A Slender Reputation: An Autobiography*, 1994 (London: Warne).
2 *Ibid.*
3 *Ibid.*
4 *Ibid.*
5 *Ibid.*
6 Isabel's unpublished memoirs are in the Tate Archive.
7 In fact, she did have a child in 1934 by Jacob Epstein, whose wife Margaret conspired to claim the child as her own.

CHAPTER 16

1 Lost for many years, this Famous Women Dinner Service has recently re-surfaced from a private collection and fifty dinner plates were installed in the new exhibition galleries at Charleston in 2018.
2 Ronald Blythe, *First Friends: Paul and Bunty, John and Christine – and Carrington*, 1999 (London: Viking).
3 Deborah Baker, *In Extremis: the Life of Laura Riding*, 1993 (New York: Grove Press), p. 119.
4 Whitney Chadwick, *Women Artists and the Surrealist Movement*, 1985 (London: Thames & Hudson).
5 Katie Roiphe, *Uncommon Arrangements*, 2007 (New York: Dial Press).
6 *First Friends*.
7 Francine Prose, *Lives of the Muses: Nine Women and the Artists they Inspired*, 2003 (California: Aurum Press).
8 Sebastian Peake, *Child of Bliss*, 1989 (Oxfordshire: Lennard/Queen Anne Press).
9 Cecil Collins, *The Vision of the Fool*, 1947 (London: The Grey Walls Press Ltd).
10 Part one of *Smoke in the Valley, Austerity Britain 1948–51*, 2007 (London: Bloomsbury).
11 Nomi Rowe (ed.), *In Celebration of Cecil Collins: Visionary Artist and Educator*, 2008 (London: Foolscap).
12 *Ibid.*
13 *Ibid.*

CHAPTER 17

1 News cuttings in Fry Art Gallery archive.
2 *The Art of Acquisition*, Fry Art Gallery, 2015.
3 Maeve Gilmore, *A World Away: A Memoir of Mervyn Peake*, 1970

(London: Victor Gollancz).
4 *Ibid.*
5 Mary Fedden, 'The Artist Masterclass', in *The Artist*, May 2008.
6 The potter Ursula Darwin, later Mommens, 1908–2010.
7 Quoted in Christopher Andreae, *Mary Newcomb*, 2007 (London: Lund Humphries).
8 Quoted in the Kettle's Yard exhibition of the Nicholsons – Ben and Winifred – and Christopher Wood.
9 'A Scot at the Academy', *Sunday Times*, 7 May 1961.
10 See Philip Vann, obituary of Jean Cooke in *The Guardian*, 2008.
11 When she was replaced by Katharine Whitehorn.
12 'Battle-Axe or Doormat', *The Observer*, 19 April 1959, quoted in Adam Federman, *Fasting and Feasting: The Life of Visionary Food Writer Patience Gray*, 2017 (Vermont: Chelsea Green).
13 See Christopher Reed, *Art and Homosexuality: A History of Ideas*, 2011 (Oxford: OUP) and Lisa Wainwright, 'Robert Rauschenberg's Fabrics: Reconstructing Domestic Space', in Christopher Reed (ed.), *Not at Home: Suppression of Domesticity in Modern Art and Architecture*, 1996 (London: Thames & Hudson).
14 Architect and member of the Independent Group; see chapter 18.
15 *Surrealism and Design*, 2007 (London: V&A Publishing); Frederick Kiesler, *Inside the Endless House: Art, People and Architecture*, 1964 (New York: Simon and Schuster).

CHAPTER 18

1 Quotes from Independent Group members come from David Robbins (ed.), *The Independent Group: Postwar Britain and the Aesthetics of Plenty*, 1990 (Cambridge, USA and London: MIT Press).
2 Quoted in Grayson Perry, *Playing to the Gallery: Helping Contemporary Art in Its Struggle to Be Understood*, 2014 (London: Penguin), based on his 2013 BBC Reith Lectures.
3 See Robert Burstow, 'The Geometry of Fear: Herbert Read and British Modern Sculpture'

and 'The Second World War', in Benedict Read and David Thistlewood (eds), *Herbert Read: A British Vision of World Art*, 1993 (Leeds City Art Gallery & Henry Moore Foundation).
4 The political clause of the constitution having been removed in 1953.
5 Iona and Peter Opie, *The Lore and Language of Schoolchildren*, 1959 (Oxford, OUP).
6 One-woman exhibition at Scottish National Gallery of Modern Art, Edinburgh, 2016–17.
7 Quoted in Robert Kudielka (ed.), *The Eye's Mind: Bridget Riley Collected Writings 1965–1999*, 1999 (London: Thames & Hudson).
8 *Sunday Times*, December 1979.
9 Born Hungary, died USA.
10 Gillian Ayres was also working with Ripolin enamel paint in the 1950s, like Picasso, on large canvases onto which she threw paint and turps. Born in 1930 she is a little 'young' for my book, especially as she carried on working until 2018.
11 *The Independent Group: Postwar Britain and the Aesthetics of Plenty*.
12 Rachel Cooke, *Her Brilliant Career: Ten Extraordinary Women of the Fifties*, 2013 (London: Virago).
13 Richard Hamilton's first wife Terry was killed in a car crash in 1962.
14 b. 1922 – artist and critic, married to Reyner Banham.
15 German philosopher and critical theorist.
16 Quoted in David Kynaston, *Family Britain 1951–57: Tales of a new Jerusalem*, 2009 (London: A&C Black).
17 Quoted in *Mary Martin: The End is Always to Achieve Simplicity*, 2005 (Huddersfield Art Gallery).
18 Alison Smithson published *A Portrait of the Female Mind as a Young Girl* in 1966.
19 Now in the National Portrait Gallery, London.
20 Ruth Artmonsky, *A Snapper Up of Unconsidered Trifles: A Tribute to Barbara Jones*, 2008 (London: Artmonsky Arts).
21 She became unexpectedly pregnant and pregnancy scans revealed she had cancer; refusing an abortion or chemotherapy that could damage her baby, she died when her daughter was five months old.

INDEX

Page numbers in *italic* refer to illustrations